2003

2003

Max Beckmann

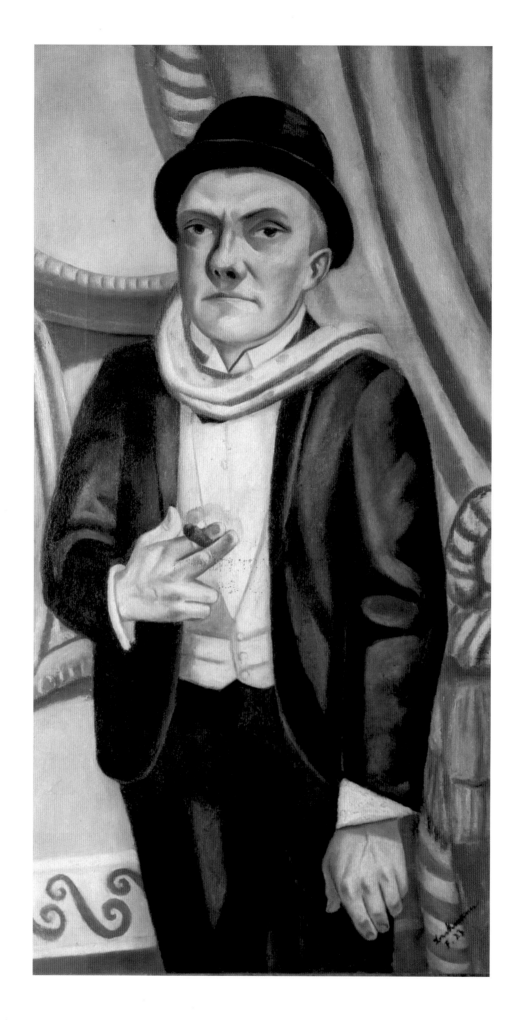

Max Beckmann

Edited by Sean Rainbird

THE MUSEUM OF MODERN ART

The *Max Beckmann* exhibition has been organised as an association between the Musée national d'art moderne, Centre Georges Pompidou, Paris, Tate Modern, London, and The Museum of Modern Art, New York

Centre Georges Pompidou, Paris
10 September 2002 – 6 January 2003

Tate Modern, London
12 February – 5 May 2003

MoMA QNS, New York
25 June – 30 September 2003

The New York showing of *Max Beckmann* is supported in part by The International Council of The Museum of Modern Art. The accompanying publication is made possible by The International Council of The Museum of Modern Art.
The accompanying educational programs are made possible by BNP Paribas.

First published in 2003 by order of the Tate Trustees by Tate Publishing, a division of Tate Enterprises Ltd, Millbank, London SW1P 4RG
www.tate.org.uk

Text by Didier Ottinger © Editions du Centre Pompidou, Paris 2003
Text by Robert Storr © Robert Storr 2003
All other texts © Tate 2003

Works by Max Beckmann © DACS 2003 and © 2003 Artists Rights Society (ARS), New York/ VG Bild-Kunst, Bonn
Francis Bacon © Tate 2003
Otto Dix © DACS 2003
Jasper Johns © Jasper Johns/VAGA, New York/ DACS, London 2003
Philip Guston © Philip Guston Estate 2003
Jörn Immendorff © Jörn Immendorff, courtesy of Galerie Michael Werner, Cologne/New York
Pablo Picasso © Succession Picasso/DACS 2003

A catalogue record for this book is available from the British Library

ISBN 0-87070-241-6 clothbound
ISBN 0-87070-242-4 paperbound

Designed by Stephen Coates, AugustProjects
Printed and bound in Italy by Conti Tipocolor

Cover:
Self-Portrait with Red Scarf 1917
80 × 60 (31½ × 23⅝)
Staatsgalerie Stuttgart

Frontispiece:
Self-Portrait in front of a Red Curtain 1923
110 × 59.5 (43 ³/8 × 23.5 ½)
Private collection, Courtesy Neue Galerie, New York

Measurements of artworks are given in centimetres, height before width, followed by inches in brackets.

Paintings by Beckmann that are referred to in the text but not illustrated are followed by a reference number, beginning 'G'. This relates to the *catalogue raisonné* of Beckmann's oil paintings by Erhard Göpel and Barbara Göpel. See Bibliography for full details.

Contents

Foreword

This collaboration marks the first occasion since the 1960s that Paris, London and New York have hosted comprehensive surveys dedicated to the work of Max Beckmann. We are delighted to present his extraordinary achievements to an international audience and firmly believe the power of his art will come as a revelation to those visitors who are encountering his work again or those seeing it for the first time. The selection for each venue has been made by the curators: Didier Ottinger for the Centre Pompidou, Sean Rainbird for Tate Modern and Robert Storr for The Museum of Modern Art. Their association has created an exhibition with a common core but shaped to the requirements of each city.

Beckmann stands as an isolated giant of early twentieth-century European art. In Germany he struck out on a notably individualistic path; expressive rather than Expressionist, seeking what he called a 'transcendental objectivity' for his figuration alongside the sober realism of 1920s New Objectivity. His experience in Paris, where he saw the work of Picasso and Matisse, encouraged the development of a more painterly approach. A fusion of these elements generated a rich pictorial universe of allegory and myth in the 1930s and 1940s. Beckmann used his paintings to distance himself from daily reality, but also to comment on his position as an artist during the calamitous period of European history through which he lived. For him this meant early celebrity followed by defamation when at the peak of his powers and reputation. He went into exile during the period of the Third Reich, before he found final sanctuary and a new lease of life in the United States, where he died in 1950.

Our debt to lenders to the exhibition is enormous. Many of Beckmann's paintings are becoming more fragile with age and their presence in the exhibition is a testament to the deep sense of responsibility felt by owners towards the artist. Several institutions, particularly those in Munich and St Louis, have major holdings of Beckmann's work; to them we owe a special vote of thanks as the loss of whole groups of works to the exhibition has a great impact on their own displays. The same can be said for institutions and collectors with smaller groups of exceptionally fine works or single masterpieces which are focal points in their collections. They include, in particular, private collectors and museum collections in Berlin, Cambridge, Düsseldorf, Hamburg, Hanover, Mannheim, New York, Stuttgart and Washington. Tate Modern and The Museum of Modern Art are showing a common group of works. However, a small number of loans, including some works on paper and individual paintings, have been made available only to single venues. We hope the realisation of the show in London and New York will match these owners' profound respect for the artist and their confidence in the ability of our two museums to enhance an understanding of Beckmann's great achievement.

Many staff at Tate Modern and The Museum of Modern Art have contributed to the success of this project and it is difficult to thank all of them adequately. The exhibition has been created and managed by dedicated teams in both London and New York. At Tate Modern Sean Rainbird has been assisted by Susanne Bieber. Robert Storr, at The Museum of Modern Art, has been assisted by Roxana Marcoci and Elizabeth Grady. They have relied heavily on the support of colleagues in the exhibition departments of both museums, and on the technical and specialist support of registrars, conservators, art handlers, communications

and education colleagues, fundraisers and many others.

Our colleagues in Paris have produced a separate French catalogue to complement their version of this survey exhibition. This present catalogue, shared between Tate Modern and The Museum of Modern Art, is the first comprehensive English-language catalogue on the artist published since Beckmann's centenary retrospective in 1984. It contains new research by German, American and British scholars, using documentary material published over the past decade. There are, too, several distinctive contributions by practising artists, for whom Beckmann's contribution to art has had special significance. We are especially grateful to them for agreeing to share their insights in a medium other than the one with which we more usually associate them. Impressively illustrated, this beautiful catalogue was designed in London by Stephen Coates. It has been edited by Judith Severne and Sarah Derry, with picture research by Odile Matteoda-Witte. We offer them, along with Celia Clear, Sophie Lawrence and Roger Thorp, our sincerest thanks.

Generous support for the catalogue has been received from Robert and Mary Looker, and from Stephen and Anna-Marie Kellen. To them we owe especial gratitude for giving such immediate and unquestioning support to the realisation of this ambitious catalogue.

Nicholas Serota
Director, Tate, London

Glenn D. Lowry
Director, The Museum of Modern Art, New York

Curators' Acknowledgements

This exhibition would not have happened without the assistance and advice of many colleagues, collectors and individuals in many places and institutions across the world. We are profoundly grateful to them for their generosity and belief in the project. The enthusiasm of the Beckmann heirs for this project has been present from the very beginning. The interest shown from the show's inception by Maja Beckmann and Mayen Beckmann and their insights into and information about Beckmann have added immeasurably to the quality of the show. We are greatly heartened by their support.

Our deepest debt is to those individual and institutional owners who have agreed to be parted from their important and valuable works for many months. Our warmest thanks go to those lenders, listed on p.290, including private collectors who have preferred to remain anonymous.

We would like to thank all contributors to the catalogue, Didier Ottinger, Anette Kruszynski, Jill Lloyd, Susanne Bieber, Barbara Copeland Buenger, Leon Golub, Charles Haxthausen, Ellsworth Kelly, William Kentridge and Nina Peter, for sharing their insights into this fascinating artist.

Many people have helped with advice, information, introductions, securing loans and finding solutions to seemingly insuperable problems. Their contribution has made this a better show and a more informed catalogue than would otherwise have been the case. To each of them we owe a vote of thanks. We are particularly indebted to: Doris Ammann, Frances Beatty, Beatrice von Bormann, Wolfgang Büche, Frances Carey, Mieke Chill, Howard Creel Collinson, Christoph Danelzik-Brueggemann, Lisa Dennison, Anthony Downey, Richard Feigen, Walter Feilchenfeldt, the late Annaliese Foster, Hildegard Fritz-Denneville, Barbara Göpel, Dorothee Hansen, Fabrice Hergott, Cornelia Homburg, Barbara Honrath, Joachim Kaak, Erika Költzsch, Christian Lenz, Jeremy Lewison, Ulrich Luckhardt, Annemarie Lütjens, Karin von Maur, Evan M. Maurer, Manfred Meurer, David Nash, Peter Nisbet, Norbert Nobis, Katrin Rademacher, Seamus Rainbird, Hilde Randolph, Ines Schlenker, Sabine Schulze, Jody Simon, C. Staufer, Andreas Strobl, Ben Willikens, Christiane Zeiller, and Henry and Martin Zimet.

The preparatory period for this exhibition has been accompanied by profound shifts within each of our museums. In London the opening of Tate Modern and attendant modifications to the organisation of staff have called for particular concentration and dedication in seeing this project through to successful completion. The opening of MoMA QNS, where this exhibition travels after its London showing, maintains the continuity of The Museum of Modern Art's exhibitions programme during the current, ambitious programme of expansion in Manhattan. The dedication of many Tate and MoMA staff kept the project on course. We are most fortunate in having their support and participation.

In London we would like to thank Susanne Bieber in particular, for her dedication to the realisation of so many organisational aspects of the project; also, Nicholas Serota, Silvia Baumgart, Sophie Clark, Emma Dexter, Cecile Malaspina, Odile Matteoda-Witte, Stephen Mellor, Jacqueline Michell, Ruth Rattenbury, Jonathan Thristan, Sarah Tinsley, and Sheena Wagstaff. We had essential and valuable support from our colleagues in Conservation and Transport, led by Stephen Dunn, Tim Green, Elizabeth McDonald, Brian McKenzie, Gillian Smithson and Calvin Winner; Art Handling, led by John Duffet, Phil Monk, and Glenn Williams; Education

and Interpretation, led by Jane Burton, Stuart Comer and Dominic Willsdon; Communications, led by Claire Eva, Jane Scherbaum, Calum Sutton and Nadine Thompson; Visitor Services, led by Dennis Ahern, Brian Gray, Adrian Hardwick and Marcus Horley; and Development, led by Jane Brehony, Jennifer Cormack, Jules Foster, Richard Hamilton and Andrea Nixon. Tate Publishing never wavered in their backing of the catalogue; we would like to thank in particular Judith Severne for her editorial expertise and tireless attention to every detail, and her colleagues Celia Clear, Sarah Derry, Sophie Lawrence and Roger Thorp.

In New York, we would like to thank: Ronald S. Lauder, Chairman; Robert B. Menschel, President; Agnes Gund, President Emerita; Glenn D. Lowry, Director; James Gara, Chief Operating Officer; Jennifer Russell, Deputy Director for Exhibitions and Collection Support; Stephen Clark, Associate General Counsel; Michael Margitich, Deputy Director, External Affairs; Monika Dillon, Director, Exhibition Funding and Associate Director, External Affairs; Ruth Kaplan, Deputy Director Marketing and Communications; Deborah Schwartz, Deputy Education Director; Carol Coffin, Executive Director, The International Council; Jay Levenson, Director, The International Council; Michael Maegraith, Publisher. We had essential and valuable support from our colleagues in the Department of Painting and Sculpture from Kynaston McShine, Acting Chief Curator, Kirk Varnedoe, former Chief Curator, Cora Rosevear, Associate Curator, Roxana Marcoci, Curatorial Assistant, Avril Peck, Loan Assistant, Elizabeth Grady, Research Assistant, Cary Levine, Assistant, Hester Westley, Intern, and Noa Turel, Intern; Department of

Drawings from Gary Garrels, Chief Curator; Department of Prints and Illustrated Books from Deborah Wye, Chief Curator; Exhibitions and Collection Support from Beatrice Kernan, Assistant Director; Exhibitions from Maria D. Beardsley, Coordinator of Exhibitions, and Randolph Black, Associate Coordinator of Exhibitions; Exhibition Design and Production from Jerome Neuner, Director, David Hollely, Designer/ Production Manager, and Peter Perez, Framing, Conservator; Conservation from James Coddington, Chief Conservator, and Michael Duffy, Conservator; Collection Management and Exhibition Registration from Ramona B. Bannayan, Director, Jennifer Wolfe, Senior Assistant Registrar, Heidi O'Neill, Assistant Registrar, Peter Omlor, Manager of Art Preparation and Handling, and Robert Jung, Assistant Manager; Library and Museum Archives from Milan Hughston, Director, Michelle Elligott, Archivist, and Jenny Tobias, Associate Librarian, Reference; Communications from Kim Mitchell, Director; Marketing from Peter Foley, Director; Education from Francesca Rosenberg, Assistant Director, and Amy Horschak, Museum Educator, Coordinator of Internships and International Adult Education Programs; Graphic Design from Edward Pusz III, Director, and Claire Corey, Production Manager; Information Systems from Keisuke Mita, Manager; Visitor Services from Diana Simpson, Director.

Sean Rainbird
Senior Curator, Tate

Robert Storr
Senior Curator, The Museum of Modern Art

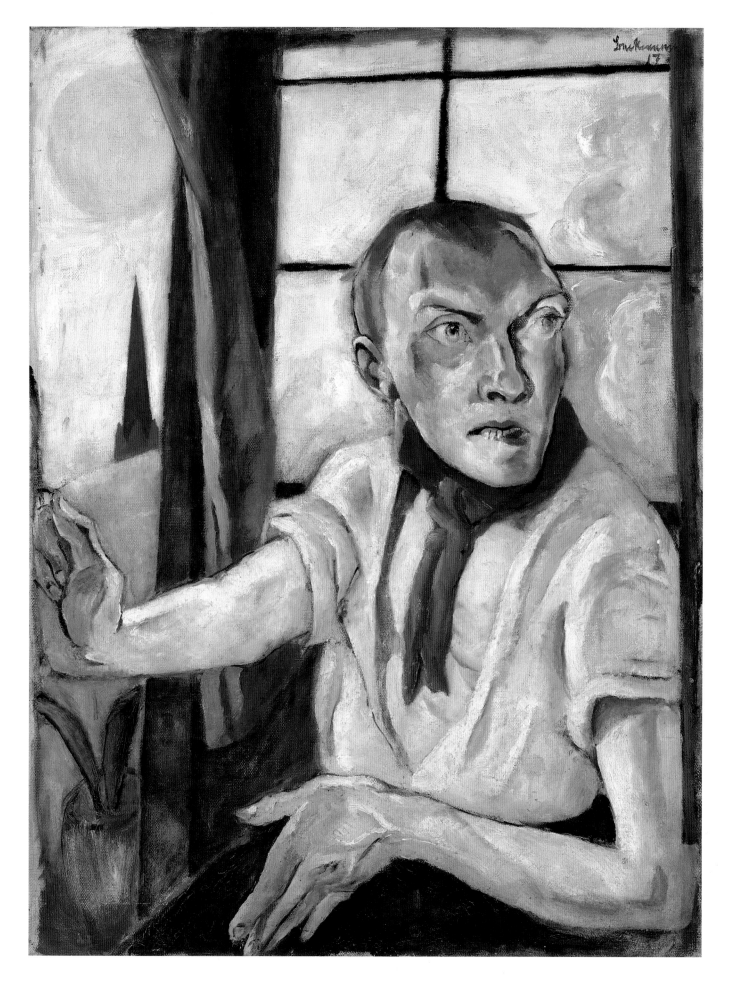

The Beckmann Effect
Robert Storr

no.1
*Self-Portrait with
Red Scarf* 1917
80 x 60
(31 1/$_2$ x 23 5/$_8$)
Staatsgalerie
Stuttgart

What is to be done with what Max Beckmann did? What has been done with it? If influence is the measure of an artist's historical significance, then Max Beckmann has had perhaps the least impact on his contemporaries or on subsequent generations of any of the major painters of his period. Not, of course, that there was any shortage of Beckmann imitators from the 1920s through to the 1950s when he was most active and his work was most widely seen. Nor did he lack for students during the many years he taught – in Frankfurt at the Städel Art School between 1925 and 1933, at the School of Fine Arts at Washington University for two years starting in 1947, at the University of Colorado in the summer of 1949, and finally at the Brooklyn Museum Art School from 1949 to 1950. But while a number of the young artists who flocked to him went on to significant achievements of their own – in America

the geometric sculptor George Rickey and the gestural figure painter Nathan Olivera come first to mind – only a few of them, notably his Viennese disciple Marie-Louise von Motesiczky, worked in anything resembling their mentor's idiom. It is to Beckmann's credit that he discouraged students from aping his manner, though the temptation must have been irresistible to many. However, is it also evident that unlike his German peers at the Bauhaus, the Dutch artists of the de Stijl group, the Russian Suprematists and Constructivists who propagated their ideas through the house organs and academies of the Soviet avant-garde, and French painters such as Ferdnand Léger who set up their own atelier schools, Beckmann did not have a method or a codified formal approach to profess. The paradoxical upshot is that Beckmann stands out among major twentieth-century

modernists as a father figure without progeny.

What Beckmann did have was the authority of a man both charismatic, and, in spontaneous as well as studied ways, enigmatic. Diaries, statements, letters and published records of his conversations offer the vivid impression of someone generally reluctant to analyse his own practice yet given to philosophical and poetic speculations. Although accented with displays of pugnacious irony, the lofty tone and mystical vocabulary of his writings draw the reader in – just as his words mesmerised those such as Stephan Lackner or Joseph Pulitzer who were to lucky enough to have heard them first hand – while throwing up a screen of secondary verbal images that partially obscures the basic visual logic of his work.[1] Beckmann, of course, was a master at concealing one thing with another, and in fundamental ways his work's visual logic is precisely a matter of such overlappings and conflations, and of the game of semiotic hide-and-seek they set in motion and perpetuate through the inherent instability of his compositions. In the long run, however, concentration on the artist's dramatic personality and high-flown rhetoric has come at some cost to the art he made.

On the one hand, many sympathetic interpreters have had a tendency to be carried away by the opportunities afforded them for an essentially literary exegesis to his work. Its pictorial dynamics are often given short shrift except for a few generalisations about their theatrical or archaising aspects, qualities that will come up for further discussion later on. On the other hand, sceptics and outright detractors have been all too quick to dismiss Beckmann as a 'merely' literary artist of an especially credulous, conservative and therefore suspect variety. For such hostile critics his fascination with the hermetic traditions and his susceptibility to the transcendental nonsense of theosophical mother superior Mme Blavatsky and her ilk are the indisputable proof that his work is essentially an exercise in retrograde mystification in modern dress.

Although in every respect his aesthetic opposite, Mondrian shared Beckmann's metaphysical longings and his weakness for theosophical metaphor and jargon, but efforts at rescuing this paragon of the avant-garde from the clammy embrace of late Symbolism and its table-tapping enthusiasts have required turning a blind eye to or simply lopping off the inconvenient aspects of Mondrian's production in which Symbolist influence and his own esoteric impulse are most evident. Historians have imposed a tactful silence about the large body of his writings in which those ideas remained embedded long after he turned to pure abstraction.

Beckmann's pronouncements are fewer in number than Mondrian's and less systematic overall, while the integral part that otherworldly poetics played in his aesthetic thinking is plainly visible throughout his middle and late career and latent before that. Thus there is no question of setting the problem of his presently unfashionable metaphysical leanings aside, as has been attempted with Mondrian.[2] Nevertheless, when Beckmann exclaims in his 1938 *ars poetica* 'On My Painting' that 'Space and space again, is the infinite deity which surrounds us and in which we are ourselves contained', we must step back from his grandiloquent but vague onslaught of abstract statements and ask ourselves not what theology Beckmann subscribed to, or what romantic precedent he meant to evoke, but rather what spatial model these exalted sentiments were intended to describe, what circumstances or

factors account for them, and why having served Beckmann so well they proved so hard to pass along, but so crucial to the handful of artists who have taken them up again?[3]

From the very beginning of his career it was obvious that the space Beckmann intuited and then deliberately built to house his teeming world of emblematic beings and things unfolded in his imagination at odd, contorted angles to the evermore reductive space developing out of mainstream modernism. Having allied himself with his elders in the Berlin Seccession in the defence of Edvard Munch, who had been attacked by Berlin's old guard artists, Beckmann had come to terms to some extent with the initial geometric and chromatic distillations of Impressionist and Post-Impressionist painting. However, he never relented in his objections to the decorative flattening and patterning of the picture plane typical of work influenced by the Jugendstil and Art Nouveau. Moreover, at the same time as he was looking to Munch for inspiration, whose colour blocks, cloisonné forms and cursive drawing framed psychologically charged scenarios with which the young artist readily identified, despite the fact that these were the very devices he deplored in the work of others. Beckmann devoted himself to creating overloaded 'machines' that improbably and inelegantly synthesise Michelangelo, Rubens and Delacroix, among other old masters, and Lovis Corinth and Max Slevogt among the new. The most fully developed examples were *The Battle* 1907 (G85), *Resurrection* 1909 (G104), *Scene from the Destruction of Messina* 1909 (G106) and *The Sinking of the Titanic* 1912 (no.6). In them the turgidness and awkwardness of the early Paul Cézanne is also felt (whether as a consequence of

no.2
Small Death Scene
1906
110 × 71 (43 1/4 × 28)
Staatliche Museen
zu Berlin,
Nationalgalerie,
Eigentum des
Landes Berlin

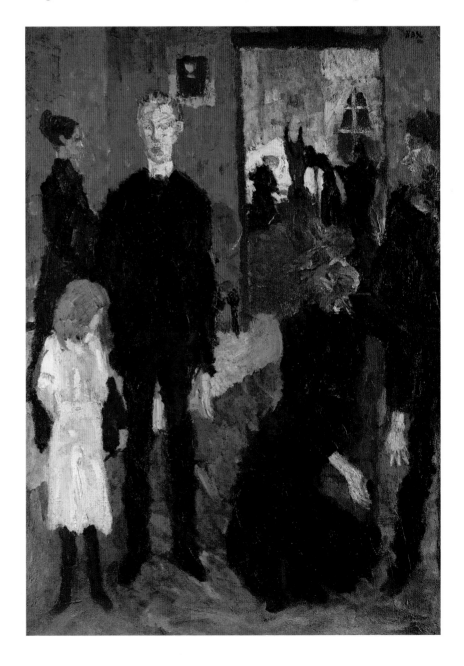

comparable immaturity or of conscious influence), but otherwise the paintings seem stranded between their indebtedness to all too obvious historical sources and a youthful hubris that mistakes itself for radicalism. In short, Beckmann's awareness of the possibilities offered by turn-of-the-century painting lagged behind his energy, but that abundant energy made him assertive in the area of his greatest confusion, namely the spatial realm that had been opened to his generation by Munch, Cézanne, Georges Seurat, Paul Gauguin, and Vincent van Gogh.

Although Beckmann admired Cézanne, van Gogh and Munch – but always with qualifications – he was hard on Gauguin, passed over Seurat and, before the First World War, saved his most disparaging remarks for Henri Matisse. After seeing an exhibition of Matisse's work at Paul Cassirer's gallery in Berlin in 1909 he wrote:

I disliked the Matisse paintings intensely. One piece of brazen impudence after another. Why don't these people just design cigarette posters, I said to Shocken, who fully shared my opinion. Curious these Frenchman – otherwise so intelligent – can't say to themselves that after the simplification practiced by Van Gogh and Gauguin, it's time to go back to multiplicity. There is no way past those two: you have to take what they have achieved, turn back, and look for a new path from some earlier point on the route.'[4]

He would be equally dismissive of Wassily Kandinsky and of Picasso, whose abstract work he referred to contemptuously as 'chessboard,' or 'necktie' art.[5]

no.3
*Young Men by
the Sea* 1905
148 × 235
(58 1/4 × 92 1/2)
Kunstsammlung
zu Weimar

no.4
*Double-Portrait of
Max Beckmann and
Minna Beckmann-Tube*
1909
143.5 × 112
(56 1/2 × 44 1/8)
Staatliche Galerie
Moritzburg Halle,
Landeskunstmuseum
Sachsen-Anhalt

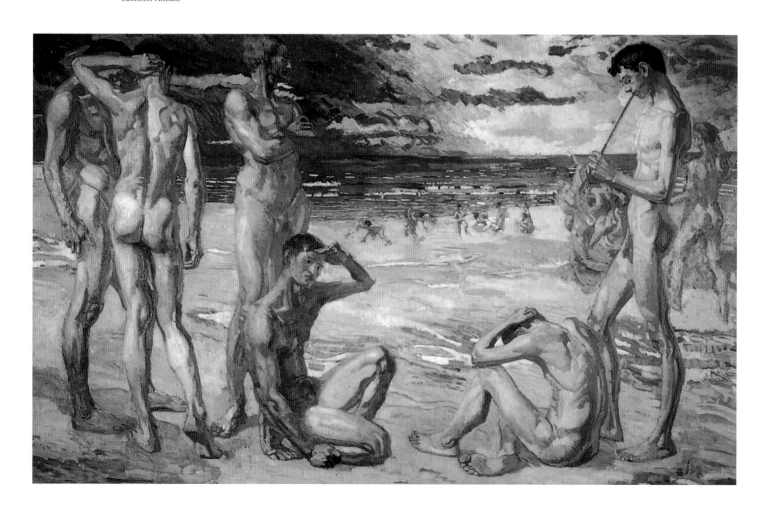

In retrospect Beckmann's judgements seem stuffy and myopic, and place him in the company of ordinary philistines of the period. Indeed, as was common among traditionalists who felt obliged to acknowledge the advent of the new modes of painting but were loathe to cede any substantial ground to them, Beckmann contended that abstraction as such was unnecessary or redundant because it constituted nothing less – or more – than the formal template or foundation essential to the composition of all great works, and, while serving that function had no need to be made visible for its own sake. And yet, countering the position of a friend who ranked the structure of paintings below 'the overall impression', Beckmann declared: 'I would place it above. The structure is the handwriting of the painting.'[6] On another occasion, he elaborated:

it is ludicrous, in any case, to talk so much about cubism, or structural ideas. As if there were not a structural idea embodied in every good painting, old and new – including, if you like, those calculated to achieve cubist effects. The great art lies in concealing these – in a sense – basic compositional ideas in such a way that the composition looks completely natural, and at the same time rhythmical and balanced: constructed in the best sense of the word. What is feeble and overly aesthetic about the so-called new painting is its failure to distinguish between the idea of a wallpaper or poster and that of a 'picture'.[7]

Compounding this categorical argument was Beckmann's disdainful gendering of decorative art. After his return　　⇒→ 23

Images of the Times in Beckmann's Early Work
Sean Rainbird

In published comments and private correspondence both early in Beckmann's career and at later intervals, the artist repeated an intention to make art that was directly relevant to the times in which it was made. 'Right now', he exclaimed in his 'Creative Credo' written in September 1918 in the immediate aftermath of Germany's devastating military defeat and consequent social and political upheaval, 'we have to get as close to people as possible … [so] that we give them a picture of their fate'.[1] To achieve this the artist could not afford to be a distant observer. Rather, as Beckmann had declared in November 1917, one needed to be 'a child of one's time'.[2] These observations echoed a similar intention expressed in his diary ten years earlier about creating an art 'that can

always be immediately present in the essential aspects of life'.[3]

In late 1908 Beckmann first depicted a public event, one that showed a collective experience rather than the solitary moods one encounters in his many early coastal landscapes. Before then his most ambitious multi-figure paintings had been large-scale biblical and mythological scenes. These include *The Battle* 1907 (G85), *The Deluge* 1908 (G97) and *Mars and Venus* 1908 (G91). *Balloon Race* (no.5) shows a scene in the winter of 1908 that Beckmann might have witnessed: hot air balloons ascending from a stadium in a contest named after the newspaper publisher James Gordon-Bennett. However, Beckmann's picture appears less concerned with depicting a race than with creating a dreamy

no.5
Balloon Race
(Ascent of the
Balloons in the
Gordon-Bennett
Race) 1908
70 x 80.5
(27 ¹/₂ x 31 ³/₄)
Staatsgalerie
Stuttgart

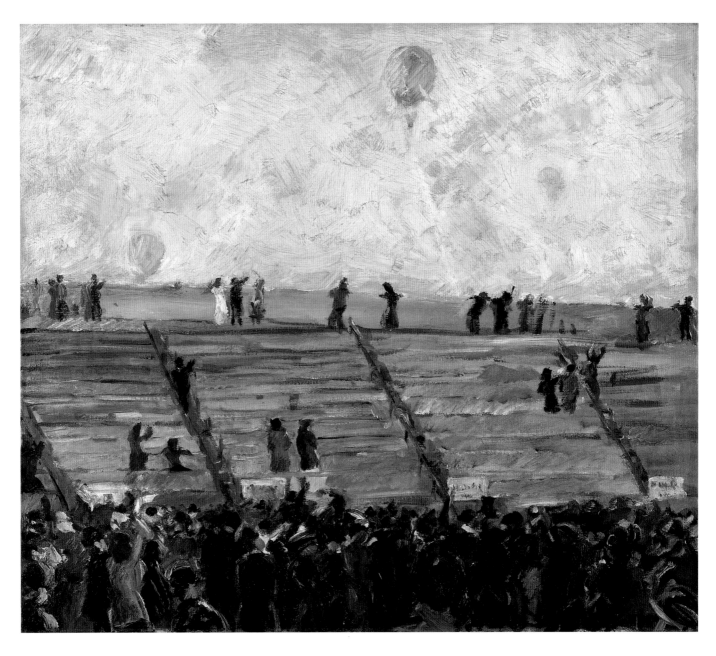

atmosphere, with balloons gliding above the crowd of spectators into the distance behind some tiered stands.

Shortly afterwards, Beckmann attempted to give people 'a picture of their fate' – rather more forcefully than in this impressionistic painting – in the first of two ambitious pictures inspired by widely reported catastrophic events. For the two paintings, Beckmann reactivated the by now defunct – at least for the modern artist – narrative genre of history painting. On 31 December 1908 he read about a devastating earthquake three days earlier in Messina, southern Italy. A particular detail caught Beckmann's attention: the widespread collapse of the city's buildings resulted in prisoners escaping from gaol. It was their crazed assaults on Messina's citizens

that suggested 'the idea for a new picture'.[4]

The artist kept a diary record of his work-in-progress.[5] He used newspaper photographs as source materials,[6] and recorded visits from models who sat for individual figures in the painting. The diary documents the diligence and careful planning behind the gradually assembled composition. Beckmann clearly felt that the work's grand status as a contemporary history painting demanded such efforts, and modelled the painting on the work of exponents of the early nineteenth-century French tradition, in this case Delacroix. Its truth to life extended to the colour scheme; it was painted almost exclusively in factually accurate but visually deadening ashen greys and browns. This dullness prompted Hans Kaiser, writer of

the earliest monograph on the artist, to state it was not the colour 'but the pathos of Beckmann's vision that reminded one of Delacroix'.[7] A new, contemporary subject in Beckmann's work had accordingly, wrote Kaiser, required a new treatment.

Writing in 1913 with the benefit of hindsight, Kaiser acknowledged the adverse comments the painting had provoked when exhibited at the 1909 Secession. It was criticised for being 'journalistic and illustrative'.[8] In its defence he proposed that the passions and grandiloquent gestures, particularly of the man and woman on the lower right, symbolised the spirit of the times, especially the volatile energies of contemporary Berlin.[9] The critic Julius Elias suggested Beckmann was not yet artistically

equipped for such subjects and had produced a caricature rather than the unedited 'grotesque expression' that the confusion of life experiences demanded. It was precisely the presence of the grotesque in the everyday, full of inconsistencies, brutalities and irony, that became Beckmann's oft-repeated objective for the multitude of drawings and prints he made during the First World War, based on his observations and impressions at the front as a medical orderly. Another commentator, Robert Schmidt, dismissively and provocatively proposed that the Messina picture would be better used as a film poster, a rather different status of image than indicated by Beckmann's high ambitions for his work.

These criticisms reflect Beckmann's ambition, but also scepticism that art could still tackle such narrative subjects on a grand scale. The implication was that these needs were better served by the increasing actuality of news media and either still or cinematic photography. Before the First World War, however, Beckmann repeatedly produced treatments of contemporary, religious and mythological subjects long since abandoned by his modernist peers. The critics, though, did not always differentiate between those of his pictures that took contemporary themes as their subject and those that did not.[10] The actuality of the Messina earthquake gave the painting no added impact in terms of drama or sensation, but it further opened the divide between reportage and painting in the grand manner that made Beckmann's picture appear ponderous and overblown.

Beckmann's imagination continued to be exercised by the contemporary vitalistic urge for survival in extreme circumstances and for the search for dominance over fellow humans when the existing order is unexpectedly overturned. In 1913 he revisited the idea of competitive survival in *Crashing Cyclist* (G170), which shows a dramatic, possibly fatal crash during a six-day cycle race, the kind of popular entertainment Beckmann attended throughout his life.[11] Writing in his diary at the very end of 1912 (the year-end appears to be a time Beckmann took stock and conceived of new challenges), Beckmann assessed his own position as an artist still breaking through yet challenged by those who were even younger.[12] Perhaps this sentiment helped motivate him in the early summer of 1913 to paint his most ambitious history painting yet.

Three years after the Messina picture, which Beckmann, perhaps discouraged by its adverse critical reception, never again exhibited during his lifetime, his imagination was fired by another incident of contemporary catastrophe. The loss of the *Titanic*, a large, technically advanced and supposedly unsinkable luxury liner, on 15 April 1912, was a resounding moment of hubris. It was steaming at dangerously high speeds through an area with icebergs in an attempt to win, on its maiden voyage, the Blue Riband for the fastest Atlantic crossing. The composition shows Beckmann emulating his artistic forebears again, this time Théodore Géricault's monumental *The Raft of the Medusa* of 1819 (Louvre, Paris). Beckmann's picture, however, entirely lacks the

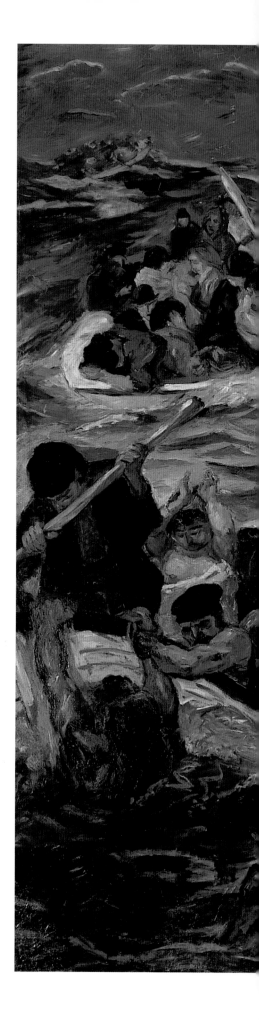

no.6
The Sinking of the Titanic 1912
265 × 330
(104 3/8 × 129 7/8)
The Saint Louis Art Museum. Bequest of Morton D. May

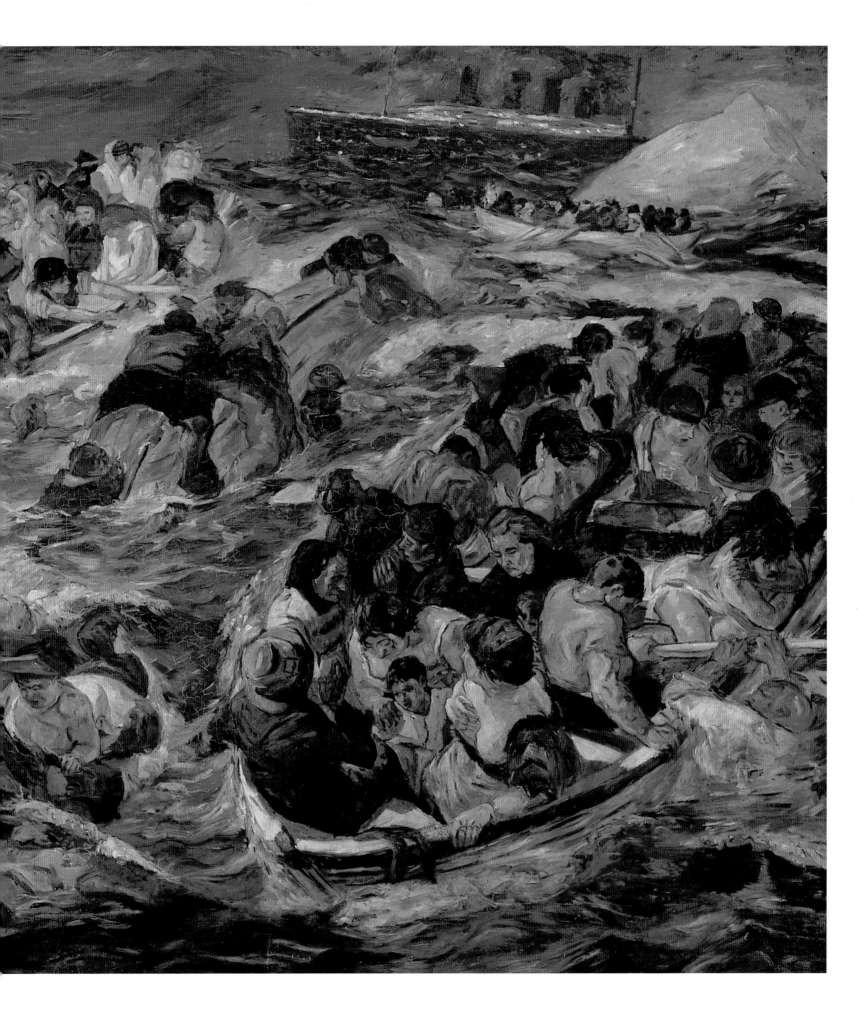

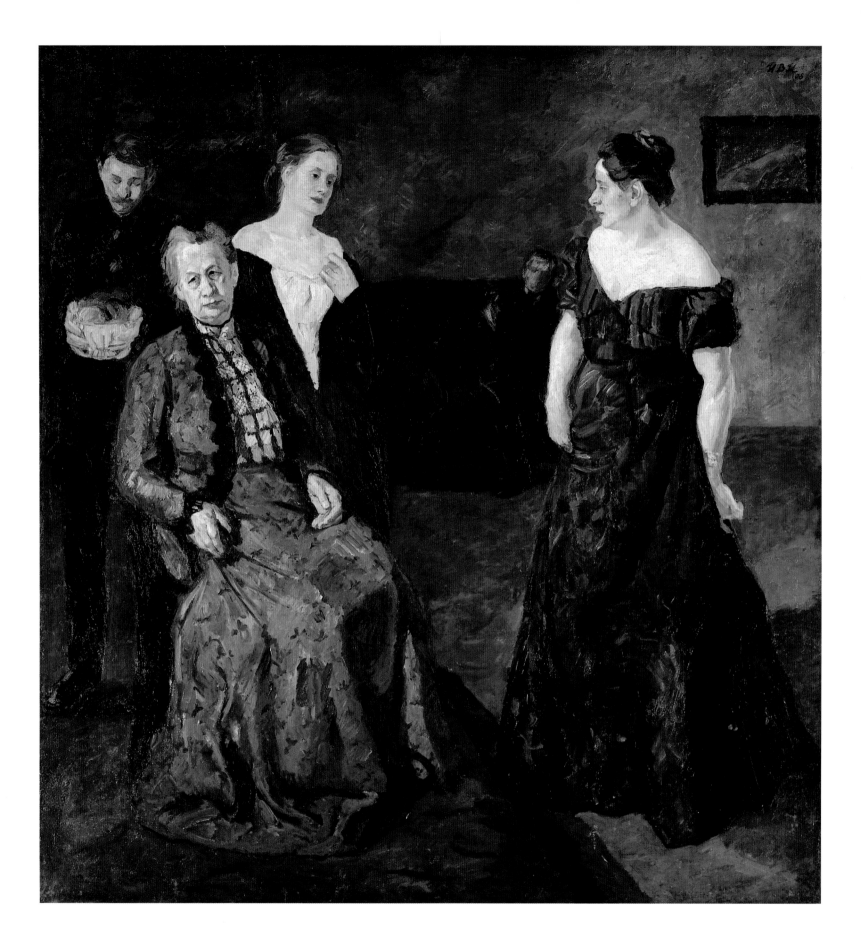

tension generated by the hopeful striving of Géricault's figures as they vainly and despairingly strain after the speck of a ship that might have rescued them, now disappearing over the horizon. Aside from acknowledging the picture's monumentality and its compositional pyramid of heroically naked or half-clothed bodies united in their focus on the disappearing ship, Géricault's public would have brought to it their knowledge of the scandalous sequence of events which led to the shipwreck and subsequent cannibalism among the survivors, which had inspired the artist.

A similar wave of publicity and empathy surrounded the sinking of the *Titanic*, stoked by survivors' stories, and photographs and sketches made on the scene by both the shipwrecked and their rescuers. Beckmann aimed to elevate the episode, created not by individual culpability but by a more general failure of modernity, to the level of universal experience. However, his conception is caught awkwardly between the veracity of witness reports and the product of his imagination, anchored in a respectful paraphrasing of his artistic antecedents. Unlike the Messina picture, though, closeness to truth was subordinated to other concerns. The earliest pencil sketches, based on press reports, show the upended stern of the sinking liner, with lifeboats floating around it. However, Beckmann elected to depict the ship alongside a gleaming iceberg, still afloat and with all lights blazing, a visionary presence rather than an unfolding calamity. In the seas that dominate the foreground of the painting are six lifeboats, more circling aimlessly than at the mercy of the elements. Incidents of struggle as people fight for places in the inadequate number of boats are outweighed by the passivity and resignation of most of the tightly packed passengers. In most cases they are dressed neither in ball gowns, as some survivors reportedly were, nor in lifebelts. Nor are they, with few exceptions, fully extracted from their own times as are many of the heroic nudes in Gericault's picture.

When Beckmann showed *The Sinking of the Titanic* (no.6) at the 1913 Berlin Secession the critical response was mixed. Recognising and praising the artist's level of ambition, Emil Waldmann suggested the picture showed the artist well short of mastery but not afraid of failure,[13] while Max Osborn compared it unfavourably with Beckmann's group portrait also on display, *Conversation* (no.7): here, he claimed, was where Beckmann showed his 'extraordinary talent'.[14] Curt Glaser, a writer and collector who continued to support Beckmann, most notably in his contribution to a monograph on the artist published in 1924, suggested, 'his painterly qualities don't help it to fame because something essential is missing'.[15] Beckmann, according to Glaser, merely showed an episode, leaving the sense of catastrophe 'curiously absent'.

The defining of this essential component continued to preoccupy both the artist and his critics. A decade later, Paul Westheim judged Beckmann's ambition to paint pictures for art history as a false objective, with the outcome that, 'when he painted the Titanic catastrophe, he was defeated by the demands for actuality made of the journalist'.[16] That task, he concluded, was better left in the hands of reporters and photographers. The corrective lay with Beckmann's less assertive images, 'when he painted the portrait of the Baroness Hagen or the small Balloon picture',[17] each of which encapsulated his true character: 'Beckmann is more Beckmann, when he occasionally lets go'.[18]

Beckmann was not alone in coming up against the limitations inherent in constructing universal statements. While his uncompromising ambition and willingness to take risks were regarded by some critics as praiseworthy attitudes, the genre of history painting as inherited from the previous century proved insufficient to satisfy demands in an age where photography, journalism and early cinematic technology could capture and distribute contemporary events with far greater speed and verisimilitude. Antique mythology or biblical subjects had a continued presence in Beckmann's own early works and those of German artists of the late nineteenth and early twentieth centuries, such as Lovis Corinth, Hans von Marées and Max Klinger, creating a weighty vehicle for totalising sentiments. However, the horrors of the First World War and their unique impact on individuals had demonstrated the loss of the common currency of shared beliefs and values that had validated those inherited formulas.[19]

During the war years Beckmann discovered a quality of thin-skinned directness when

no.7
Conversation 1908
177 × 168.5
(69 5/8 × 66 3/8)
Staatliche Museen
zu Berlin,
Nationalgalerie

recording his feelings, rather than the 'disguised sentiment'[20] identified by Westheim. The shift was noted by an anonymous critic in 1916 who commented on Beckmann's recent prints: 'he has become simple and modest in the face of profound experiences and has gained a new freshness and immediacy'.[21] Around the same time the writer Victor Wallerstein compared *The Sinking of the Titanic* unfavourably with Beckmann's more recent wartime prints and drawings.[22] It was in these media that Beckmann finally made the most significant breakthrough in his stated aims of giving people an image of their times. As a printmaker, proposed Gustav Hartlaub in his introduction to Beckmann's first significant career retrospective in Mannheim in 1928, the artist had become the 'protagonist of his epoch' (p.6). His vision had, according to Hartlaub, become modern ('zeitgemäss') but also relevant ('zeitnotwendig') to his times.[23] Hartlaub regretted his inability to show any of Beckmann's large early paintings, referring *en passant* to their inconsistency as 'missed pitches and direct hits' ('Würfe und Treffer'). But with his postwar print portfolios, especially *Hell* (see p.56), the artist had finally come of age. This shift was already being noticed by the coming generation: because he was sympathetic to more recent trends in art, in 1918 Beckmann was being proposed as a possible professor in a student poll (along with Max Pechstein and Oskar Kokoschka) conducted by the Munich Academy.[24]

Notes

1 Barbara Copeland Buenger, *Max Beckmann: Self-Portrait in Words. Collected Writings and Statements, 1903–1950*, Chicago and London 1997, p.183.

2 Ibid., p.180.

3 Diary entry for 9 January 1909, in Buenger 1997, p.98.

4 Diary entry for 31 December 1908, in Hans Kinkel (ed.), *Max Beckmann: Leben in Berlin. Tacebuch 1908/1909*, Munich 1983, p.13. The violence that humans could unleash upon others was exemplified by an arrest in Berlin that Beckmann witnessed while returning home late one night. See diary entry for 30 January 1909, in Kinkel 1983, p.37.

5 Listed in Erhard and Barbara Göpel, *Katalog der Gemälde*, Bern 1976, vol.1, p.90.

6 See the press photograph of a ruined facade of buildings published in *Berliner Illustrierte Zeitung*, 17 January 1909, on which Beckmann based the upper-right section of his picture, illustrated in Ulrich Weisner and Klaus Gallwitz (eds.), *Max Beckmann: Die frühen Bilder*, exh. cat., Kunsthalle Bielefeld 1982, p.191.

7 Author's translation. Original reads: 'sondern das Pathos der Vision, was schon an Delacroix denken lässt.' See Hans Kaiser, *Max Beckmann*, Berlin 1913, p.28. Kaiser mentions in particular Eugène Delacroix's *Massacre at Chios* 1824 (Louvre, Paris) as the compositional model for the couple in the foreground of Beckmann's picture and for the combination of violent perpetrators and innocents.

8 Kaiser 1913, p.28.

9 Ibid., pp.28–9. Author's translation. Original reads: 'die monumentale Haltung und die Einzelschicksale der Gestalten, die gerstörte Stadt und die räumliche Stimmung vertiefen sich durch das Medium der Farbe zu einem realistischen Symbol Berlins, zur Aufassung des menschlichen Lebens, des rings von Gefahren und Sensationen bedroht ist'.

10 At the 1909 Secession Beckmann also showed a smaller painting of a shipwreck and two grand religious compositions. These were *Deluge* 1908 (G97), which shows male and female nudes leaving or entering water via a steep bank, and *Resurrection* 1909 (G104), one of the largest single canvases Beckmann ever painted. This latter painting, plainly based on Rubens's treatment of the same theme now in the collection of the Alte Pinakothek in Munich, earned the comment from the critic Robert Schmidt that it was a 'tasteless Rubens imitation'. See Robert Schmidt, 'Die achtzehnte Ausstellung der Berliner Secession 1909', in *Die Kunst für Alle*, vol.24, 1908–9, pp.441–8, quoted in Ewald Gässler, 'Studien zum Frühwerk Max Beckmanns. Eine motivkundliche und ikonographische Untersuchung zur Kunst der Jahrhundertwende', PhD thesis, Göttingen 1974, p.330.

11 In their 1949 worklist of Beckmann paintings Benno Reifenberg and Wilhelm Hausenstein record the title as 'Todessturz', heightening a sense of mortal danger.

12 Doris Schmidt (ed.), *Max Beckmann. Frühe Tagebücher 1903–4, 1912–13*, Munich and Zurich 1985, p.109. Beckmann writes, 'Trotzdem ich erst 28 Jahre bin Gefühle von altern und Angst überholt zu werden. Rennfahrergefühle. Coryphäe beim Auftauchen neuer Champions. Ziemlich lächerlich missvergnügt darüber'.

13 See Gässler 1974, p.373.

14 Ibid., p.372.

15 Ibid., p.373.

16 Author's translation. Original as follows: 'Dann, wie er die Titanic-Katastrophe ausmalte, erlag er dem Akualitätstrieb des Reporters', in Paul Westheim, *Für und Wider: Beckmann Der wahre Expressionist*, 1923 [n.p.].

17 Author's translation. Original as follows: 'als er das Bildnis der Gräfin Hagen machte oder den kleinen Ballonflugplatz', in Westheim 1923 [n.p.].

18 Author's translation. Original as follows: 'Beckmann ist mehr, auch mehr Beckmann, wenn er sich gelegentlich einmal gehen lässt', in Westheim 1923 [n.p.].

19 The fully committed failure of Beckmann's history paintings has a parallel in the all-embracing spirituality of Piet Mondrian's contemporaneous *Evolution* triptych of 1910–11 (Haags Gemeentemuseum, The Hague), and for similar reasons. 'The fact that this whole sphere of representation was no longer available', wrote Bridget Riley, 'had been an essential mainspring in the formation of Modern art in the nineteenth century. Mondrian had to discover for himself that literary symbolism and personal invention could not make up for this loss. The creation of a common social language does not lie within the scope of an individual and the lack of such a basis [had] to be accepted by Modern painting': Bridget Riley, *Mondrian: Nature to Abstraction*, exh. cat., Tate Gallery, London 1997. Unlike Mondrian, who shortly afterwards left provincial Holland for cosmopolitan Paris to experience at first hand the developments in modern art that decisively shaped his art in the decade that followed, Beckmann left his bracingly decisive exposure to Paris until the late 1920s. After 1913, though, he too retreated from deploying the grandiose gesture to address the most pressing issues of his times.

20 'verkapptes Sentiment', in Westheim 1923 [n.p.].

21 'Er ist vor grossen Erlebnissen wieder einfach und bescheiden geworden und hat eine neue Frische und Unmittelbarkeit gewonnen', quoted in Gässler 1974, p.387.

22 In Gässler 1974, p.387.

23 Gustav Hartlaub, *Max Beckmann*, exh. cat., Kunsthalle, Mannheim 1928, p.6.

24 Joan Weinstein, *The End of Expressionism: Art and The November Revolution in Germany 1918–19*, Chicago and London 1990, p.166.

no.8
Sunny Green Sea
1905
80 × 110
(31 ¹/₂ × 43 ¹/₄)
Private collection

[16] ←≪ visit to the 1909 Matisse show in Berlin, Beckmann wrote:

> Then after lunch, walked to Cassirer and looked at Matisse once again; found him even more insignificant and unoriginal than the last time. The same impersonality with which he imitates Monet and Degas in one of the older paintings, he now evolves into Gauguin, Van Gogh, and assorted Indian or Chinese primitives.[8]

Only months before, an exhibition of Chinese art had prompted this reaction from him: 'And then I did find the Chinese too aesthetic for me, too delicate: feminine, as Dora Hitz rightly said. Also too decorative: I want a stronger spatial emphasis. My heart beats for a rougher, commoner, more

vulgar art: not one that generates dreamy, fairy-tale moods'.[9] Here again one hears an echo of his impatience with the 'chinoiserie' of Jugendstil and Art Nouveau, as well as with Matisse and the more modern artists he tosses into the same basket. To contemporary ears Beckmann's condemnatory use of 'feminine' has a problematic as well as distasteful ring, and his subsequent celebration of a 'masculine mysticism' he associated with Gabriel Mäleßkircher, Matthias Grünewald, Pieter Breughel the Elder, and van Gogh exacerbates matters.[10] Nevertheless, in the context, this binary opposition between the 'female' attenuation, and the 'male' flexing of forms bespeaks not only the prejudices of the period but also announces a principled aesthetic demurrer.

Thus, just as Fauvism reached its apogee and Matisse's impact on German Expressionism was greatest, just as

Kandinsky was venturing into the uncharted territory of non-objective painting and just as Cubism's promise was being fulfilled and consolidated by Picasso and Braque, Beckmann in effect pulled back from the brink of opportunity and argued for a re-departure from an unspecified 'earlier point on the route'. Eventually Beckmann revised his view of both Braque and Picasso and learned from and competed with them on equal terms, though he never let down his guard with respect to pure abstraction. But the moment at which he balked marked his work as deeply as the discoveries that came after the partial hiatus of the First World War. In that regard it is worth recalling that the set piece paintings he made between 1905 and 1912 are of interest not only as an index of his huge if still unfocused ambition, but also for their formal qualities. The most consistently pronounced aspect, from the relatively modest *Sunny Green Sea* 1905 (no.8) through *The Battle* 1907, and *Scene from the Destruction of Messina* 1909 and *The Sinking of the Titanic* 1912, is the high horizon line and the virtual occlusion of deep background space by foreground waves, hills, ruined buildings or clustered figures. Even *Resurrection* 1909 with its levitating clouds of bodies moves upward in columns almost parallel to the picture plane rather than deep into the hollow interior suggested by Beckmann's composition. From the outset, then, he turned away from the orderly world laid out by Renaissance perspective, and applied himself instead to carving out and buttressing a niche for himself and for his cast of characters that occupied an ambiguous place between the flat surface on which he worked and the full-bodied reality he imagined, the space, in sum, of a painterly bas-relief.

Beckmann's experience of the First World War gave the space towards which he had been groping unexpectedly sharp new dimensions. His intense drawing and etching during this period produced the first intimations of his dramatic transformation from an ambitious stylist entangled in the hand-me-down conventions of the nineteenth-century grand manner, to a painter working simultaneously out of his own experience and out of art historical precedents newly suggested by and appropriate to it. More than any other time in his life Beckmann's rhetoric seemed to match the actual dynamics of his art. There is a breathless quality to the letters he wrote while in uniform, a feeling of hyper-alertness and anticipation that diminishes only gradually as weariness takes over and the carnage mounts. For Beckmann as for Léger and many others of their generation, war was a revelation.

In 1915, Beckmann, by then working as a medical orderly at the Belgian Front, noted:

> Yesterday I was off duty. Instead of going on some short trip or another, I plunged like a wild man into drawing and made self-portrait [sic] for seven hours. I hope ultimately to become ever more simplified, ever more concentrated in expression, but I will never – this much I know – give up fullness, roundness, the vitally pulsating. Quite the contrary, I want to intensify it more all the time – you know what I mean by intensified roundness; no arabesques, no calligraphy, but rather fullness and plasticity.[11]

Compare the vigour of this assertion of the importance of 'fullness, roundness, the vitally pulsating' with the defensive tone that creeps into his previous belittling of Matisse and Picasso. And consider that all around him were buildings

and bodies that had been – or would be – smashed and fragmented. In his letters home, Beckmann lingers over details of just this sort. 'I spent the entire day at the front and saw remarkable things. In a totally destroyed village into which shells were still being fired, I sketched a dead horse that stretched its stiff legs – from which the hide had been partially stripped away – into the air.'[12] Worse, is his description of dying: 'His face was still young, very delicate. Horrible the way you could suddenly look right through his face, somewhere near the left eye, as if it were a broken porcelain pitcher.'[13] And yet more macabre: 'Dead soldiers were carried past us. I sketched a Frenchman who stuck out partially from his grave. A grenade explosion has disturbed his rest.'[14] While it was tempered by a growing sense of the pointlessness of this death and destruction, Beckmann's enthusiasm for the sights and sounds of war – and one can only call it that – was predicated on the instinctive understanding that war not only gave him a subject (though, compared to Otto Dix and Ludwig Meidner, he made relatively few pictures that directly reported on his experience) but a way of seeing hinted at but never before realised in his work. 'Many of these details will be useless to me, but slowly the atmosphere does trickle into one's blood, and provides me with confidence for images that I saw earlier in spirit already. I want to work through all this internally in order to be able to produce these things in an almost timeless manner later.'[15]

In a way the blasted landscape and shattered men Beckmann studied grotesquely mimicked the disjointed planes and broken volumes of modernist abstraction in alternately garish or exsanguinated hues. The horse with shredded legs, the wounded man with his skull cracked like a 'porcelain pitcher' and the Frenchman half-buried in the ground, were obscene readymades of Expressionist dislocation and Cubist low relief. It was also against the background of war that the polarity of harrowing emptiness and vital superabundance took its definitive form. An element of synaesthesia enters in at this point, since Beckmann first articulated his new understanding of these spatial antipodes in musical terms that signal a shift from the harmonics of his grand prewar pictorial compositions, to the dissonance of his postwar ones. His early exhilaration at finding himself amidst the tumult resonates clearly in a letter of 14 October 1914, less than three months into the conflict:

Outside the wonderfully grand sound of battle. I went out past hordes of wounded and exhausted soldiers that came from the battlefield and listened to this unique, horridly grand music. It's as if the gates to eternity are being ripped open when one of these great salvos echoes toward you. Everything suggests space, distance, infinity to you. I wish I could paint this sound.[16]

Within a year this exalted infinity had become a wasteland whose furthest reaches were plumbed by the crash of exploding shells and spanned by the whistling of bullets. By then, rather than paint this tumult or the emptiness it pervaded, Beckmann wanted to paint that emptiness out. In May 1915, he thus wrote:

Every so often the thunder of cannon sounds in the distance. I sit alone, as I so often do. Ugh, this unending

void whose foreground we constantly have to fill with stuff of some sort in order not to notice its horrifying depth. Whatever would we poor humans do if we did not create some such idea as nation, love, art with which to cover the black hole a little from time to time. This boundless forsaken eternity. This being alone.[17]

Henceforth Beckmann's nemesis was the depopulated sublime he glimpsed from hillside lookouts and the trenches. His *horror vacuii* conjures a place where indiscriminate and meaningless death reigns. For the artist any and all signs of life, from the most delightful to the most debased, serve to block this view of the ultimate and total annihilation from which he had escaped but which always threatens to engulf humanity. It is a vision that the First World War adumbrated with ghastly clarity, and that the Second World War and the Atomic Age revealed in its full and terrifying extent.

Beckmann's plunge into this murderous modernity coincided with his unexpected immersion in late Gothic and Northern Renaissance art. It was during a leave in Brussels in 1915 that he first saw – or any rate saw with freshly sensitised eyes – the work of Breughel, Lucas Cranach, Rogier van der Weyden, and nameless German and Flemish 'primitives'. What impressed him in particular was 'their almost brutal, raw sincerity, almost peasantlike strength'.[18] Foresaking his earlier inspirations – Michelangelo, Rubens, Delacroix, and Corinth as well as Edouard Manet and Max Lieberman – Beckmann began to claim for himself the constraining formats, angular compositions, hard modelling and 'brutal' descriptiveness of fourteenth-, fifteenth- and sixteenth-century German and Netherlandish art.

According to standard genealogies of style, the deliberate anachronism of Beckmann's about-face would seem to parallel that of the Italian painters of the Metaphysical School and of the still more backward-looking Novecento in the same period. Among them figure Giorgio de Chirico, Carlo Carrà, Gino Severini, and Mario Sironi, all former modernists who in the aftermath of the First World War cut their ties with the avant-garde and sought to revive the traditions of the Italian Renaissance and of classicism generally. Then, of course, there was Picasso, bell-wether of the 'return to order', who, as of 1914, drew in the manner of Ingres and subsequently pastisched the work of the brothers Le Nain, even as he continued to paint in a variety of other modes, some abstract. The postwar 'return to order' and backlash against Cubism and Expressionism by some of the avant-garde artists who had invented those tendencies, but suddenly found themselves in league with their longstanding aesthetic enemies in the arrière-garde, epitomised a broad cultural retrenchment that extended across Europe and across the Atlantic. However, for painters who served in combat, or like Beckmann, bore witness to the casualties, the idea of fracturing forms and the space they occupy took on an entirely different and more literal meaning than it had before the war.

Partially or wholly reconstituting representational modes that had once been taken apart for the sake of aesthetic innovation signified, in the hands of some veterans, something quite distinct from the superficially similar revival of illusionism typical of the neo-classical and neo-romantic artists whose work sought refuge in a fantasised past. For exponents of the Neue Sachlichkeit, or New Objectivity, such as Beckmann and Dix, the insistence on the palpable solidity

of images was not just a reaction against earlier modernist distortions of reality. It was a response to that reality's literal dismemberment and devastation. Beckmann's 'Creative Credo' of 1918 thus evinces a determination to reconstruct a substantial pictorial language that by-passes Expressionism as well as Naturalism.

> I don't cry. I hate tears, they are a sign of slavery. I keep my mind on my business – on a leg, on an arm, on the penetration of surface thanks to the wonderful effects of foreshortening, on the partitioning of space; on the relationship of straight and curved lines, on the interesting placement of small, variously and curiously shaped round forms next to straight flat surfaces, walls, tabletops, wooden crosses, or house façades. Most important for me is volume, depth, trapped in height and width; volume on a plane, depth without loosing the awareness of the plane, the architecture of the picture.[19]

In essence, then, it was impossible to depict the enormity of destruction he and his contemporaries had seen in visual terms that took the schematic dismantling of the phenomenal world for granted. Without a sense of the integrity of shapes and of their context the violence which they had observed and wanted to evoke was, in effect, camouflaged by style. For Beckmann, the wrenching visions of the late war needed to be portrayed in all their nakedness, and that mandated that each element of a composition assume an even greater specific density than was found in nature, whilst the whole was designed to withstand or at least register extreme tensions generated around them.

The complex, often cellular structures of medieval and Renaissance panel painting – and by extension stained glass with these same qualities plus dark mullions and leading that contrast with luminous colour – provided Beckmann with formal prototypes. With the often scant or counterintuitive spatial intervals between figure and ground (in keeping with Beckmann's preference for frontal compression but now rendered in stiff rather than loose contours), the structure of panel painting remedied the previous disorganisation of his overcrowded paintings yet allowed for the emphatically physical pictorial dynamics he demanded. Leapfrogging through art history in reverse while holding fast to the memory of things upon which his eyes and art had 'gorged' during military service, the 'earlier point on the route' to modern painting, about which he had speculated in 1909 and to which he now doubled back, was centuries rather than years or decades before the Post-Impressionists. However, as 'primitives' of his era, Cézanne and van Gogh were granted a special standing alongside Beckmann's new heroes, Gabriel Mäleßkircher, Matthias Grünewald and Breughel.[20]

The progressive digestion and recasting of these precedents can be easily tracked in the sequence of paintings that preoccupied Beckmann following his demobilisation in 1915. Formally speaking, the vast unfinished *Resurrection II* 1916–18 (fig.13 on p.102) is a reprise of *The Sinking of the Titanic* 1912 (no.6), with the inclined foreground merged with the mountain on the horizon in the later painting substituting for the solid wall of water in the earlier. Scattered over the surface of *The Sinking of the Titanic* are clusters of lumpy figures that seem to be struggling less against the turbulent waters welling up around them than against the maelstrom-like suction of

page 28
no.9
Descent from the Cross 1917
151.2 × 128.9
(59 1/2 × 50 3/4)
The Museum of Modern Art, New York. Curt Valentin Bequest, 1955

page 29
no.10
Christ and the Woman Taken in Adultery 1917
149.2 × 126.7
(58 3/4 × 49 7/8)
The Saint Louis Art Museum. Bequest of Curt Valentin

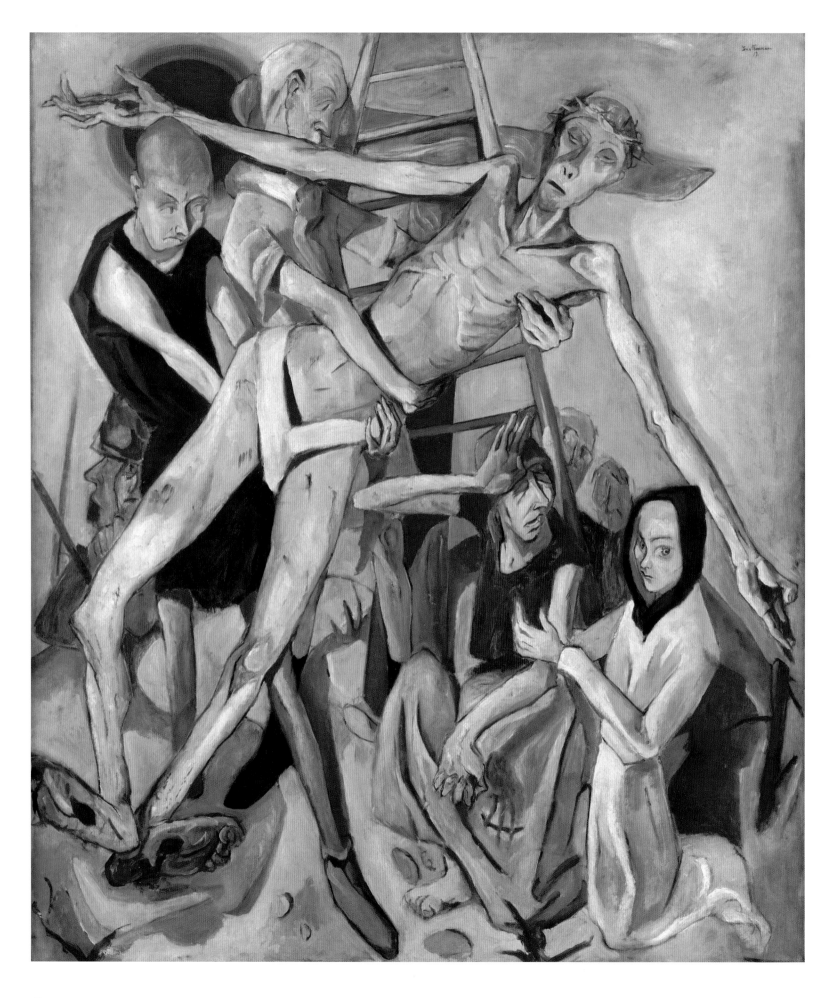

28

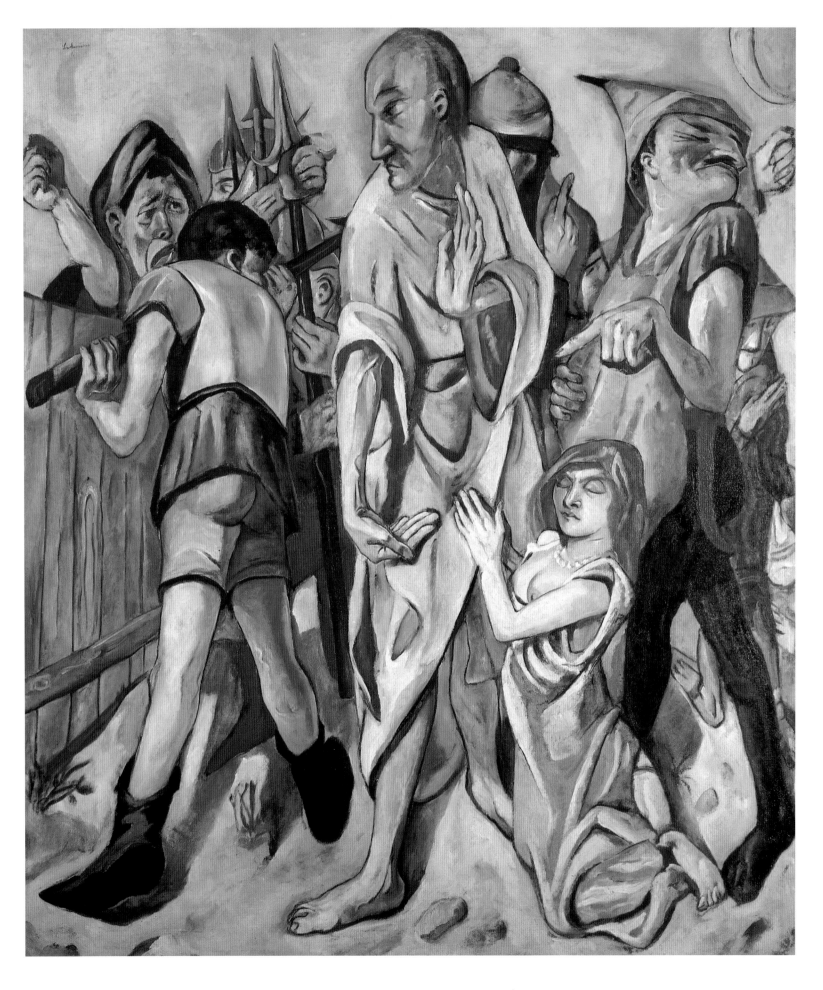

three dimensions collapsing into two. In *Resurrection II*, by comparison, the generally sinewy bodies are dispersed across the canvas like scraps of wood on the desert floor, though some appear to float above and others seem half buried in arid earth. Direct references to the tortured anatomy of late Gothic painting are explicit in the figures in the upper half of the picture, but as yet Beckmann had not absorbed the compositional lessons of such work, and the multipart scenario and abrupt changes in scale from area to area are not united by any larger and more integrated conception of the whole. *Descent from the Cross, Christ and the Woman Taken in Adultery* and *Adam and Eve*, all 1917 (nos.9–11) are in some measure a retreat from the ambition of *Resurrection*, but in them Beckmann perfects his hybrid of anachronistic and quasi-Cubistic figuration while nuancing his sometimes gratingly colourful, sometimes blanched palette.

In *The Night* 1918–19 (no.59) the transformation of Beckmann's art and the realisation of his wartime presentiments are complete. Revolution supplied him with his subject, but the agony of the image is equally a matter of calculated violence done to the conventions of representation. Matching the hideousness of medieval martyrdom paintings and crucifixions, Beckmann describes the atrocities of modern civil war with pointed political ambiguity; the identities of the pipe-smoking torturer who twists the hanged man's arm and the brute in front of the window, and their party affiliation, is never made entirely clear. But the visceral pain evoked by this scene is not only the product of explicit cruelty, but of the punishing contraction and inversion of convexities and concavities, which buckle windows, floorboards and ceiling beams and generate outward

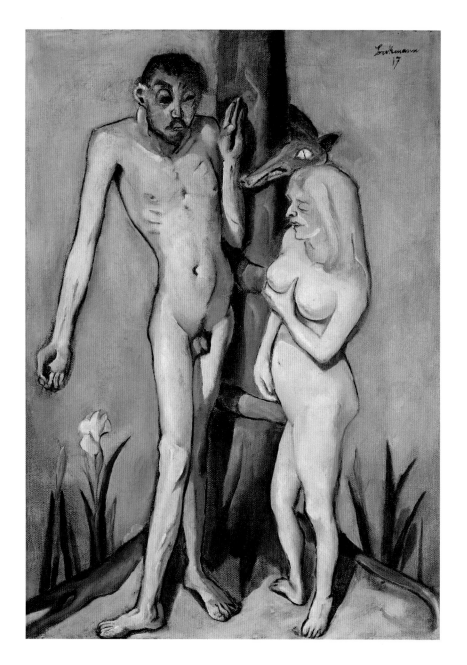

no.11
Adam and Eve
1917
79.5 × 56.7
(31 $^1/_4$ × 22 $^3/_8$)
Staatliche Museen
zu Berlin,
Nationalgalerie

fig.1
The Night 1918–19
(See no.59 on
pp.98–9
for large
reproduction)

pressures that all but crush the foreground victims sandwiched between these flexing architectural planes and the invisible picture plane. In *The Night*, space is put on the rack. For Beckmann a painting was an organic entity, and this painting, in particular, a corporeal spasm. In the wan light of his nocturnal hell no distinction is made between animate and inanimate imagery. Human legs and table legs are splayed in the same way; the tautness of stretched fabric or the tensile strength of a window frame are analogous to distended flesh and rigid, brittle bone.

Although less excruciating, other canvases such as *Family Portrait* and *Carnival,* both 1920 (nos.12, 13), and *The Dream* 1921 (no.14), ratchet perspective in and out in comparable fashion, as do cityscapes such as *The Iron Footbridge* 1922 (no.44). Packed with incident, these paintings of the late

1910s and early 1920s set the formal terms for the remainder of Beckmann's career. And whilst his oeuvre is replete with calmer, less congested paintings in the traditional genres – still life, portraits, landscape – structurally they are exceptions to or partial relaxations of the rule established by the paradigm-setting canvases, and reworked through the latter half of Beckmann's career in his triptychs and other similarly dynamic or heavily freighted pictures.

The lateral zig-zag composition and volumetric rise and fall of Northern medieval and Renaissance altarpieces contained grisaille renditions of carved niches that at times almost erased the perceptual difference between painting and sculptural relief. Adapting them to his purposes, Beckmann in effect invented his own faceted version of modernist 'push-pull', a term coined by Hans Hofmann. Hofmann was an

no.12
Family Portrait
1920
65.1 x 100.9
(25 ⁵/₈ x 39 ³/₄)
The Museum of
Modern Art, New
York. Gift of Abby
Aldrich Rockefeller,
1935

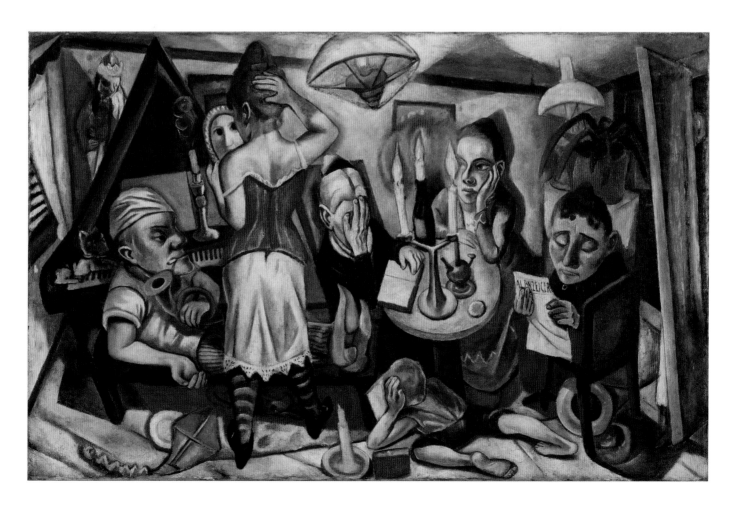

no.13
Carnival 1920
186.4 × 91.8
(73 3/8 × 36 1/8)
Tate, London.
Purchased with
assistance from the
National Art
Collections Fund
and Friends of the
Tate Gallery and
Mercedes-Benz
(UK) Ltd 1981

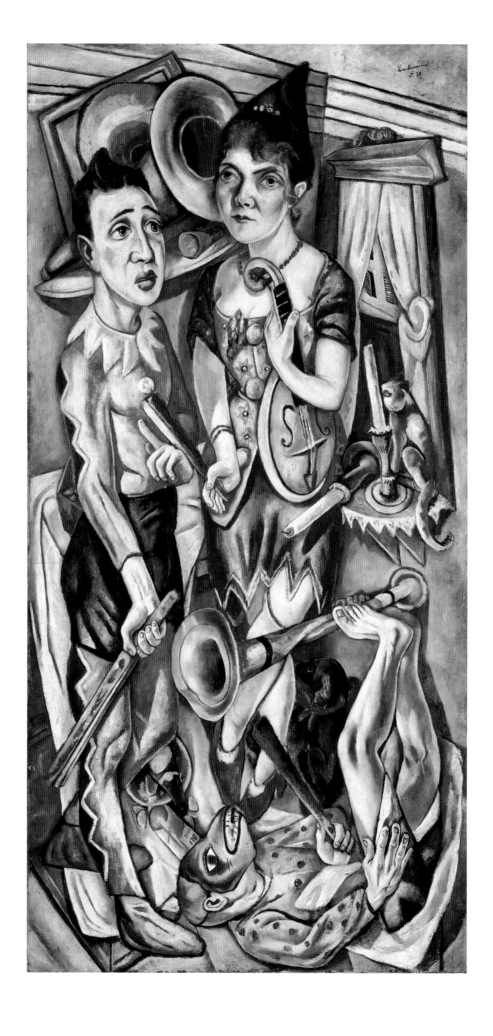

no.14
The Dream 1921
184 × 87.5
(72 1/2 × 34 1/2)
The Saint Louis Art
Museum. Bequest
of Morton D. May

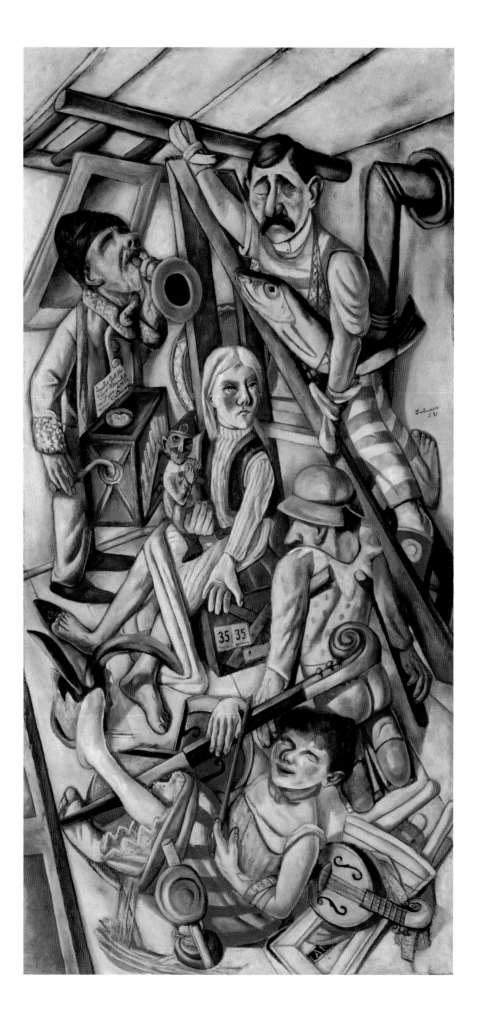

acquaintance and disciple of Matisse. His theory of push-pull is predicated on the tendency of colour of different intensities spread over different areas to advance or retreat in relation to one another in a way that creates the optical sensation of deep space but obviates its literal delineation. Beckmann's push-pull diverges from Hofmann's in that it is based on drawn and modelled forms, but it is no more consistent perspectivally than Hofmann's. Like Hofmann's it derives much of its force from the surface tension the picture plane exerts on the different aspects of the composition. In Hofmann's work 'flatness' reigns supreme. The formal energy of Beckmann's work is produced by a contest between volume and compression, where bowed shapes and oblique angles leverage flatness, but flatness prevails overall.

As Beckmann's art developed, he reconciled himself with Matisse. For example, the tipped floor and slanted bar at the right-hand margin of *The Bath* 1930 (no.74) or the similar slash of colour at the edge of *Self-Portrait with Horn* 1938 (no.150) recall comparable, albeit subtler, less muscular devices in Matisse's *Grand Interior at Nice* 1918–19 (Art Institute of Chicago). Here the gently rising stroke and leaning interval on the left-hand side of the painting operates as a vertical *repoussoir*, accenting the scene's very lack of depth with a graphic device – the diagonal – that is usually employed to suggest recession but at this acute angle does the opposite. Moreover, by the late 1930s Beckmann's previously pasty, chalky hues began to resemble the broad, matt application and chromatic range and saturation of his former *bête noire,* not to mention the corresponding ways in which both men, inspired by Manet, used black as a colour. In all, Beckmann's corrugated or tactile surfaces of the late 1910s

through to the 1920s offered an alternative to the syntax of Cubist and Fauvist paintings, but assimilated a number of their qualities by turning tonal sheets or chromatic membranes into chiselled facets that were juxtaposed without regard to the demands of realism. As time went on, Beckmann eased the tension on structures that held together this amalgam of eccentric shapes and grafted geometries, eventually allowing flat areas and flattened forms to slip in front of or behind each other. But paintings from *Hell of the Birds* 1938 (no.101) to *Acrobat on a Trapeze* 1940 (no.100), *The King* 1933, 1937 (no.95) and all of his triptychs show that at any moment Beckmann could pull that structure tight again and its fleshed-out volumes would swell, thrust and bind as they had before.

Triptychs permitted Beckmann a greater concentration and a more elaborate choreography of images than the single canvas. Peter Selz dates the return of multi-panel formats in German art to 1880 when Hans von Marees painted his *Judgement of Paris* (whereabouts unknown). The idea was quickly picked up by Max Klinger, Franz von Stuck, Fritz von Uhde and others.[21] In fact, the practice had been revived by the Romantics as early as 1814, and was widespread in Belgium, France, Germany and the Netherlands for a century and more to follow, particularly among Symbolist and Naturalist artists eager to sacralise their poetic or humanist themes. Among the painters roughly of Beckmann's generation who painted polyptychs before him were Piet Mondrian (*Evolution* 1910–11, Haags Gemeentemuseum, The Hague), Erich Heckel (*Woman Convalescing* 1913, Bush-Reisinger Museum, Cambridge, MA), Emil Nolde (*Mary of Egypt* 1912, Folkwang Museum, Essen), August Macke

(*Zoological Garden* 1912, Lenbach Museum, Munich), and Otto Dix (*Metropolis* 1927–8, Galerie der Stadt, Stuttgart). For his part Matisse had composed his *Moroccan Triptych* in 1912 (Pushkin Museum, Moscow), and in 1931–2 painted the tripartite *The Dance II* (The Barnes Foundation, Merion, Pennsylvania). In short, in 1932 when Beckmann set to work on his first triptych, *Departure* (no.60), a considerable legacy of modern variations on multipanel painting stood between him and the medieval prototypes to which they more or less explicitly referred. That said, Beckmann's painterly allusions to Gothic figuration are more pronounced than those of most of his contemporaries in this period, though Ernst Barlach (as a sculptor and printmaker) and Karl Schmidt-Rottluff (as a printmaker) had gone at least as far in this direction.

If the Romantics and the Symbolists had borrowed from the art of the Middle Ages in order to give their images a pietistic aura, Beckmann, in quoting dramatic religious scenes, was far more attracted to the profane aspects of the work of this period. To that extent he seemed to have been as interested in the contorted buffoonery of the misericords and burlesque marginalia found on the pews near church altars as in the altarpieces themselves. Such medieval and Early Renaissance mixtures of vulgar masquerade and all-too-human humanism have been discussed at length by Mikhail Bakhtin in his writings on Rabelais's 'carnivalesque'. It is unnecessary here to recapitulate his basic arguments concerning the social function of ritualised role-reversal and mockery. Suffice it to say that the martyrdom of *The Night* (no.59) and the mystical allegories that issued from it have, as their counter-term in Beckmann's oeuvre, myriad examples of such socially critical grotesquery. Moreover, the transition from such outdated versions of the grotesques to manifestly modern ones was smoothed by the actual continuity of popular theatre, for which Beckmann was an enthusiast.

Herein lies another important distinction to be made between Beckmann's use of antique motifs and that of Picasso, Severini and the neo-classicists. Accurately assessing the nature and political as well as poetic significance of their appropriations from the past requires carefully distinguishing among the social signs inscribed in their separate selections of models for paraphrase. Whilst Commedia della Arte had originated as a popular theatrical form in the sixteenth century, by the eighteenth it had been embraced and fundamentally reconfigured by artists in noble courts and salons. The late nineteenth- and early twentieth-century resuscitation of Harlequin and his cohort – in the poetry of Guillaume Apollinaire, in Sergei Diaghilev's commissions for Les Ballets Russes and so on into painting – was therefore a return to a semi-aristocratic tradition with already refined vernacular prototypes rather than to a true vernacular tradition. Beckmann's nightclub and sideshow performers are, to a far greater degree, the linear descendants of their medieval and Renaissance archetypes but they do not appear in period costume, nor do their sometimes Gothic antics and postures trigger nostalgia for a lost era. Neither, for that matter, are they 'völkisch' in the way sanctioned by the nominal aesthetes who formed the 'modernist' wing of the Nazi Party, and who, for so long as Hitler allowed, championed the work of ideologically fence-sitting artists such as Barlach, Heckel, Nolde and Schmidt-Rottluff.[22] Rather they are the contemporaries and colleagues of Bertolt Brecht's underworld characters, and of the Weimar *demi-monde* in general.

Overlaid on the iconic elements, but, more importantly, on the structures of Beckmann's medievalising allegories, were the characters and staging conventions of popular theatre. That Beckmann was conscious of this is as obvious from commentaries on his art as from his art itself. In a 1939 letter to Stephan Lackner he wrote not as an imitator of but as a close observer and self-styled competitor of Grand Guignol.

One must admit that unknown stage-directors try everything to make the situation more interesting, in the sense of a penny-dreadful. Critically we must state that unfortunately, they don't have many new ideas any more, and that we now have the right to stage something new. And that, after all, will occur sooner or later. I, for my part, am busily preparing new stage sets among which the play may go on.[23]

Beckmann's 'sets' translated all the standard apparatus of the real thing into painting equivalents: 'flats' and 'teasers' defined the frame in which action took place and cropped details where necessary; the raked 'stage' gave an at once frontal and overhead view while shoving the 'players' forward into the laps of the 'audience', surrogates for which sometimes included heads pinched between the lip of 'stage' or platform and the lower edge of the canvas. Surrogates of this kind were like caricatural antitheses of the representative figures that appear in Caspar David Friedrich's transcendental landscapes. Beckmann's work is the total collapse of Friedrich's expansiveness measured against such figures. Under these conditions simultaneous narratives or *tableaux vivants* were superimposed, distributed to distinct areas of a picture – 'downstage,' 'upstage,' 'stage left,' 'stage right' – or partitioned off by the bits of decor – a door, mirror, pillar – or, in the triptychs, by the fissure which separates one panel from the next. Within this intricate spatial construct, members of Beckmann's 'cast' would unite as a chorus, face-off in conflict, pantomime, clown at the footlights and stand in introspective isolation; they would orate, scream, deliver asides, soliloquise and stand silent. And, as is always true of the grotesque, Beckmann's jarringly encompassed both tragic themes and comic relief. For example, in the left-hand panel of *Departure* hideous tortures reminiscent of *The Night* are depicted, while in the right-hand panel a drole though solemn drummer marches past seemingly oblivious to the anguish behind him. Whatever their role, all those who take to the boards in his paintings are oriented toward the 'audience'. They strike poses that project their exaggeratedly stereotypical or cryptic personas in the direction of the viewer, of whom they appear to be more aware than of each other. Thus there is no suspension of disbelief – no naturalism or supernaturalism – in Beckmann's theatricality. But there is a suspension and conflation of time. Once again medieval and Renaissance precedents fuse with the music hall and the circus. In the former the protagonist of a story may show up several times, or episodes from the story that happened in sequence may be presented in contiguous sections. In the latter, beginning, middle, and end telescope into a continuous flow of multiple performances consigned to one, two or three rings just as they might be to one, two or three panels in an old painting.

By these means, Beckmann arrived at his own rendition of the early twentieth-century notion of 'simultaneism' in which the plastic and symbolic layering of a work contrives to

represent a world of multiple dimensions of space and time within a single context. The paintings reflect the viewers' awareness of the complex and simultaneous unfolding of events and the shifting focus of consciousness they experience in the age of speed. Simultaneism was an invention of Cubist painting and collage, carried forward into new media by photographic and cinematic montage. It was a quintessentially modernist trope that expressed itself in aesthetic terms that usually highlighted not only the competing nature of images under such circumstances but also their disparate types of facture – illusionistic and anti-illusionistic painting techniques, mechanical reproduction, typography, relief, and so on. Beckmann's compound of popular theatre and Gothic painting achieved a similar visual estrangement and recombination of images. These afforded him many of the same opportunities to explore the dynamics of narrative and representation, but in a style that stood apart from, while being informed by, the prevailing practices of the Cubist, Dada, Constructivist and Surrealist avant-garde. Out of these styles Beckmann synthesised a coherent but patently artificial manner, creating a contained but internally disjointed setting in which seemingly incoherent or contradictory images could be incorporated into this mis-en-scène.

Beckmann regularly took a seat at the theatre or at cabaret tables and also wrote Expressionist plays. Art historian Claude Gandelman has argued that by capitalising on his appetite for and critical understanding of all forms of theatre, Beckmann managed to assimilate his borrowings from medieval art and assign them functions that went beyond and in some way counter to the 'timeless' aesthetic of pure pathos (in German, Pathosformel) towards which so much other work that drew on those antecedents tended. Gandelman's descriptions of the experimental productions of Weimar dramatist-directors Erwin Piscator and Bertholt Brecht suggest intriguing correlations between their radical spatial remapping of the stage and polyptych design. They also underscore how the techniques that Piscator and Brecht developed were used to turn the passive spectator of conventional theatre into an engaged participant confronted by 'objective' contrasts which brought his or her suppressed inner conflicts and the irreconcilable choices he or she faced into sharp but deliberately inconclusive focus. Gandelman writes:

It is my opinion, that, if Max Beckmann used a traditional Pathosformel [of the triptych], it was precisely *in order to* turn it into anti-pathos. Beckmann did for the traditional triptych form just what Brecht did for the 'pathetic' ballad form, or for the pathetic rhetoric of the Bible in his Hauspostille and in his early Neue Sachlichkeit plays, what Neue Sachlichkeit composers like Hindemith, Eisler or Weill were doing for traditional pathetic and emotional forms in music. Beckmann, like Brecht, was an exponent of the anti-pathetic and anti-dramatic spirit of the Neue Sachlichkeit.[24]

It is going too far, perhaps, to say that Beckmann's histrionic paintings are, in the final analysis, basically anti-dramatic as well as anti-pathetic. Indeed, works such as *The Night* and *Departure* have both qualities in carefully calibrated proportion. Yet neither painting promises a dramatic resolution: the night described in the former will end terribly but also be repeated ad infinitum, and in the

meantime action is arrested at the height of its ferocity and gruesomeness; whilst the question of a 'destination' for the departed goes poignantly unanswered in the latter. Nor do they resolve on a single emotional chord. Beckmann's paintings are dialectical. In every respect their elusive symbols and taut but unstable pictorial structure juxtapose antithetical terms – often at the highest pitch of contradiction – and hold them in that state of tension for viewers to examine, decipher, assimilate and reorder in their minds. There is no prospect that the painter will release the viewers from the discomfort these contradictions may cause or shortcut their engagement by easing the tension or handing over the keys to his semiotic codes.

By and large, this dialectical component of Beckmann's work has gone unacknowledged in contemporary critical discourse. Consequently, the parallels with and alternatives to avant-garde collage and montage of the 1910s, 1920s and 1930s that Beckmann's work raises have likewise been by-passed. Instead, the tendency has been to regard Beckmann as a stalwart defender of the verities of traditional painting – which he was in his writings – rather than as a formal innovator within that tradition who, in his studio practice, paved the way for others who shared his reservations about formal reductionism but also his drive to make pictures that portrayed modernity in its sometimes raucous, sometimes grand, too often horrifying and always manifold aspects. When reduced to simple description or fulsome adjectives the richness of Beckmann's art loses its definition – and its critical edge. Thus, complacent conservatives cling to him while denigrating painters of today, whose deep disquiet and abrupt painterly attack recalls his, even as those working their way

through the heritage of radical modernism – Dada and Constructivism especially – tend to ignore the possibilities implicit in his accomplishment, and may actually scorn him, like some postmodern critics, as just another backslider of the post First World War era.

Both camps underestimate Beckmann's legacy, but, as was said in the beginning, the search for Beckmann's immediate heirs is, for the most part, a frustrating, even distracting exercise. Turning to his own generation, for example, one can find many qualities in common between Beckmann and the pioneering American modernist Marsden Hartley. Like Beckmann, Hartley favoured bold, dense, unatmospheric colours, heavy black contour drawing, the liberal use of chroma-subduing whites, and a range of angular shapes or curved lozenges all of which give his canvas a monumental, almost carved feeling. Like Beckmann, he also leaned strongly toward mysticism and its esoteric sign languages. Moreover, he spent the years preceding the First World War in Germany, though in that period he flirted with Fauvism and Cubism – putting him at opposite ends of the stylistic continuum from Beckmann who disdained both – and, between 1912 and 1914, Hartley came up with his own Symbolist variant on Cubism. In 1946, a year before Beckmann's immigration to the United States and a year following his wartime isolation in Amsterdam when he almost entirely disappeared from view, Clement Greenberg reintroduced the German painter to the American public by noting that 'his affinities with Hartley are amazingly close'.[25] These affinities, however, are just that; they are not evidence of any direct impact of Beckmann on Hartley. Hartley never mentions Beckmann in his considerable writings, and some of his most 'Beckmannesque' paintings

predate those of Beckmann himself or were made before Hartley (who left Germany in 1915) would have had a chance to see Beckmann's postwar work in America or in France where Hartley travelled on and off in the 1920s. Furthermore, despite its iconic, sometimes compartmentalised or cloisoné composition, Hartley's work never addressed the issue of the simultaneous contrast of narratives, moods, pictorial systems or points of view with anything approaching the complexity of Beckmann's.

Except, then, for superficial stylistic similarities with the work of other, generally lesser, artists, one looks in vain for a 'Beckmann effect' until the 1970s. The fact that it finally registered in that period has much to do with the stresses of the time, and the ways in which they made Beckmann's dangling proposals useful in unanticipated ways. The two most significant examples are the American painter Philip Guston and the German Jörg Immendorff.

Guston was the first to latch onto the potential contained in Beckmann's mix of nested symbols and theatrical spatial constructs, but only with a long delay between his initial emulation of Beckmann and his ultimate absorption and unrestrained redeployment of the options and ideas extracted from his example. Guston's first important encounter with Beckmann was at a 1939 exhibition of his work at the Buchholz Gallery in New York. This came towards the end of Guston's years as a Depression era mural painter, when (like his friend Jackson Pollock), he was preoccupied by José Clemente Orozco, Diego Rivera, and David Alfaro Siquieros, as well as by Picasso. Thereafter, throughout the 1940s, Guston attempted to adapt Beckmann's approach and the metaphysical aura of de Chirico to the American scene,

with varying degrees of success. Starting in 1950 he abandoned figuration for more than a decade and a half, and returned to it full force in 1969 in response to the polarising effects of racial strife, the Vietnam war and the rise of Richard Nixon. In the 1940s Guston was consumed by the problem of finding an idiomatic American equivalent for Beckmann's way with line and colour. By the late 1960s this had been replaced by a bravura gesturalism, powered by his mastery of Abstract Expressionism but harnessed to broad caricatures. None the less, all the essential traits of Beckmann's paradigm are there, metamorphically changed by different historical circumstances and Guston's extraordinary painterly fluency and gift for improvisation. Thus the scenes Beckmann composed out of scavenged bits and pieces of pre-modern paintings and the theatre recur in Guston's visions of a ravaged imperial America with its lumpish, woebegone Everyman and its slapstick thugs. While Guston never resorted to the triptych format, *Flatlands* 1970 with its panoramic refuse in staggered rows or the tiered universe of *Pit* 1976 (fig.2) with its orchestra pit/crack-of-hell foreground, rock strewn stage, curtain-like fires and central painting as stage-within-a-stage involve the same problems of the congestion and/or encapsulation of images tackled by Beckmann. In Guston, as in Beckmann, these devices created room in which a divided soul in a divisive time and place could ruminate, act out, dissent, argue with the world and disagree with itself. And they transfer such self-questioning to the viewer by means of formal and pictorial oppositions – aggression and delicacy, melancholy and lampoon, and hard to identify with, impossible to shrug off personifications of the painter and the 'man/woman-in-the-street' in which

fig.2
Philip Guston
Pit 1976
Oil on canvas
190 x 294.5
(74 ¾ x 116)
National Gallery of
Australia, Canberra.
Courtesy of the
McKee Gallery,
New York

existential anxiety and inscrutability combine.

Much the same seems to have been the case when at the end of the 1970s Immendorff, prankster acolyte of Joseph Beuys and later agit-prop painter for the Maoist Left, began to execute a group of paintings on the themes of East/West confrontation, the shadowy but omnipresent Nazi past, and the rise and fall and rise of the post-1960 counter-culture. Immendorff's series is collectively titled 'Café Deutschland' after a more prosaic painting, *Café Greco* by Renato Guttuso (1976, Sammlung Ludwig, Aachen), in which the artist rounded up various notables such as de Chirico and sat them down in the eponymous meeting place in Rome as incarnations of the past. Instead of choosing an equally venerable site in Germany, Immendorff created an infernal punk club, based on a bar in Düsseldorf (fig.3). There amidst balconies, banquettes, bars and cellars he choreographed a riot of symbols representing the Germany's clashing ideologies and warring generations. The paint handling is vigorously slapdash, and the whole ambiance hallucinogenic rather than 'objective', but here again basic coordinates and strategies derived from Beckmann are readily recognisable although much altered. Subsequent series such as *Café Flore* 1991 and recent, even more literally theatrical pictures such as *The Rake's Progress* 1993–4 move the location to Paris between the world wars – where Immendorff appears as a time-travelling interlocutor with Beckmann, Max Ernst, Francis Picabia, Kurt Schwitters and others – or to William Hogarth's London where his concerns shift the emphasis away from politics to art. Still the manipulation of his story-overlapping/story-splitting space-frame remains essentially the same throughout Immendorff's work, as does the dialectical interplay of his personifications of history.

With its costumes, props, and skits, Immendorff's invention in the mid-1960s of the anarchic art tendency, LIDL – like Dada this nonsense word signifies a childlike playfulness – establishes his roots in conceptual and performance-based practices that flourished in spite of or at the expense of painting in that period. Immendorff's wholehearted return to painting in effect helped partially to close an aesthetic gap that had been opened by Neo-Dada of the late 1950s through to the mid-1970s. Immendorff's fusion of 'idea' art and painting was paralleled by that of numerous, otherwise quite dissimilar painters, including Anselm Kiefer, Sigmar Polke and Gerhard Richter, but alone among them Immendorff with his overtly hectic theatricality points towards Beckmann.[26]

In Immendorff's subterranean soul-sick world all is cacophony. Taking Beckmann's cue – and making the link Beckmann did between sight and sound, the crash of war and the pile up of waste – Immendorff erects visual barriers against the emptiness of Cold War culture out of Cold War detritus that mimic a rock-and-roll 'wall of sound'. That his style is more cartoonish than Beckmann's does not signal a decline in seriousness but a change in the vernacular he appropriates in his period from the vernacular Beckmann tapped into in his time. Even though at its best Immendorff's work has the ominousness of Beckmann's it has none of the latter's melancholy or brooding quality. Guston's does.

In the final analysis, Guston's paintings of 1967 to 1980 constitute the most fully realised complement to Beckmann's oeuvre, in part at least because in the work of both artists a sense of the material density of human things is clearly

fig.3
Jörg Immendorff
*Café Deutschland
(Style War)* 1980
Oil on canvas
280 × 350.7
(110 1/4 × 138)
The Museum of
Modern Art, New
York. Gift of Emily
and Jerry Spiegel

counterposed against the spatial vastness of all that transcends individual human existence. Crucial in this dynamic is the degree to which volume, mass and tactility belong to objects and not to the space itself. Thus Beckmann would write: 'A comprehensive construction attempts the translation of the three dimensional space of the world of objects into the two dimensions of the picture plane.'[27] And so while the armatures of Beckmann's picture may be heavy, they never rival the specific gravity of the figures and their symbolic attributes that they support. Guston's actors and props have this same physicality to them, but in paintings such as *Painter's Table* 1973 (private collection) and even more so in *Painter's Forms* 1972 (fig.4) and *Painter's Forms II* 1978 (estate of the artist) an equivalency is created between objects and language, such that in the last example a disembodied mouth disgorges stamping or marching legs as if it were uttering the words for 'mob' or 'fascism'. Just as one may usefully read the present through the past which prepared it, so too one may profit on occasion from reading the past in the light shed by the present. In addition to recalling Beckmann's derivations from medieval art and the stage, one may reconsider the literary aspect of his images and the structures holding them in place from a linguistic perspective. In that context, as is true for Guston, Beckmann's protagonists and the emblematic forms with which they coexist are the subjects and objects, nouns, verbs and adjectives of pictorial phrases whose syntax is the overall architecture of the picture, with each panel of the triptych resembling paragraphs in a fragmentary fable, or, more accurately perhaps, stanzas in an incomplete Symbolist poem. This said, Guston's approach to such 'objective' symbolism

diverges significantly from Beckmann's when it comes to their differing attitudes toward the space in which images of this type accumulate. And, given the dialectic of object and emptiness they share, those differences are telling.

As previously noted, Beckmann's void has its origins in the howling no man's land of the First World War. Initially, then, his *horror vacuii* had an accent on horror; thereafter, it became associated in Beckmann's mind with a more general spiritual agoraphobia. Returning to Beckmann's remarks about the spatial dilemma implicit in his art quoted from from 'On My Painting', at the beginning of this essay, one reads:

> Height, width, and depth are the three phenomena that I must transfer into one plane to form the abstract surface of the picture, and *thus to protect myself from the infinity of space* [author's emphasis] ... Space and space again, is the infinite deity which surrounds us and in which we are ourselves contained ... Often, very often, I am alone ... Then shapes become beings and seem incomprehensible to me in the great void and certainty of the space that I call God.[28]

In so far, therefore, as space was an 'infinite deity' it was also a merciless one, the absolute negation of the ephemeral things of the world and of the individual in particular.

By contrast Guston's work embraced the void with a measure of serenity. Whether images of the sea in which figures bob like people shipwrecked in a biblical flood – *Night* 1977, or *Deluge III* and *Group at Sea* 1979 (estate of the artist) – or visions of the desert in which they appear as monoliths or mirages on a desolate horizon – *Head* 1975 (estate of the

fig.4
Philip Guston
Painter's Forms
1972
Oil on wood
122 × 152.5 (48 × 60)
Courtesy McKee
Gallery, New York

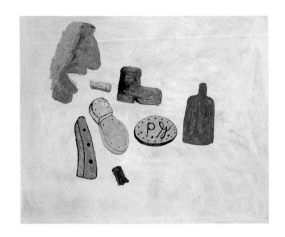

artist), *Back View* 1977 (Museum of Modern Art, San Francisco) – Guston's paintings just as frequently depict the emptiness he elsewhere hid from view with mounded, often menacingly intrusive forms – *The Door* 1976 (private collection) and *The Street* 1977 (estate of the artist) – and that Beckmann's *always* obscured by similar means. Indeed, the two huge iconic eyes riding above the waves in *Source* 1976 (estate of the artist), are solace itself. Guston's ability to contemplate such a barren landscape or seascape allowed him to do what Beckmann forbid himself, which was to let emptiness heighten awareness of its opposite. His equation of forms and words helps to explain how this works. Returning to the example of *Painter's Forms* and *Painter's Forms II,* Guston's visceral depiction of speech in action appears against a virtually blank background, reminding us that during the phase of Guston's career when he was most engaged with abstraction one of his principal sources of inspiration was the composer John Cage, the aesthetic avatar of silence. Fathomless pictorial 'silence' was intolerable to Beckmann but its total absence in his paintings projects it onto the mind's eye like one colour shadowing its brighter complementary.

Pursuing this filiation a step further we arrive at the late work of Jasper Johns, not someone commonly associated with Beckmann, but a disciple of Cage and an admirer of Guston. His paintings from *Racing Thoughts* 1983 (fig.5) and *The Seasons* 1985 (*Summer*, The Museum of Modern Art, New York; *Fall*, collection of the artist; *Winter* and *Spring*, private collections) onwards through the 'Catenary' paintings of the early to mid-1990s – canvases with comparatively spare compositions sometimes ornamented by whirling Milky Ways – evince a related struggle between symbolic congestion and

vertigo-inducing openness or vortex depths. Bringing Johns into the discussion is in no way meant to suggest a heretofore unacknowledged influence of Beckmann on Johns's art, but rather to call attention to a painterly painter known for his use of collage and montage techniques and free-substitution of image for sign. Johns continues to explore the problems Beckmann posited, problems of a literary or symbolic art whose solution rests not on style in a general sense, or touch as a signature gesture but on an overall conception of the logic, the poetics and, at the limit towards which Beckmann himself strained, the metaphysics of pictorial space. 'The structure is the handwriting of the paintings', Beckmann said.[29] Imitating someone else's handwriting is pointless except when forgery or overt appropriation is the motive. Nevertheless there is much still to be learned about, and much that can yet be done with the syntax of the sentences Beckmann wrote. And in a period when he no longer seems like one of modernism's great recalcitrants but more and more like one of its greatest mavericks, the question of his impact is addressed not only to the artists of his moment and immediately after but to the present and near future.

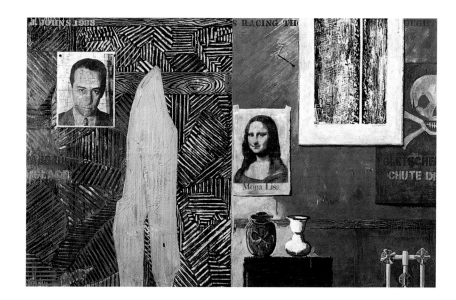

fig.5
Jasper Johns
Racing Thoughts
1983
Encaustic and
collage on canvas
121.9 × 190.8
(48 × 75 1/8)
Whitney Museum
of American Art,
New York

Notes

1 Stephan Lackner, *Max Beckmann: Memories of a Friendship*, Coral Gables, Florida 1969, is a testament to the bond between the artist and his patron as well as an indispensable resource on Beckmann's work and state of mind from the late 1920s until his death. The author of this text was lucky to have had the chance to listen to the late Joseph Pulitzer describe with relish his encounters with Beckmann in St Louis in the late 1940s. Among the scenes described was a morning visit to the painter who lounged on a sofa covered with oriental carpets and sighed over the effects of the champagne he so loved and had consumed in such ample quantities the night before; in short a scene of old-world bohemia in the strait-laced American middle west of the immediate postwar era.

2 On the whole contemporary formalist or 'theory' driven critics have observed an awkward silence about the mystical tendencies of Mondrian, Wassily Kandinsky, Kazimir Malevich and other innovators of the period demonstrating their continued obliviousness to or unwillingness to explore the murky terrain between ostensibly progressive modernism and the many supposedly retrogressive ideologies that sprung up in the late nineteenth and early twentieth centuries, ideologies that digressed from utopian materialism of the revolutionary Marxist kind as much as as they had previously taken issue with bourgeois materialism of the positivist kind. It is territory ripe for comprehensive description and urgently in need of detailed critical analysis.

3 Barbara Copeland Buenger (ed.), *Max Beckmann: Self-Portrait in Words. Collected Writings and Statements, 1903–1950*, Chicago and London 1997, p.302.

4 Ibid., p.96.

5 Ibid., p.70.

6 Ibid., pp.91–2.

7 Ibid., p.116.

8 Ibid., p.103.

9 Ibid., p.98.

10 Ibid., p.181.

11 Ibid., p.149.

12 Ibid., p.157.

13 Ibid., p.160.

14 Ibid., p.163.

15 Ibid., p.163.

16 Ibid., p.143.

17 Ibid., p. 173.

18 Ibid., p.158.

19 Ibid., pp.183–5.

20 Ibid, p.159. 'For me war is a miracle, even if a rather uncomfortable one. My art can gorge itself here.' From a letter dated April 18, 1915.

21 Peter Selz, *Max Beckmann Retrospective: 200 Paintings, Drawings and Prints from 1905–1950*, with contributions by Harold Joachim and Perry T. Rathbone, exh. cat., The Museum of Modern Art, New York 1964, p.55.

22 Although none of these artists was an avowed Nazi (though Nolde's anti-Semitism and Nazi sympathies were well known), all at least temporised or allowed themselves to be courted by Nazi officials who sought to co-opt them for the regime as Mussolini had co-opted the Futurists. In the end, however, Hitler's profound artistic conservativism overruled these 'progressives' and all the artists named were included in the infamous *Degenerate Art* exhibition of 1937 organised to pillory modernism, thus saving those who vacillated most or leaned furthest toward fascism the taint of guilt by association.

23 Lackner 1969, p.79.

24 Claude Gandelman, 'Max Beckmann's Triptychs and the Simultaneous Stage of the '20s', *Art History*, vol.1, no.4, December 1978, p.480.

25 With his usual swagger, and his usual, though generally forgotten or forgiven tendency to stumble over his own breathtakingly presumptuous and shortsighted judgements, Greenberg simultaneously acknowledged Beckmann's authority and condescended to him because of perceived aesthetic shortcomings:

To one whose acquaintance with the German painter Max Beckmann is confined to his clumsy and callow triptych *Departure* at the Museum of Modern Art, the exhibition at the Buchholz Gallery of fifteen paintings he executed in Holland between 1939 and 1945 provides a surprise ... And these are such in five or six pictures to warrant calling Beckmann a great artist, even though he may not be a great painter ... True he reminds us of much we have already seen in German Expressionism and in Marsden Hartley – his affinities with Hartley are amazingly close. And it is also true that he often paints badly, using black contour lines to animate and sustain his colour; that his colour gets muddy at times and is saved only by his drawing and the unity it gets from paint surface rather than from harmony. But for all that, the power of Beckmann's emotion, the tenacity with which he insists on the distortions that correspond most exactly to that emotion, the flattened, painterly vision he has of the world, and the unity this vision imposes – so realising decorative design in spite of Beckmann's inability to think it through consciously – all this suffices to overcome his lack of technical 'feel' and to translate his art to the heights. In my opinion Beckmann is superior to Rouault. Rouault exploits black and raw umber in much the same way, but the adeptness with which he shows off his *metier* and the paint quality of his temperament put Beckmann's craft to shame. Yet Beckmann realises his whole being in paint, and Rouault does not.

John O'Brian (ed.), *Arrogant Purpose 1945–1949: Clement Greenberg. The Collected Essays and Criticism,* vol.2, Chicago and London 1986, pp.80–1.

26 In conversation with the author, Immendorff downplayed any connection with Beckmann, embracing Beuys as his mentor, but it is difficult to accept his disclaimer at face value, though easy to understand why he would want to avoid being viewed as Beckmann's 'latter-day' follower.

27 Buenger 1997, p.294.

28 Ibid., pp.302–3.

29 Ibid., pp.91–2.

no.15
*Portrait of Fridel
Battenberg with
her Head in her
Hands* 1916
Pencil on paper
30.8 x 23.5
(12 1/8 x 9 1/4)
Graphische
Sammlung im
Städelschen
Kunstinstitut,
Frankfurt am Main

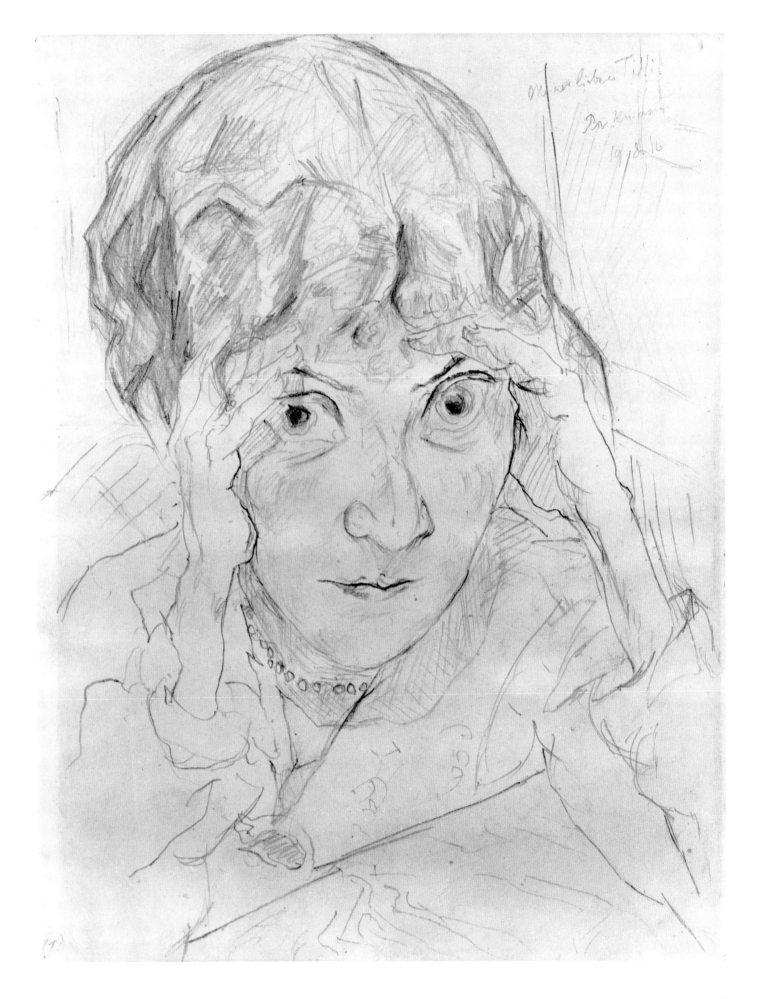

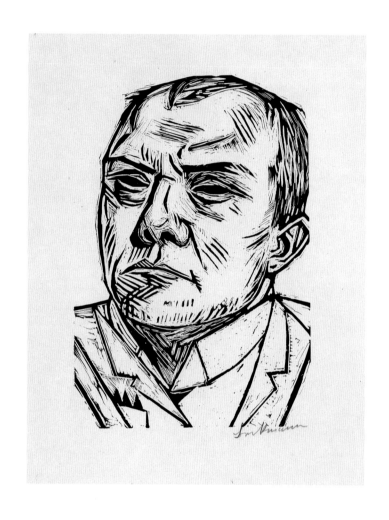

no.16
Self-Portrait 1922
Woodcut on paper
22.2 × 15.4
(8 ³/₄ × 6 ¹/₈)
Lent to Tate,
London, by the
Trustees of the
Marie-Louise von
Motesiczky
Charitable Trust
1996

no.17
Self-Portrait 1917
Pen and black ink
on paper
31.7 × 24.3
(12 ¹/₂ × 9 ¹/₂)
The Art Institute
of Chicago. Gift of
Mr and Mrs Allan
Frumkin

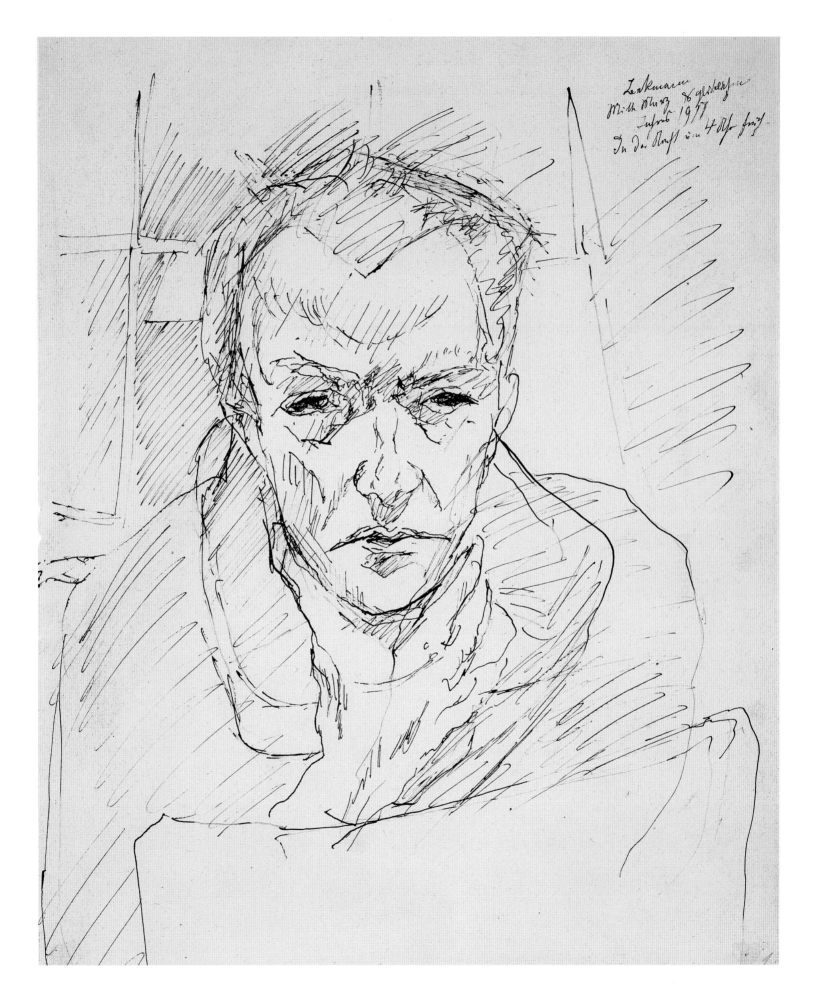

47

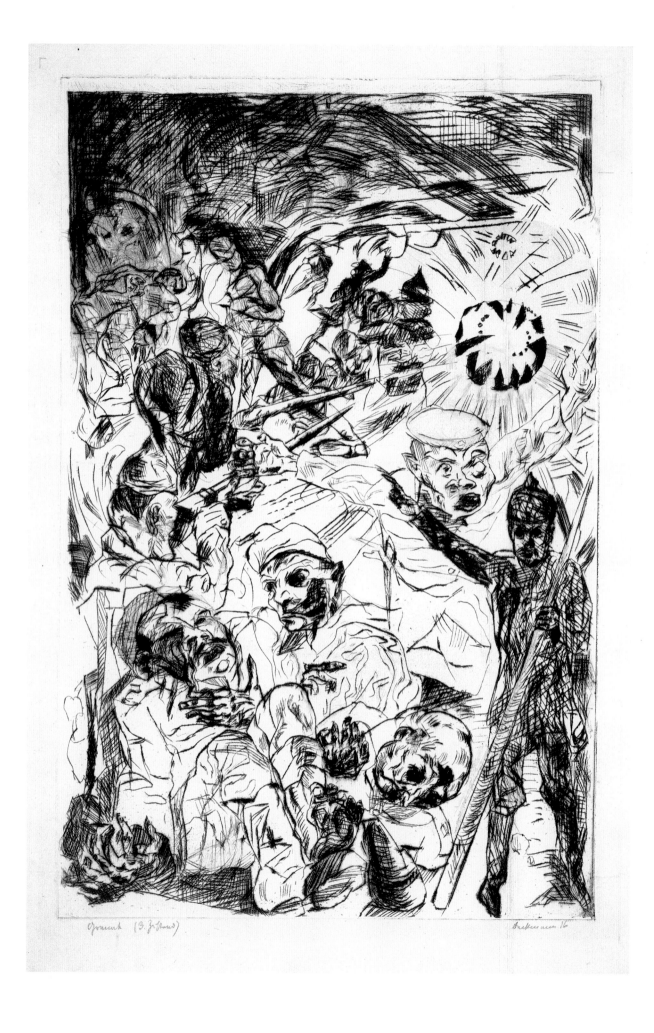

Granate (B. Zeitung) Beckmann 16

48

no.18
The Grenade 1916
Drypoint on paper
38.6 × 28.9
(15 ¹/₄ × 11 ³/₈)
The British
Museum, London

no.19
Happy New Year
1917
Plate 17 of *Faces*
portfolio
Drypoint on paper
23.9 × 30
(9 ³/₈ × 11 ³/₄)
The British
Museum, London

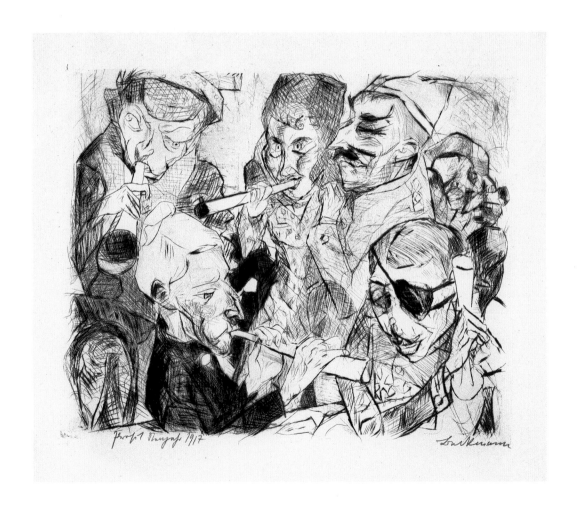

no.20
Lovers II 1918
Plate 5 of *Faces*
portfolio
Drypoint on paper
21.9 × 25.7
(8 5/8 × 10 1/8)
The British
Museum, London

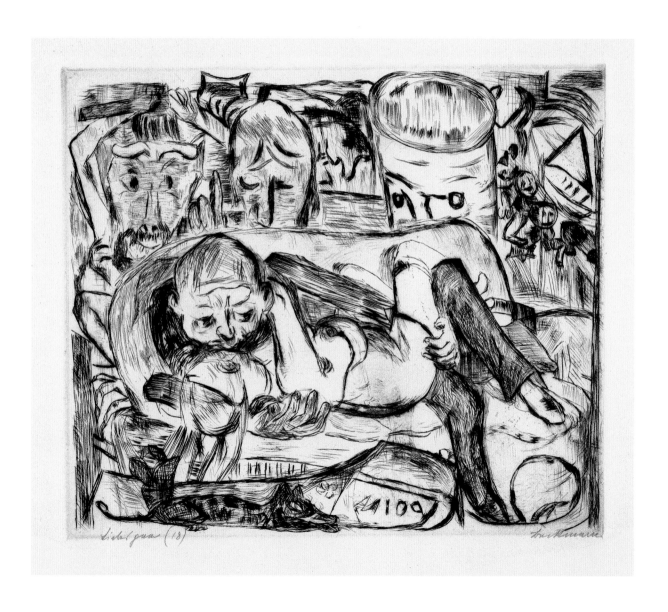

no.21
The Yawners 1918
Plate 7 of *Faces*
portfolio
Drypoint on paper
30.8 × 25.5
(12 1/8 × 10)
The British
Museum, London

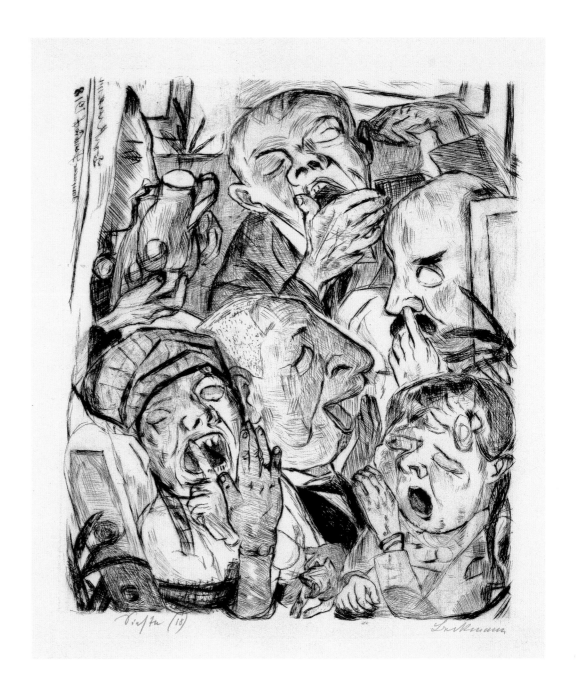

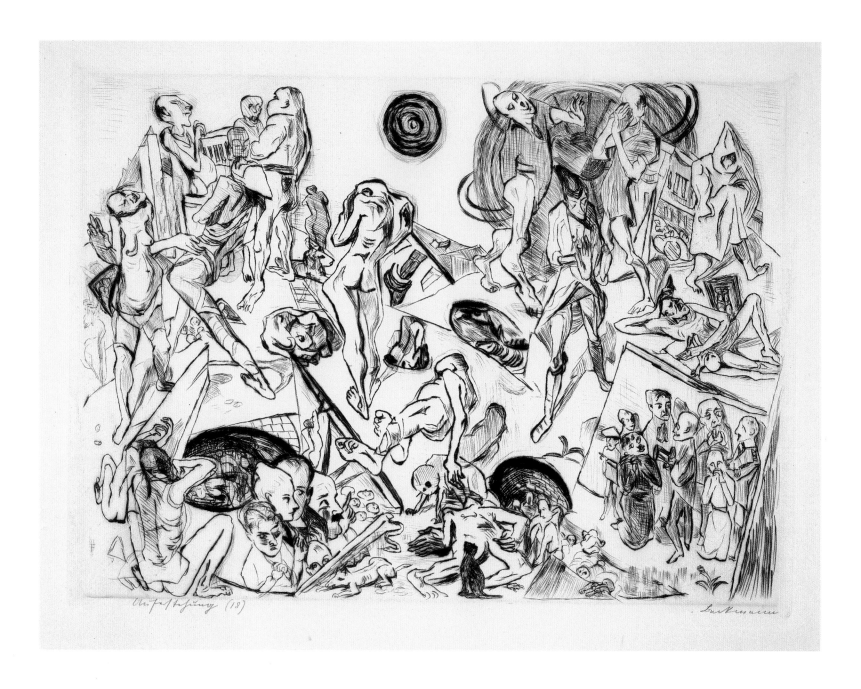

no.22
Resurrection 1918
Plate 12 of *Faces*
portfolio
Drypoint on paper
24 × 33.2
(9 ¹/₂ × 13 ¹/₈)
The British
Museum, London

no.23
*Sketch for 'The
Street'* 1919
Black chalk on
paper
85.5 × 61
(33 ³/₄ × 24)
The British
Museum, London

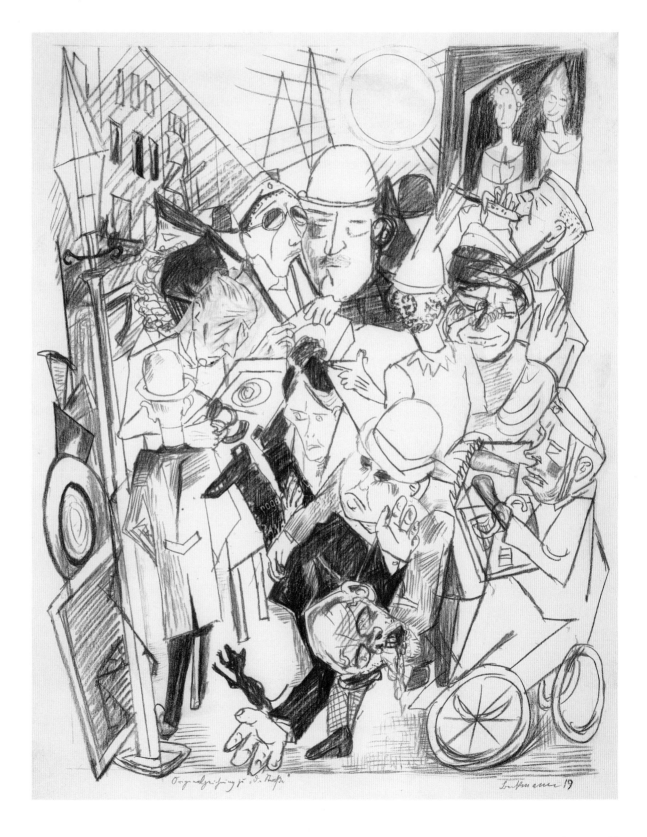

nos.24–8
Five sketches for
The Night
Museum
Kunst Palast,
Sammlung der
Kunstakademie,
Düsseldorf

no.24
1918
Blue ink on paper
18.8 × 23.8
(7 $\frac{1}{2}$ × 9 $\frac{3}{8}$)

no.25
1918
black ink on paper
21.5 × 29.5
(8 $\frac{1}{2}$ × 11 $\frac{5}{8}$)

no.26
1917
Pencil on paper
16.5 × 19.7
(6 $\frac{1}{2}$ × 7 $\frac{3}{4}$)

no.27
1918
India ink on paper
16.1 × 21
(6 $\frac{3}{8}$ × 8 $\frac{1}{4}$)

no.28
1917
Pencil on paper
20 × 21.6
(7 $\frac{7}{8}$ × 8 $\frac{1}{2}$)

24

25

26

27

28

Hell 1919

Honoured ladies and gentlemen of the public, pray step up. We can offer you the pleasant prospect of ten minutes or so in which you will not be bored. Full satisfaction guaranteed, or else your money back.

With these words, written beneath the *Self-Portrait* (no.29) on the title page of the *Hell* portfolio, Beckmann plays the circus barker beckoning his audience to draw near and see with its own eyes the brutal reality of life in postwar Germany. In his artistic statement 'A Confession' of 1918, Beckmann wrote: 'I need to be with people. In the city. That is just where we belong these days. We must be part of all the misery that is coming.' In the *Self-Portrait* the artist's eyes are wide open,

unflinching and steadfast in confrontation of the dark spectacles of life playing out in the city streets, bars and private dwellings.

Although Beckmann's sarcastic and flippant tone suggests frustration with the futility of the human condition, he nevertheless desired to embrace life and humanity in all its ugliness. In 'A Confession' he wrote:

It's the only course of action that might give some purpose to our superfluous and selfish existence – that we give people a picture of their fate. And we can do that only if we love humanity. Actually it's stupid to love humanity, nothing but a heap of egoism (and we are a part of it too). But I love it anyway. I love its

nos.29–39
Hell 1919
Portfolio of ten transfer lithographs plus cover
Published by I.B. Neumann, Berlin 1919
Edition of 75
No.4/75
National Gallery of Scotland, Edinburgh

no.29
Self-Portrait 1919
Image size:
63.4 × 41.8
(25 × 16 1/2)

no.30
Plate 1: *The Way Home* 1919
Image size:
73.3 × 48.8
(28 7/8 × 19 1/4)

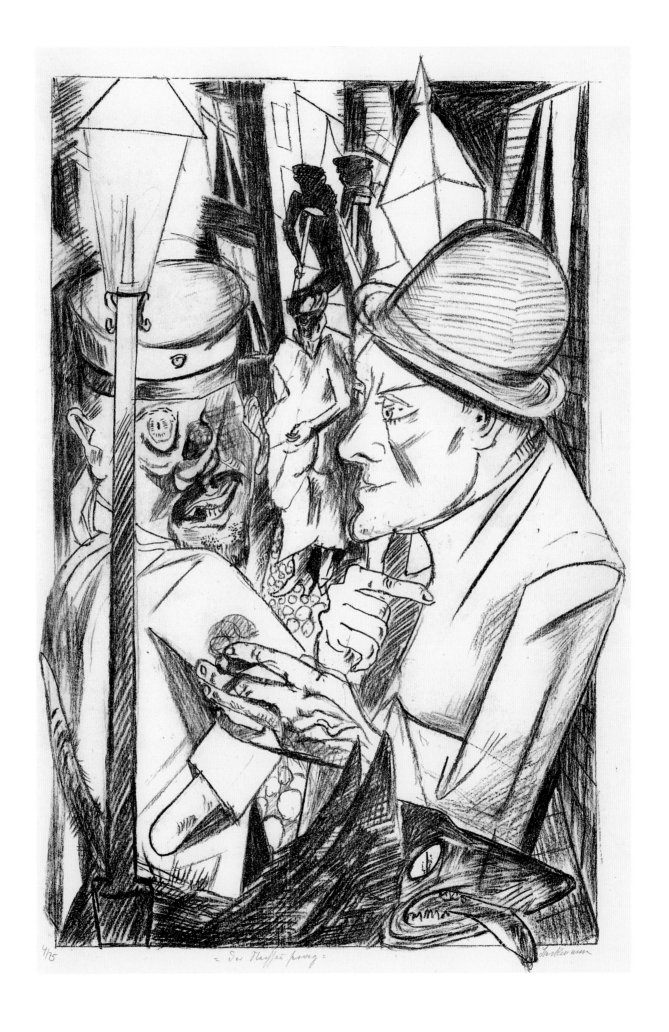

4/75 = Der Nachhauseweg = Beckmann

meanness, its banality, its dullness, its cheap contentment, and its oh-so-very-rare heroism.

Beckmann worked on the eleven lithographs for the *Hell* portfolio during the summer of 1919. He chose a large format, emphasising the importance of the project. In November 1919 Beckmann's dealer in Berlin, I.B. Neumann, published *Hell* in an edition of seventy-five. He additionally printed 1,000 booklets of the series with photo-lithographic reproductions to guarantee a wide distribution.

The first plate of the series, following Beckmann's *Self-Portrait*, is entitled *The Way Home* (no.30). In this night scene, illuminated by the light of a street-lamp, Beckmann portrays himself grabbing a mutilated war veteran by his right arm. Beckmann eagerly points to his left trying to guide the veteran in the proper direction. At the same time Beckmann seems to draw the attention of the veteran, along with the viewer, to the prints that follow in the portfolio.

The scenes depicted in *The Street*, *The Martyrdom* and *The Last Ones* (nos.31, 32, 38) refer to the events during or immediately following the November Revolution of 1918, a political upheaval in Germany after the end of the First World War in which communist, socialist and nationalist sympathisers clashed violently over the political future of the country. Street demonstrations often turned into fatal battles and such recurring events may have inspired *The Street,* where the foreground shows an injured or possibly dead figure being carried out of the crowd. In *The Martyrdom*, Beckmann depicts the murder of the communist leader Rosa Luxemburg, which was committed during the left-wing Spartacist uprisings in January 1919. Beckmann endows this work with Christian symbolism: mocked, harassed and beaten by aggressive soldiers and grinning officials, the woman is portrayed in a posture typical of Christ's Crucifixion. *The Last Ones* is based on press photography of the Spartacist uprisings and illustrates combatants firing through an opening at targets outside while bleeding and screaming victims lie among them.

In *Hunger* (no.33) Beckmann provides a bleak glimpse into the private life of a family, where austere and starving faces pray around a dinner table barren of food. *The Night* (no.35) reveals a terrible scene, in which a family gathering is forcefully interrupted by criminals, who inflict pain, fear and humiliation on the family members. This lithography duplicates the painting *The Night* (no.59), completed by Beckmann just before he began work on the *Hell* portfolio.

Beckmann moves his unflinching gaze from the dark aspects of private life to the disheartening atmosphere of social gatherings. In *The Ideologues* (no.34), he casts a suspicious eye on the self-absorbed activities of intellectuals, among them the writers Annette Kolb, Heinrich Mann and Carl Sternheim. Crowding around a lectern, each intellectual appears to be fervently espousing their own ideology in isolation. *Malepartus* (no.36) depicts wealthy couples dancing and sipping champagne, blissfully oblivious to the pervasive suffering outside. *The Patriotic Song* (no.37) shows demoralised war veterans in a pub drowning their sorrows in alcohol and music.

The Family (no.39), the final lithograph, returns to the private sphere of the family home. A small boy, probably Beckmann's son Peter, is excitedly showing off his toy grenades. A pious old woman (a portrait of Beckmann's mother-in-law) is shielding the boy from Beckmann himself and the dark world outside the window. In the face of human ignorance and suffering, as depicted in the *Hell* portfolio, Beckmann appears to be intolerant towards Peter's playing with instruments of destruction. He indignantly points outside the picture frame to the hellish reality of life, challenging his family as well as the viewer not to close their eyes. One could also interpret Beckmann's forceful gesture pointing upwards as venting his anger against God as expressed to his friend and dealer Reinhard Piper: 'My religion is disdain towards God, defiance towards God. Defiance, that he created us so, that we can not love each other.'

Susanne Bieber

no.31
Plate 2: *The Street*
1919
Image size:
67.3 x 53.5
(26 1/2 x 21)

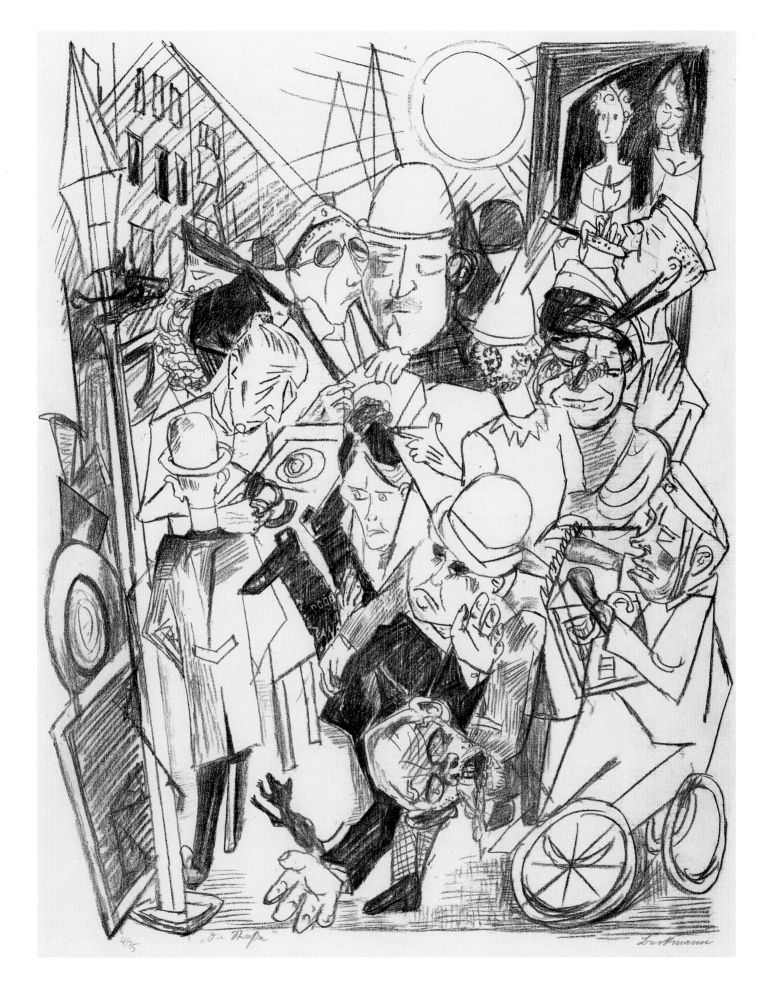

4/75　　　　"Die Straße"　　　　　　　　　　　　　　　　　　Beckmann

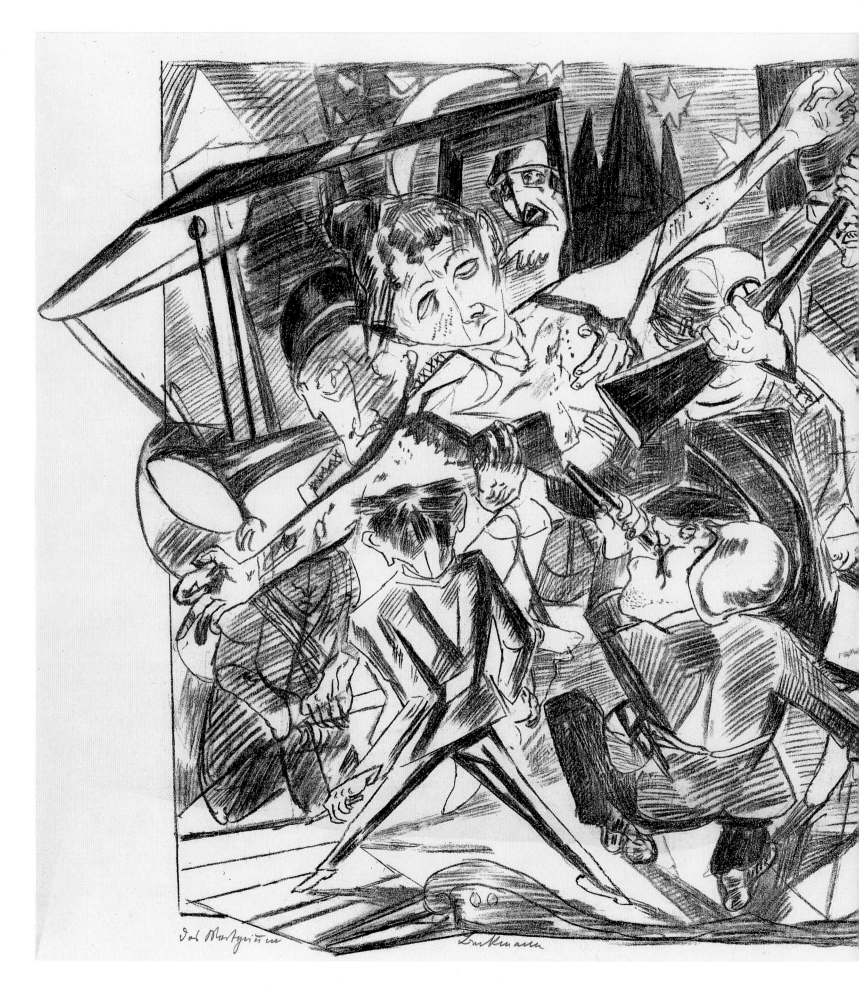

Das Martyrium Beckmann

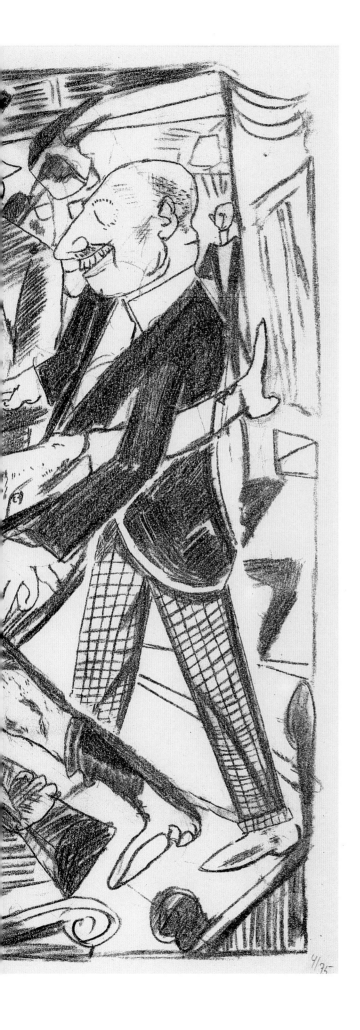

no.32
Plate 3: *The Martyrdom* 1919
Image size:
54.5 × 75
(21 1/2 × 29 1/2)

no.33
Plate 4: *Hunger*
1919
Image size:
62 × 49.8
(24 3/8 × 19 5/8)

no.34
Plate 5: *The
Ideologues* 1919
Image size:
71.3 × 50.6
(28 1/8 × 19 7/8)

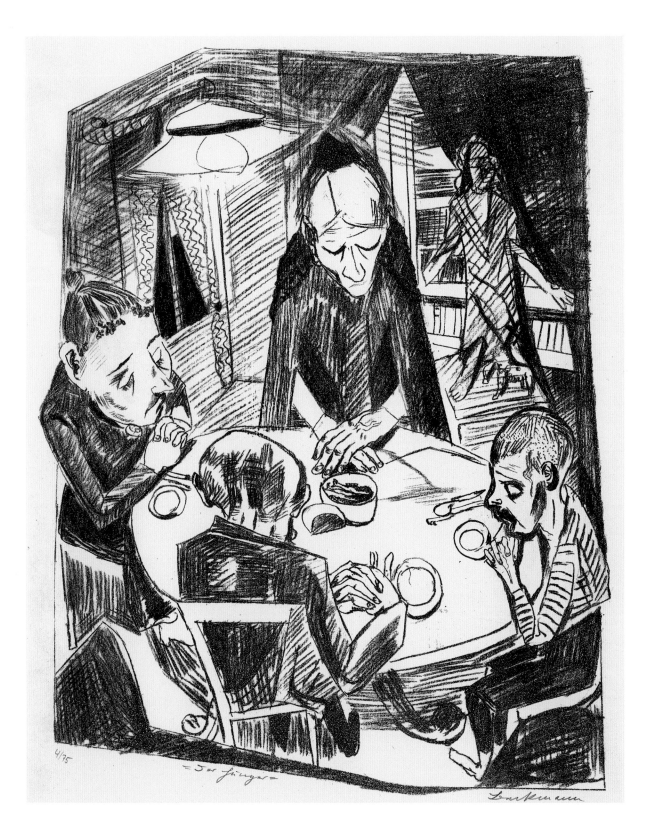

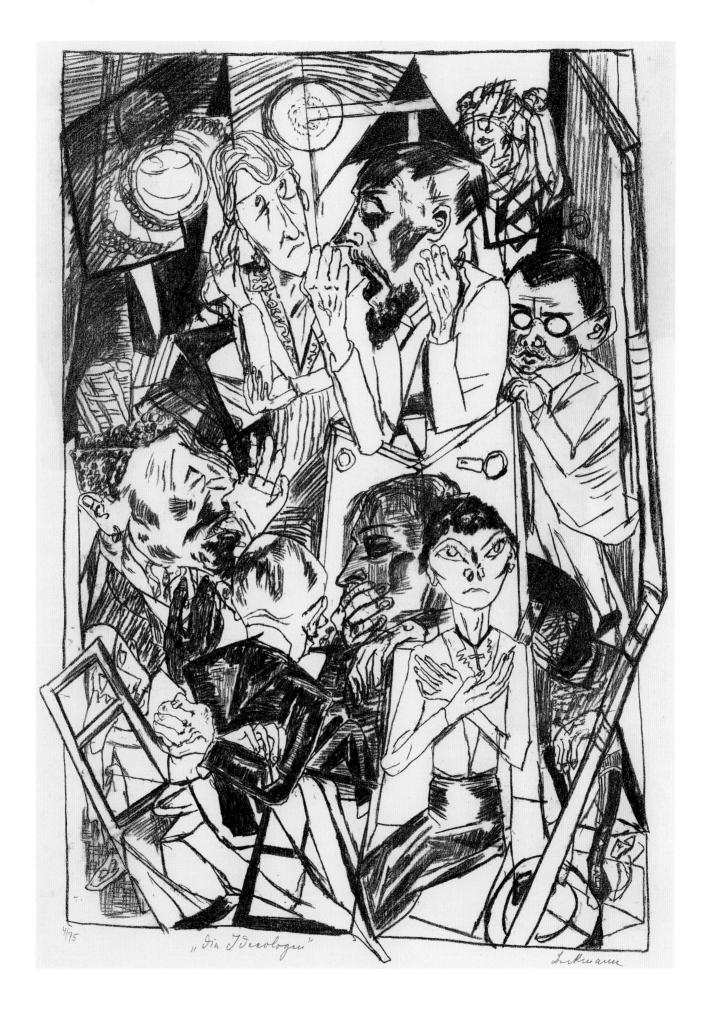

4/75 „Die Ideologen" Beckmann

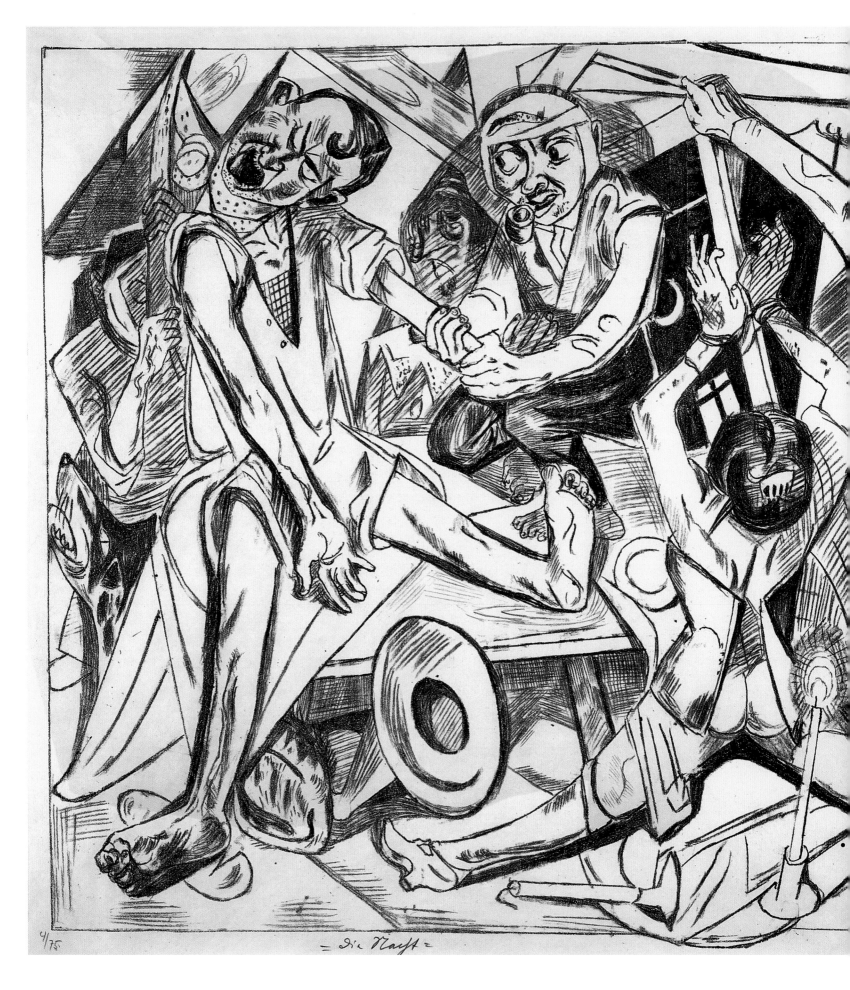

4/75 = Die Nacht =

no.35
Plate 6: *The Night*
1919
Image size:
55.6 x 70.3
(21 7/8 x 27 5/8)

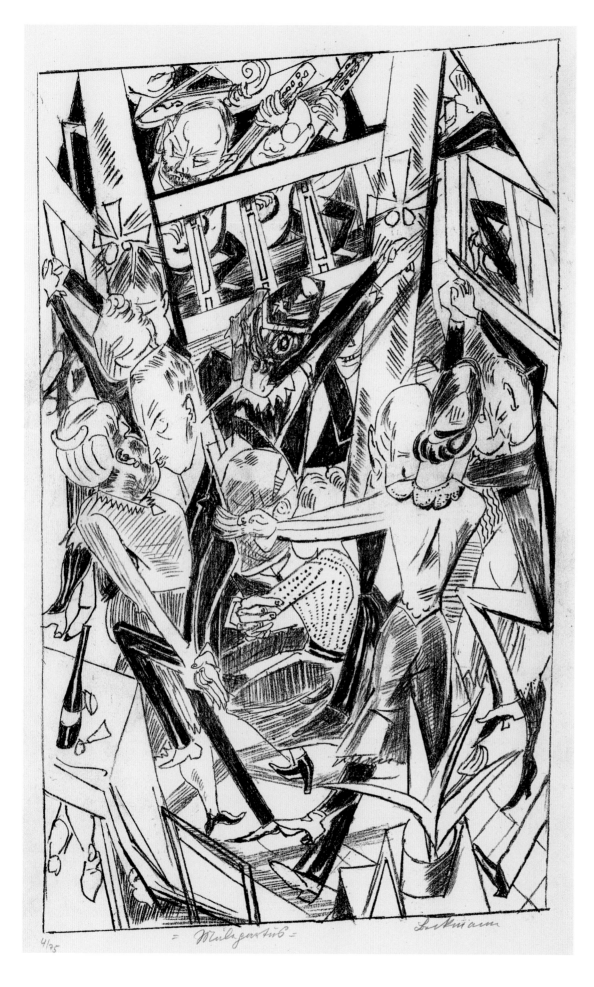

no.36
Plate 7: *Malepartus*
1919
Image size:
69 × 42.2
(27 1/8 × 16 5/8)

no.37
Plate 8: *The Patriotic Song*
1919
Image size:
77.5 × 54.5
(30 1/2 × 21 1/2)

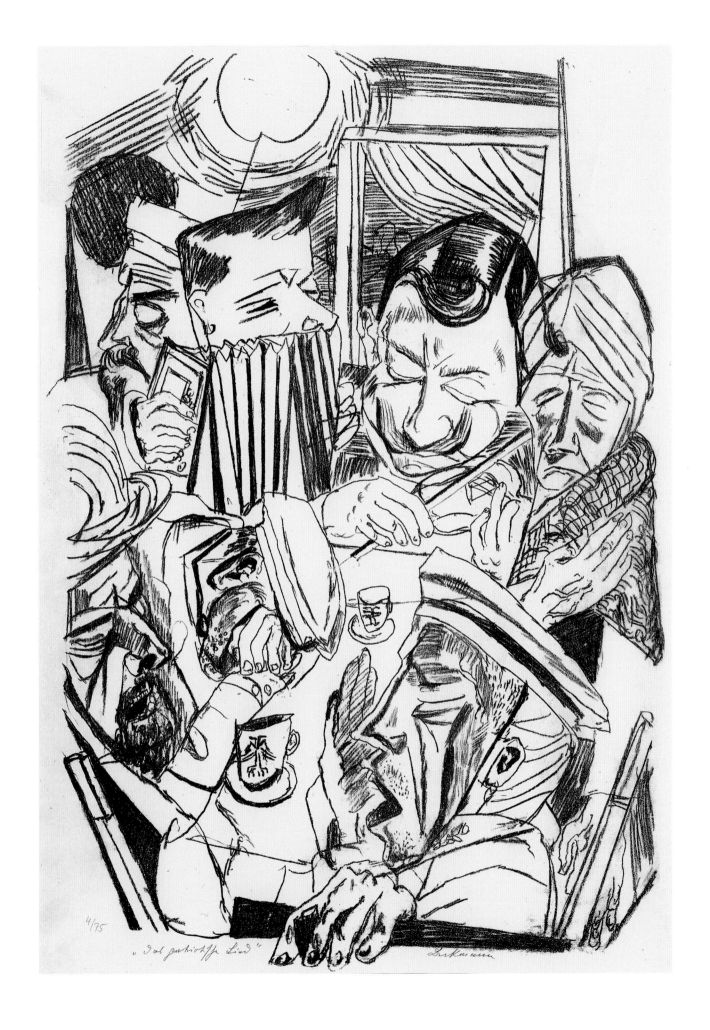

4/75　　　　　„Das patriotische Lied"　　　　　Beckmann

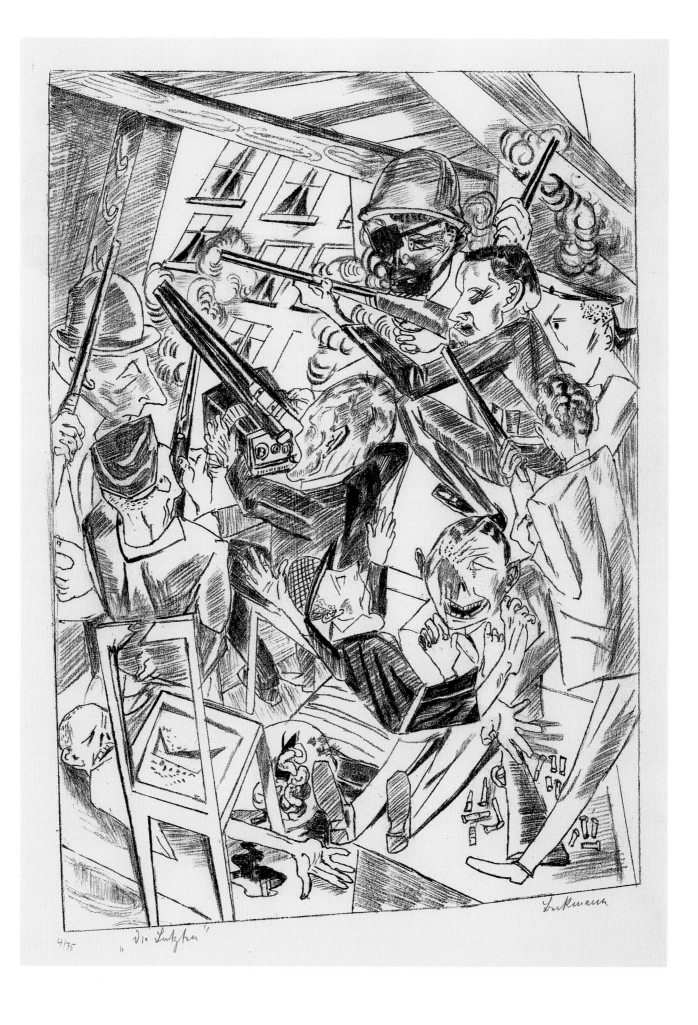

4/75 „Die Letzten" Beckmann

no.38
Plate 9: *The Last Ones* 1919
Image size:
75.8 × 46
(29 7/8 × 18 1/8)

no.39
Plate 10: *The Family* 1919
Image size:
76 × 46.5
(29 7/8 × 18 1/4)

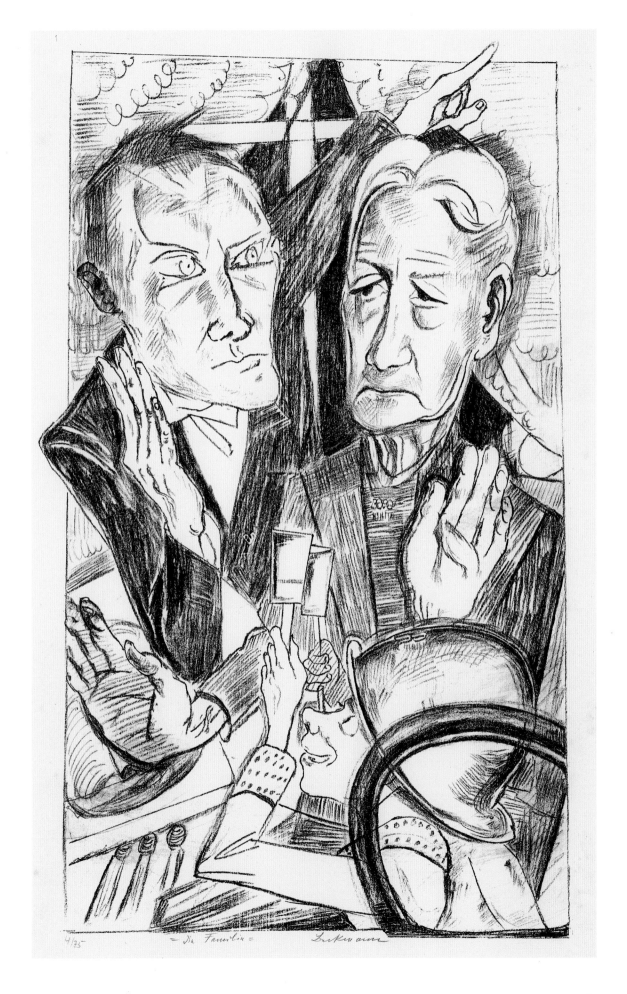

no.40
Group Portrait
Eden Bar 1923
Woodcut on paper
70 × 55.5
(27 1/2 × 21 7/8)
Private collection

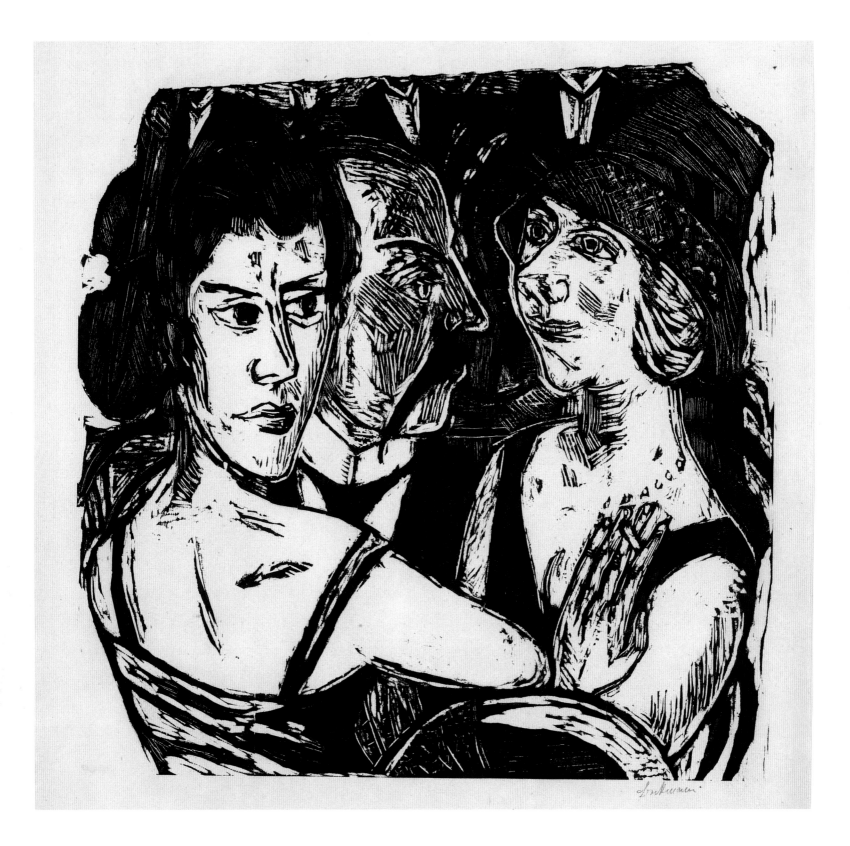

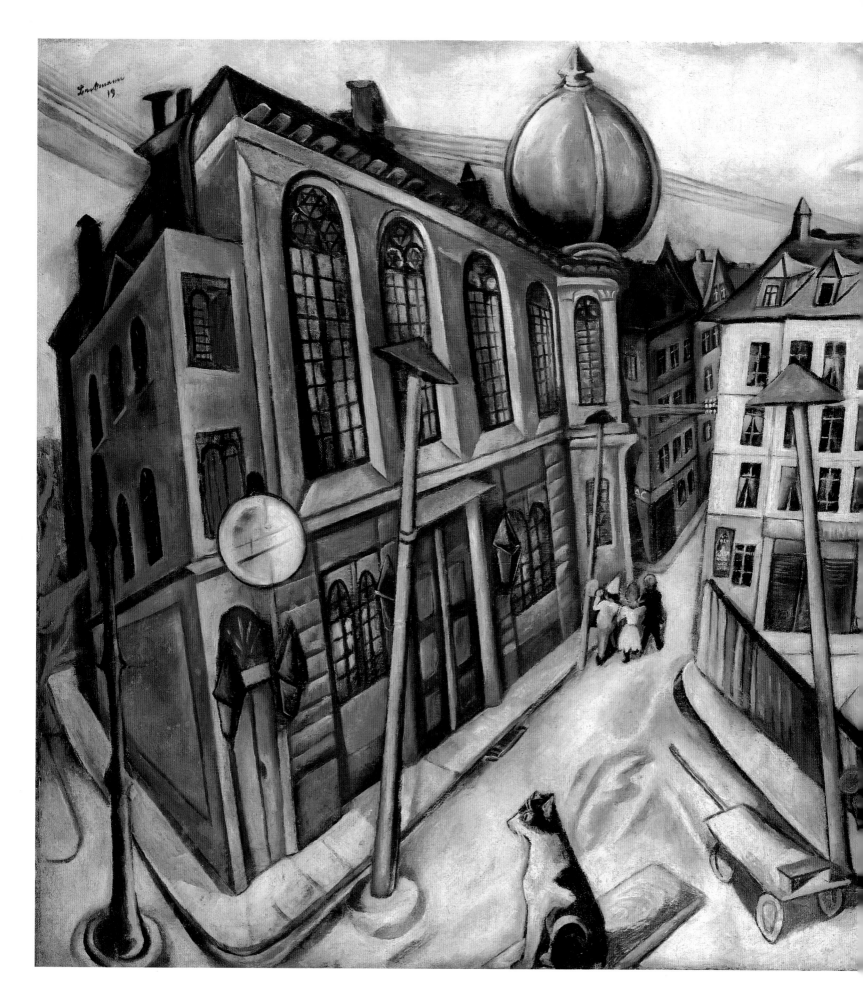

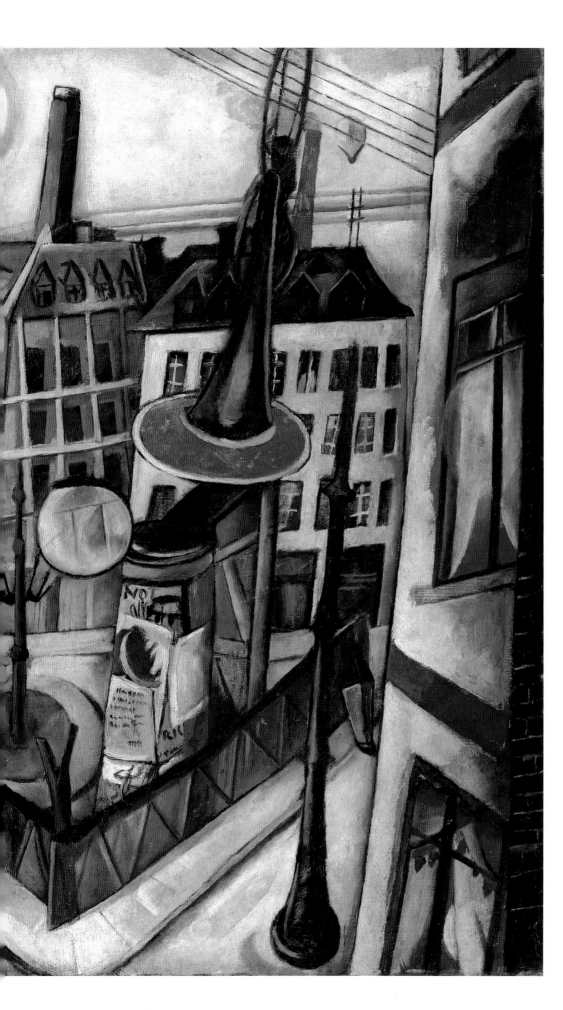

no.41
The Synagogue
1919
89 × 140
(35 × 55 1/8)
Städtische Galerie
im Städelschen
Kunstinstitut,
Frankfurt am Main

Beckmann's Frankfurt Cityscapes: Concepts of Space
Susanne Bieber

In 1915 Max Beckmann sought refuge in the city of Frankfurt after suffering a nervous breakdown while working as a medical orderly at the Belgian front. Within a few years he had regained his creative energies and in 1918 declared in an artistic statement titled 'A Confession' his determination to 'be a part of all the misery that is coming. We have to surrender our heart and our nerves, we must abandon ourselves to the horrible cries of pain of a deluded people ... [we must] give people a picture of their fate.'[1] This suggests Beckmann's preference for a subject matter that depicts the vibrant and brutal aspects of the human condition. Indeed, the most critically acclaimed works of Beckmann's post-war period, for example his paintings *The Dream* and *The Night* (nos.14, 59) or the

fig.6
Beckmann
Cupola of the
Synagogue in
Frankfurt 1919
Black crayon on
paper 37.2 × 26.5
(14 5/8 × 10 3/8)
Private
collection

no.42
Study of Houses for
'The Nizza in
Frankfurt am Main'
1921
Pencil on paper
37.8 × 37.2
(14 7/8 × 14 5/8)
Graphische
Sammlung im
Städelschen
Kunstinstitut,
Frankfurt am Main

graphic cycle *Hell* (nos.29–39), show
disturbing scenes of human drama featuring
sexual and political victims, desperate
cripples and starving families.

Given Beckmann's ambition to depict
subject matter that mirrors the dark aspects
of the human condition, it is intriguing that
during the same period he created a group
of cityscapes wholly devoid of such content.[2]
These works, for example his paintings *The*
Synagogue, The Nizza in Frankfurt am Main
and *The Iron Footbridge* (nos.41, 43, 44) show
topographically recognisable views of the
city of Frankfurt. The subject matter of these
cityscapes centres not on human drama, but
on the relatively static and inert architecture
of a city: buildings, streets, squares and
bridges. Human figures recede in importance,

appearing almost incidental. They are
dwarfed by their urban surroundings and
are depicted self-contentedly performing
mundane activities: taking a stroll across the
bridge or along the riverbank, manoeuvring
a raft on the river, making their way home
from a carnival celebration or enjoying the
view of a park.

Beckmann's group of cityscapes was
inspired by his immediate surroundings
in Frankfurt, a modest city nestled along
the river Main with idyllic gardens and
prosperous middle-class residents. The motifs
lay within walking distance of Beckmann's
studio in 3 Schweizer Strasse. *The Iron*
Footbridge depicts one of the nearby bridges
crossing the Main, with the neo-gothic Church
of the Three Kings on the Sachsenhauser

riverbank. The former Börneplatz features
in *The Synagogue* and the park named after
local gardeners who had worked along the
Italian Riviera around Nice is rendered in
The Nizza in Frankfurt am Main. Beckmann
appreciated the relative peace and tranquillity
of Frankfurt, which may explain his choice
of subject matter.[3] Such an account, however,
seems incongruous with the tone of
'A Confession', and leads one to wonder if
Beckmann was investigating other issues
in these paintings.

A closer examination of Beckmann's
statements and correspondence discloses
an overriding and lifelong interest in formal
issues with an emphasis on pictorial space.
In his 1918 'A Confession' he elaborated not
only on subject matter, but also on form:

no.43
The Nizza in
Frankfurt am Main
1921
100.5 × 65.5
(39 ¹/₂ × 25 ³/₄)
Öffentliche
Kunstsammlung
Basel,
Kunstmuseum

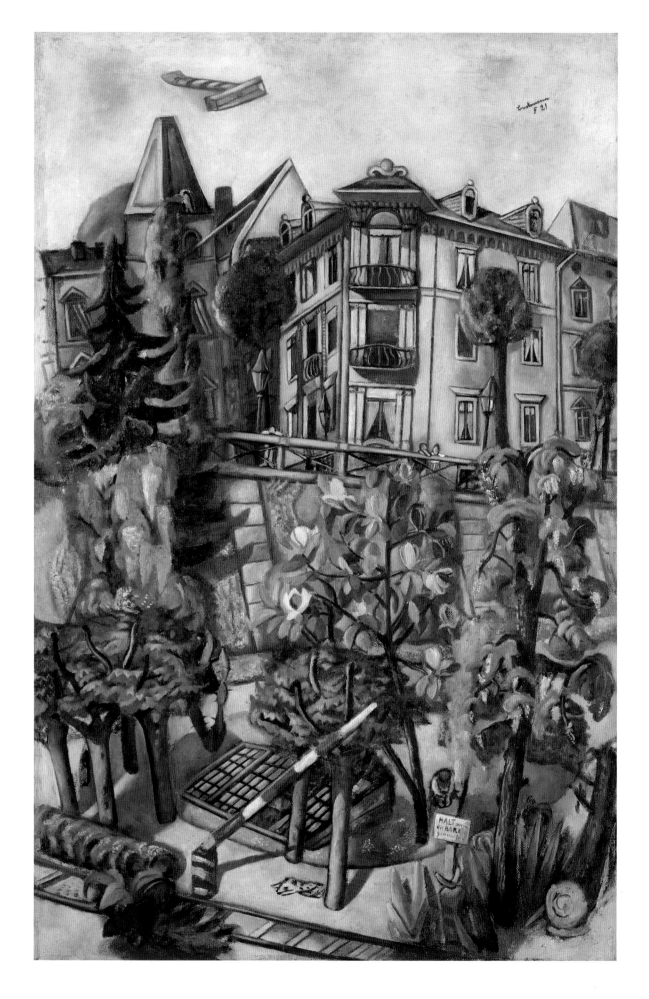

'I try to capture the terrible, thrilling monster of life's vitality and to confine it, to beat it down and to strangle it with crystal-clear, razor-sharp lines and planes.'[4] Beckmann defines the formal tools, namely 'crystal-clear, razor-sharp lines and planes', that enable him to capture his subject matter. The subsequent paragraph in 'A Confession' is devoted to formal issues, in which Beckmann concludes that 'most important for me is volume, trapped in height and width; volume on the plane, depth without losing the awareness of the plane, the architecture of the picture.'[5] In a letter to the art critic Wilhelm Hausenstein, Beckmann explained: 'The image, the wall or the canvas itself, that needs to be thought and sensed through not only in its depth, but also in the height of space, in all various layers of space, is and will be my continuous work. The "humanness" is an accompanying circumstance of time.'[6] And in his speech 'On My Painting' presented in 1938, Beckmann confirmed: 'It is not the subject that matters but the translation of the subject into the abstraction of the surface by means of painting.'[7] In these statements Beckmann emphasised the overriding importance that formal matters play in his art, even more important than the particular content of the work, such as the 'humanness', which he demoted as being merely an 'accompanying circumstance of time'. He repeatedly stressed the importance of 'space', 'volume' and 'depth' in relation to the picture plane, revealing his primary formal interest in pictorial space.

Beckmann's attention to pictorial space, however, should not be construed as a mere desire to paint with illusionistic accuracy; his interest in space was far grander. By means of pictorial space he aspired to penetrate his objects to their unutterable reality, to reveal the metaphysical core of things beyond appearance. He had already articulated this belief before the First World War, in a statement published in 1914: 'As for myself, I paint and try to develop my style exclusively in terms of deep space, something that in contrast to superficially decorative art penetrates as far as possible into the very core of nature and the spirit of things.'[8] Beckmann's concept of space is indebted to the French painter Paul Cézanne, whom he revered as 'a genius' in his article 'Thoughts on Timely and Untimely Art' of 1912. 'In his paintings', Beckmann continued, 'he succeeded in finding a new manner in which to express that mysterious perception of the world … If he succeeded in this, he did so only through his efforts to adapt his colouristic visions to artistic objectivity and to the sense of space, those two basic principles of visual art.'[9] Beckmann's concept of pictorial space is closely linked with the notion of objectivity; an objectivity that is opposed to purely abstract art, but also rejects illusionistic painting; rather, it is what he called a 'transcendental objectivity'.[10] It takes as its starting point the real object in space, but aspires to transcend it and therefore inevitably transforms the object and its spatial relations.

In the Frankfurt cityscapes Beckmann animates the inertness of the architecture with formal tools, which might reflect his aspiration to reach for the metaphysical core of things. Using lines, planes and light, he manipulates space and elicits personality from otherwise static, geometric buildings. He exaggerates volume and subverts the long-established rules of single point perspective. The cupola in *The Synagogue*, for example, is enlarged in its roundness in comparison with the more realistic sketch (fig.7) probably drawn from life. In the painting the cupola is no longer an inert part of a building, but seems to swell and breathe. The synagogue itself is rendered in a contorted perspective similar to a view through a fisheye lens, and the various buildings have multiple vanishing points that together convey an undulating motion. The church and houses in *The Iron Footbridge* are less agitated, but the bridge is exaggerated in size and perspective and threatens to stride out of the picture, like an industrial monster. A comparison with a photographic picture postcard of the Iron Footbridge (fig.7) showing even the crane in the lower left corner, illustrates how Beckmann manipulates space and animates the shapes of his objects.[11]

In addition to revealing the vitality or essence of things by means of formal tools, Beckmann desired to anchor or constrain this vitality within the two-dimensional canvas. As a painter Beckmann did not repudiate the flat material surface of paintings in order to achieve an illusionistic scene as if viewed through a window, so highly recommended by the Renaissance theoreticians. Instead he counters the roundness of objects with flattening devices such as dark outlines. The

no.44
The Iron Footbridge
1922
120.5 × 84.5
(47 ¹/₂ × 33 ¹/₄)
Kunstsammlung
Nordrhein-
Westfalen,
Düsseldorf

fig.7
Postcard view of the
Iron Footbridge and
Church of the Three
Kings, Frankfurt am
Main c.1920

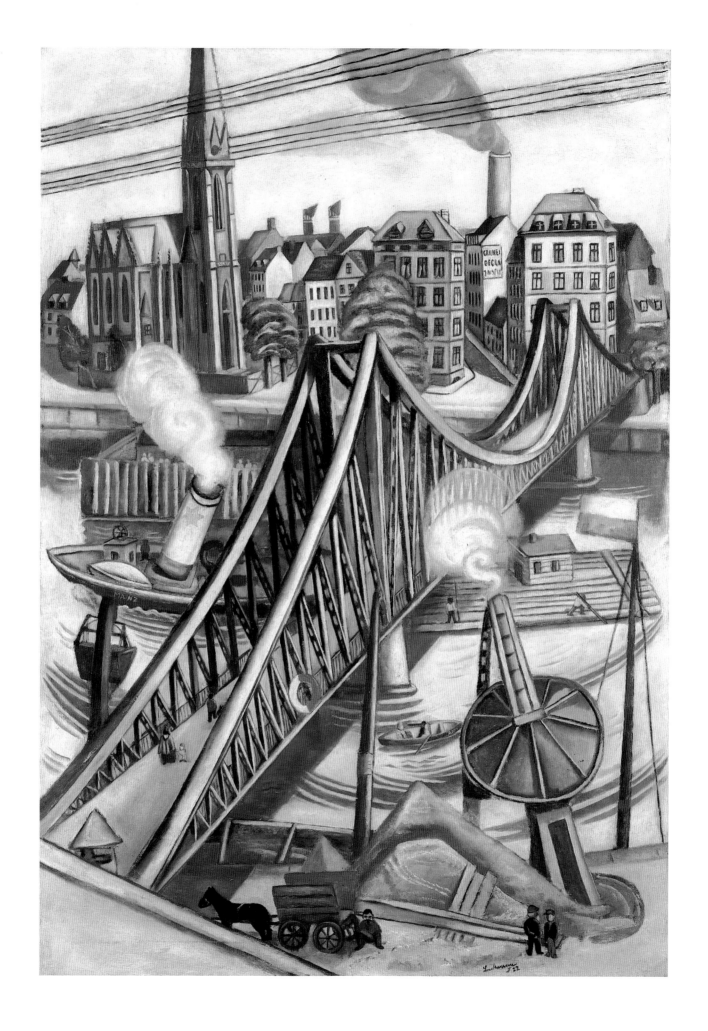

bloated cupola in *The Synagogue*, or the animated bridge and crane in *The Iron Footbridge*, for example, are confined by sharp, dark edges, which inhibit their vitality within the two-dimensional surface of the canvas.[12] Beckmann also constrains objects and buildings by a taut composition. The little rowing boat in the lower part of *The Iron Footbridge* is visually curbed by a flagpole to the left and the crane to the right. In addition, Beckmann reduces pictorial depth by undermining the principles of atmospheric perspective. In *The Nizza in Frankfurt am Main*, for example, the colours and details of the elegant villas in the background are as intense and clear as those of objects in the foreground, thereby pulling objects that are spatially placed 'behind' each other into

the flat plane. Set out as an objective in 'A Confession', Beckmann succeeded in creating volume that is 'trapped in height and width; volume on the plane, depth without losing the awareness of the plane'.[13]

Throughout his artistic career Beckmann pondered on space in its infinite dimension, which he conceived on one hand as something frightful that needed concealing and on the other hand as a divine entity that he desired to grasp. In a letter of 1915 from the war front to his wife Minna, Beckmann wrote: 'Ugh, this infinite space, whose foreground we constantly have to fill with stuff in order not to see its horrifying depth.'[14] And in his speech 'On My Painting' of 1938 he explained, that 'height, width, and depth are the three phenomena that I must transfer into one

plane to form the abstract surface of the picture, and thus to protect myself from the infinity of space'.[15] One might conclude that in his paintings Beckmann attempted to shield himself from the incomprehensible infinity of space by means of compression and flatness. In the same speech, however, Beckmann attested his eagerness not to conceal, but to grasp infinity: 'Space, and space again, is the infinite deity which surrounds us and in which we are ourselves contained. That is what I try to express through painting.'[16] The artistic translation of real, three-dimensional space into pictorial, flat space seems to allow at once the protection from and the comprehension of infinite space.

In his Frankfurt cityscapes Beckmann transforms a panoramic view into a limited

no.45
Garden View from the Window 1916
Pencil on paper
24 x 31.8
(9 ¹/₂ x 12 ¹/₂)
Graphische
Sammlung im
Städelschen
Kunstinstitut,
Frankfurt am Main

and claustrophobic space. He depicts the city scenes from a bird's eye vantage point typical for paintings of this genre, to allow an encompassing vista. He then, however, establishes the horizon on the upper third of his canvas, so that the streets, plazas and bridges occupy the largest part of the picture whilst pushing the sky, the face of infinite space, to the upper fringes. In most of his cityscapes a row of tall houses is arranged parallel to the picture plane to clearly demarcate and fence in our vista. Rarely does the viewer catch a glimpse into the infinite distance; and in *The Synagogue,* for example, even the slender segment of the sky is obstructed by electricity cables.[17] At times Beckmann further emphasises a confined view by squeezing a traditionally horizontal cityscape into a vertical format.[18] Another look at the picture postcard of the iron footbridge showing roughly the same view as the painting illustrates how Beckmann squeezes an open and panoramic composition into a limited pictorial space.[19]

Beckmann's concepts of space lie at the heart of his oeuvre. His Frankfurt cityscapes could be interpreted as deliberate articulations of space – space as defined by the voluminosity of objects, space as a tool to penetrate to the unutterable essence of things, space as a three-dimensional expanse to be translated onto the two-dimensional canvas, space in its infinity at once to be feared and concealed and to be grasped. 'Space, and space again',[20] as Beckmann proclaimed, was one of his lifelong obsessions.

Notes

1 'A Confession' was written in 1918 for Kasimir Edschmid's publication *Tribune der Kunst und Zeit*, but was not published until 1920 in an issue titled 'Creative Credo'. Max Beckmann, 'Creative Credo, 1918', in Barbara Copeland Buenger (ed.), *Max Beckmann: Self-Portrait in Words. Collected Writings and Statements, 1903–1950*, Chicago and London 1997, p.184.

2 In addition to the group of cityscapes, Beckmann painted numerous landscapes during this period, which are also devoid of dramatic human subject matter. See Nina Peter, *Max Beckmann. Landschaften der Zwanziger Jahre*, Frankfurt 1993, and Susanne Rother, *Beckmann als Landschaftsmaler*, Munich 1990.

3 Beckmann frequently travelled to Berlin to visit his family and his dealer I.B. Neumann. To the latter he wrote after a visit to Berlin: 'Hopefully you enjoy the scuffle around the exhibition. To me all this seems to be very distant, and so it is very well.' Letter to I.B. Neumann, April 1922, in Klaus Gallwitz, Uwe M. Schneede, Stephan von Wiese (eds.), *Max Beckmann: Briefe,* vol.1: 1899–1925 (edited by Uwe M. Schneede), Munich and Zurich 1993, p.217.

4 Max Beckmann, 'A Confession', 1918, in Buenger 1997, p.184.

5 Ibid., p.184.

6 Letter to Wilhelm Hausenstein, 15 February 1922, in *Max Beckmann: Briefe*, vol.1., 1993, pp.212–13.

7 Beckmann delivered the speech 'On My Painting' during the opening of the *Exhibition of Twentieth Century German Art* at the New Burlington Galleries in London. Max Beckmann, 'On My Painting', 1938, in Buenger 1997, p.302.

8 This statement was published in the art journal *Kunst und Künstler*, edited by Karl Scheffler, in an issue titled 'The New Programme'. Max Beckmann, 'The New Programme', 1914, in Buenger 1997, p.132.

9 'Thoughts on Timely and Untimely Art' was written by Beckmann as a response to an article by Franz Marc titled 'The New Painting'. Marc had referred to Cézanne's work, which for him, however, was the harbinger of Cubism and abstract art. Cézanne's example led Marc and his friend Wassily Kandinsky, as well as the contemporaneous French avant-garde, to flatness and abstraction. Beckmann's statement stands in clear opposition to Marc's. The two articles plus Marc's response to Beckmann were published in Paul Cassirer's magazine *Pan II* in 1912. Max Beckmann, 'Thoughts on Timely and Untimely Art', 1912, in Buenger 1997, p.115. See also Dietrich Schubert, 'Die Beckmann–Marc Kontroverse von 1912: "Sachlichkeit" versus "innerer Klang"', in Bernd Hüppauf (ed.), *Expressionismus und Kulturkrise*, Heidelberg 1983, pp.207–44; and Joachim Poeschke, '"Meinen Stil zu gewinnen ..." Beckmann und Cezanne', in Christian Lenz (ed.), *Max Beckmann. Vorträge 1996–1998*, Munich 2000.

10 Max Beckmann, 'A Confession', 1918, in Buenger 1997, p.185. Beckmann explained to Reinhard Piper that he was not only concerned with 'truthful representation [Gegenständlichkeit]', but also with the 'metaphysical in representation'. In Reinhard Piper, *Nachmittag. Erinnerungen eines Verlegers*, Munich 1950, pp.25, 27. Beckmann's championing of representational art was closely associated with the artistic movement Neue Sachlichkeit, originally the title of an exhibition organised by G.F. Hartlaub, director of the Mannheim Kunsthalle, in 1925, in which Beckmann's work featured dominantly. The following year, however, Beckmann criticised the developments of Neue Sachlichkeit writing to Hausenstein: 'To bring up for debate representation in a new form of art, has been my impetus ... Meanwhile this principle is frequently taken up, unfortunately more often misunderstood and banalised than I desire. Instead of the essential feeling for space and form a partly literary, partly uninspired and flat form of representation was created in Berlin. In Munich even a thin and anarchistic one.' Letter to Wilhelm Hausenstein, 12 March 1926, in Klaus Gallwitz, Uwe M. Schneede, Stephan von Wiese (eds.), *Max Beckmann: Briefe*, vol.2: 1925–1937 (edited by Stephan von Weise), Munich and Zurich 1994, p.34.

11 For a comprehensive analysis of *The Iron Footbridge* see Christoph Schulz-Mons, 'Kirchner und Beckmann in Frankfurt', in *Zeitschrift für Kunstgeschichte 43*, 1980, H.2, pp.203–10; and for *The Synagogue* see Christian Lenz, 'Max Beckmann's *Synagoge*', in *Städel-Jahrbuch*, N.S., no.4, Munich 1973, pp.299–320.

12 The use of dark outlines and with it a stronger emphasis on flatness became more dominant in Beckmann's paintings of the late 1920s. See Ortrud Westheider, *Die Farbe Schwarz in der Malerei Max Beckmanns*, Berlin 1995.

13 Buenger 1997, p.184.

14 Letter to Minna Beckmann-Tube, 24 May 1915, in *Max Beckmann: Briefe*, vol.1, 1993, p.136.

15 Buenger 1997, p.302.

16 Ibid., p.303.

17 Compare Beckmann's Frankfurt cityscapes with, for example, the Venetian cityscapes by Canaletto, where the horizon is generally in the lower half of the painting giving more room to the sky and a view into the distance.

18 Beckmann even reduced the width of the canvas for *The Iron Footbridge* during the painting process. See Erhard Göpel and Barbara Göpel, *Max Beckmann. Katalog der Gemälde*, Bern 1976, vol.1, p.157.

19 In accordance with Erwin Panofsky's 'Perspective as Symbolic Form' based on Alois Riegl's writings, one might argue that Beckmann's formal language, especially his depiction of space, is representative of his world view. Erwin Panofsky, 'Die Perspektive als "Symbolische Form"', in *Vorträge der Bibliothek Warburg 1924–1925*, Leipzig and Berlin 1927, pp.258–330.

20 Max Beckmann, 'On My Painting', 1938 in Buenger 1997, p.302.

no.46
Landscape near Frankfurt (with Factory) 1922
66 x 100.5
(26 x 39 1/2)
Rose Art Museum, Brandeis University, Waltham, Massachusetts. Gift of Mr and Mrs Harry N. Abrams, New York

no.47
Main River Landscape 1918
Plate 6 of *Faces* portfolio
Drypoint on paper
25.1 x 30
(9 7/8 x 11 3/4)
The British Museum, London

no.48
Landscape with
Lake and Poplars
1924
60 x 60.5
(23 5/8 x 23 7/8)
Kunsthalle
Bielefeld

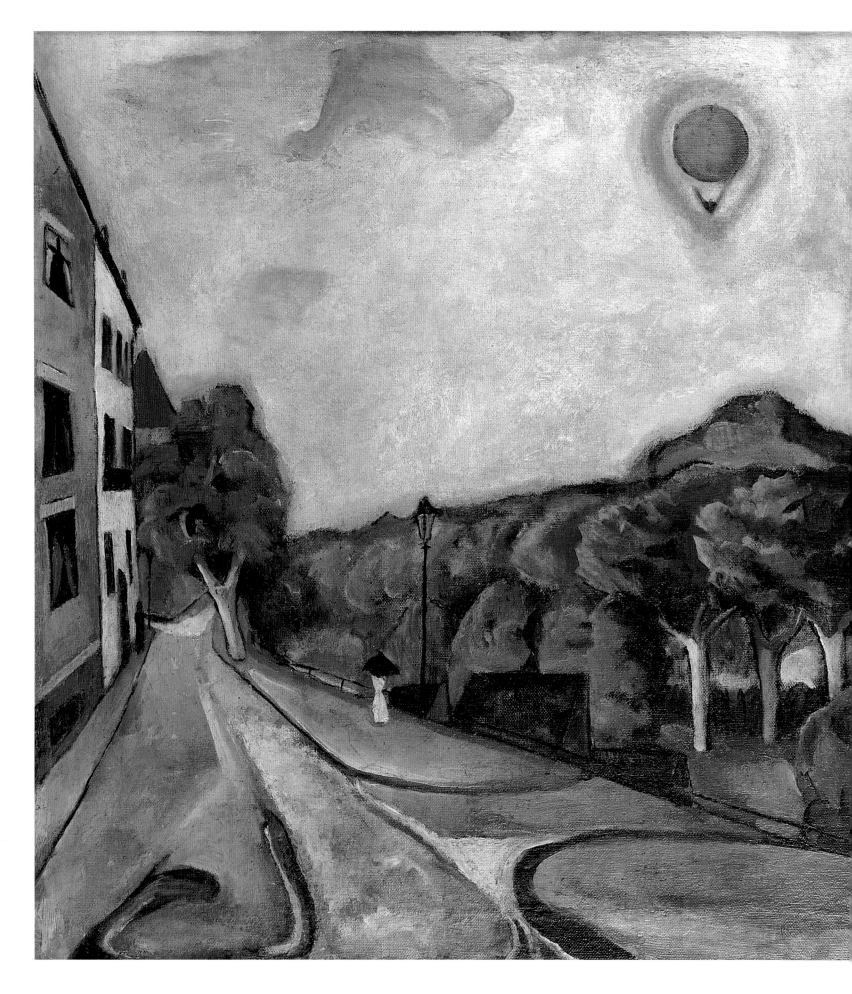

no.49
*Landscape with
Balloon* 1917
75.7 x 100.5
(29 7/8 x 39 5/8)
Museum Ludwig,
Cologne

no.50
*Landscape with
Balloon* 1918
Plate 14 of *Faces*
portfolio
Drypoint on paper
23.3 x 29.5
(9 1/4 x 11 5/8)
The British
Museum, London

fig.9
Italian beach scene
c.1924. Family of
the artist

The Painter on the Beach: Beckmann's Italian Paintings
Nina Peter

In 1924 Max Beckmann travelled to Pirano on the Adriatic with his wife and son; by then he and his wife had already been living apart for some time. This journey was to become an important experience for Beckmann: 'I spent two weeks in Italy by the Adriatic Sea and saw wonderful things there which I now want to try to recreate.'[1]

Two pictures with beach scenes and boats were the outcome. The subject matter was not new to Beckmann. Nineteen years earlier he had had his first major success with a classical-looking beach scene entitled *Young Men by the Sea* (no.3). But the figures in the paintings he was now producing had abandoned their classical nakedness for contemporary beachwear, and the paintings themselves were inspired by Beckmann's real-life holiday.

In the painting *Lido* (no.51), Beckmann depicts a mysterious female figure with a wrap and a bathing cap walking along the shore. Another woman, with a towel round her head and shoulders, walks in the other direction, gazing out at the viewer. On the return journey from Pirano, Max Beckmann had met the young Mathilde von Kaulbach ('Quappi') in the home of a family he knew. A year later she became his second wife. Beckmann depicts the advent of this new relationship in the guise of a beach scene.

The second picture sparked off by this holiday is *Italian Fantasy* 1925 (no.53). It is a painting of three Italian men singing, and one woman, all in a boat outside a harbour. The highly symbolic motif of a journey is crammed into a narrow vertical format. The

colours – green, white and red – give the whole a contemporary, folkloric feel.[2] Beckmann himself saw this painting as 'a very quirkily grotesque, beautiful thing'.[3] He said that he felt he simply had to include a woman in the company of these three men, so without further ado he 'just added' Quappi.[4] The presence of the frightened-looking female figure in the boat shows a complete lack of communication between the sexes.

The following year, after he and Minna Tube had divorced, Beckmann and Quappi married and returned to Italy on their honeymoon. Beckmann described the pictures he painted directly after this as 'great'. He was especially pleased with the painting *The Bark* (no.52): at last he had produced another major work. The subtitle he gave it,

no.51
Lido 1924
72.5 × 90.5
(28 ¹/₂ × 35 ⁵/₈)
The Saint Louis Art
Museum. Bequest
of Morton D. May

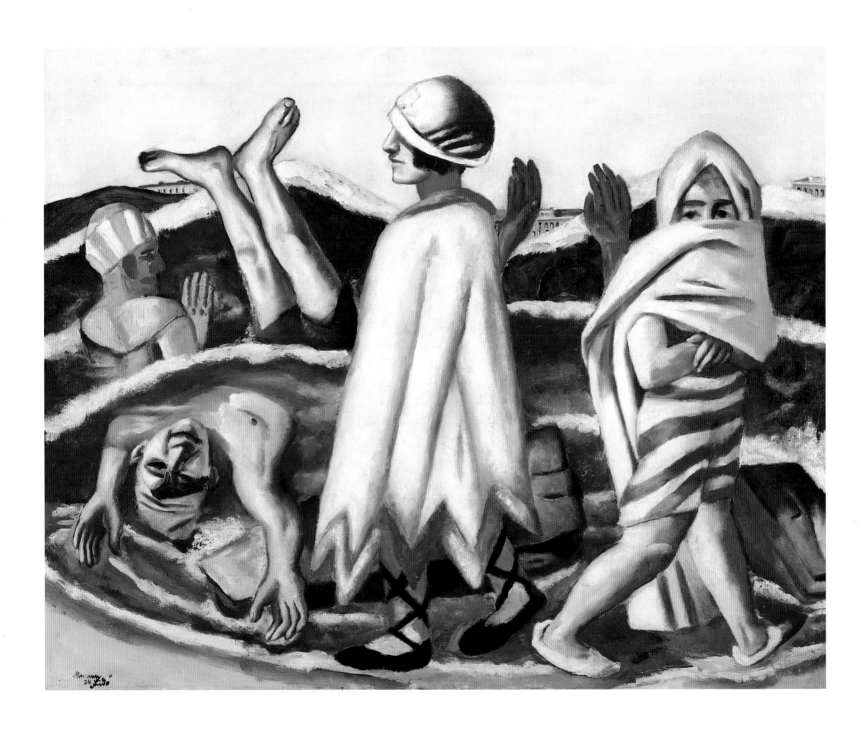

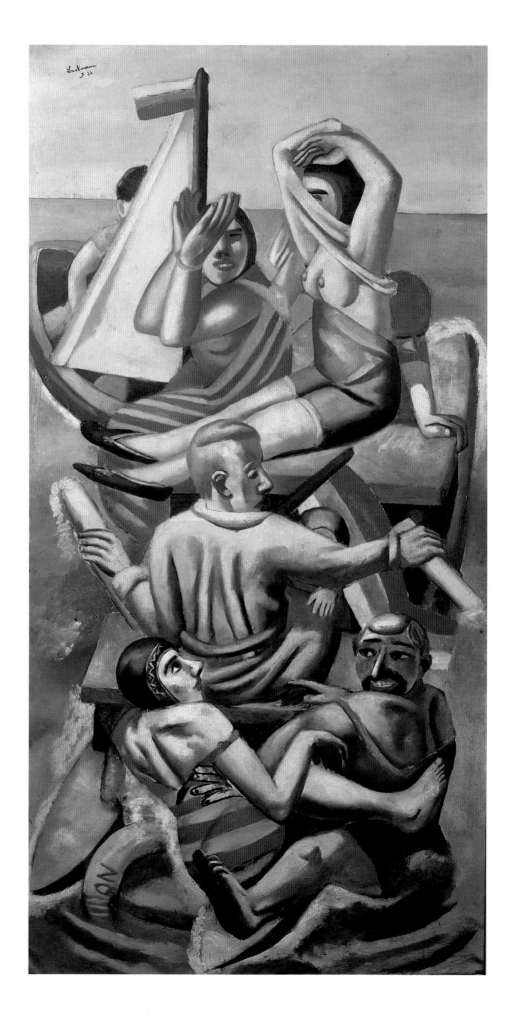

Play of the Waves, is an allusion to Arnold Böcklin's painting of the same name, and points clearly to the importance of the art-historical context for Beckmann. In the picture itself, however, the only connection to Böcklin is the man with the lascivious eyes who is trying to take hold of the woman in the bathing suit. The theme of the painting is a collision between a small sailing boat, with just one man on board, and a group of young people in a rowing boat. Quappi is sitting upright on the rowing boat, baring her breasts in an almost ritualistic manner. The colours used to depict her make the connection with the man in the sailing boat; his black cap might be read as a subtle reference to Max Beckmann himself.[5]

In addition to this boat scene, Beckmann painted *GalleriaUmberto*, which he himself described as a 'wicked painting' (no.89). It depicts a dream in which water has flooded into the Galleria Umberto in Naples, and a body can be seen hanging from the ceiling.[6] A *carabinieri* carries a bleeding victim on his shoulders, another is seen sinking down in the flood water, his hands outstretched above him. The figure of the man in the red and yellow striped bathing costume, clutching a large fish, had already appeared earlier in *The Dream* 1921 (no.14). The Mantuan sphere hanging next to the corpse confirms that the scene depicts a vision, which can be interpreted – not least because of the Italian flag and the *carabinieri* – as a premonition of the decline of Fascism.

The nationalist mood in Italy, which had been under Mussolini's rule since 1922, is

no.53
Italian Fantasy
1925
127 x 43 (50 x 16 7/8)
Kunsthalle
Bielefeld

pages 88–9
no.54
The Harbour of Genoa 1927
90.5 x 169.5
(35 5/8 x 66 3/4)
The Saint Louis Art Museum. Bequest of Morton D. May

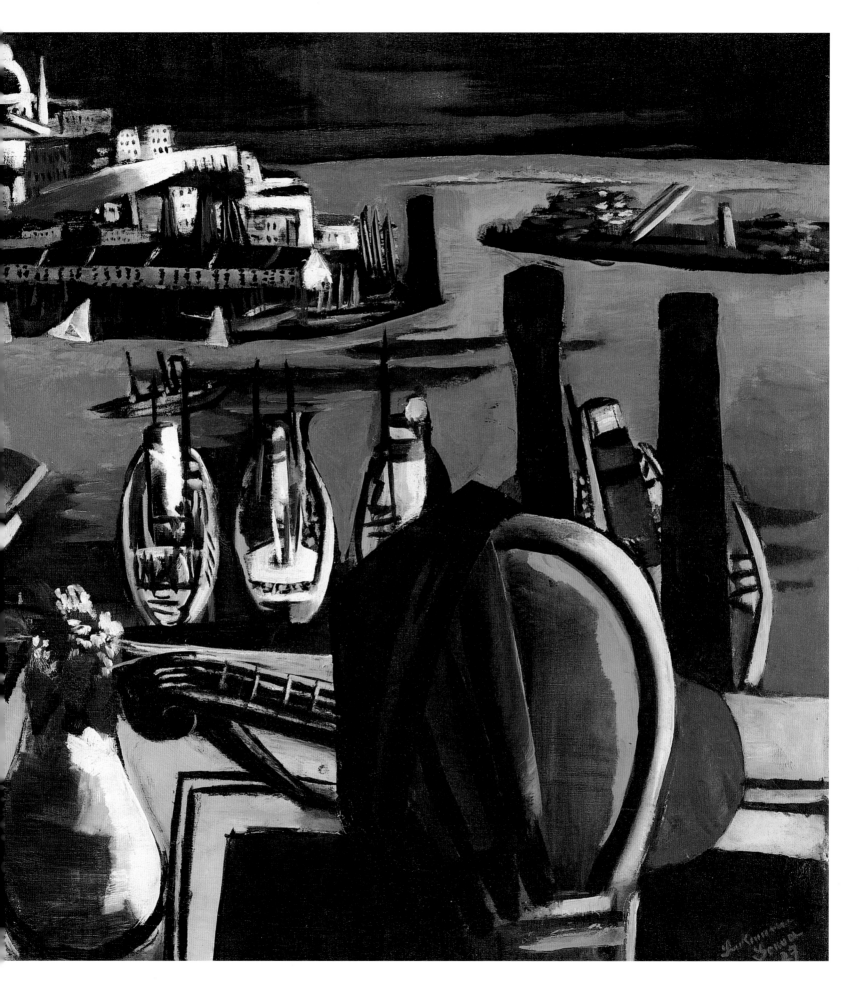

highlighted by the national colours and flags that appear in both *Italian Fantasy* and *The Bark*. And the same mood is seen again in a landscape painted by Beckmann in 1927. The size of *The Harbour of Genoa* (90.5 × 169.5 cm) indicates that Beckmann was treating this urban landscape just as seriously as any of his figure compositions (no.54). Looking out over the city from a balcony, the painting shows a composite view of the station and the harbour in Genoa. Broadly speaking the painting really only uses three colours: black, white and blue-green. The dark blue-green of the sea is laid with virtuoso skill over a black ground. The distinctly uncanny atmosphere of the picture and the emphasis on the colour black can be read as a reference to the political situation in Italy. A similar atmosphere pervades Klaus Mann's description of Genoa not long after Beckmann's visit: 'There is a great deal of hustle and bustle in the "cavernous", dark narrow alleyways of Genoa. More often than not there is something military afoot, a procession of black-shirts, a little parade.'[7]

Despite the much-simplified depiction, the city itself can be identified as Genoa. Beckmann had in fact taken photographs of the station (fig.11) and of the harbour view, and he also had in his possession a postcard of the harbour.[8] The reason why Beckmann wanted to include the station in this composition becomes clear from his letters. In July, Quappi had gone to visit her family. She and Beckmann had arranged to meet in Genoa after this six-week separation, and at the time Beckmann wrote to her: 'I am so much looking forward to seeing you at last, at last

my darling and to seeing our southern sea!'[9] In view of this, the white flowers in the vase and the mandolin on the balcony balustrade can be read as symbols of the painter's anticipation of love. In *The Harbour of Genoa* Beckmann both documents his own personal situation and reflects the wider political events of that time.

The importance of Beckmann's Italian trips for his own artistic output can be seen from the following statement: 'It was through nature (and not through Antiquity) that I arrived at a new way of depicting the essence of a situation.'[10] The interpolation 'and not through Antiquity' sets his own situation apart from that of Arnold Böcklin, whose sea scenes with mythical creatures were of considerable interest to Beckmann, as may be seen in *The Bark*. Equally, it could set him apart from Picasso, whose beach scenes in the early 1920s certainly were inspired by Antiquity.[11] Beckmann's memories of the beaches of Italy had a lasting influence on his repertoire of motifs. Boats, mariners and the sea return in later paintings – but whereas they were depicted straight from life in the Italian paintings, and presented in the context of their own time, later on they appear in a more fragmentary, mythological guise.

Translated from German by Fiona Elliott

fig.10
Genoa Railway
Station *c*.1920s
Family of the artist

Notes

1 Letter to I.B. Neumann of 9 August 1924. in Klaus Gallwitz, Uwe M. Schneede, Stephan von Weise (eds.), *Max Beckmann: Briefe*, vol.1: 1899–1925 (edited by Uwe M. Schneede), Munich and Zurich 1993, pp.252–5. The letter continues: 'I am painting portraits still lifes landscapes visions of towns rising up out of the sea, beautiful women and grotesque monsters. People bathing and female nudes in short a life – a life that simply exists. Without thoughts or ideas. Filled with colours and forms from nature and from out of myself. – As beautiful as possible. – This will be my work for the next ten years.'

2 The boat can be read as a 'ship of life'.

3 Letter to I.B. Neumann, 31 August 1924., in *Max Beckmann: Briefe*, vol.1, 1993, p.257.

4 Letter to Mathilde Kaulbach, 2 June 1925, in *Max Beckmann: Briefe*, vol.1, 1993, pp.289–91.

5 Beckmann often depicted himself with a black cap, as in *The Bath* 1930 (no.74), *Self-Portrait with Black Cap* 1934 (G391), and the lithograph *Self-Portrait* 1946, sheet 1 of the portfolio *Day and Dream* (no.129).

6 After Mussolini and his closest associates had been executed in 1945, their bodies were hung up for the public to see in just this manner. The motif of a body hung up by the feet already existed in Sheet 39 of Goya's *The Disasters of War* of 1810–14.

7 Trans. from Erika and Klaus Mann, *Das Buch von der Riviera* (1931), Berlin 1989, p.158.

8 The relevant photographs and the postcard are in the private collection of the Beckmann family. For more on Beckmann's use of photographs he took in Italy, see Nina Peter, *Max Beckmann: Die Landschaften der Zwanziger Jahre*, Frankfurt 1993, pp.91–3.

9 Letter to Mathilde Beckmann, 14 August 1926 in Klaus Gallwitz, Uwe M. Schneede, Stephan von Weise (eds.), *Max Beckmann: Briefe*, vol.2: 1925–1937 (edited by Stephan von Wiese), Munich and Zurich 1994, p.67.

10 Letter to I.B. Neumann, 25 January 1926 in *Max Beckmann: Briefe*, vol.2, 1994, pp.30–1.

11 See Christian Lenz, *Max Beckmann und Italien*, Frankfurt 1976, p.29.

no.55
Rimini 1927
Pastel on paper
48.5 × 64
(19 1/8 × 25 1/4)
Private collection

no.56
*Young Boy with
a Lobster* 1926
Charcoal with
whitening on
paper 64 × 48
(25 ¼ × 18 ⅞)
Karin and Rüdiger
Volhard

no.57
Newspaper Seller
1928
Black chalk on
paper 63.5 × 48.5
(25 × 19 ⅛)
Private collection

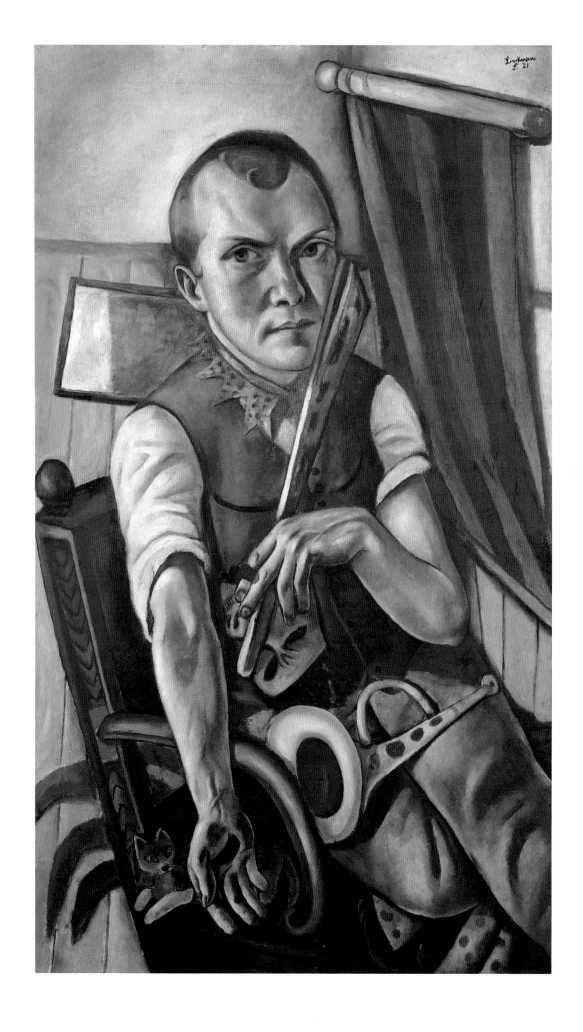

Beckmann and the Triptych: A Sacred Form in the Context of Modernism
Anette Kruszynski

no.58
Self-Portrait as Clown 1921
100 x 59
(39 ³/₈ x 23 ¹/₄)
Von der Heydt-Museum
Wuppertal

Max Beckmann's reputation is founded largely on his triptychs. Together these constitute an exceptional group of monumental works, created during the last twenty years of Beckmann's life, that took the viewing public completely by surprise. It was not just that he was using a pictorial form that looked anachronistic in the twentieth century; it was the fact that he did so repeatedly at significant stylistic and personal turning points in his artistic career.

By the time of his death in 1950 he had completed nine triptychs, although he had worked on yet more over the years, some of which still exist as detailed sketches.[1] He began his first, *Departure*, in 1932 in Frankfurt, when he was approaching the age of fifty, completing it the following year in Berlin (no.60). In fact, Beckmann was working on *Departure* during the time when he was considering the move to Berlin,

following a long period of growing recognition through exhibitions, sales, and a chair at the Art Academy in Frankfurt. Because of the changed political situation and the pressure being exerted by the increasingly powerful National Socialists, Beckmann finally decided to continue with his work, but as an 'internal émigré'. Thus *Departure* came to be regarded as a symbol of freedom, of a utopia denying violence and authoritarian rule. Beckmann continued to comment on the social situation in subsequent three-part paintings, but, like the first triptych, these also revealed much of his deeper concerns as an artist. *The Argonauts* 1949–50 (fig.18 and no.163), the last of Beckmann's triptychs, clearly addresses, among other things, the artist's search for human knowledge and understanding through art.[2]

In his triptychs Beckmann formulated the principles to

which he aspired in his art and his life, providing, as it were, periodic reports on his own progress. The triptychs allowed him to express complex ideas within a familiar, fixed hierarchical system, but, most importantly, the combination of three canvases served as a means to depict different aspects of a topic at one and the same time. Beckmann did not, however, use this simultaneity to present a narrative as such, but rather to give visual form to the dialectic relationship between different ideas, and to contrast antithetical notions.

The turn of the twentieth century had been marked by a crisis in representation, and visual artists reacted to this in various ways. Wassily Kandinsky, resisting Positivism and Materialism, sought to overcome everyday reality by striving for new spiritual heights and dematerialisation. Giorgio de Chirico, by contrast, pursued a different artistic path, seeking a 'metaphysical' representationalism, casting the things in his paintings in a new, alien light. Like de Chirico, Max Beckmann also determinedly produced representational paintings. Seemingly unimpressed by contemporary art trends, he combined traditional forms with modern thinking as the central reference point of his creative output. In doing so he set himself apart from positions held by artists such as Pablo Picasso or Henri Matisse, who fundamentally rejected monumental works with sacred overtones.

Beckmann had in fact developed his own independent artistic standpoint long before the 1930s when he worked on *Departure*. Even before the First World War, when he was still searching for his own characteristic visual language, he was already experimenting with the triptych as a form. Thus *Departure* marks the end of a long path, and it is worth retracing its various milestones. These show that more

perhaps than any other artist, Beckmann knew how to use the traditional features and motifs of sacred art to give his own themes added impact.

The classical triptych consists of three parts. As a rule, the central section is flanked by wings of lesser importance in terms of both their form and their function. In the late nineteenth century this historical pictorial form, with its firm foundations in religious painting, continued to be alive and affective, in view of the still-dominant role of the traditions that had inspired it since its inception in the Middle Ages. However, as the sacred context waned, the original meaning of the triptych also lost ground. 'The now empty shell sanctifies the profane.'[3] Both Max Klinger and Hans von Marées used the triptych with this in mind. Marées, for instance, replaced the original object of worship – the life and suffering of Christ – with a visual discourse on the harmony and proportions of the human body. In the early twentieth century, avant-garde artists sought to reactivate the triptych for the sake of its intrinsic meaning. Artists such as Edvard Munch, Emil Nolde and Oskar Kokoschka, however, only turned to its traditional pictorial form in exceptional cases and never as a metaphor of salvation. A prominent example of just this may be seen in the work of Otto Dix, who used the triptych for his fundamental critique of the social conditions around him.

Beckmann, for his part, had from the outset been searching for new creative solutions using largely familiar sacred pictorial genres and forms. Up until the First World War his thinking was founded on the Vitalism of Friedrich Nietzsche. Beckmann saw life as an all-embracing struggle that must be fought and won each day. In his style he showed

a conservative leaning towards late Impressionism. Like Hans von Marées, Lovis Corinth and Max Liebermann, he worked with monumental formats. This in turn led to huge crowd scenes, as in *The Sinking of the Titanic* 1912 (no.6). And from 1912 onwards, he often spoke out in polemic terms against contemporary innovative movements such as Expressionism or the French avant-garde, which he dismissed as decorative whim seeking only to serve its own ends. He criticised the 'new painting' for being, as he saw it, no different to a poster, dismissing it as framed Gauguin wallpaper, Matisse fabrics, Picasso chess boards and Sibero-Bavarian holy martyr posters.[4] He concluded his argument with the ambitious yet somewhat vague declaration: 'To me a picture suggests a whole, individual, organic world.'[5]

The shattering experience of the First World War, however, caused Beckmann to rethink his position. Now he wanted to offer his fellow human beings moral support – helping them to create a better world – through art that was founded on a notion of social salvation. In 1912 he had already commented to Franz Marc that the 'moral laws within us' are as 'eternal and immutable as the laws of art'.[6] In 1918 he put this rather more clearly: he yearned for a new mysticism and planned 'to build a tower in which people could shout out all their fury and despair, all their poor hopes, their joy and their wild longings.' The aim of his enthusiastically proclaimed programme was 'a new church' and, above all, art that would present people with a picture of their fate, bringing them face to face with their own situation so that they would be moved to overcome it or change it.[7] This moral purpose, combined with the will to create a better world, stayed with him until the mid-1920s when it was finally replaced by his own more individualistic approach.

Beckmann described his new pictorial language as 'transcendental objectivity' (transzendente Sachlichkeit). The intention was to 'give expression to the artistic facts, to create a sense of spatial depths and the feeling of plasticity that goes with this'.[8] At one point he stated: 'The most important thing for me is to find my way back to a clear, absolutely solid form. Roundness on a plane, depths in our sense of a plane. To capture as much vitality as possible in lines and planes that are in themselves as clear as glass.'[9] Still deeply shocked by the events of the First World War, shaken by change and revolution, and having gone through what he himself called a 'process of fermentation',[10] in 1919 Beckmann produced *The Night* (no.59), the impressive yet disturbing result of his inner turmoil. At the time it stood as the high point of a series of works that had started with *Self-Portrait as a Medical Orderly* 1915 (G187) and continued with works such as *Carnival* 1920 (no.13) and *The Dream* 1921 (no.14). Beckmann's new style of painting was above all surprising for its cool, sober quality, which is clearly linked to the concurrent emergence of Neue Sachlichkeit (the New Objectivity). Yet, as we see in *The Night*, Beckmann combined emotionless forms with their own antithesis, that is to say, with brutal, emotionally charged content. With his 'transcendental objectivity' he had found a creative escape from his own ingrained resistance to Expressionist painting. At the same time, Beckmann's new artistic style also reflected an intense engagement with the work of his contemporaries: his precisely calculated use of colour would have been unimaginable without his knowing the Fauves and their work. Other similar works, by Henri Matisse for instance, had been on show in Berlin during 1908

and 1909 in the gallery of Paul Cassirer, with whom Beckmann was in touch at the time. In addition, his pictorial language, with its sharp angles and distorted perspectives, points to an interest in the Cubists, although it also owes much to his familiarity with the 'Berlin' style of Expressionism that surfaced in Ernst-Ludwig Kirchner's work in 1912.

With his 'transcendental objectivity' Beckmann was now able to express his sense of tradition and to incorporate into his own work something of the formal language of the old masters he revered. Beckmann's interest in older art has been well documented – and he himself always listed his immediate role models as Rembrandt, Goya, Courbet and Italians such as Piero della Francesca, Orcagna, Uccello, Titian and Tintoretto.[11] In addition, his arguments with the Expressionists, who found at least one of their ideals of a universal spiritual culture in the Gothic era rather than in modern industrial society, meant that Beckmann was also well aware of the forms of medieval art.[12] Above all, he cited northern European painting in the fifteenth century as a major influence, specifically the work of those such as Matthias Grünewald, Rogier van der Weyden or Mäleßkircher, known today by the name of Gabriel Angler (active 1440/50). Angler's semi-grisaille technique seems to have particularly impressed Beckmann, who had seen many of these works himself and knew others from Curt Glaser's book *Zwei Jahrhunderte deutscher Malerei*, published in Munich in 1916. The formal language of these late-medieval works – populated by figures with elongated limbs and deeply expressive faces and gestures – seems to have had a similarly catalytic effect on Beckmann as Iberian and 'primitive'

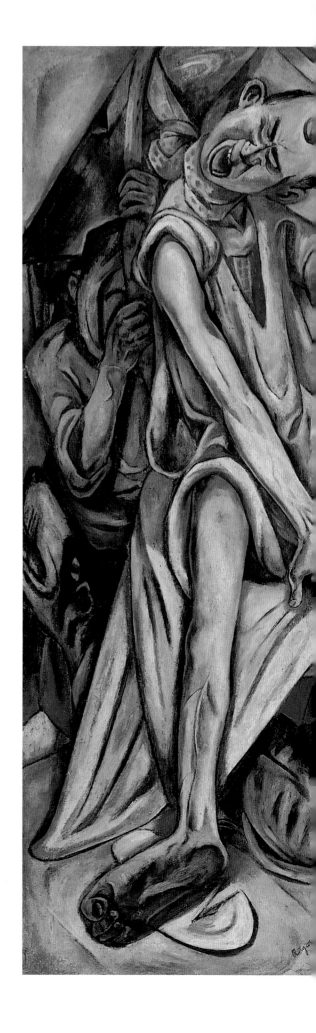

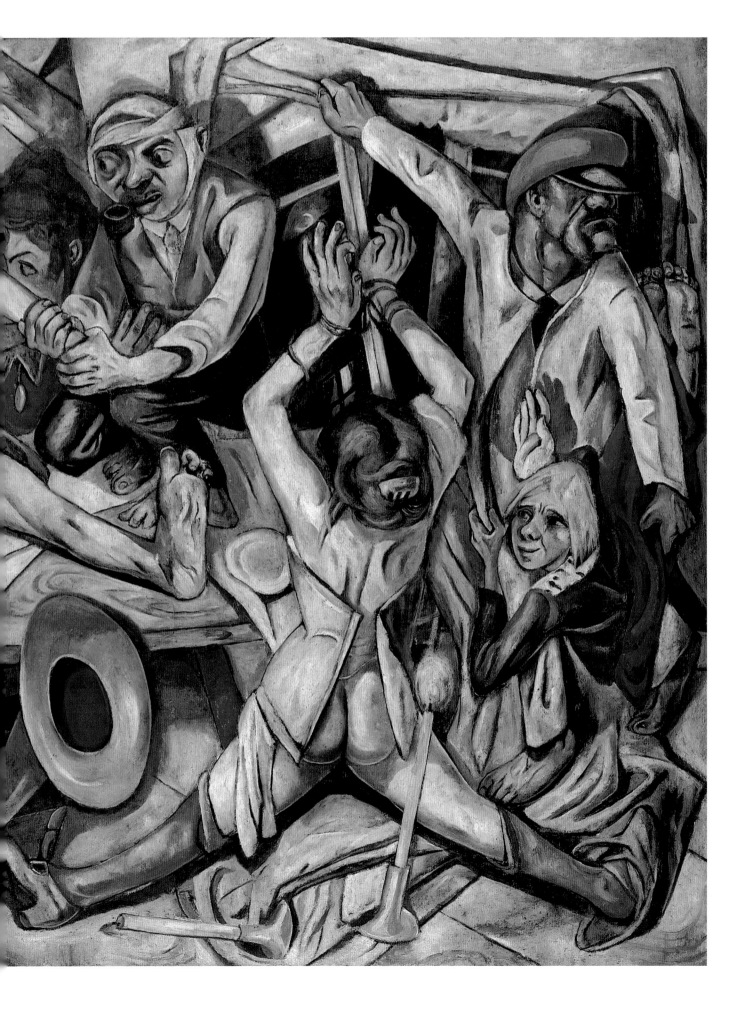

no.59
The Night 1918–19
133 × 154
(52 3/8 × 60 5/8)
Kunstsammlung
Nordrhein-
Westfalen,
Düsseldorf

sculpture had on Picasso. But Beckmann was also interested in the themes depicted by the old masters, and in 1916 and 1917 particularly he addressed a number of Christian subjects in his paintings, such as *Resurrection* (see fig.13), *Adam and Eve*, *Descent from the Cross* and *Christ and the Woman Taken in Adultery* (nos.8, 9, 11).

Around 1918, however, Beckmann's sense of tradition in both the form and content of his works took a decisive new direction, and there was a clear shift in his approach to the traditional repertoire of painting. Around the time he was working out his new pictorial programme, that is to say, at the point when he was just finishing *The Night*, he started to abandon Christian themes. In July 1919 he declared that 'the days of humility before God are over. My religion is arrogance towards God, defiance towards God. Defiance because He has created us in such a way that we cannot love each other. In my pictures I reproach God with all those things that He has done wrong.'[13] Beckmann's impassioned anger can in part be explained by the events of the First World War, which had fundamentally shaken his view of himself as an artist. Like other avant-garde artists, he was searching for a mode of expression that could adequately address the destruction that had taken place: George Grosz, always uncompromising in his moral precepts, concentrated on biting caricature and bitter irony. Similarly bent on fundamental renewal, although also issuing an optimistic rallying cry, Oskar Kokoschka produced the painting *The Power of Music* 1918–19 (Stedelijk van Abbemuseum, Eindhoven). Movements such as Dada and Bauhaus pursued a different path by aiming to reshape daily living in all its various facets. And although Beckmann was now deploying a language of forms much influenced by

earlier religious imagery, religious themes as such no longer had a place in his work.[14]

There are numerous examples of Beckmann drawing on religious motifs. *The Night*, an allegory of the events and social situation of the time, as though Beckmann were taking stock and setting out his stall both in terms of his personal biography and his artistic style – depicts the brutal murder of a family.[15] In the context of Beckmann's use of the language of Christian imagery, however, this work may be seen above all as a paraphrase of traditional depictions of martyrdom. The figure of the strangled man particularly calls to mind traditional images of the story of Christ's Passion.[16] Similarly, the position of the artist's arm and upturned palm in *Self-Portrait as Clown* 1921 (no.58) could be interpreted as a Christ-like gesture. Yet another example may be seen in the *Hell* cycle of lithographs. The relevant plate, entitled *Martyrdom*, depicts the murder of Rosa Luxemburg (no.32).[17] Despite the many details that derive from the actual circumstance of that event, the composition has clear echoes of depictions of the Crucifixion. In 1920, Beckmann completed *Carnival*, a haunting mixture of abandoned gaiety and melancholy.[18] As Charles Haxthausen has pointed out, the two main figures are reminiscent of the depictions of saints on altar paintings, as seen for instance in the figures of St Constantine and St Helena by Cornelisz Engelbrechtsz *c*.1515–20 (fig.12).[19] And if one bears in mind precursors of that kind, then details such as the slapstick or the stringed instrument that the two protagonists hold in their hands in *Carnival* seem almost to fulfil the same function as the attributes used to identify particular saints. But in Beckmann's case these items have lost their original symbolic

significance. In *The Dream*, with its seemingly motley collection of five figures, which Hans Belting has interpreted as the 'closed inner reaches of the consciousness', Beckmann again drew on sacred works from the past.[20] Charles Haxthausen, for one, sees *The Dream* as a contemporary version of a *sacra conversazione*. As such, Beckmann's composition could be compared with the work of the Master of the Virgo inter Virgines of 1495 (fig.13), which shows the Madonna and Child surrounded by the Saints Catherine, Cecilia, Barbara and Ursula.[21] The agave flower that the blond girl in *The Dream* rests her foot on thus momentarily calls to mind the medieval significance of this symbol of immaculate motherhood, although, once again, it soon becomes clear that the original meaning bears no relationship to the events depicted by Beckmann.

Beckmann's strategies – first drawing on Christian themes, and later on Christian forms – did not arise from any iconoclastic intentions. His avowed interest in tradition and in the art of the old masters rules that out. And the artist was certainly not pursuing the same path as the Cubists, who questioned traditional easel painting by including scraps of newsprint, wallpaper and other objects in their works. On the contrary, Beckmann was moving in the opposite direction. He 'sanctified' the profane and used the dignity and awe-inspiring characteristics of religious art to lead his viewers towards a potentially transcendental experience. For, despite all the ruptures and rejections in the avant-garde art of the day, the early twentieth-century viewer was familiar with sacred compositional devices, and above all, knew how to read them. This is not least a reflection of the discussions

fig.12
Cornelisz
Engelbrechtsz
*St Constantine
and St Helena*
c.1515–1520
Oil on canvas
87 × 57
(34 1/4 × 22 1/2)
Bayerische
Staatsgemälde-
sammlungen,
Munich,
Alte Pinakothek

fig.13
Master of the Virgo
inter Virgines
*Sacra
Converzsazione*
c.1495
Oil on canvas
123 × 103
(48 1/2 × 40 1/2)
Rijksmuseum,
Amsterdam

surrounding the notion of a 'pathos formula' that the art historian Aby Warburg had instigated in the late nineteenth century. This term could be applied to a whole variety of gestures that were known to the viewer from religious contexts and were, as such, immediately comprehensible.[22] Beckmann was relying on this virtually intuitive response to his pictorial forms. By deploying the familiar compositional patterns from depictions of the Christian story of redemption – the worship of the faithful and the suffering of Christ – he was able to imbue his artistic work with the necessary seriousness. Yet Beckmann did not rely on a particular iconography, or seek to use attributes in the traditional manner, so that the contents of his works should be understood in a particular way. On the contrary, he rather liked to include a few red herrings that would lead the

viewer into an intellectual cul-de-sac, as the details mentioned earlier show. His use of traditional pictorial motifs and patterns served solely to give profane subject matter a transcendental dimension.[23]

Above all, the triptych – with its dignified, monumental character and its place in the tradition of religious painting – was a suitable vehicle for Beckmann's intentions.[24] As mentioned above, his first experiments with the three-part compositional form go back to his beginnings as an artist, when he was still evolving his artistic agenda, decades before he was to complete his first full triptych in 1933. A photograph from 1912 (fig.14) shows Beckmann in his studio at the age of twenty-eight at a time when his debates with Franz Marc had already made him into a controversial figure. To quote Hans Belting, Beckmann is seen in the haughty pose of one 'who

fig.13
Resurrection II
1916–18
(unfinished)
345 × 497
(135 7/8 × 195 5/8)
Staatsgalerie
Stuttgart

puts his own interpretation on the world and thus has it in his control – hands in his pockets, legs crossed, his gaze fixed on the viewer.'[25] The artist has positioned himself in front of three paintings, arranged as a triptych, which were at the centre of his work hitherto. On either side of the monumental central composition, *The Sinking of the Titanic* 1912 (no.6), are 'wings' in the shape of a nude study (G103) for the painting *Resurrection* 1908, and *Large Death Scene* 1906 (G61). The latter work was particularly important to Beckmann because for him it contained an idea that he was to pursue throughout his life.[26] Thus, *The Sinking of the Titanic* – this 'fable of humanity in contemporary dress', as Belting described it – is flanked by symbols of life and death.[27] The fact that photographs of this kind can in effect be taken as an artistic credo has recently been shown by Wolfgang Kersten and Osamu Okuda in their study of a photograph of Paul Klee's studio that was taken at the artist's request in 1920.[28] In the early twentieth century this still comparatively new medium was handled with such care that every photograph from that era has to be seen as the outcome of precise compositional deliberations. Thus, for the photograph of himself in his studio, Beckmann chose paintings that most convincingly expressed the Vitalist concept of art that he ascribed to at that stage in his life. And the decision to arrange these paintings as a triptych confirms that Beckmann already had this monumental pictorial form in mind at a time when he was not yet ready to translate these thoughts into paint on canvas.

Following this, Beckmann continued to explore the triptych as a form, for instance when he was working on his contribution to the 'Creative Credo' and was seeking a suitable form to express his social and moral concerns. The work in question is his second, unfinished *Resurrection*, painted between 1916 and 1918 (fig.13). Its internal organisation means that this single composition could in fact be described as a triptych. In the central zone we see an isolated figure from behind, turning away from the actual event. By virtue of the figure's position and its relationship to the centrally placed, dark heavenly body, it symbolises the fundamental hopelessness of the situation. By flanking this with lighter-coloured areas, Beckmann as it were set this central section of the work free, giving it added emphasis by means of symmetrically placed groups of figures. These groups fulfil the same function as the wings of a triptych. In contrast to the traditional iconography of Christ's Resurrection, Beckmann did not here make a distinction between those chosen to enter the heavenly paradise and those damned to descend into Hell. Instead, the emaciated figures with distorted limbs on both sides of the composition awaken memories of the experience of war that Beckmann had captured elsewhere in countless drawings and sketches. Thus in this later *Resurrection*, we see not so much a depiction of the salvation of humankind but rather a 'vision of the dead', the inescapable downfall of the world with no hope of salvation through judgement from on high. Unusually, Beckmann chose a horizontal format for this work, which Wolf-Dieter Dube takes as a return to the classical triptych format, as seen in the work of the fifteenth-century artists Stephan Lochner and Hans Memling.[29] However, Beckmann was so dissatisfied with both the style and the content of *Resurrection* that he left it unfinished. In one of the sketchbooks, now held in Washington, there is a sketch from 1921 that clearly contains a design for

fig.14
Beckmann in his studio 1912
Max Beckmann Archive, Munich

fig.15
Sketch for a Triptych 1921
Pencil on paper
16.5 × 21
(6 ¹/₂ × 8 ¹/₄)
National Gallery of Art, Washington DC

a triptych (fig.15).[30] Between two vertical formats we see a horizontal central section, accentuated by two striking cross-beams. There are no further details on the sheet as to the subject matter, although the measurements written below the sketch do confirm that this was intended as a triptych ('1,25 × 140 // 2 Stück [2 each] 45 × 1,40').

Taking this sketch into account, it seems reasonable to regard three works mentioned earlier in this essay as a hypothetical triptych. The works in question are the horizontal-format *The Night*, with the two taller works – *The Dream* and *Carnival* – as the side wings (fig.16). Moreover these were painted between 1918 and 1921, that is to say, immediately before the sketch described above. In both their composition and contents there are links between these three paintings that make it conceivable that they could have been intended as a triptych. All the titles allude to a world other than everyday reality, and the paintings themselves have in common a stage-like pictorial space with a wooden floor and beams.[31] Furthermore, there are intricate connections between the figures portrayed in these compositions. The girl at the centre of *The Dream* is turning her head towards what would be the centrally placed *The Night*. Her outstretched arm with its open palm reaches out to the hand of the strangled figure in the central composition. The pose of the latter, with outstretched legs, continues the movement towards the right of the triptych through to the legs of the abducted child, thrown into the air. These in turn correspond to the legs of the clown on the floor in *Carnival*. The composition of the latter is finished off by a diagonally distorted window, which generates a counter-movement back towards the 'central panel'.

There is no identifiable narrative connection between the three works. Each presents a variation on the hopelessness of the fate of humankind, along the same lines as the message underpinning the unfinished *Resurrection*. *Carnival* has been interpreted as the prison of the human soul, while *The Dream* can be seen as a depiction of the inability of human beings to communicate or even to speak. If one views these two works as the side-wings of a triptych, then the central panel could be regarded as a modern version of Christ's Passion. *The Night* in fact portrays the cornerstones of Beckmann's own self-image at that time; it symbolises decline, but at the same time it also relays Beckmann's challenge to himself – to take his own fate into his hands. Recognising the hopelessness of a situation is the necessary preliminary to change. Against the background of the classical medieval triptych, any such arrangement of these three paintings would in fact be focused, *ex negativo*, on the hope of salvation.

In the 1920s Beckmann consolidated his artistic position in Frankfurt. His style became more lavish and painterly, and his new-found confidence was evident in large-format, sumptuous works such as *Large Still Life with Telescope* (fig.17). In his pictorial output Beckmann felt no need of the Christian missionary zeal of the postwar years. The notion that self-help was the only way to better one's own situation was now replaced by the conviction that people were not in fact in need of salvation, because they themselves were God.[32] As far as Beckmann was concerned, artists were autonomous, all-powerful creators and demiurges, and should present themselves in suitably contemporary attire. So his preferred work-clothing had to be as elegant as possible, as we see in his *Self-Portrait in Tuxedo* 1927 (no.88). At the same time, he

fig.16
Hypothetical triptych combining *The Dream*, *The Night*, and *Carnival*

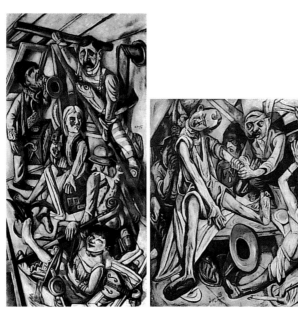

still expressed himself in a language with sacred overtones, as in his declared intention to build 'modern places of worship'. He compared the task of the artist to that of a priest who has to help people to recognise their responsibility for themselves. In response to a question as to his political position, he stated that politics would only be of any interest to him when it had turned its attention to 'metaphysical and transcendental matters – in other words, religious issues – in a *new* form'.[33] At this stage in his life, Beckmann was again experimenting with the idea of the triptych in his drawings. In 1929 he produced three sketches, composed in such a way that they could very well form a triptych.[34] Two vertical formats entitled *Paradise* and *Storm* are accompanied by a third, horizontal-format sketch, which could easily be imagined as the central section of a triptych.

During his time in Frankfurt, there was one painting with a Christian theme that remained of central importance to Beckmann. This work was the unfinished *Resurrection* (fig.13), which stood like a salutary reminder in his studio. Visitors to the studio commented that this work alone was always turned to face the room, whereas Beckmann always faced the other paintings to the wall, whether they were finished or not. Peter Beckmann, the artist's son, also saw *Resurrection* as a key work in his father's oeuvre and regarded it as something of an interim report, justifying what had been and laying the foundations for what was still to come. Wolf-Dieter Dube concludes: 'the *Resurrection* of 1916/18 already contains an early form of the idea of the triptych.'[35]

Under the gaze of *Resurrection* in the 1930s Beckmann started on *Departure*, his first full triptych (no.60). Against the background of political developments that at best were oppressive and at worst promoted open terror, this work can be seen as a counterweight of sorts to the officially approved art of the time. The two side paintings are dominated by scenes of torture, violence, enslavement and blindness, calling to mind *The Night*, *Carnival* and *The Dream*. And the cramped interiors with several figures and symbolic objects are similarly reminiscent of the scenarios in Beckmann's early paintings. Another connection can be seen in the figure of the man chained to the column in exactly the pose that Beckmann had already used for the female figure in *The Night*. On the right panel of *Departure* there is a further reference to an earlier work: the lower section of the composition is devoted to music, here in the shape of a drum, recalling *The Dream* where there is a maiden with musical instruments and banners bearing the words 'TANZ, MUSIK, GESANG, LIEBE' (dance, music, song, love). The central panel in *Departure* is the direct opposite to the side motifs. In fact the scene at sea would simply be the image of peace and contentment, if such details as the swathed head of the ferryman were not designed to point to the fragility of this harmony. Instead of a depiction of suffering and torment as in *The Night*, here Beckmann's depiction of a crossing to unknown shores introduces the prospect of possible salvation. At the same time he gives symbolic expression to his own state of mind at the time: for the artist, the starting point from which to master new ventures is now not as important as the path he takes.

In *Departure*, Beckmann once again drew on sacred imagery. The king on the boat, generously releasing fish from the net, could be a St Peter; but here the artist has taken Peter's actual task – fishing for souls for the Church of Christ –

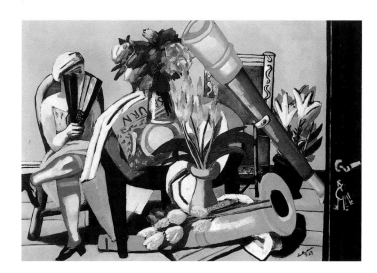

fig.17
Large Still Life with Telescope
1927
oil on canvas
141 × 207
(55 1/2 × 81 1/2)
Staatsgemälde-
sammlungen,
Staatsgalerie
Moderner Kunst,
Munich,
Pinakothek der
Moderne
G275

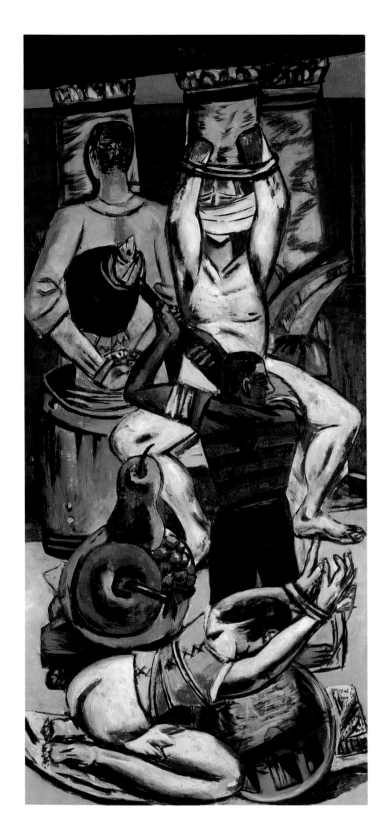

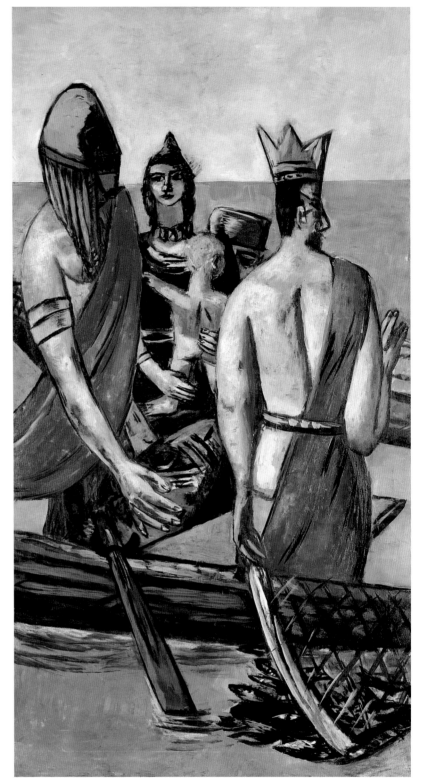

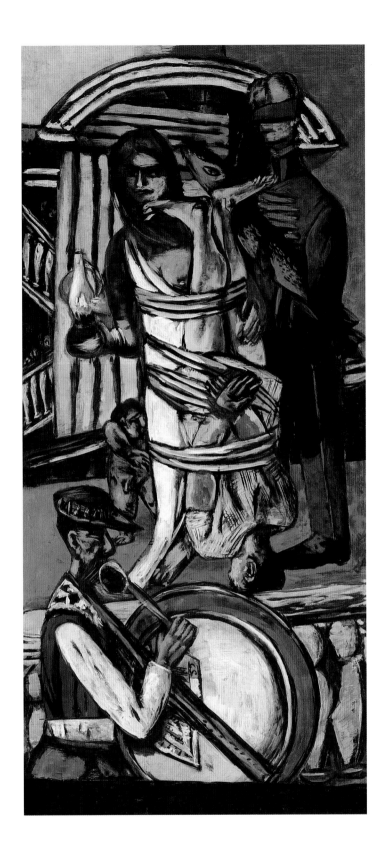

no.60
Departure 1932,
1933–5
Side panels:
215.3 × 99.7
(84 3/4 × 39 1/4)
Central panel:
215.3 × 115.2
(84 3/4 × 45 3/8)
The Museum of
Modern Art, New
York. Given
anonymously (by
exchange), 1942

and has turned it into the opposite. In the case of the figures of the mother and child, where the mother, as Beckmann himself put it, carries the greatest treasure of all, namely freedom,[36] he has adopted elements of classical depictions of the Madonna. Indeed he went even further when he attributed religious characteristics to *Departure* and compared the work to a miraculous holy picture or a relic. In a letter to his friend the art dealer Curt Valentin, he wrote: 'For me this painting is a kind of rosary, or a ring of colourless figures, who can glow when there is real contact and who tell me truths that I cannot express with words and did not know before. It can only speak to people who, consciously or not, have within them more or less the same metaphysical code.'[37]

Beckmann had already referred as early as 1919 to a metaphysical meaning that a painting should convey to the viewer. When he was once looking at *The Night* together with his friend Reinhard Piper, he pointed out the 'metaphysics of the representational nature of the work' that was the real essence of his paintings and could be conveyed by the contents independently of what was actually visible.[38] However, in the 1930s, when Beckmann was able to look back on the reception of his work with a wealth of experience, he came to the conclusion that at best he was only able to convey a hint of his intentions to the public. By this time the artist had lost the confidence that he had enjoyed in the period after the First World War. In those days he had assumed that his intention to mediate the contents of his paintings purely via the viewer's intuitive ability to read the formulas of sacred imagery was sure to be successful. Now he came to the sobering conclusion that the contents of his works were only accessible to those individuals who shared 'the same metaphysical code'. In view of this, Beckmann now concentrated on a pictorial form that by its very nature – its history and its material dimensions – was monumental. Beckmann returned to the triptych. He took this pictorial form as a matrix for his own intentions, since it could be used in a number of ways and was extremely open to variation. The triptych offered Beckmann a way of working towards the transcendental effect that he sought, and a way to create symbolic myths and images dealing with fundamental human issues. However, his choice of this form should also be seen in the context of the general prevalence of monumental forms at the time, ranging from Pablo Picasso's classicism to the architecture of Wilhelm Kreis. Even in the films of the day, as in Fritz Lang's *Metropolis* (1927), there was a tendency towards gigantic sets and designs[39] – again coupled with a whole range of Christian pictorial motifs.

When one considers the immense symbolic power of the triptych, the sizes and formats that Beckmann chose for his three-panel works were only of secondary importance. Traditionally, the central panel can be larger than the two side panels, but can equally well be shorter or – as in *Carnival* 1942–3 (G649) – narrower. In view of the fact that the triptych is by definition a hierarchical genre, Beckmann paid great attention to the relationship between the panels in both composition and colour. In *Departure*, for example, the three parts form a balanced whole, with smaller side panels flanking a dominant central section. In *The Argonauts*, on the other hand, the dominance of the central section is underlined by its size.

In Beckmann's view, the role of art was to explain the world and to set out programmes to help people live their lives.

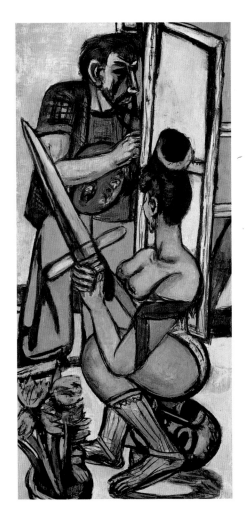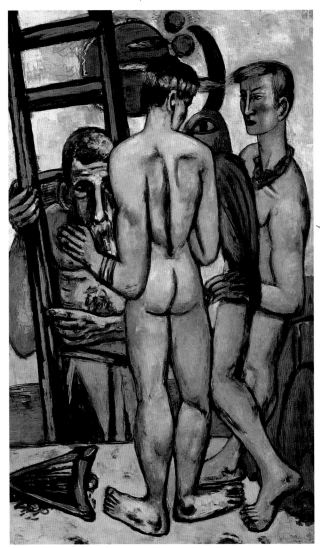

fig.18
The Argonauts
1949–50
Side panels:
189 × 84
(74 3/8 × 33 1/8)
Central panel:
203 × 122
(79 7/8 × 48)
National Gallery of
Art, Washington
DC. Gift of Mrs
Max Beckmann
(See no.163 on
pp.256–7 for larger
reproduction)

These aims stayed with him throughout his life. Nevertheless, the methods he used to translate them into pictures underwent many changes. With his experience of the First World War, the Vitalist principles influenced by the writings of Friedrich Nietzsche that were evident in his thinking around 1912 gave way to thoughts of salvation and redemption. But soon religious themes were supplanted by sacred motifs, and as he attained a higher social standing, he shifted his attention towards the apotheosis of the artist, which in turn led to his interest in monumental pictorial forms.[40] *Departure* is located at an important turning point in this development. It sums up Beckmann's intentions to date, and as such may be seen as the outcome of a long period of gestation. At the same time, *Departure* is also the starting point for all Beckmann's later triptychs, in which he addressed violence and how we deal with it, tackling the basic problems of human co-existence and repeatedly engaging with the function of art in the context of how human beings manage their own lives. At no time was it Beckmann's purpose to question the traditional easel painting. Unlike other exponents of the avant-garde, he did not achieve innovation in his style by destroying existing stock themes; on the contrary, his approach was to consciously include and exploit tried and tested sacred elements. His experiments with hierarchical compositions arose from his fundamental desire to find creative solutions by combining traditional formulas with innovative stylistic means. In Beckmann's view, a compositional structure that was familiar to the viewer from sacred works was the perfect means by which to give his own themes the desired impact. Thus the triptych serves to underline the seriousness of his intentions. As an

idea or as a viable form, the triptych was Beckmann's constant companion in his work. As the ideal combination of monumentality and tradition it served him as a means to mediate and strive for higher knowledge. This, combined with his own individual pictorial language, ensured that he emphatically made his mark within the context of the avant-garde art of the day.

Translated from German by Fiona Elliott

Notes

1. In the *catalogue raisonné* compiled by Erhard Göpel and Barbara Göpel, *Max Beckmann. Katalog der Gemälde*, Bern 1976, the completed triptychs are listed as nos.412, 439, 536, 570, 604, 649, 704, 789 and 832. No.834 is the unfinished triptych *Ballet Rehearsal*.

2. See Charles S. Kessler, *Max Beckmann's Triptychs*, Cambridge, Mass. 1970; see also Reinhard Spieler, *Max Beckmann. Bildwelt und Weltbild in den Triptychen*, Cologne 1998.

3. Klaus Lankheit, *Das Triptychon als Pathosformel*, Heidelberg 1959, p.5.

4. The controversy with Franz Marc took place in March 1912 in the journal *Pan*, reprinted in *Max Beckmann. Die frühen Bilder*, exh. cat., Kunsthalle Bielefeld/Städtische Galerie im Städelschen Kunstinstitut Frankfurt am Main, Bielefeld 1982, p.34.

5. Ibid., p.33.

6. Ibid., p.34.

7. See Max Beckmann's contribution to 'Schöpferische Konfession', 1918, published in 1920 in *Tribüne der Kunst und Zeit*, no.12, 1920, ed. by Kasimir Edschmid, reprinted in Anette Kruszynski (ed.), *Max Beckmann: 'The Night'*, exh. cat., Kunstsammlung Nordrhein-Westfalen, Düsseldorf 1997, p.150.

8. To quote Beckmann as early as 1912. See Kunsthalle Bielefeld 1982, p.32. For further comments of this nature see 'A Confession.'

9. Letter in mid-March 1919 to Julius Meier-Graefe, in Klaus Gallwitz, Uwe M. Schneede, Stephan von Weise (eds.), *Max Beckmann: Briefe,* vol.1: 1899–1925 (edited by Uwe M. Schneede), Munich and Zurich 1993, p.177.

10. Letter of August/September 1917 to the Mannheimer Kunsthalle, in Klaus Gallwitz, Uwe M. Schneede, Stephan von Weise (eds.), *Max Beckmann: Briefe*, vol.3: 1937–1950, (edited by Klaus Gallwitz), Munich and Zurich 1996, p.531 (addendum to vol.1).

11. See Christian Lenz, *Max Beckmann und die Alten Meister. "Eine ganz nette Reihe von Freunden",* Bayerische Staatsgemäldesammlungen, Munich 2000.

12. See Magdalena Bushart, *Der Geist der Gotik und die expressionistische Kunst*, Munich 1990. In addition Beckmann certainly knew Wilhelm Worringer's treatise *Formprobleme der Gotik* of 1911.

13. Comment by Beckmann to his publisher and friend Reinhard Piper, in Rudolf Pillep (ed.), *Max Beckmann. Die Realität der Träume in den Bildern. Aufsätze und Vorträge. Aus Tagebüchern, Briefen, Gesprächen 1903–1950*, Leipzig 1987, p.94.

14. From the 1930s onwards Beckmann increasingly combined Christian themes with mythical topics, although he was now no longer concerned with the apportioning of guilt and with the Fall from Grace. In 1937 he produced the sculpture *Adam and Eve* (no.76), and in the early 1940s he at times used the name *Adam* for the triptych *Carnival* 1942–3. See Erhard Göpel (ed.), *Max Beckmann. Tagebücher 1940–1950*, Munich and Vienna 1979, entry for 1 August 1942.

15. For an interpretation of the work see Kruszynski 1997.

16. See, among others, Günter Aust, 'Max Beckmann und die Spätgotik', in Bazon Brock and Achim Preiß (eds.), *Ikonographia*, Festschrift für Donat de Chapeaurouge, Munich 1990, p.267.

17. See Alexander Dückers (ed.), *Max Beckmann. 'Die Hölle' (1919)*, Staatliche Museen Preußischer Kulturbesitz, Kupferstichkabinett, Berlin 1983, pp.88–9. Beckmann repeated *The Night* for the cycle.

18. See Sarah O'Brien-Twohig, 'Beckmann's "Fastnacht"', in *Max Beckmann*, exh. cat., Josef-Haubrich-Kunsthalle, Cologne 1984, pp.161–88. The figures are Beckmann's friend Fridel Battenberg and another friend, the dealer and publisher I.B. Neumann. Because of the eccentric hand position, the figure lying on the ground can be identified as Beckmann.

19. See Charles W. Haxthausen, '"Das Gegenwärtige zeitlos machen und das Zeitlose gegenwärtig". Max Beckmann zwischen Formalismus und Mythos', in Kruszynski 1997, p.39.

20. See Hans Belting, *Max Beckmann. Die Tradition als Problem in der Kunst der Moderne*, Munich and Berlin 1984, p.68.

21. See Haxthausen in Kruszynski 1997, p.40.

22. In the early 1930s, Fritz Saxl took Warburg's term, coined in 1893, and introduced it into the field of philosophy. See Martin Warnke, 'Pathosformel', in Werner Hofman, Georg Syamken and Martin Warnke, *Die Menschenrechte des Auges. Über Aby Warburg*, Europäische Bibliothek, vol.1 (ed. by Henning Ritter), Frankfurt 1980, pp.61 et seq.

23. For more on this see Charles Haxthausen in Kruszynski 1997, pp.39–40.

24. For a history of the triptych see Klaus Lankheit, *Das Triptychon als Pathosformel*, Heidelberg 1959.

25. See Belting 1984, p.18.

26. See the letter from mid-March 1919 to Julius Meier-Graefe, in *Max Beckmann: Briefe*, vol.1, 1993, p.177.

27. Belting 1984, p.18.

28. Wolfgang Kersten and Osamu Okuda, 'Einblick in die Künstlerwerkstatt, Ölgemälde 1909–1922', in *Paul Klee – Im Zeichen der Teilung*, exh. cat., Kunstsammlung Nordrhein-Westfalen, Düsseldorf, and Staatsgalerie Stuttgart 1995, pp.161–72.

29. See Wolf-Dieter Dube in *Max Beckmann. Retrospektive*, exh.cat., Haus der Kunst, Munich, and Nationalgalerie Berlin 1984, p.87. In his first *Resurrection* of 1909 Beckmann retained the vertical format of the classical triptych (G104).

30. Contained in the sketchbook, accession no. 1984.64.55, National Gallery of Art, Washington, DC. For more on the realisation of various sketches as paintings and triptychs see Dagmar Walden-Awodu in *"Geburt" und "Tod". Max Beckmann im Amsterdamer Exil. Eine Untersuchung zur Entstehungsgeschichte seines Spätwerks*, Worms 1995, pp.97–8, 169.

31. There are also similarities in the application of the paint, although the colours are different: *The Night* and *The Dream* are characterised by pallid tones and have few colour accents, *Carnival* is dominated by glowing blues and reds. There are considerable differences in the angles of vision, the perspectives and the dimensions of the figures.

32. See Max Beckmann, 'Der Künstler im Staat', in *Europäische Revue*, vol.3, part 4, July 1927, pp.288–91, reprinted in Pillep 1997, pp.116–21.

33. Beckmann made this comment in 1928; cited in Pillep 1997, p.126.

34. These drawings are held today in the National Gallery in Washington. See Walden-Awodu 1995, p.27, fig.4.

35. Dube 1984, p.88.

36. See Beckmann's comments to Lilly von Schnitzler in February 1937, in Pillep 1987, pp.129–30.

37. Letter of 11 February 1938 to Curt Valentin in *Max Beckmann: Briefe*, vol.3, 1996, p.29. For more on this see Haxthausen in Kruszynski 1997, p.46.

38. See Pillep 1987, p.93.

39. Contemporary critics seem to have reacted with a degree of scepticism to Fritz Lang's preference for monumental sets. See Siegfried Kracauer, *From Caligari to Hitler: A Psychological History of the German Film*, Princeton 1947, p.150. In *Metropolis*, Lang also replicated sacred configurations: Maria gathers the suffering people around her like a Madonna offering protection, and the worker in front of the huge clock-face adopts the typical pose of a martyr. Beckmann was interested in films, he certainly knew *Metropolis*, and in the late 1940s he compared the architecture of New York with the sets in Fritz Lang's film *The Cabinet of Dr Caligari* (1923); see his letter of 25 November 1949 to Minna Beckmann-Tube, in *Max Beckmann: Briefe*, vol.3, 1996, pp.293–5.

40. Beckmann viewed his own output as 'the most complex of painting … in a new, completely irreal ideality.' Letter to I.B. Neumann of 15 December 1926, in Mayen Beckmann and Michael Semler (eds.), 'Max Beckmann. Briefe an I.B. Neumann', Berlin 1997 (typescript), p.21.

no.61
*Carnival (Pierrette
and Clown)* 1925
160 x 100
(63 x 39 ³/₈)
Städtische
Kunsthalle
Mannheim

no.62
*Double-Portrait
Carnival* 1925
160 x 105.5
(63 x 41 ½)
Museum Kunst
Palast, Düsseldorf

no.63
Quappi in Blue
1926
60.8 x 35.2
(24 x 13 ⅞)
Bayerische
Staatsgemälde-
sammlungen,
Munich,
Pinakothek der
Moderne.
Donation Günther
Franke

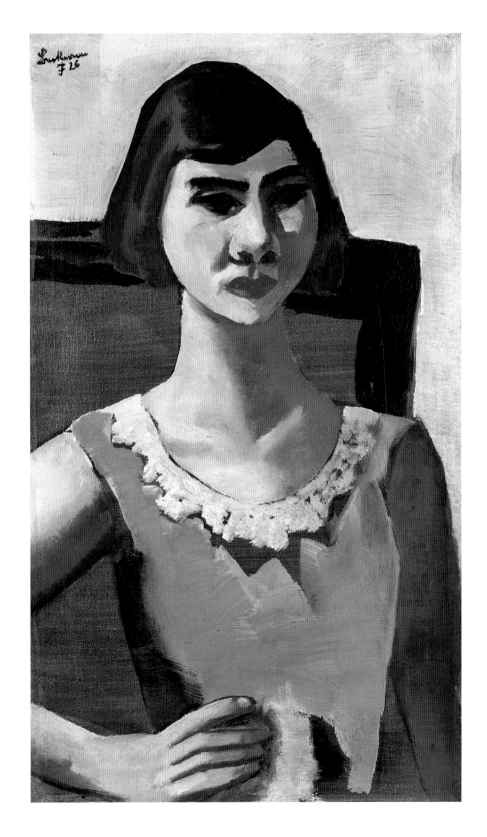

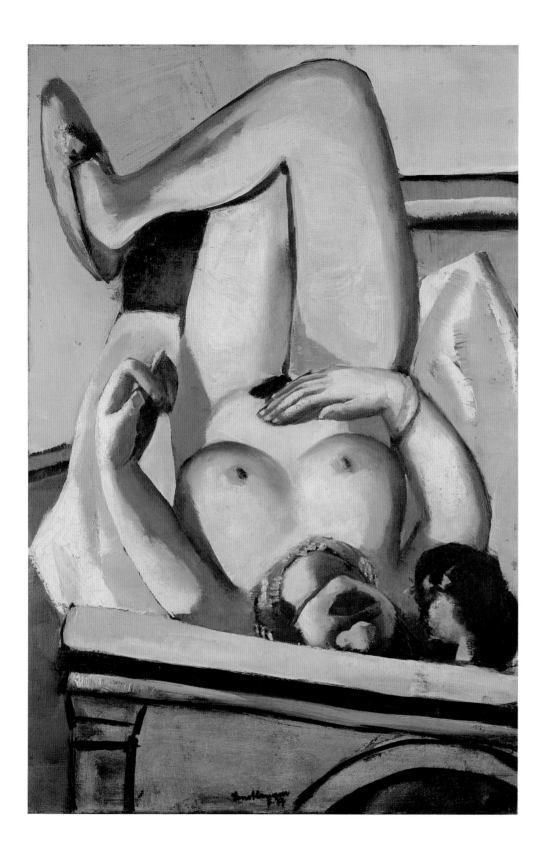

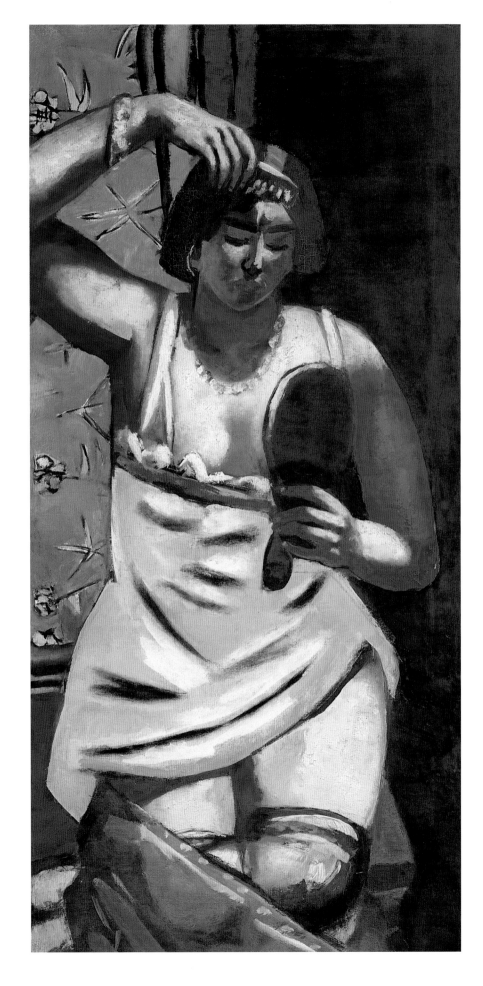

no.64
Female Nude with Dog 1927
67 × 47
(26 3/8 × 18 1/2)
Museum
Wiesbaden

no.65
Gypsy Woman
1928
136 × 58
(53 1/2 × 22 7/8)
Kunsthalle
Hamburg

no.66
The Night 1928
Black chalk on
paper 65.5 × 187
(25 3/4 × 73 5/8)
Sprengel Museum
Hannover. Gerda
and Theo Garve
Foundaton, in
memory of
Christoph and his
mother Else Garve

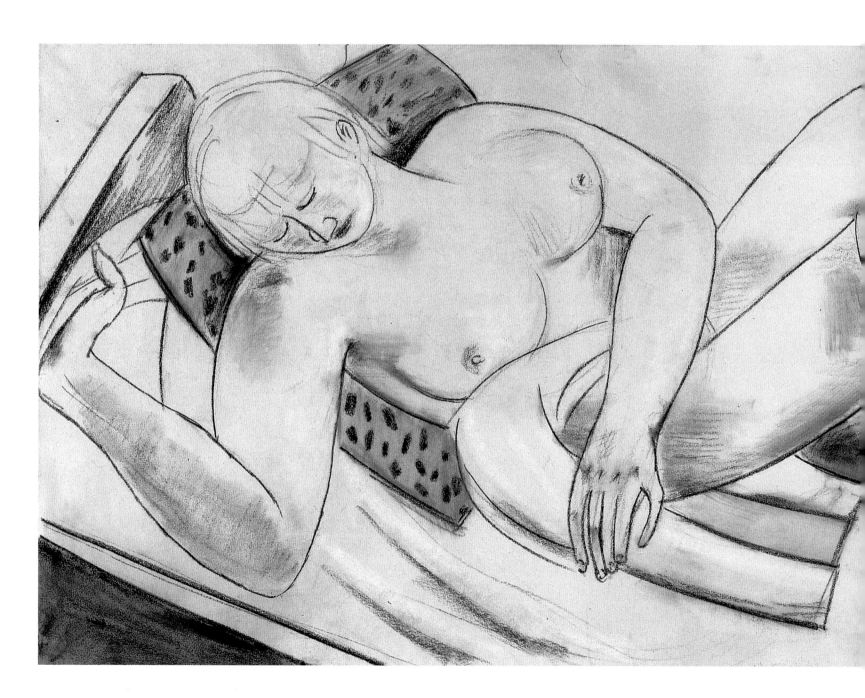

no.67
Football Players
1929
213 × 100
(83 7/8 × 39 3/8)
Wilhelm-
Lehmbruck-
Museum, Duisburg

no.68
Aerial Acrobats
1928
215 × 100
(84 5/8 × 39 3/8)
Von der Heydt-
Museum
Wuppertal

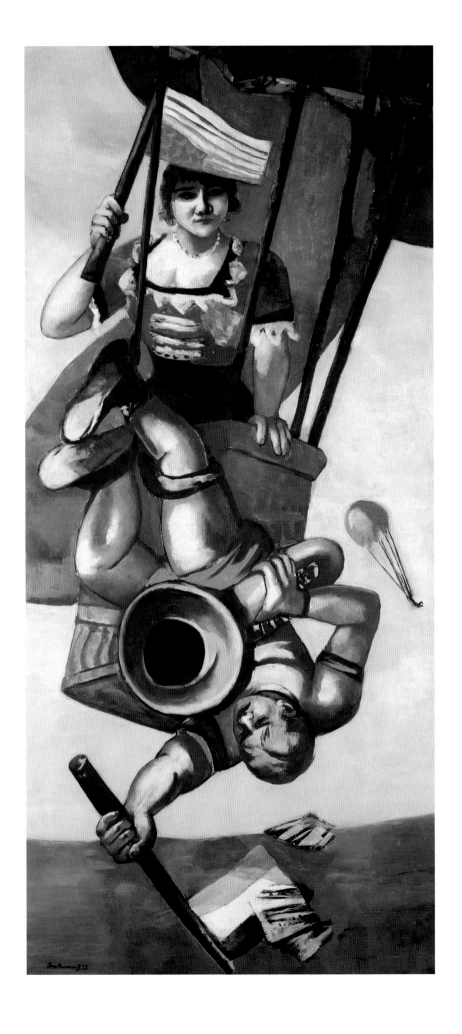

no.69
*Scheveningen,
Five a.m.* 1928
56.9 × 63
(22 3/8 × 24 3/4)
Bayerische
Staatsgemälde-
sammlungen,
Munich,
Pinakothek der
Moderne.
Donation Günther
Franke

no.70
*Bathing Cabin
(Green)* 1928
70.2 × 85.7
(27 5/8 × 33 3/4)
Bayerische
Staatsgemälde-
sammlungen,
Munich,
Pinakothek der
Moderne.
Donation Günther
Franke

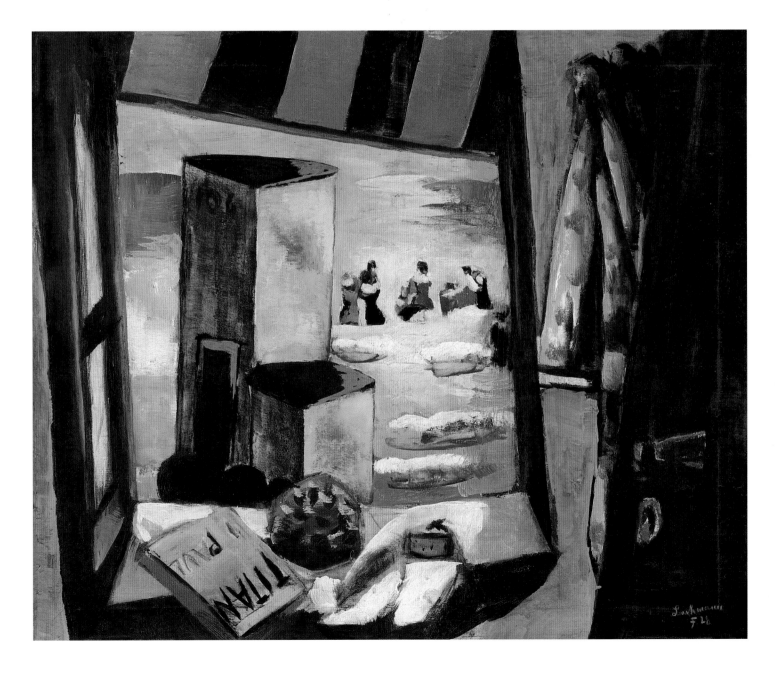

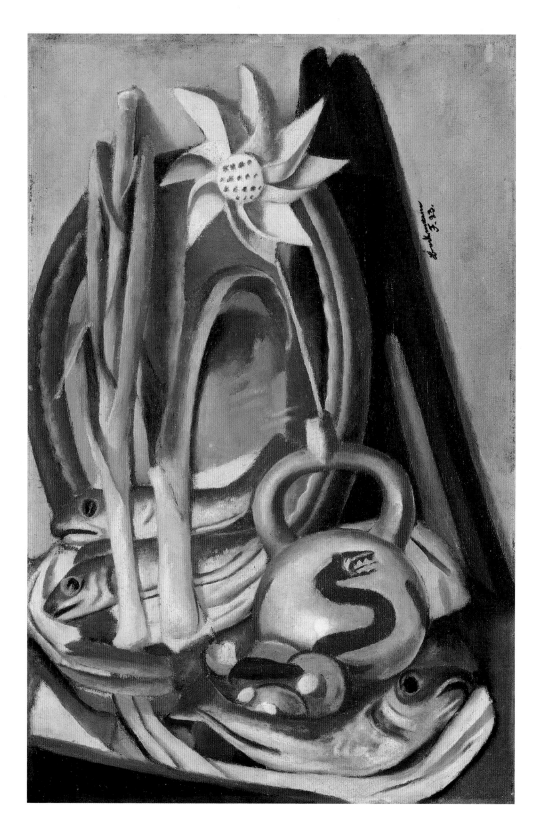

no.71
*Still Life with Fish
and Pinwheel* 1923
60.5 × 40.3
(23 3/4 × 15 7/8)
Frederick R.
Weismann Art
Museum,
University of
Minnesota,
Minneapolis. Gift
of Ione and
Hudson Walker

no.72
*Still Life with Fallen
Candles* 1929
55.9 × 62.9
(22 × 24 3/4)
The Detroit
Institute of Arts.
City of Detroit
Purchase

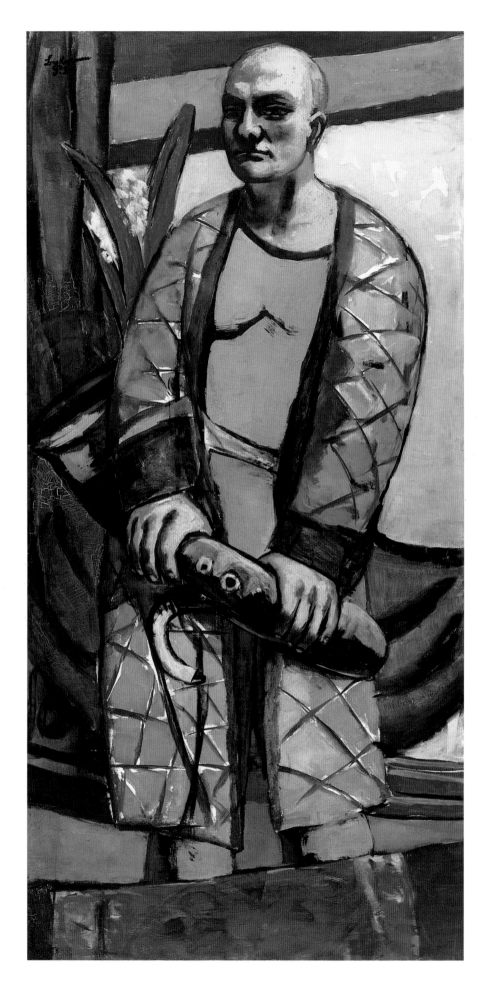

no.73
Self-Portrait with Saxophone 1930
140 x 69.5
(55 1/8 x 27 3/8)
Kunsthalle Bremen

no.74
The Bath 1930
174 x 120
(68 1/2 x 47 1/4)
The Saint Louis Art Museum. Bequest of Morton D. May

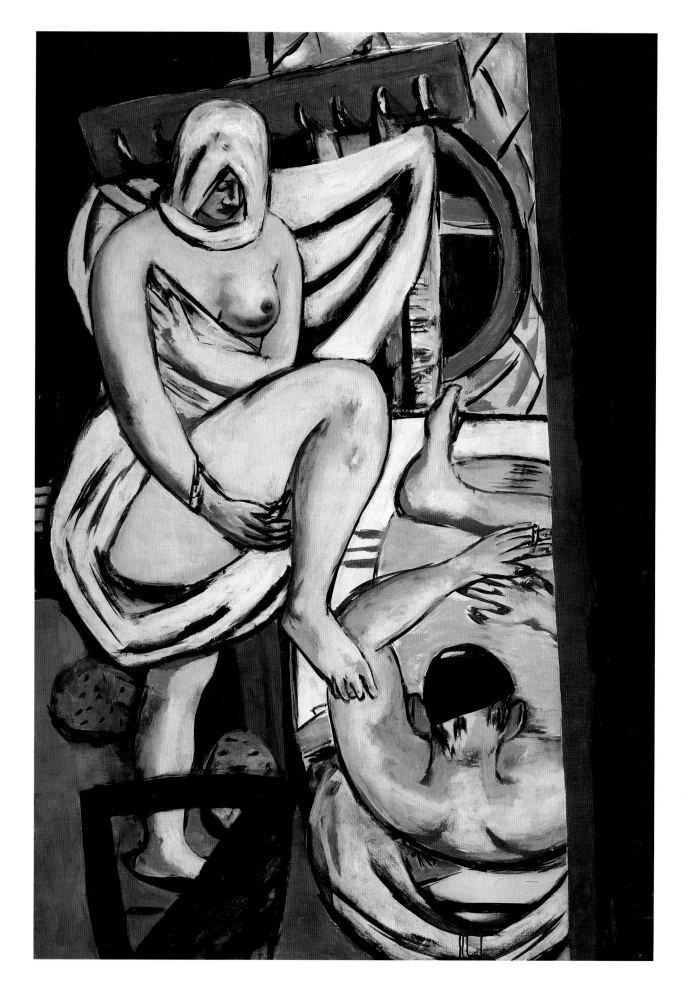

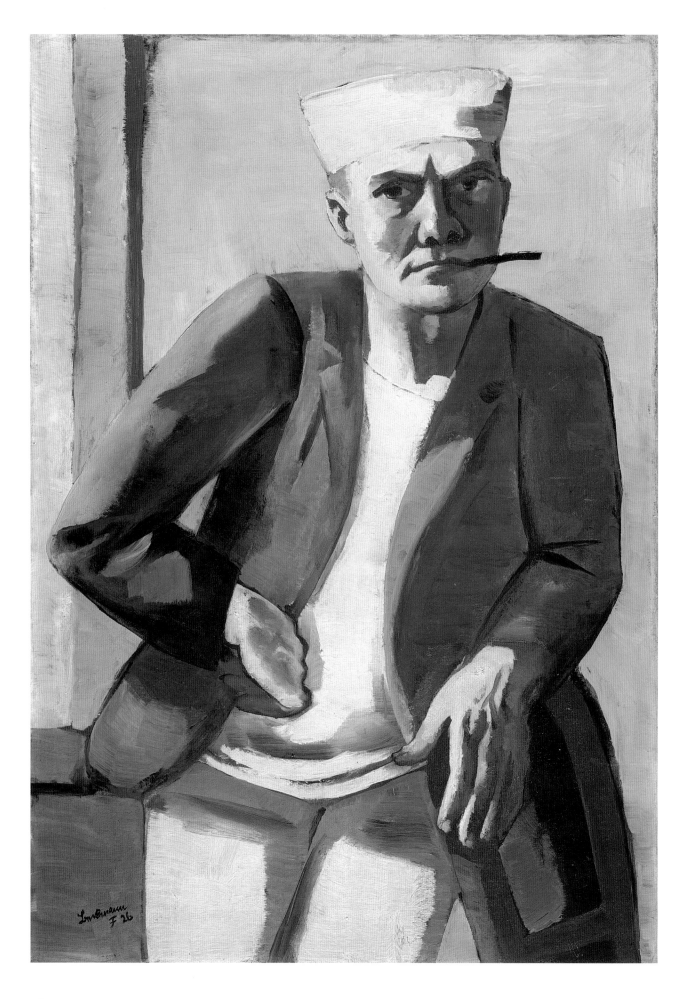

Beckmann's Lucid Somnambulism
Didier Ottinger

The only thing available to us is the reality of our dreams in images.
Max Beckmann, Diary, 4 April 1946

On 13 July 1929 Max Beckmann informed his Berlin dealer, I.B. Neumann, that he had just arranged to rent a studio and an apartment in Paris, and from then until 1932 he spent nine months of each year in the French capital.[1] He wanted to make his mark in the city of Matisse and Picasso, to offer his work for direct comparison with that of the masters who had made the name of Paris synonymous with modern art.

Beckmann had no anxieties about this confrontation. The year before, there had been a major retrospective of his work in Mannheim that was very well received by the critics when it travelled to Munich and Berlin. The National Gallery in the German capital had acquired two of his recent works, *Self-Portrait in Tuxedo* 1927 (no.88) and *Large Still Life with Fish* 1927 (G270), and he had just gained an award from the Carnegie Institute in Pittsburgh.[2] And it was of him that Julius Meier-Graefe, the most eminent of German critics and art historians, had said, 'Once again we have a master among us.'[3] News of such successes had already reached Paris, where Christian Zervos had written in the *Cahiers d'Art* that Beckmann was 'surely the German artist who most deserves our attention'.[4]

In Paris, Beckmann's painting gained in ease and authority, his forms simplifying and relaxing, his palette becoming brighter. More recent work shown at the Galerie de la Renaissance during March to April 1931 showed how well he had assimilated Parisian painting: *Football Players* 1929 (no.67), a dynamic construction of bodies in movement, recalls

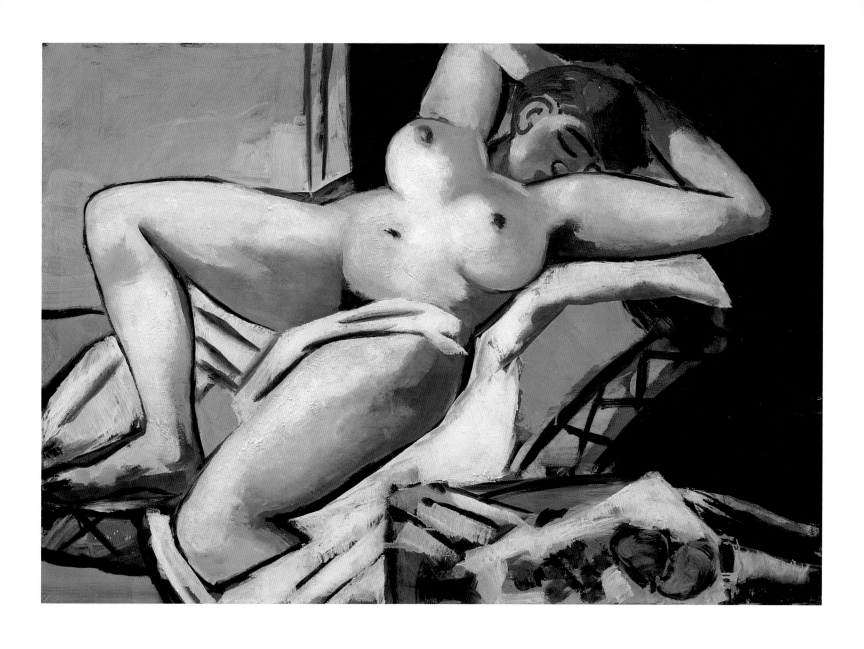

no.77
Reclining Nude
1929
83.4 × 119
(32 7/8 × 46 7/8)
The Art Institute of
Chicago. Joseph
Winterbothom
Collection

no.78
Crouching Woman
1935 (not cast
before 1962)
Bronze
17.8 × 22.9 × 50.8
(7 × 9 × 20)
Private collection,
Courtesy Richard
L. Feigen and Co.,
New York

Delaunay's *The Cardiff Team*;[5] *Reclining Nude* 1929 (no.77) responds to the sumptuous colour and sensual delight of Matisse's odalisques; while *Portrait of an Argentinian* (G305), painted that same year, reconnects to Beckmann's youthful passion for the aristocratic elegance of Manet.

The development of Beckmann's work in Paris, however, cannot be thought of as a mere conversion to the norms of modernist classicism. Some of the paintings in the 1931 show bear witness to the long-lasting and complex dialogue he always entertained with the work of Pablo Picasso.[6] This dialogue was no contest of formalisms, for Beckmann was little interested in the Cubist Picasso;[7] the opponent he wanted to wrestle with was the Picasso he felt closest to, the one who was just then beginning a long-lasting flirtation with Surrealism, the artist who repeatedly turned to mythology. This Picasso had recently made a series of engravings of Ovid's *Metamorphoses,* depicting a cruel eroticism of cannibal kisses and mortal embraces, and was otherwise producing works whose destination and final form were more unpredictable than ever. Beckmann's *Parisian Carnival* painted in 1930 (fig.19), seems like a response, almost point by point, to Picasso's *The Kiss* (fig.20), painted a few years earlier. There is the same brash and dissonant colour, the same choppy construction, and the sexual cannibalism of the one has its counterpart in the sadistic choreography of the other. Behind the melting eye lies the bare blade.

SURREAL COINCIDENCES

Was Beckmann a Surrealist? The question is certainly worth pondering. What 'objective chance' is it that sees Philippe Soupault, that pioneer of Surrealism, writing the text that

fig.19
Parisian Carnival
1930
216 × 105
(85 × 41 3/8)
Bayerische
Staatsgemälde-
sammlungen,
Munich,
Pinakothek der
Moderne.
Donation Günther
Franke
G322

fig.20
Pablo Picasso
The Kiss 1925
130.5 × 97.7
(51 3/8 × 38 1/2)
Musée Picasso,
Paris

served as an introduction to Beckmann's Paris exhibition? Yet surprisingly, the 'inventor' of Surrealism misses the surreal in Beckmann. He praises him for his 'intellectuality and self-possession', and insists on seeing him as 'an architect' who 'believes that one of the most important elements in painting is construction.' In the still lifes, he admires the fact that he 'doesn't risk missing the bird for the shadow.'[8] But Soupault himself has a problem of focus: his analysis takes proper account of the work on show at the gallery, but neglects the *Large Still Life with Fish*, less important as a 'bird' than as a door onto the 'shadows' of Beckmann's complex symbolism. Quite naturally, the introduction does not look at works mentioned in the catalogue but which do not appear on the walls of the gallery; so there is nothing about *Sleeping Woman* (G227), surrounded by her open books, painted in 1924, the

year of the official foundation of Surrealism, nothing about *Parisian Carnival* or *Galleria Umberto* 1925 (no.89), an image of dream or nightmare inspired by Italian Fascism, whose true nature Beckmann could already sense, which mixes reality and hallucination. For his first Paris exhibition, Beckmann had clearly preferred to appear half-masked.

Beckmann specialists certainly agree in seeing in his Paris period the appearance of tendentially Surrealist motifs, and *Man and Woman (Adam and Eve)*, painted in 1932 (no.82), is the most surreal of all his pictures. In a landscape metaphysical in its unreality, a man and woman, both naked, turn their backs on each other. Between them stand trees of improbable form, hung with explicitly sexualised fruits. The year 1932 marks an important turn in Beckmann's work. The painter began work on his first triptych, *Departure* (no.60),

no.79
Female Dancer
c.1935
Bronze
17.5 × 70 × 25
(6 7/8 × 27 5/8 × 9 7/8)
Galerie Pels-Leusden,
Berlin

a painting that achieves far more than formal innovation: it puts into question the nature of the connection between the work and reality. *Departure* marks the beginning of a new iconography for Beckmann, that of symbolism, on a world of legend peopled with kings and knights, in which men and women, culture and barbarism, stand opposed, a polarised world, as is proper to the mythological. Contemporary with the triptych is a series of watercolours of figures from Greco-Roman mythology that point up the opposition of the sexes, among them *Odysseus and the Sirens* 1933 (private collection, New York) and *The Rape of Europa* 1933 (private collection). Other works show Beckmann turning to diverse sources in order to express his new mythological world. *The Snake King and the Stagbeetle Queen* 1933 (private collection) is inspired by Sumerian creation narrative, *Brother and Sister* 1933 (G381) takes the figures of Siegmund and Sieglinde from the *Niebelungen*, whilst *Journey on the Fish* 1934 (no.80) superimposes Christian and pagan iconographies.

Beckmann's mythological turn, which followed a phase whose realism is too rapidly assimilated to Neue Sachlichkeit (the New Objectivity), should be seen in the context of the more general interest in mythic thought that characterised the 1930s.[9] In 1931, the art historian Carl Einstein wrote a text on 'the problems of contemporary art' that considered the phenomenon. He noted a change in the nature of artists' relationships to the real: 'It turns out that the Greek tradition, this clear and historically well-established conception of the world, is slowly but surely breaking down, and one is seeing the beginning of something that I would describe as a Romantic turn.'[10] For him, this development marks the advent of a mythical style of thought, in which the dream has a central role: 'One can almost speak of an attempt to create new objects – objects which emerge on the basis not of an external optical image, but of hallucinatory internal processes.'[11] Einstein's study, and his diagnosis of the change in art, relied on recent developments in Picasso's work, which had left behind the Cubist architectonics to transcribe the message of the unconscious. The art historian summed up his analysis in a single, laconic formula: 'the tendency to myth is back.'[12] Beckmann, who was at that time close to Einstein,[13] must have been aware of the article, and it was with the 'romantic', Surrealist Picasso that he wanted to engage in Paris.

MODERN MYTHS

In the literary field, Hermann Broch detected, as Einstein had in the plastic arts, the emergence of an art whose principles were those of mythic thinking. In a study of James Joyce written in 1936 – writing in terms that could be applied directly to Beckmann's mythological works – Broch posed the question of the relationship that exists between individual subjectivity and what he called 'the spirit of the age':

To great artistic endeavour has fallen the task of acting as the focus for the anonymous forces of the time, gathering them together within itself, as if it were itself the spirit of the age, bringing order to their chaos and so harnessing them to the service of its own ambitions. This is a mythic task: mythic in the secret of its action, mythic in its sensual concretisation and in its symbolisation of the forces secretly at work in the chaos, mythic as accomplishment and mythic as act.[14]

no.80
Journey on the Fish
1934
134.5 × 115.5
(53 × 45 1/2)
Staatsgalerie
Stuttgart

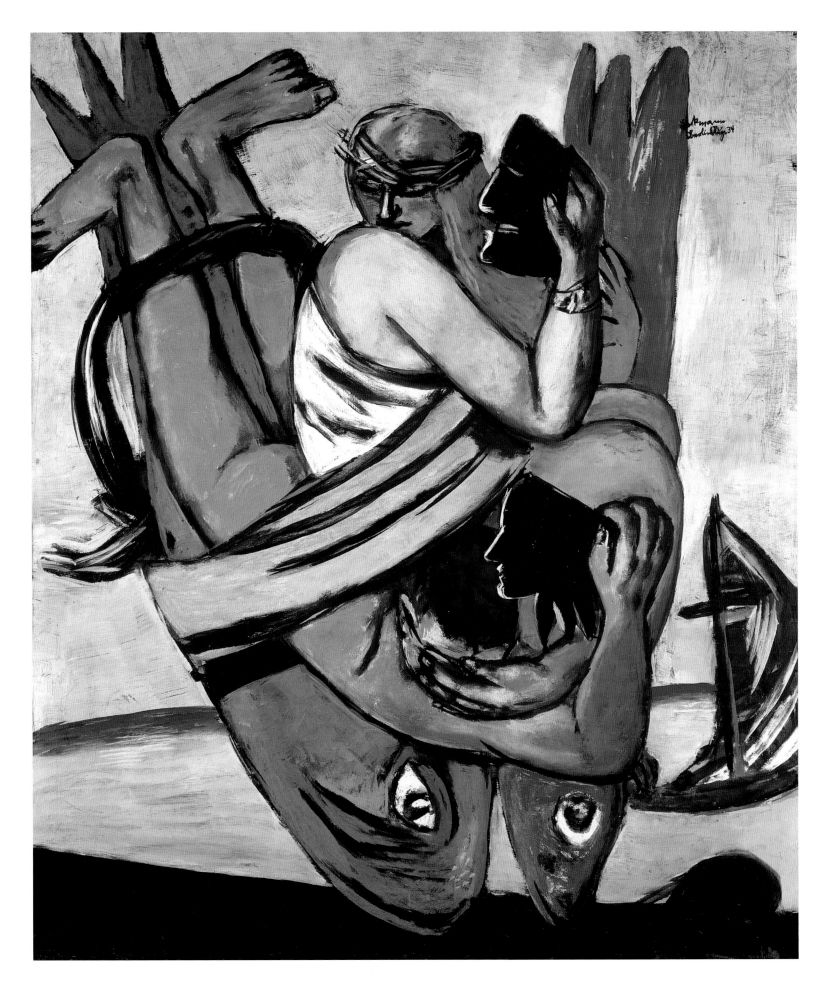

Broch's analysis, connecting the most subjective to the most universal, can be applied to Beckmann's series of self-portraits. Beckmann's project, unparalleled in the history of twentieth-century art, has nothing of the narcissistic; it is rather an attempt to make from the multiple instances of his own image a mirror of the world. Broch too had seen in the life of Leopold Bloom, the 'hero' of Joyce's *Ulysses*, 'the universal everyday life of the age'.[15]

This universalisation of facts, of singular existence, is achieved at the cost of a profound challenge to the foundations of a modern culture that had been identified with the rationalist conquest of the world:

the disruption that pervades [Joyce's] work reaches beyond rationality and consciousness ... but it is also charged with a profound pessimism, a deep aversion for all traditional yet already defunct forms of existence, a deep aversion for rational thought, which, as finely-honed as it may be, is no longer capable of judgement ... in short, it is a revolution charged with disgust for culture, a disgust that is also in accord with the age, being a disgust with the rationality that drives an excessively rational age into irrationality.[16]

The association that Broch identifies between 'disgust for culture' and artistic creation in the mythic register helps explain the significance of Beckmann's trajectory after the First World War: his works of the early 1920s are indeed concerned with challenging the values of so-called advanced culture. Only the Dadaists, who emerged at the same time, offered as radical a rejection. At the end of a war that had led Beckmann to physical and psychological collapse, his

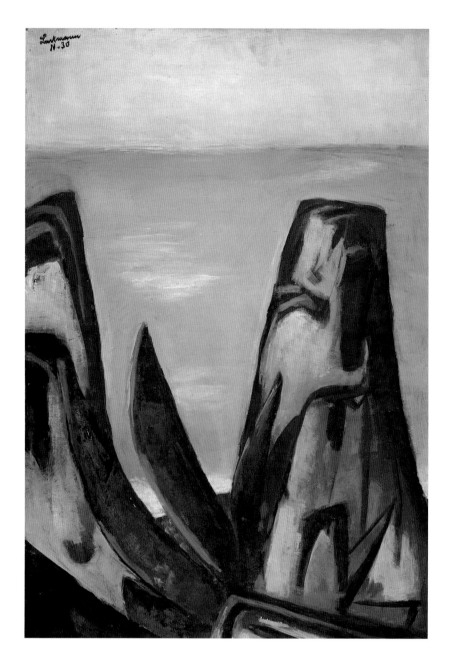

no.81
Marine (Côte d'Azur) 1930
90 x 60
(35 3/8 x 23 5/8)
Private collection,
Courtesy Galerie
Kornfeld, Bern

questioning was rooted in the experience of modern society as fiasco. Its ideals had been perverted as science, until then associated with 'progress', had been turned against man. Beckmann's disillusionment found expression in both form and iconography. For a while, Beckmann had thought that primitive art, and faith in a renewed Christianity, might prove a crucible for the emergence of new collective values; thus during 1917 he painted *Descent from the Cross*, *Christ and the Woman Taken in Adultery* and *Adam and Eve* (nos.9, 10, 11). But he had chosen the wrong track, one that Nietzsche had taken: lost illusions cannot be replaced by obsolete myths. Having rejected the idea of any return to the past, Beckmann wavered between cynicism and a deliberately reinvented innocence. Between 1919 and 1923, his paintings were striking for their 'naivety': his urban scenes looked like toy villages, the construction of his pictures ignored the scientific rules of perspective. Like so-called 'primitive art' and children's drawings, they were organised in accordance with 'hierarchical perspective', in which the size of an object is determined by its subjective interest for the painter, and during these years Beckmann's most important artistic reference was Le Douanier Rousseau. His identification with Rousseau amounted to a manifesto, expressing a desire to rediscover a fresh eye, a gaze unaffected by modern culture. In 1938, during the lecture he gave in London on the occasion of the exhibition *Twentieth Century German Art*, Beckmann paid homage to 'my grand old friend Henri Rousseau, that Homer of the porter's lodge, whose prehistoric dreams have sometimes brought me near the gods.[17]

The alternative to innocence available to the postwar Beckmann was cynicism, a cynicism clothed in romantic irony. This took two forms: either the world being escaped, or otherwise grotesquely travestied, as illustrated in two paintings of 1921. *The Dream* (no.14) is the first of a long series of oneiric works; the *Self-Portrait as Clown* (no.58) is a critique of the real, a stripping bare of the 'farce of life' and its parade of mountebanks. Images of music hall and circus are parodical representations of the rites and values of society, which are travestied the better to be revealed. This parodic reality is a modern version of the irony of the Romantics, for whom the world was only a game, a dream in the mind of the creator. Commenting on Beckmann's work in his anthology *Die Kunst des 20. Jahrhunderts,* Carl Einstein points out the filiation: 'There is here perhaps a Romantic irony, because this compositional naturalism can also be attributed another significance; despite the description, what is at work is a non-naturalist, fantastical vision of the world.'[18]

Unlike the Romantics, Beckmann lived after the 'death of God', in an age when transcendent values had fallen into crisis. In the theatre of existence, the artist was no longer the guide the Romantics had dreamed of and revolutionaries thought they had discovered – he was no more than a clown, an entertainer, the eternal joker in the antechambers of power. *The Night* 1918–19 (no.59) is a synthesis of the separate paths that would be explored some years later in *The Dream* and *Self-Portrait as Clown*. The painting has Rousseau's naivety, the faces of the characters tending to caricature, and they have the disrupted gestural language of rag dolls. But it also has the force, the troubling ambiguity of a dream image. Its reeling space extends the distorted perspectives of Giorgio de Chirico, while the image is both horrifying and grotesque,

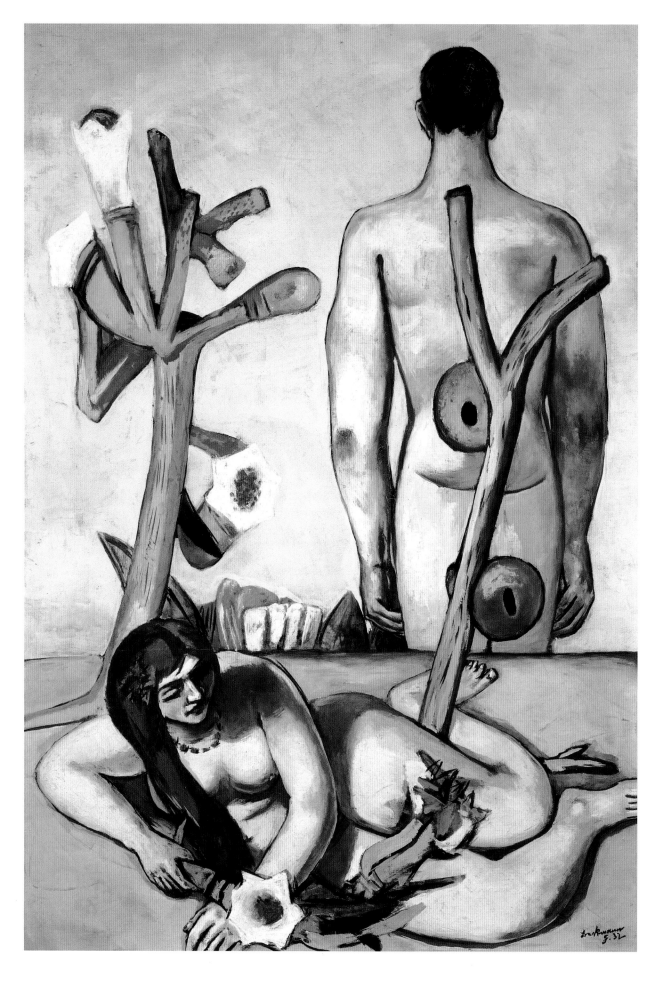

no.82
*Man and Woman
(Adam and Eve)*
1932
175 × 120
(68 7/8 × 47 1/4)
Private collection

as dreams very often are. Mixing the naivety of Rousseau and images of dream or irony with reality, *The Night* foreshadows Beckmann's later mythological works, and is distinct from them only in the method to which the artist remained loyal at the time.

PARANOID-CRITIQUE

'A form of self-hypnosis' is how Beckmann described his art in a letter to Lilly von Schnitzler in 1943.[19] As well as emphasising his painting's profound affinities with Surrealism, this definition also connects him to the Romantic tradition. This connection, to which the painter himself laid claim by carrying, in his 1938 *Self-Portrait with Horn*, the horn associated with the German Romantic authors (no.150),[20] explains the challenge that modernist orthodoxy has faced

in dealing with his work. It is difficult to place his painting in a history of art which, from Hebart to Hildebrand and from Fiedler to Greenberg, has endeavoured to assimilate art to objective knowledge, a story described by Jean-Marie Schaeffer: 'The essentialism of the pictorial avant-gardes ... ended up in an autoteleological purism that tried to reduce art to what were taken to be its fundamental internal components.'[21] 'Pure forms', 'pure visibility' presupposes a watertight separation that prevents all relation between the artistic subject and the world. If the painting, as Vasari conceived of it in the Renaissance, had been a window on the world, it was also an instrument of knowledge, a means of objectifying the world. Endowed with the tools and methods of science, painting had played its part in the rationalist project of the new humanism. This objectifying

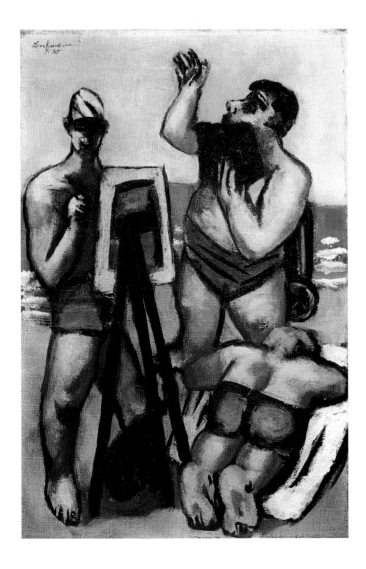

no.83
Artists by the Sea
1930
36.5 x 24
(14 3/8 x 9 1/2)
Private collection,
Courtesy Richard L.
Feigen & Co.

no.84
The Beginning
1946–9
Side panels:
165 x 85 (65 x 33 ¹/₂)
Central panel:
175 x 150 (69 x 59)
The Metropolitan
Museum of Art,
New York. Bequest
of Miss Adelaide
Milton de Groot,
1967

intention led the twentieth century to close the classical window, so as to be able to insist on the material reality of the work itself.

For Beckmann, a painting was something else altogether. In the left-hand panel of the triptych *The Beginning* 1946–9 (no.84), the characteristic rectangular structure of the stretcher that bears the painted canvas is superimposed on the leading of a stained-glass window. The luminous image is that of a blind organ-grinder. The picture is this window, not giving onto a profane world, but opening onto ideas, open to revelation.

Beckmann's library, and the comments he was inspired to make on the works in it (known to us from a study by his son Peter), help to identify his spiritual affinities.[22] His reading gives us a genealogy of successive reinterpretations of the teachings of the Jena Romantics: after Novalis and Schlegel come Jean Paul Richter, with his apologia for the dream, Wilhelm Worringer and the idea of *Einfühlung* ('empathy'), Carl Einstein and the principle of 'formal animism',[23] Carl Gustav Jung and the collective unconscious. All these writers speculated on an art whose key word would be unity, an art born of the fusion between artist and world, open to images of hallucination, dream and fantasy. The authors share with Surrealism their definition of the subject and of the real, and their definition of the creative process.

Beckmann for a long time had the novels of Jean Paul (the pseudonym of Jean Paul Richter, 1763–1825) at his bedside, and it was this author's novel *Titan* (first published in 1846) that inspired his triptych *Actors* of 1941–2 (no.107). Jean Paul is the heir of the Romantics; he was like the poet described by Novalis:

The poet is out of his senses [*sinnberaubt*] in the true meaning of the term – that is why everything comes together in him. He represents the subject-object – the soul and the world – in the most literal sense of the term. Whence the infinite character of a good poem, its eternity. The disposition for poetry is closely related to the prophetic and religious disposition, to the visionary sense [*Sehersinn*]. The poet orders, fuses, selects, invents – without understanding himself why he acts in this way rather than another.[24]

Jean Paul wanted to extend the perceptual field beyond the frontiers of reason. Albert Béguin, who wrote the preface to his first collection of 'dreams' published in French translation in 1931, wrote: 'Jean Paul had recourse to all kinds of stimulants, especially alcohol and coffee, in order to provoke his hallucinations. "You may deliberately arrange to have a parade of images pass before your eyes," he writes in *A Glance at the World of Dreams*.'[25] Jean Paul formulates his theory of the dream in *On the Natural Magic of the Imagination* (1795), which relates poetry to dream and makes the imagination the sole means of access to universal symbolism. Beckmann retains and adapts these poetics. Uncommon as it might have been in the late 1920s, there was nothing outlandish about such a conception of artistic creation. In the magazine *Documents*, which he co-founded with Georges Bataille, Carl Einstein had made himself the champion of a poetics of ecstasy. In the second issue he published a study that related the painting of André Masson to the practice of totemic religion. Determined to struggle against 'philosophical idealism', he called for a 'return to mythological creation', to

a 'psychological archaism'. Considering Masson's paintings, he noted that 'the motif has become an immediate psychological function. One part of the object represents the totality, and these paintings of Masson's provoke a mythic reaction, by a sort of infection. Given that in ecstasy the ego disappears, we see the appearance of a syntonic attitude.'[26] Whether dealing with Cubism or the Surrealists, Carl Einstein's articles in *Documents* adhere to a poetics of ecstasy, of sacramental participation. In the name of the same anti-idealist stance, Georges Bataille for his part appealed to excess, to 'self-abandonment'. Whether in the work of Sade, who 'had as his goal the clear consciousness of what can only be achieved by "release" ... That is to say ... the suppression of the difference between subject and object,'[27] or in the Lascaux cave paintings – 'what is impressed upon us as we stand before them is the untrammelled communication between the human being and the world that surrounds him, man giving himself up to it in harmonising himself with the world whose riches he discovers',[28] Bataille believes only in 'ecstatic' artistic creation.

Applied to painting, this method can be used to describe the genesis of Abstract Expressionist work, and it can also account for the production of a painting by Beckmann. In his study of Beckmann's triptychs, Reinhard Spieler describes how Beckmann found the subjects for his pictures in experiences and dreams, producing a quick sketch that defined the composition in a few lines. This general form preceded any iconographic research. As it was being painted, the work would change title several times. The painter endeavoured to make the painting as abstract as possible, in order to multiply the possibilities of interpretation, the work's meaning being intended to remain as open and as general as

possible.[29] The above could also be applied to the genesis of works by Picasso, as can be seen in the film by Henri-Georges Clouzot.[30] Like Picasso, Beckmann made use of what Carl Einstein, speaking of Masson, called 'training in ecstasy', talking about it in his London lecture of 1938:

> What is important for me is the consistent application of a formal principle which comes in when the object is transformed by the imagination ... When you want to reproduce an object, you need two things: firstly, there must be complete identification with the object, and secondly, something completely different must come into play. It's difficult to explain this second element, almost as difficult as finding one's own self.[31]

In 1948, in his *Three Letters to a Woman Painter,* he gives his own version of 'training in ecstasy': 'Certainly art is an intoxication. Yet it is a disciplined intoxication.'[32]

EINFÜHLUNG: AVATARS OF A NOTION
The debate that took place in Germany in 1911 on the publication of Worringer's *Abstraktion und Einfühlung*[33] led to what Dora Vallier calls the 'epistemological fracture' which marked the birth of the avant-garde. These discussions, in which Beckmann played a part, help situate him within early twentieth-century German art. Before 1914, he could still claim to belong to the avant-garde. Following Max Liebermann, he had apprenticed his art to the French painting of the Impressionists and of Cézanne, which embodied the values of modernity. In 1911, when the painter Carl Vinnen (the exponent of a classicising landscape art) published

a pamphlet attacking the purchase of French art by German museums, a collective response was published soon after by Reinhard Piper, *Die Antwort auf den 'Protest deutscher Künstler'*. Worringer, whose work had hitherto been confined to ancient art, championed the French painters under attack, describing Cézanne, van Gogh and Matisse as 'synthesizing and expressionist artists',[34] and bringing their art under his concept of *Einfühlung*: 'Modern aesthetics, which has taken the decisive step from aesthetic objectivism to aesthetic subjectivism, i.e. which no longer takes the aesthetic as its starting point, but proceeds from the behaviour of the contemplating subject, culminate in a doctrine that may be characterised by the broad and general name of "the theory of empathy" [*Einfühlung*].'[35]

The notion of *Einfühlung* has its origins in the Romantic literature of Novalis, Schlegel and Jean Paul. In her introduction to the French translation of Worringer's book, Dora Vallier recalls that in 1873 Robert Fischer had described *Einfühlung* as 'a pantheistic tendency proper to human nature, to be one with the world.'[36] Deprived of its links to the real by the artists of Blaue Reiter, *Einfühlung* changed its meaning. In spring 1912, the review *Pan* published a study by Franz Marc of 'the new painting', in which he claimed that 'art has always been, in its essence, the boldest advance beyond nature and the "natural," a bridge to the spiritual realm'.[37] A fortnight later, Beckmann replied in the same review: placing his art under the banner of *Einfühlung*, he identified in Marc's work (and that of the Blaue Reiter more generally) features that Worringer had associated with 'abstraction'. Echoing Worringer, who had described space as 'the ⟫→[149]

Leon Golub on Beckmann

Chicago in the 1930s was relatively isolated as far as international modern art was concerned, with exceptions such as the Arts Club and Katherine Kuh's gallery. She was a totally independent and forceful exponent of European and other modernists. From 1938 to 1940 I attended Wright Junior College and studied German for one year. The German instructor had an avid interest in German art and I especially remember the books she had on medieval German art. That is how I discovered late German Gothic sculpture, Depositions from the Cross, Pietàs – things like that with their extreme gestures and emotionality. Then in the early 1940s I studied art history at the University of Chicago, and got to know Peter Selz who was completing a thesis on German Expressionism. Although

I have no specific recollection of discussions with him about Max Beckmann, I was quite aware of Beckmann's work.

So Beckmann wasn't the biggest item in my life, but he was definitely an item. Early on I was more interested in Orozco and Picasso. Picasso's *Guernica* was exhibited at the Arts Club in 1937 – I was fifteen, and the experience was huge. At that time the Art Institute acquired an early Orozco of Zapata. But Beckmann was a good example in that more than the other two he represented a position that was both 'in' and 'out'. He was not as slippery as Picasso and not as obdurate as Orozco. He was a suave brute. He liked to picture himself as a sophisticated tough guy. I like that rough aspect and I like his wariness, his watchfulness.

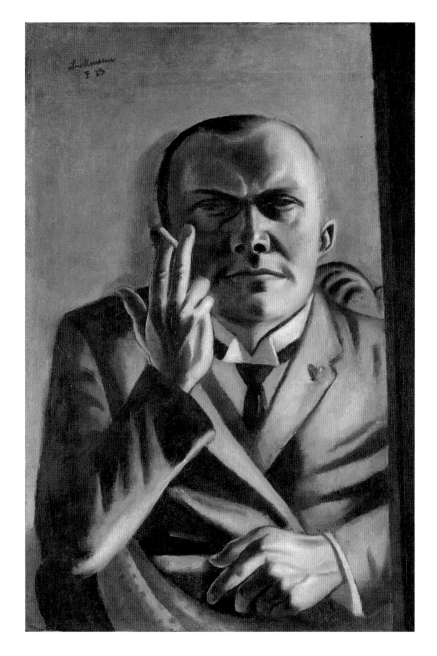

no.85
Self-Portrait with Cigarette on a Yellow Background
1923
60.2 x 40.3
(23 3/4 x 15 7/8)
The Museum of Modern Art, New York. Gift of Dr and Mrs F.H. Hirschland, 1956

The three or four legs of my interests during my School of Art Institute years, (1946–50) were the Art Institute, *Cahiers d'art* and *Minotaure*, and the Field Museum of Natural History, but Beckmann's art played a major part in this mélange, as did the early work of George Grosz. Their example goaded and incited me. I claim to go after the 'real', events and their controversial inputs and consequences, material that is hard-nosed, that takes on what is going on. I've called myself an Expressionist, and even the most realist aspects of my work – like the 'Mercenaries' – have an Expressionist bias to them. Still it's the hardness of Beckmann's early work – the Neue Sachlichkeit paintings – that I like. Those pictures are less ironic, less parodistic than later work. Although his art may be rich in allegorical resonance, it is simultaneously full of raw images, terse abbreviations with a strong sensual immediacy. In fact, this applies throughout his career. It is vehement in early paintings such as *The Night* 1918–19 (no.59) (and already evident in the *Large Death Scene* 1906; G61) and it is fully extended in the impacted, dislocating stresses of the triptychs. Beckmann affirms the physicality of the body even though he fractures it and parts gesticulate or swell convulsively – rumps, breasts, limbs – under the pressure of other bodies. Yet all this comes with a suppressed, wicked humour.

You never know with types like Beckmann whether they are playing it straight or manipulating you. I suspect that he didn't intend these images of the bourgeois world to be seen just as grotesques. He must have been laughing, stepping back and observing the context that he was painting with a sardonic eye, and observing himself in that context with the same eye. There is a sly amusement at the whole situation. Beckmann is not a wit, but he twists things and the ironies of his work run in several directions at once. He has to have been aware of that. In reality you don't have skinny little drummers next to big-assed women, not to mention fish all over the place, and nobody knew that better than Beckmann. If you think of Breughel and Bosch they were also dealing with everyday grotesques and yet their images are hugely human. They are not just exaggerations; they are extraordinary personifications. As well as personifications

of common foibles, of religious and political manias, they are sarcastic self-recognitions. Breughel rode his demons and they rode him. Although the setting is very different, a similar kind of human content moves through Beckmann's images – and similar experiences recur. Beckmann isn't just making expressionistic distortions. He's a gambler playing a complex game.

There is often an aspect of self-parody in Beckmann, even a clownishness. He is multifaceted, yet lumping incongruities together. He doesn't seem so deeply invested in symbolism per se, because he was so involved in the fragmented context in which he was living, the disorder of Germany. And instead of bringing order to the situation, he kicks it around and gives it a disorder of his own. Guston owes him a lot. Plenty of meaning but go figure. I can't help but think that his symbols are telling but somehow hollow. I'm not being negative when I say that. I think Beckmann had a kind of radical self-realisation about all of this.

I bought a book years ago of popular (sixteenth century?) images in which everything is upside down, horses are riding men, children are beating their parents, fish are catching people – things like that. These prints were vastly popular because they satisfy a need to escape the pressure of the ordinary, the everyday; they let off steam. And you get that in Beckmann. He must have known stuff like that. Anyway, Beckmann's pictures do this with many more transformations, many more levels. His is also a world upside down or downside up.

Nevertheless, like the post-medieval examples, the symbolism in Beckmann's work is pretty crude. But crudeness can be power. There is a relation between his blunt painting and his blunt symbolism. They're one and the same.

Sure, there is mysticism in Beckmann's work, but I don't really look for that so it is hard for me to see. In any case his is a very personal mythology. In a pre-Freudian era you wouldn't have been able to analyse him in the way that one claims to be able to do now. By contrast, take Ensor, who also made an impression on me. In his work you encounter petty-bourgeois scenes with skulls, masks and such all around – on a mantelpiece, for instance. Ensor has a kind of medieval thing insofar as the skulls are real in a way they are not after the nineteenth century. Despite Ensor's own sophistication, they are a throwback – direct, tangible symbols. In Ensor they are *in* the room with you and you had better watch out because they will chew you up. That is not true of Beckmann. In this respect Beckmann could even be described as post-Demonic. Sure Beckmann is right there giving it to you; but at the same time you and he know it is a kind of charade, as well. Ensor says, 'This is real, you'd better believe it.' Beckmann says, 'Well, between you and me we know that this isn't real but somehow it hits on the real.' So he is not just fooling around. He's saying that the whole fucking twentieth century is up for grabs. Ensor didn't go that far.

Addendum: In 1964 Nancy Spero and I came to New York after five years in Paris and we rented an apartment on Broadway and 71st Street, popularly known as Needle Park, although in fact the area was quite bourgeois. We were on the second floor; directly above us was Beckmann's widow, Quappi. We became friendly, and visited her apartment on various occasions. There she was surrounded by Beckmann's art. but her awareness of it never took the form of personal reminiscences. She was too dignified for that.

no.86
Portrait of N.M. Zeretelli 1927
140 × 96
(55 1/8 × 37 3/4)
Courtesy of the Fogg Art Museum, Harvard University Art Museums. Gift of Mr and Mrs Joseph Pulitzer, Jr

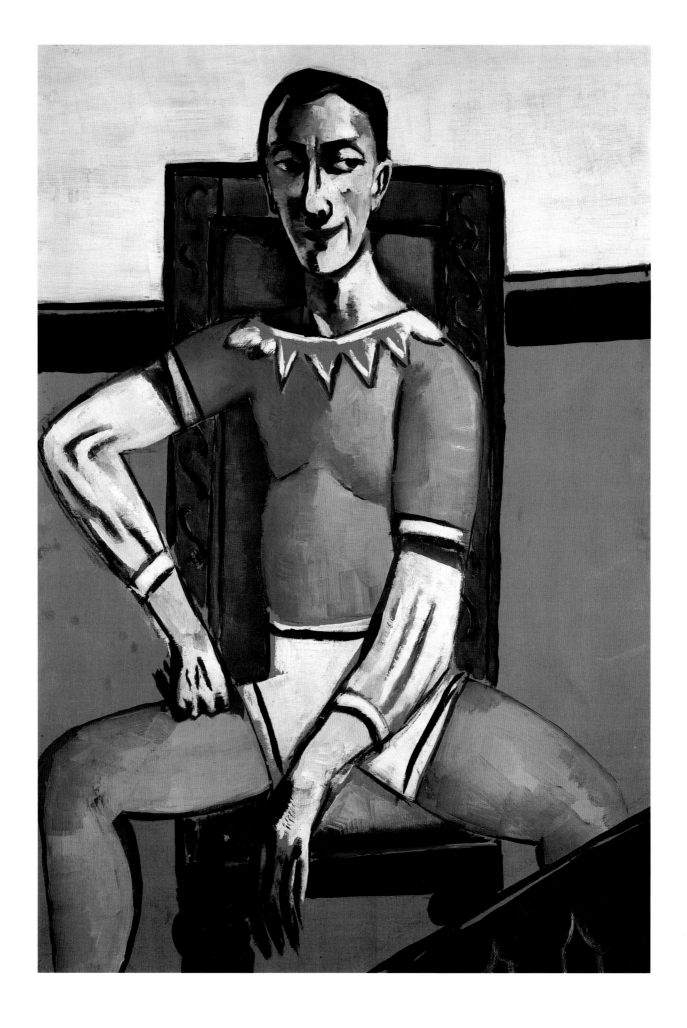

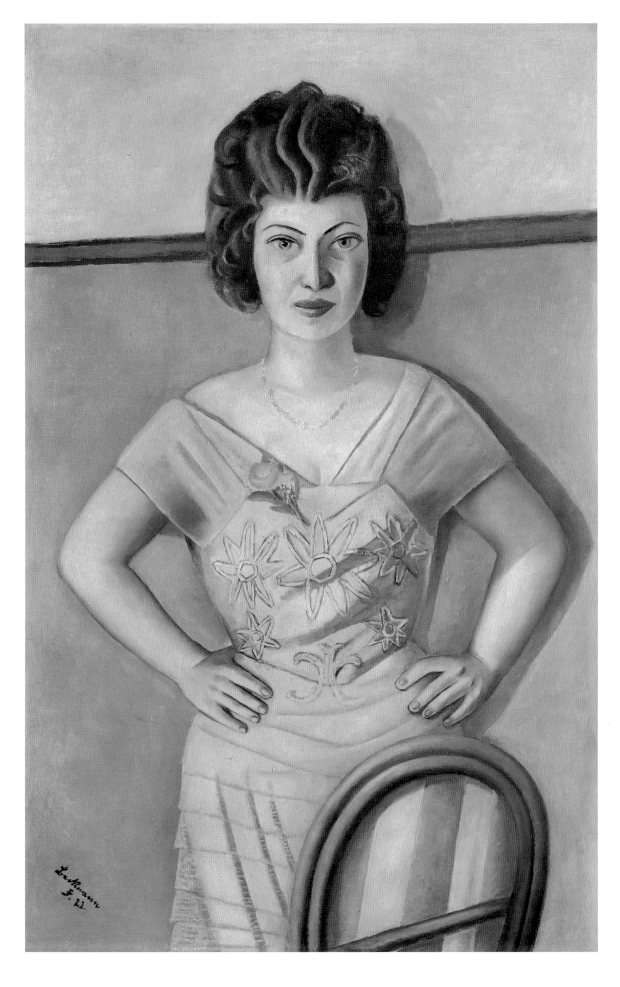

no.87
*Portrait of Frau
Dr Heidel* 1922
100 x 65
(43 1/4 x 25 5/8)
Kunsthalle
Hamburg

major enemy of all striving after abstraction',[38] Beckmann laid claim to Cézanne's 'sense of space' and derided the 'artisanal platitude' of the Blaue Reiter works. Worringer had associated the art of *Einfühlung* with the expression of the organic world; Beckmann claimed Cézanne for the cause, describing a tree of his as 'an organism in its own right, in which one is conscious of the bark, the air that surrounds it, and the ground in which it stands'. When finally, he sums up what distinguishes himself from Marc, he contrasts his own paintings, capable of evoking 'an entire individual, organic world' with those produced by the aesthetic of distancing, of removal from the world, that was inherent in an abstractive approach. In a letter of 8 February 1918, he tells his publisher Piper of a lecture of Worringer's he had just attended: 'At a lecture here in Frankfurt, Worringer explained to a horrified audience that Expressionism was going round and round in a cul-de-sac and had no future; I can now prove, by my paintings and drawings, that one can be new without adopting Impressionism or Expressionism.'[39]

Beckmann's struggle in 1918 was already a rearguard action. Blaue Reiter had taken over *Einfühlung*, and had effectively altered its meaning. The term no longer meant empathic identification with the world, but denoted the intensity of a self-absorbed subjectivity. Will Grohmann drew attention to this development, noting that these artists were obsessed by the idea of 'satisfying a psychological need, and not at all such a need for imitation as leads to *Einfühlung*'.[40] By appropriating the notion of *Einfühlung,* the Expressionist, abstract avant-garde prevented its application to any realist art, leaving it to find historical legitimacy only in formalism.

When André Breton, self-proclaimed heir of German Romanticism, decided to make his reply to Pierre Naville, who had declared that there could be no such thing as Surrealist painting, he wrote a series of articles under the collective title 'Surrealism and Painting'. The first of these, in July 1925, was entirely devoted to Picasso, and illustrated by his Cubist works. The principles of Surrealist painting set out by Breton find their place in the Romantic tradition: 'To meet the need for an absolute revision of real values, on which all today are agreed, the work of art will therefore refer to a purely internal model or will not exist.'[41] The second instalment of 'Surrealism and Painting', adorned this time with paintings by Braque, opens with the defence of a vision formed by unconscious images: 'For a long time, I think, men will feel the need to return to the source of that magic river that flows from their eyes, which bathes in the same light and the same hallucinatory shadow those things which are and those which are not.'[42] Breton's 'ecstatic' Cubism foreshadows what Carl Einstein would soon describe in *Documents*: 'The Cubists first eliminated the conventional subject, which lies on the periphery of the visual processes. The subject is no longer an objective thing separate from the spectator; the thing seen participates in the latter's activity, which organises it in accordance with his succeeding subjective optical impressions.'[43] These readings of Cubism would have no successors. The 'epistemological fracture' of the early 1910s 'disimpassioned' Cubism, to make it the origin of a project concerned with the expression of 'pure form' whose last word would be abstraction.

When *Einfühlung* once again made its appearance in the context of avant-garde art, it was tolerated only as applied to a rigorously abstract art, rehabilitated by Action Painting,

theoretical offspring of the Surrealist 'ecstasy'. 'The action painting is of the same metaphysical substance as the artist's existence. The new painting has broken down every distinction between art and life', Harold Rosenberg wrote of the painters of the New York School after the Second World War.[44]

One can date to sometime around 1912 Beckmann's departure from what was becoming the mainstream of modern art. His landscapes and still lifes remain loyal to a poetics of participation, to the principle of fusion between the painter's subjectivity and the subject of his work. Dramatising the elements of his still lifes by means of scale or lighting, he imbues them with mood, making them biographical documents and entitling them to be considered among his self-portraits. His landscapes, such as *The Harbour of Genoa* 1927 (no.53), are charged with images of dream, fantasy and memory. The only comparable works are paintings of the same type by Picasso, which may be understood as encoded autobiographical statements, their rebus-like qualities being demonstrated by recent studies.[45]

It is the 'paranoid-critical method' developed by Salvador Dalí, 'a spontaneous method for the acquisition of irrational knowledge based on the critical and systematic objectivation of delirious and disordered associations and interpretations,'[46] that seems best suited to account for the production of such works.

THE SOCIAL RESPONSIBILITY OF THE ARTIST
In his dispute with Franz Marc in 1912, Beckmann took the side of the modern, a commitment he would never abandon. In the review *Pan,* he criticised Gauguin, whom Marc had offered as an exemplar, for having taken refuge in Polynesia on account of being incapable of creating archetypes for and of his own time. He condemned Matisse for similar reasons, calling him 'an even more deplorable representative of this ethnology museum art: the Asian department'. The virulence of these attacks corresponds to the intensity of his desire to engage with his own time. Beckmann's hope of 'creating archetypes rooted in our own age' was shared by the Surrealists, and Louis Aragon, in the introduction to his novel *Le Paysan de Paris* of 1926, made the expression of modern myths Surrealism's prime ambition: 'New myths spring up beneath every step we take. Legend begins where man has lived, where he lives. All that I intend to think about from now on is these despised transformations.'[47]

Beckmann took his theory of myth from Carl Gustav Jung, whose *Relationship between the Self and the Unconscious* is one of the books in which he made marginal notes. In his theory of the 'collective unconscious', Jung's thought is connected with that of the early Romantics. Like them, he believes in the existence of universal values shared by the whole of humanity: 'The unconscious processes of the most remotely separated peoples and races show a quite remarkable correspondence, which displays itself, among other things, in the well-authenticated similarity between the themes and forms of autochthonous myths.'[48] When Jung reports that 'the Elgonyis, natives of the Elgon forests, explained to me that there are two kinds of dream, the ordinary dream of the little man and the "big vision" only the great man has, e.g. the medicine-man or chief',[49] he was attributing to the shaman of primitive societies the role the Romantics had assigned to the poet.

In 1926, Beckmann formulated a theory of art in which

the artist is the equivalent of Jung's 'medicine-man': 'The artist in the contemporary sense is the conscious shaper of the transcendental idea. He is at the same time the shaper and the vessel ... The contemporary artist is the true creator of a world that did not exist before he gave shape to it.'[50] The Surrealists also claimed this social responsibility for the artist. In elegiac mode, André Breton invoked the relationship uniting poet and people: 'There is nothing like this sudden, fugitive possibility of the fusion between the soul of the poet and the spirit of the crowd, under the aegis of very particular external events, to inspire bitter regret at the disappearance of such contact since.'[51]

Beckmann discovered in Jung's work a 'method' similar to that advocated by the Romantic poets, and Jung's interest in states of consciousness favourable to the emergence of dream-like and fantastical images recalls the 'intoxication' of Jean Paul and Novalis. These states of self-hypnosis or 'lucid somnambulism' favour the appearance of myth and symbol. The symbol, as defined by Novalis, is the product of this deliberate scrambling of the frontiers between reason and unreason, between self and world. Jean-Marie Schaeffer sums up the conditions for the emergence of romantic symbolism: 'the symbol is the work of the productive imagination, it is situated in the privileged place where the universal and the particular, the intelligible and the sensuous, but also the formal and the material, the meaning and the figure are represented in each other.'[52] Beckmann's work certainly corresponds to this definition. Their symbolism and the 'open' meaning of the images have for a long time been a stumbling block to exegesis. When Beckmann's dealer Curt Valentin passed on the query of an art-lover who wished to decipher the enigma of *Departure* 1932, 1933–5 (no.60), he received a stinging reply: 'If people are incapable of understanding for themselves, from their own inner light, there is no point showing them ... It should be noted that *Departure* is not a work with a message, and it is, I dare say, valid for all times.'[53] For Novalis, the symbol is 'Image – not allegory – not symbol of something else [*eines Fremden*] – symbol of itself.'[54]

PARERGA AND PARALIPOMENA
Beckmann was twenty-two when he first read Schopenhauer's *Parerga and Paralipomena*, and his diary and correspondence testify to a real familiarity with the philosopher's works.[55] He found in Schopenhauer a theory that integrated dream activity into the process of knowledge. Reviving a tradition that went back to Greek antiquity, Schopenhauer attributed to the dream the capacity to reveal higher truths.[56] Scattered throughout *Parerga and Paralipomena* are images describing an illusory reality, close to the veil of *maya* in the Vedic tradition: 'Let us recall ... the so widely recognised resemblance between life and dream.' 'We are nothing but temporal, ephemeral creatures, of the order of dream, beings that fly swiftly away like shadows.'[57] Schopenhauer favours intuition over the Kantian 'faculty of reason'. 'That time and space, with regard to their form, are represented *a priori,* has been taught by Kant; but this may be so too of their content, as is taught by lucid somnambulism.'[58]

These ideas, with their associated 'ecstatic' conception of art, helped fashion Beckmann's process of artistic creation, the nature of his relationship with the real, a relationship that made the real the site of every deception and every illusion

(the painter's regular recourse to images of theatre, circus and music-hall are a clear expression of this sense of artifice), but also the only source from which it is possible to extract Ideas and Truths. The work of extracting meaning to which Beckmann committed himself reproduces the process of the emergence of thought as described by Schopenhauer:

The process of our innermost thoughts is not as simple as it seems in theory; it is in fact a very complex sequence. To make it clearer, let us compare our consciousness to a body of water of some depth; distinctly conscious thoughts are only the surface; the mass of liquid, on the other hand, is made up of confused thoughts, vague feelings, the echoes of intuitions and of our experience in general, all these joined to the characteristic disposition of our will which is the kernel of our being. So the mass of our consciousness is in perpetual motion, in proportion, of course, to our intellectual vivacity, and thanks to this continuous agitation there rise to the surface the precise images, the clear and distinct ideas expressed by words and the determinate resolutions of the will.[59]

This description corresponds almost exactly to the theme that Beckmann never stopped painting, that of the 'young men by the sea'. The first work in his catalogue of 1905, and returned to regularly year after year, this motif provided too the subject for his last triptych, *The Argonauts*, painted in 1949–50 (no.163). The young men standing against infinite space are like 'the clear and distinct ideas', the spontaneous, fragile epiphenomenon or emanation of the confusion of waves, of the most varied and contradictory 'vague

feelings', 'intuitions' and 'experiences'. Like meaning, they are snatched from the waves of existence, the storms of history. 'Nature is a wonderful chaos to be put into order and completed', Beckmann said in 1948.[60] Even the flute-player, a recurring figure in this theme of young men at the sea's edge, is suggested by Schopenhauer in his allegory of the life of the mind.

The normal human being ... possesses only the first intellect, which one may call the subjective, as the intellect of genius is the objective. Although this subjective intellect may be endowed with varying degrees of perspicacity and perfection, it is nonetheless distinctly separate in register from the double intellect of the genius – just as however high may be the notes achieved by the chest voice, they are always essentially different from the falsetto, which is, rather like the two upper octaves of the flute and the harmonics of the violin, the product of two columns of air vibrating in unison, separated by a node; while in the chest voice and the two lower octaves of the flute, it is simply the whole column that vibrates. This allows one to understand the specificity of genius, which is visibly expressed in the works and even in the physiognomy of those who are possessed of it.[61]

Beckmann's artistic ambition is summed up by the quest for the 'perfect sound' that harmonises higher truth with the chaos of the world and of human history. Only art is capable of producing this perfect sound. If the young men in *The Argonauts* triptych are an image, they are also an emanation of art, of the music and painting that Beckmann

painted on the two outer panels of the work. Schopenhauer's 'precise images, clear and distinct ideas' develop from the humming chaos of the depths. Beckmann's images emerge from a deliberate confusion of forms and symbols, their intensity proportional to the confusion of the chaos from which they come.

The reading of Mme Blavatsky's work, which Beckmann undertook at the end of 1932 (at the moment of the mythological transformation in his art), fits in with this programme of deliberate ferment. The artist had no regard for the quasi-religious significance of theosophical writings, annotating the pages with a series of acerbic comments – 'tremendous nonsense', 'all this tripe reads very nicely'. What he was looking for was not enlightenment but confusion.[62] The religious syncretism that Blavatsky proposed rested on a compilation of narratives – tales, legends and myths of all ages and origins. These formed a corpus of ideal images, a treasury to which Beckmann returned again and again. His artistic goal was to bring out from this hotchpotch the 'primordial images', the 'archetypes' required by the meaning of his works. This poetics of meaning, 'sprung from the foam of the sea' like Aphrodite, also explains the relationship of Beckmann's art to history. His painting feeds on historical eventuation, it is intimately linked to the present moment. Rather than the passive mirror of history, it is its seismograph, registering its violence, the issues at stake, the struggle between culture and barbarism, of brutal forces against civilisation (perhaps the true and only subject of Beckmann's triptychs). Like Picasso's *Guernica* of 1937, through their symbolism Beckmann's paintings transmute the images of a place and a time into universal figures.

DREAM STORIES

It is in the cinema that one sees images most closely related to Beckmann's. In its significance and its composition, the world depicted by Stanley Kubrick in *Eyes Wide Shut* (1999) offers an exact equivalent, Kubrick producing a reality permeable to dream and fantasy. The screenplay is based on *Traumnovelle*, a 1926 short story by Arthur Schnitzler. Close to Freud, Schnitzler shows the slow, subtle contamination of the real by images from the hind-world of desire and the instincts discovered by psychoanalysis. Kubrick gives visible form to the rise of this fantastical tide that gradually submerges a reality protected only by flimsy barricades of habits and carefully measured madness (from the cannabis the characters smoke). Soon, fantasy and reality have become one (in the orgy scene in the mansion). By the end, life is no more than a dream, the rules that order it no more than absurd rituals.

David Lynch's *Mulholland Drive* (2001) is another film concerned to make visible the irruption of dream into reality, and it is at the same time an anatomy of the phantasmagoria that is called 'cinema'. Two heroines, who switch names and personalities, alternate their accounts of the same events, the one the dream double of the other, and their intertwining stories gradually chip away at the reliability of what one had thought to be the most stable of realities. As in Beckmann's paintings, and just as in Alfred Hitchcock's films, objects acquire the obsessional character of fetishes. Like the 'symbolically functional objects' of the Surrealists, they are vehicles for the revelation of personal destiny (a blue key, the sum due under a contract in Lynch; the horn, the candle and the sword in Beckmann). Lynch turns Hollywood – its

geography, its social rituals – into an allegory of cinema, victim to the hubris that is ready money. When the heroine wants to find the solution to the enigma that is her life, she goes to the theatre, where she finds a paradoxical response: on stage, a moving song she takes for the expression of the highest truth turns out to be no more than pre-recorded music. The presenter of the show announces: 'It's a tape, everything is an illusion.' The cinematic illusion is of the same kind as that engendered by Beckmann's paintings, which fix their images at the intersection of a world perceived and a world projected, images drawn from the real, from history, but moulded from dream and hallucination. Beckmann learned from Schopenhauer that existence was no more than a veil, an illusion; he accepted this, populating his works with a humanity of actors and clowns. In his copy of *Parerga and Paralipomena* he underlined the words: 'the world is a dark cavern in which we are confined'. At the end of the war, first in Holland and then in the United States, Beckmann assiduously frequented the cinema. In these dark enclosures he contemplated the shadows of a reality whose fitful glimmer he fixed on his canvas. From seeing reality as a dream, and seeing this dream as a cinematic image, it could happen that Beckmann took reality for a film, noting in his diary on 11 October 1946: 'I went to La Gaieté and saw Cary Grant dance with a woman who was with him. At first I thought it was a scene in a film.'

In 1937 Beckmann left Germany for good. His first reflex was to go back to Paris. Once again, but in person this time, he wanted to make contact with André Breton and the Surrealists. He revealed his plans to his friend and patron Stephan Lackner, who approached Max Ernst, useful in this regard for being both Surrealist and German, but Ernst refused to effect the introduction:[63] the story of Beckmann and Surrealism is the story of this missed encounter.

Translated from French by Dafydd Rees Roberts

Notes

1 The studio was at 23 boulevard Brune and the apartment at 24 rue d'Artois. Klaus Gallwitz, Uwe M. Schneede, Stephan von Weise (eds.), *Max Beckmann: Briefe*, vol.2: 1925–1937 (edited by Stephan von Wiese), Munich and Zurich 1994, p.142.

2 *The Loge* 1928 had won Beckmann a fourth honourable mention at the 28th International Exhibition of Paintings at the Museum of Art, Carnegie Institute, Pittsburgh.

3 Article published in *Berliner Tageblatt*, 15 January 1929, on the occasion of the exhibition *Max Beckmann, Neue Gemälde und Zeichnungen* at the Alfred Flechtheim Gallery, Berlin, 12–31 January 1929. Cited in Klaus Gallwitz (ed.), *Max Beckmann in Frankfurt*, Frankfurt-am-Main 1984, pp.151–3.

4 Christian Zervos, *Cahiers d'art*, vol.3, no.2, 1928, p.93.

5 *The Cardiff Team* 1913, oil on canvas, 326 × 208 cm, Musée d'art moderne de la Ville de Paris.

6 In November 1947, again, Beckmann described his visit to the house of a certain M.K., 'where the various Picassos hanging on the stone walls laughed mockingly at me', Barbara and Erhard Göpel (eds.), *Max Beckmann. Tagebücher, 1940–1950*, Munich and Zurich 1984, p.233.

7 Even so, some of his Parisian paintings – *Rêve de Paris Colette, Eiffel Tower* 1931 (G341), for example – are an explicit nod towards Cubism.

8 Philippe Soupault, *Max Beckmann*, exh. cat., Galerie de la Renaissance, Paris, 1931, cited in Michael V. Schwarz, *Philippe Soupault über Max Beckmann. Beckmann und der Surrealismus*, Freiburg 1996, pp.12, 9 and 10.

9 This preoccupation with mythology is also found in political ideology. In 1932, the Nazi ideologue Alfred Rosenberg published his *Mythos des 20. Jahrhunderts*, clearly stating his intention to replace the values of Roman Catholicism with something else, opposing the 'will', the energy of the mythical Nordic heroes to the passivity, and femininity and depressive chthonic seductions that Christianity supposedly shares with 'Asia'.

10 Carl Einstein, 'Probleme heutiger Malerei', in *Werke, 1929–1940*, vol.3, Vienna and Berlin 1985, p.576.

11 Ibid.

12 Ibid., p.577.

13 They had known each other since 1915, and Einstein devoted a chapter to Beckmann in his *Die Kunst des 20. Jahrhunderts*, Berlin 1926.

14 Hermann Broch, 'James Joyce und die Gegenwart', Vienna 1936, reprinted in Hannah Arendt (ed.), *Création littéraire et connaissance*, trans. Albert Kohn, Paris 1985, p.188.

15 Ibid., p.191.

16 Ibid., p.192.

17 Max Beckmann, 'On My Painting', lecture given at New Burlington Galleries, London, in 1938; reprinted in Barbara Copeland Buenger (ed.), *Max Beckmann: Self-Portrait in Words. Collected Writings and Statements, 1903–1950*, Chicago and London 1997, p.307.

18 Einstein 1926, p.230.

19 Letter of 17 August 1943, in Klaus Gallwitz, Uwe M. Schneede, Stephan von Weise (eds.), *Max Beckmann: Briefe*, vol.3: 1937–1950, (edited by Klaus Gallwitz), Munich and Zurich 1996, p.87.

20 See Clemens Brentano and Achim von Arnim, *Des Knaben Wunderhorn (1806–1808)*, Frankfurt am Main 1994.

21 'What the Speculative Tradition Misunderstood', conclusion to Jean-Marie Schaeffer, *Art of the Modern Age*, trans. Steven Rendall, Princeton N.J., 2000, p.288.

22 Peter Beckmann and Joachim Schaffer (eds.), *Die Bibliothek Max Beckmanns*, Worms 1992.

23 Term used by Carl Einstein in referring to Cubist painting in 'Notes sur le cubisme', *Documents*, no.3, June 1929, p.155.

24 Novalis, *Schriften*, vol.3, 3rd ed., 1983, pp.685–6 (fragment no.671), cited in Schaeffer 2000, Part 2, pp.84–5.

25 Albert Béguin, 'Jean Paul et le rêve' (1931), reprinted in Jean Paul, *Choix de rêves*, Paris 2001, p.52.

26 Carl Einstein, 'André Masson, étude ethnologique', *Documents*, no.2, May 1929, p.102.

27 Georges Bataille, 'Sade', in *Literature and Evil*, trans. Alastair Hamilton, London 1973, p.94.

28 Georges Bataille, 'Lascaux ou la naissance de l'art' in *Oeuvres complètes*, vol.9, Paris 1993, p.81.

29 See Reinhard Spieler, 'Werk-prozess', in *Max Beckmann, Bildwelt und Weltbild in den Triptychen*, Cologne 1998, pp.64–81.

30 *Le Mystère Picasso*, film directed by Henri-Georges Clouzot, 1956.

31 Max Beckmann, 'On My Painting', in Buenger 1997, pp.298–307.

32 Max Beckmann, 'Letters to a Woman Painter', in Buenger 1997, p.314.

33 First, limited edition 1907; published in Munich in 1911 by Piper & Co.; published in English as *Abstraction and Empathy* (1953), trans. Michael Bullock, reissued Chicago 1997.

34 It is symptomatic that in the cause of fidelity to formalism French art history has obliterated the 'expressionist' aspect of these works, which at the beginning of the last century was still perceptible to the objective observer.

35 *Abstraction and Empathy* 1997, p.4.

36 Cited in Dora Vallier (ed.), 'Lire Worringer', in *Wilhelm Worringer, Abstraction et Einfühlung. Contribution à la psychologie du style*, Paris 1978, p.8.

37 Franz Marc, 'Die neue Malerei', *Pan*, 7 March 1912.

38 Max Beckmann, *Pan*, 21 March 1912, reprinted as 'Thoughts on Timely and Untimely Art', in Buenger 1997, p.116.

39 Klaus Gallwitz, Uwe M. Schneede, Stephan von Weise (eds.), *Max Beckmann: Briefe*, vol.1, 1899–1925 (edited by Uwe M. Schneede), Munich 1993, p.164.

40 Dora Vallier, 'Introduction', in Will Grohmann, *Kandinsky, sa vie, son oeuvre*, Paris 1968, p.28.

41 André Breton, 'Le Surréalisme et la peinture', *La Révolution surréaliste*, no.4, 15 July 1925, p.28.

42 André Breton, 'Le Surréalisme et la peinture', *La Révolution surréaliste*, no.6, 1 March 1926, p.30.

43 Carl Einstein, 'Notes sur le cubisme', *Documents*, no.3, June 1929, p.153.

44 Harold Rosenberg, 'The American Action Painters', in *The Tradition of the New* [1959], New York 1994, p.28. Not at all by chance, this reappearance of fusional ecstasy is accompanied by that of myth: 'The result has been the creation of private myth', Rosenberg observes of the new painting.

45 See *Picasso et les choses: Les Natures mortes*, exh. cat., Grand Palais, Paris 1992.

46 'Paranoïa-critique', in *Dictionnaire abrégé du surréalisme*, reprinted in André Breton, *Oeuvres complètes*, vol.2, Paris 1922, p.829.

47 Louis Aragon, 'Preface to a Modern Mythology', in *Paris Peasant* (1926), trans. with introduction by Simon Watson Taylor, London 1971, p.7.

48 Carl Gustav Jung, 'The Relationship between the Ego and the Unconscious', in *Two Essays in Analytical Psychology*, trans. R.F.C. Hull, London 1953, vol.7 of Jung's *Complete Works*, p.144.

49 Ibid., p.176 (Mont Elgon is in Kenya, where Jung travelled in 1926).

50 Max Beckmann, 'The Artist in the State', *Europäische Revue*, 3 July 1927, reprinted in Buenger 1997, p.287.

51 André Breton, 'La Grande Actualité poétique', *Minotaure*, no.6, Winter 1935, p.61.

52 Schaeffer 2000, p.89.

53 Letter to Curt Valentin of 11 February 1938 in *Max Beckmann: Briefe*, vol.3, 1996, p.29, .

54 Novalis, *Writings*, vol.2, 1960, p.562 (Fragment no.185), cited in Schaeffer 2000, p.89.

55 In his diary for 1 July 1944 he notes: 'Read too much Schopenhauer'.

56 The writings of Synesios of Cyrene (fourth to fifth century AD), for example, synthesise ancient speculations on the divinatory nature of dreams.

57 Arthur Schopenhauer, *Esthétique et métaphysique* (three essays from *Parerga and Paralipomena*, 1851) Paris 1999, pp.71, 159.

58 Ibid., p.99.

59 Arthur Schopenhauer, *Le Monde comme volonté et comme représentation*, Paris 1966, p.822.

60 Max Beckmann, 'Letters to a Woman Painter', in Buenger 1997, p.316.

61 Schopenhauer 1999, p.141.

62 One does not see in Beckmann the mysticism, that is to say the transposition into art of theosophical messianism, that one finds in Kandinsky, Mondrian and Kupka at the same time.

63 'As I have already told you, I am not very interested in Mr Beckmann's painting.' Max Ernst, quoted in Stephan Lackner, *Selbstbildnis mit Feder. Ein Tage – und Lesebuch. Erinnerungen*, Berlin 1988, p.104.

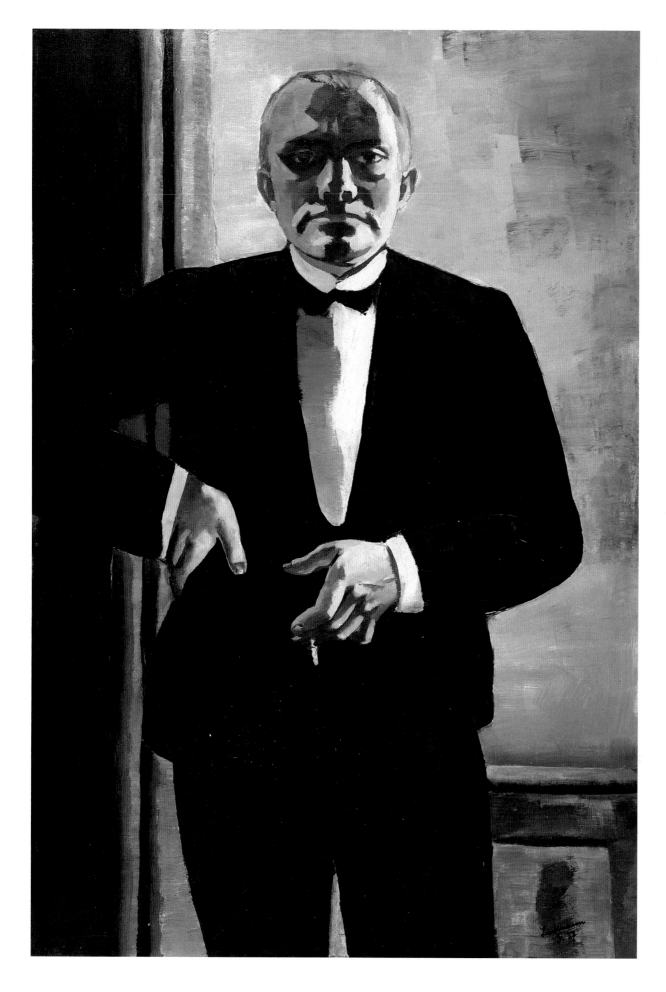

A Gathering Storm: Beckmann and Cultural Politics 1925–38
Sean Rainbird

no.88
Self-Portrait in Tuxedo 1927
141 × 96
(55 ½ × 37 ¾)
Courtesy of the Busch-Reisinger Museum, Harvard University Art Museums, Association Fund

Max Beckmann began his celebrated speech 'On My Painting', delivered on 21 July 1938, with a disclaimer: 'Before I begin to give you an explanation, an explanation which it is nearly impossible to give, I would like to emphasize that I have never been politically active in any way. I have only tried to realize my conception of the world as intensely as possible.'[1] The occasion was the exhibition of *Twentieth Century German Art*, shown in the New Burlington Galleries in London. Beckmann seldom made reference to politics in his private and public texts and when he did so it was usually in passing. But almost exactly a year earlier the *Degenerate Art* exhibition had opened in Munich, finally placing Beckmann beyond the pale in his native country, along with many other contemporary artists. Such a statement in his opening sentence was certain to draw attention to the broader circumstances in which the artist found himself.

One should not be surprised at Beckmann's stance, considering the cultural and political climate that by 1938 not only affected his livelihood but increasingly curtailed his freedom of action. The *Degenerate Art* exhibition marked a decisive intensification of the official position in Germany between 1933 and 1937, during which time Beckmann's status, both socially and commercially, was ambivalent. The artist had maintained social and commercial links with people sympathetic to, or with ties to the state: he was able to continue painting and to sell his work. In the mid-1930s Beckmann was even able, on two occasions, to take part in public exhibitions.[2]

This essay examines the shifts, at times clearly marked and at others more subtly perceptible, in Beckmann's life

and art in a decade of great political and personal change that accompanied the end of the Weimar era and the beginning of the Third Reich.[3]

* * * *

During the early 1920s Beckmann's contacts with German and Austrian aristocracy expanded through his friendships in the circle around Heinrich Simon in Frankfurt. Here he met Lilly von Schnitzler, Käthe von Porada and Irma Simon (born Baroness Schey von Koromea), among others. In 1925 he married for a second time, to Mathilde 'Quappi' von Kaulbach, daughter of the Munich society painter August von Kaulbach. Beckmann was well aware of the possible advantages he might gain from such acquaintances and friendships. His works of the later 1920s and 1930s, depicting resorts in southern France and Holland and fashionable German spa towns such as Baden-Baden, reflected the artist's own entrée into those social circles, and perhaps also the prospect of sales to a clientele who travelled to these same places.[4] Positive changes in Beckmann's life through his second marriage and his appointment to a teaching post at the Städel Art School in Frankfurt ran in parallel with Germany's economic and political progress. The hyperinflation of 1923 had gone, the currency had stabilised.[5] Germany signed the Locarno Treaty with France and Britain in December 1925, recognising the loss of Alsace-Lorraine. This paved the way for Germany to join the League of Nations in September 1926.

In the mid-1920s Beckmann was engaged with ideas about the relationship between the artist and the state, principally through the encouragement of Karl Anton von Rohan. These years were a high-water mark in Beckmann's artistic career and social success, and his confidence is expressed artistically in his sovereign masterpiece, *Self-Portrait in Tuxedo* of 1927 (no.88). Beckmann records meeting Prinz Rohan at Lilly von Schnitzler's house one evening in early June 1925. Soon after he writes to Quappi telling her of the good impression he is reported to have made on Rohan. Opportunistically, he records his sense that Rohan, 'who gets around a lot', might be of use to him.[6]

During this time Prinz Rohan was influential in discussions about cultural renewal and moves to initiate a conservative counter-revolution with a pan-European emphasis. After founding an Austrian committee in 1922 and a French one in Paris the following year, Rohan was involved with the Europäischer Kulturbund (European Cultural Union) in 1923. The Union had several key objectives, among them a reduction in the historic enmity between France and Germany. The social mix of those involved, according to Guido Müller and Vanessa Plichta, brought together 'an unsettled bourgeoisie, literary figures conscious of the orientation towards crisis and aristocrats seeking to make a contribution to society'.[7] Many people closely connected with this tendency were conservative and Catholic; they were admirers of the Holy Roman and Austro-Hungarian Empires, both of which had transcended national frontiers. These historical entities provided a counter-example to the increasing number of nation states formed after the First World War,[8] all founded on the principle of self-determination.[9]

Lilly von Schnitzler was the secretary of the German branch of the Union,[10] and was Rohan's co-sponsor when in 1925 they

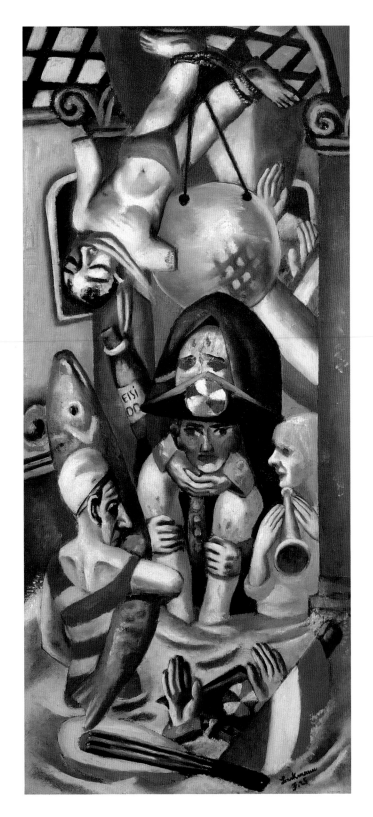

no.89
Galleria Umberto
1925
113 × 50
(44 ¹/₂ × 19 ⁵/₈)
Private collection

established the journal *Europäische Revue*.[11] Its objective was to function as a European forum for the social and intellectual elite to discuss issues, outside the parameters of party politics or religious concerns. The journal was anti-modernist and had a heroic-elitist tone, born of participation in the War by many who contributed. Rohan, a right-winger whose activities later received financial support from the Nazis, attempted in the mid-1920s to create a dialogue between democrats and the Italian Fascists, who by 1926 had consolidated their hold in Italy.[12] One could assume Beckmann had some familiarity with these pro-Fascist views when at the end of 1925 he painted *Galleria Umberto* (no.89), a dream-like picture. *Carabinieri* and priests, agents of the state, are joined by women of different ages, one in a bathing costume, in the famous glazed hall in Naples. Flooded from below, possibly symbolising the rising tide of Italian Fascism, the painting shows as a principal feature a mutilated, suspended figure, frequently interpreted as a premonitory vision of the end of Mussolini's dictatorship.[13] Rohan himself is a central figure in Beckmann's group portrait *Parisian Society* (no.91), begun in 1925 shortly after they first met.[14] Beckmann recast it to largely its present state in 1931 when Rohan acted in support of his Paris exhibition at the Galerie de la Renaissance; he slightly modified it in the late 1940s. After the mid-1920s, however, their paths seldom crossed.

Many significant intellectuals who contributed to the *Europäische Revue* were also associated with the Europäischer Kulturbund and its broad aims of spiritual and intellectual renewal. They included Thomas Mann, Hugo von Hofmannsthal, Paul Valery, Le Corbusier, C.G. Jung, and Ortega y Gasset. Ian King argues that during the Weimar

period the pan-European ideal became a cause for left-of-centre intellectuals rather than active politicians.[15] Annette Kolb, who supported the concept of socialism (rather than supporting the Socialists as a party), was, along with Beckmann, a German representative at the Vienna congress of the League of Cultural Cooperation in October 1926.[16] Beckmann had depicted her with other pacifist and left-wing intellectuals in *Ideologues* 1919 (no.34), one of the prints in his *Hell* portfolio.[17]

Rohan encouraged Beckmann, possibly at the conference, to write something for the *Revue*. Beckmann's first submission, unpublished until the late 1980s, was a biting satire on the role of the artist in the state. As a dystopic vision of artistic submission before a variety of more powerful forces Beckmann must have known it was not the kind of article Rohan would consider publishing. In a letter to Rohan of 1 January 1927 accompanying the text, Beckmann describes its origins as a dream, not unlike Goya's famous aquatint from *Los Caprichos*, *The Sleep of Reason Produces Monsters*. He relates how a shrouded figure appears in a vision and writes ten precepts with X-ray letters.[18] According to Barbara Buenger, Beckmann's satire perhaps reflected his opinion of the conference, which he dismissively described as a 'petty farce' ('kleines Affentheater').[19] His second attempt, 'The Artist in the State', appeared in Rohan's journal in July 1927. It was idiosyncratic enough for the editor to add a disclaimer dissociating himself from the 'extreme metaphysical views' expressed by Beckmann. However, certain ideas appear related to the pan-European agenda propagated by Rohan.

Beckmann wrote of the need for a new cultural centre for the practice of a new faith. This was not unlike the 'grand new dome' ('neue grosse Kuppel') of Rohan's pan-European cultural mission, which was expressed in his book *Europa* published in 1923. Rohan's aspiration for an intellectual elite was perhaps reflected in Beckmann's call for an 'aristocratic bolshevism', a concept of social equalisation achieved through levelling upwards. This formulation closely followed Rohan's own mission to create a cultural elite under the umbrella of a united states of Europe. This, he argued, was the 'only safeguard against mechanisation' that increasingly transcended national borders in the form of transport, technology and international business. Regarding parliamentary democracy as having outlived its usefulness with the First World War, Rohan looked to the support of international businessmen, such as von Schnitzler's husband Georg von Schnitzler, who was Sales Director for I.G. Farben.[20] However, he rejected as unrealistic proposals by another pan-European activist, Count Richard Coudenhove-Kalergi, to construct the political entity of a united states of Europe;[21] he admired instead nationalist movements of radical political renewal such as Fascism in Italy. There is a pictorial equivalent for Beckmann's article, in which he argues the discipline of self-reliance as the key towards artistic autonomy, leading to the ultimate deification of humanity. The picture is *Self-Portrait in Tuxedo*, painted in 1927.

During the ensuing years Beckmann experienced a process of ideological defamation that caused his position among the country's cultural elite first to be threatened, then destroyed. This process can be divided into phases. By the early 1930s Beckmann was breaking through internationally, with important exhibitions and growing sales in Europe and America. The Berlin collection, Germany's most important,

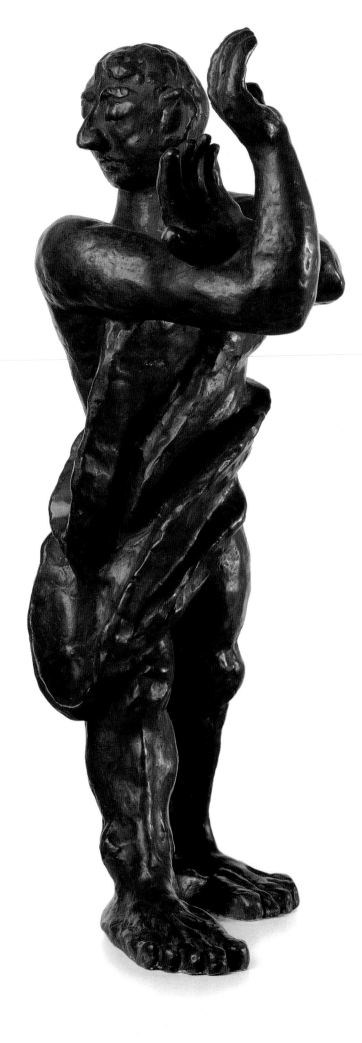

began acquiring his strongest recent works, including in 1927 *The Bark* (no.52), and the *Self-Portrait in Tuxedo* the following year. At home, however, the position of modern artists, his own success notwithstanding, came increasingly under attack. Anticipating, or at least apprehensive about, the consequences, in 1933 Beckmann moved to Berlin, still opposed to political developments yet attempting to salvage something of his prestigious career.

Influential friends and supporters from the cultural and aristocratic circles he had nurtured since the early 1920s enabled Beckmann to avoid blanket isolation: his work could still be seen and collected, if only rarely written about.[22] In 1936 Berlin hosted the Olympic Games, during which Hitler called for international opinion to view Germany in a positive light. Jonathan Petropoulis has suggested that 'the Nazi elite pursued a policy of accommodation and integration with the existing powers through the mid-1930s',[23] and that the Games marked the culmination of this accommodation. An odd glimpse into those veiled years suggests Beckmann and his wife were not entirely isolated socially, nor did the antipathy of the regime cause them to be ostracised completely. Petropoulis records Beckmann's presence (although mistakenly describing him as one of the ruling elite) at a lavish party hosted by the von Ribbentrops on 11 August 1936 during the period of the Olympic Games: 'The Ribbentrops threw numerous parties at their Dahlem villa that encouraged the mixing of these various groups in the new ruling order. One found, for example, a table with Prinz Auwi, Max Beckmann, and Gustaf Gründgen's wife.'[24] In his letters Beckmann occasionally gives his opinions on the behaviour of other cultural figures. These, more than his

no.90
Man in the Dark
1934
Bronze
58 x 40 x 40
(22 7/8 x 15 3/4 x 15 3/4)
Sprengel Museum
Hannover

presence at a banquet, probably give a better insight into his well-founded unease about unfolding events. In a letter to Quappi of April 1936, he makes a slightly dismissive mention of the conductor Wilhelm Furtwängler: 'for too long he's been kicking around my life, alas tiresome world, trembling with rapture like at the Simons fifteen years ago.'[25] Stephan von Wiese relates this to Furtwängler's behaviour following his performance in November 1934 of Paul Hindemith's prohibited opera *Mathis der Maler*. After making a public apology he was allowed to resume his directorship of the Berlin Philharmonic. Equally, he was henceforth artistically and morally compromised.[26]

During the Nazi party congress of autumn 1936 shortly after the Olympics had ended, Hitler's speech on culture promoted the subject from the the level of specialist discussion to national prominence.[27] The speech, combined with the Minister for Propaganda's prohibition of art criticism two months later in November 1936,[28] marked a decisive shift towards cultural repression. Until then the work of artists such as Beckmann, who, despite being out of favour, had powerful support and strong reputations, could still be seen on public display from time to time. Three paintings, a still life and two landscapes, were still on display in Berlin's Kronprinzen-Palais during 1936.[29] They were removed in 1937. The position of several people connected with Beckmann, particularly dealers who later collaborated with governmental agencies while continuing to support Beckmann, became unavoidably polarised. Between the autumn of 1936 and the summer of 1937 there were increasingly systematic confiscations from German public collections, leading to

no.91
Parisian Society
1925, 1931, 1947
110 × 176
(43 1/4 × 69 1/4)
Guggenheim
Museum, New York

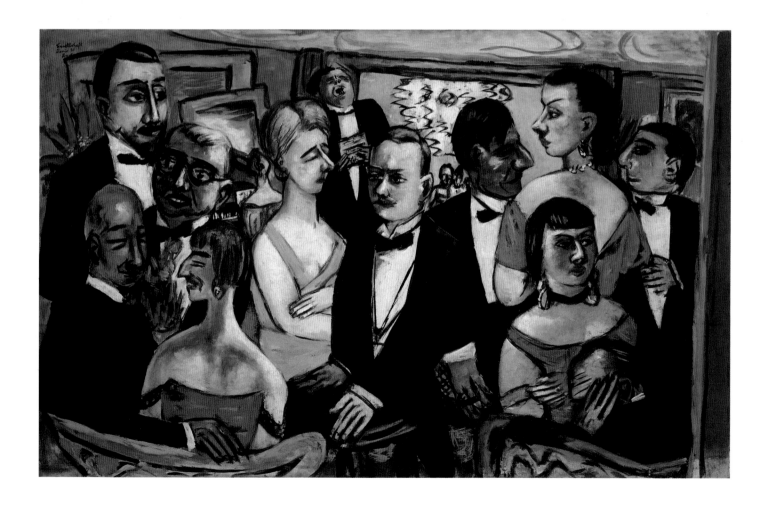

the *Degenerate Art* exhibition in July 1937, versions of which toured various cities in Germany until 1939. By the autumn of 1937 thousands of works were collected in a Berlin respository.[30] These confiscated works, when not destroyed, were regarded as a way of earning foreign currency.[31] Some of the dealers who became involved in the evaluation committees set up by Goebbels in May 1938[32] were supporters of Beckmann. The ambivalence of their role is symptomatic of the changes in behaviour required by external circumstances, as much as the expression of, or shifts in, individual loyalties. While some of the dealers profited through the State disposals of publicly acquired artworks, others were conscious of rescuing what they could, and redistributing these reclaimed works to more sympathetic owners overseas.

The art historian Hildebrand Gurlitt's activities reflect this pattern of ambiguity. In the late 1930s and early 1940s he sustained his business by acquiring works for the Linz Project, the proposed Führermuseum in Austria.[33] Yet a decade earlier the picture had looked very different. In April 1930 Gurlitt had been forced by orchestrated criticism from the Nazi *Kampfbund für deutsche Kultur* to leave his position as director of the museum in Zwickau.[34] Gurlitt's sympathies for a wide range of modern artists, from the socialist Käthe Kollwitz to the socially critical Otto Dix and George Grosz, and for Expressionists such as Emil Nolde and Karl Schmidt-Rottluff, included support for Beckmann. In 1933 he organised a Beckmann exhibition for the Hamburg Kunstverein. The second showing of the exhibition, in Erfurt, was cancelled shortly before the opening, demonstrating the political sensitivity of the show's timing. The pictures were moved to the stores in the basement where Beckmann sought permission from the authorities for his friend and patron Stephan Lackner to view them.[35] Gurlitt, however, continued quietly to support Beckmann: in October 1936 he showed a private exhibition of his paintings and watercolours.[36]

Gurlitt was not the only art historian with whom Beckmann worked who later had unavoidable connections with the Government through dealing in 'degenerate' art. When Curt Valentin, who in the early 1930s had taken over the activities of Alfred Flechtheim, emigrated to New York in January 1937, he left his Berlin business in the hands of Karl Buchholz. Using initial capital provided by Buchholz, Valentin set up a gallery in New York that bore both their names, and in early 1938 he mounted his first exhibition of Beckmann's work. The American sales achieved then (and in future) gave significant financial support to the artist during the war.[37] At almost exactly the same time, though, Buchholz became one of those dealers who, like Gurlitt, were involved with the *Verwertungskommission* set up by Goebbels in May 1938 to deal with confiscated art from public collections. Clearly the evaluation of another person's integrity was vital in establishing and maintaining relationships during such politically polarised times. Beckmann's view of Buchholz is given in a letter of 11 May 1937 to Valentin: 'I see Buchholz now and again and have the feeling that, with time, we will become good friends'.[38] For his part, Buchholz found the artist 'a grand and imposing personality'[39] and continued to buy his work. So did the dealer Günther Franke, whose commercial relationship with Beckmann as the dealer I.B. Neumann's European representative had formally ended in 1932 following Neumann's bankruptcy in New York. Although Franke's

gallery was located at the heart of the Munich district that housed National Socialist official and ceremonial buildings, he continued during the mid-1930s to show Beckmann and other defamed modern artists more or less openly.[40] A recommendation from the right source was sufficient to gain access to the back room in Franke's gallery, where he exhibited his stock of modernist artists throughout the 1930s and 1940s. Such was the experience of the young Samuel Beckett when he visited Franke in March 1937 and saw pictures by Beckmann and other defamed artists.[41]

While dissociating himself from any personal involvement in political activities, the politics surrounding Beckmann's position by the time of his London speech in July 1938 were quite clear to him and to many in his audience.[42] Beckmann's art, since 1933 largely removed from public display in most German museums, was now pilloried by the state as un-German and degenerate. In response to the 1937 *Degenerate Art* exhibition Beckmann, who was living in Berlin, immediately left Germany for Amsterdam. There his sister-in-law Hedda helped the artist and his wife Quappi find a place to live and work, which remained their home and Beckmann's studio throughout the 1939–45 war and the German occupation of Holland.[43]

His first triptych, *Departure* 1932, 1933–5 (no.60), has been understood as an allegory of the artist's exile in Holland and of his later move to America.[44] But the completion of the triptych precedes the beginning of Beckmann's period of Dutch exile by several years. It is also interpreted as a grand artistic statement about Beckmann's tactical withdrawal from Frankfurt in 1933, where he began the triptych, to Berlin. ⟫→[171]

Heinrich George's Wallenstein in Red
Barbara Copeland Buenger

Heinrich George (1893–1946) was warmly and widely admired for his performances of the classics (his favourite role was Goethe's Götz von Berlichingen), but was also closely identified with the contemporary stage of the Expressionists, Max Reinhardt, Erwin Piscator, and Bertolt Brecht. He gained further renown for his major roles in such celebrated films as *Metropolis* (1927) and *Berlin Alexanderplatz* (1931). Cast as an earnest and attentive leader, or a proletarian, a sailor, Falstaff, Götz, Luther, Napoleon, or Zola, George was prized for his earthy, human and even bestial qualities. Short, agile, quick, and high-voiced, imposing in his large girth and gargantuan in his tastes for parties and drink (see fig.22), he was celebrated as giant and gnome alike.

Max Beckmann's *Family Portrait of*

Heinrich George (no.92)[1] commemorates George's only career performance as the eponymous hero of Friedrich von Schiller's *Wallenstein: A Dramatic Poem* (1796–9). In his trilogy Schiller, seeking to admonish his own contemporaries, had compressed the events of the Thirty Years' War into a few days in order to stress fury, corruption, disillusionment, and betrayal as the resourceful generalissimo Wallenstein (1583–1634) opposed an emperor he had formerly always supported. Powerful, rebellious, and wrong-headed, Wallenstein grew partly hesitant, partly mad as he betrayed even those who had honoured him.

The painting's many elements of menace evoke not only *Wallenstein* but also real contemporary threats. The red spectrum,

fig.21
Heinrich and Jan George on the steps of their Wannsee home with their dog, Fellow II c.1937
Courtesy of Jan George

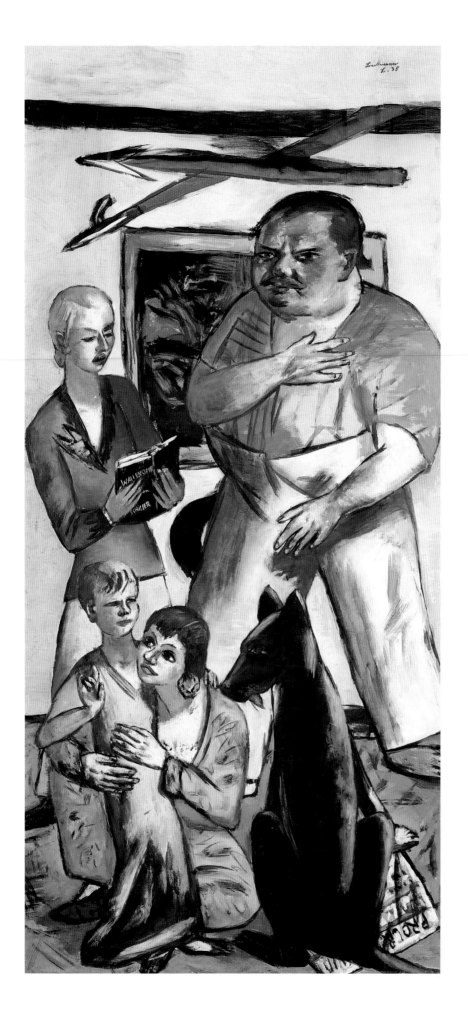

no.92
*Family Portrait of
Heinrich George*
1935
215 × 100
(84 5/8 × 39 3/8)
Staatliche Museen
zu Berlin,
Nationalgalerie

directly inspired by George's vermillion
Wallenstein costume, is predominant, from
the thinly applied rose of George's shirt to the
fire-red that Beckmann chose for the frame
(not illustrated here).[2] The room's dusky
pink space is oddly truncated by two spears
or harpoons, attached to the wall beneath
a black cornice under a greyish-white ceiling.
The spears might refer to George's own
collection of weapons, but also underline
the belligerency of both *Wallenstein* and the
cultural politics of the day. *Wallenstein* took
on a new resonance during and after the
First World War; the play inevitably evoked
reflection on contemporary events, especially
when the staging was tweaked to celebrate
the new German order.[3]

The Theater des Volkes premiered the

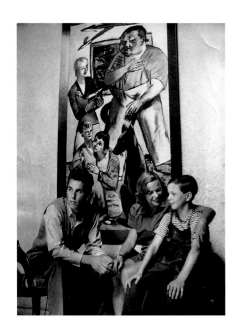

fig.22
Goetz and Jan George
with their mother
Berta, in front of the
painting by Beckmann
c.1950
Courtesy of Jan
George

entire trilogy on 11 November 1934,[4] with full orchestra and dramatic staging geared to the mass audiences accommodated by Berlin's huge Großes Schauspielhaus, a theatre made famous by Max Reinhardt, now in exile. Propaganda Minister Joseph Goebbels had secured the theatre's direction and encouraged Weimar's best Aryan actors and directors to promote National Socialist culture on a vast popular scale.[5]

George gave a staggering performance, but Beckmann's painting transports him far from the theatre to a morning rehearsal at home, where George apparently learned the demanding role in less than a week.[6] Barefoot in white trousers, hands over heart and groin, George is much larger than the other subjects, his height exaggerated by his grouping with the family's Great Dane, Fellow II, and a darkly curving, oval-backed chair. His girth is enhanced by the yellow-framed picture behind. Her body narrower than one of George's thighs, the actor Charlotte Habecker prompts from the text. In front of her is George's wife Berta Drews (1901–1987), also an actor, wearing a patterned robe,[7] and their son, the young Jan Albert Goetz George (b. 1931). Although Jan wears a girlish pink nightgown, he mimics his father's severity, raising his hand in a horn gesture to banish the huge but friendly dog.[8]

The artwork in the background depicts the head of a soldier wearing an orange hat. His face nudges up against George's right arm. The painting depicted here does not correspond to any work by Beckmann,[9] nor to any work in George's collection. Though generalised

and less prominent than the other figures, this face acts as an engaging, even nagging conscience or double, and introduces further reflection. Did Beckmann use it to evoke either the play's other characters who reproached Wallenstein, or Wallenstein's own troubled conscience; or even George in another role, perhaps as Götz von Berlichingen with the iron right hand? Might the figure also suggest George or Beckmann's own conscience?

Beckmann and George had been acquintances since Frankfurt in the 1920s; George had proposed performing in Beckmann's own play, *Ebbi*, which he had completed in the mid-1920s.[10] Now, ten years later, they met again after the opening night of *Wallenstein* and Beckmann visited the family at home at least once as he painted the portrait from memory in his studio in 1935. Berta Drews later said she and George were surprised, even embarrassed, to hear that Beckmann – who repeatedly worked without commission – was painting their portrait.[11] Were they put out because they felt obligated to purchase the painting (they already owned some Beckmann prints),[12] especially since George had just offered renewed support to Otto Dix, whom he had commissioned to paint his portrait in 1932?[13]

Beckmann had long been artistically associated with Dix, whose *Portrait of the Actor Heinrich George* (fig.24)[14] hung in the George home[15] and was unquestionably a point of departure for Beckmann. Dix depicted George with a highly expressive face, reddened flesh, and glaring eyes – an agitated, combustible modern. He had planned to

render George as Götz, but after he saw George on the set of the film *Das Meer ruft*, a First World War sea story, he decided to depict him in his role as the rugged seaman Terje Wiggen. Dix's stylised realism, sombre palette of tempera on wood, and the inscription of George's name and age in Latin (Aetatis GEORGE suae 39) recall Renaissance representations of illustrious citizens and leaders, almost as if he deliberately fashioned his George/Terje as a modern counterpart to Götz. Beckmann's grandiose, detached George might also have had an older artistic model in one of Berlin's grandest Baroque masterpieces, an almost equal-sized painting assumed to portray a hefty Tuscan general slightly Wallenstein's junior (fig.23).[16]

When Beckmann painted this portrait his professional future was far from clear. Virulent National Socialist critics in Frankfurt and Munich had attacked his art since the late 1920s, and he had moved to Berlin even before his dismissal from his Frankfurt teaching position in April 1933. His lifelong dream of broad representation in a room of Berlin's National Gallery had been realised in 1933 when ten of his works went on display in its new Kronprinzen-Palais section. The museum remained open until 1937, but almost immediately after it was opened the Beckmann room had to be rehung with less challenging landscapes and still lifes.

Unlike George, Dix, or Ludwig Mies van der Rohe, Beckmann does not seem to have joined an official artist organisation. He appears to have hoped that the low profile he kept in Berlin would permit him to work undisturbed.

By the time he met and painted George, the pre-1933 art scene had all but closed down, not least because of the persecution and exile of its Jewish members. At the same time, those who could join the official organisations had already found their financial circumstances improved. No one was sure if Hitler would stay in power, but influential friends who supported the regime assured Beckmann that he and other moderns would ultimately be accepted. Considering exile, but reluctant to leave, Beckmann apparently told George he felt ignored in Nazi Germany.[17] George, who had hated a 1931 Hollywood sojourn, felt he could live and act only in Germany.

George shared National Socialist criticisms of the modernist theatre in which he had gained fame, and argued that theatre could meet real human needs only by returning to the classics.[18] From 1933 on, he continued to perform the classics as he added new roles in National Socialist productions. In 1933 both Hitler and Goebbels warmly greeted his performances in Schiller's *Wilhelm Tell* and in the propaganda film *Hitlerjugend Quex*. In 1934 George joined the Theater des Volkes at its inception.

Beckmann deftly characterised individuals as he reflected on their and his own social, cultural, and political circumstances. Simultaneously with the George portrait, for instance, he completed a commissioned portrait of Rudolf Binding, a writer familiar to Beckmann from conservative Frankfurt circles. Newly lauded at his sixty-fifth birthday, Binding had given an enthusiastic welcome to the Third Reich.[19] Beckmann

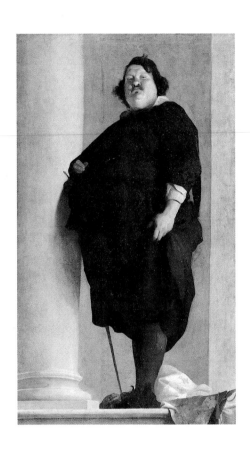

fig.23
Charles Mellin
Portrait of a Man
c.1630
Oil on canvas
203 × 121
(80 × 47 5/8)
Gemäldegalerie,
Staatliche Museen
zu Berlin

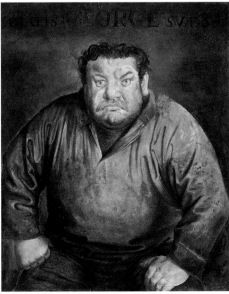

fig.24
Otto Dix
Portrait of the Actor Heinrich George 1932
Mixed media on wood
100 × 83.5
(39 3/8 × 32 7/8)
Galerie der Stadt Stuttgart

began a portrait of Mies van der Rohe after both chose exile,[20] and his 1937 *Self-Portrait in Tails* (no.93) was partly inspired by his attendance at a party at Joachim von Ribbentrop's Berlin home on 11 August 1936, just before Hitler appointed Ribbentrop Foreign Ambassador to Britain.[21] Scarcely a week after von Ribbentrop's party, Beckmann probably moved closer to a decision for exile when he travelled to London to visit Heinrich Simon, the exiled Jewish former editor and owner of the *Frankfurter Zeitung*.[22] A member of many of the same Frankfurt conservative circles in the 1920s, Simon had long been one of Beckmann's most supportive advisors, and apprised him of current events in his weekly Friday luncheons with leading contemporaries. After three years' exile in France, Palestine, and England, Simon undoubtedly had a much dimmer view of Germany than those friends who encouraged Beckmann to stay.

Family Portrait of Heinrich George is neither a simple celebration of a dramatic performance and the family life that sustained George, nor a painting that condemned him for his affiliations with the new regime. Beckmann remained absorbed by the full complexity of George's personality, position, and roles. As George rehearsed the powers, weaknesses, darkness, and humanity of Wallenstein in 1934, Beckmann recognised and framed something of his own predicament.

Notes

1 See Karl Arndt, 'Familie im Werk Max Beckmanns', in Theodore Wolpers (ed.), *Familienbindung als Schicksal*, Göttingen 1996,pp.286–342; Donat de Chapeaurouge, 'Bilder von Max Beckmann, die bisher noch nicht auf zeitgenössische Ereignisse bezogen sind', *Wallraf-Richartz-Jahrbuch*, 1992, no.53, pp.209–19; Berta Drews, *Heinrich George*, Hamburg 1959; Berta Drews, *Wohin des Wegs. Erinnerungen*, Frankfurt 1988; Kurt Fricke, *Spiel am Abgrund. Heinrich George. Eine politische Biographie*, Halle 2000; Jan George and Heike Nasseri-George (1 May 2002, interview with author); Erhard and Barbara Göpel, *Max Beckmann. Katalog der Gemälde*, vol.1, Bern 1976, pp.278–9; Peter Laregh, *Heinrich George. Komödiant seiner Zeit*, Munich 1992; Bernd Lubowski, 'Ich bin ein rundum zufriedener Mensch', *Berliner Morgenpost*, 30 May 1976. Many of these contain discrepancies and omissions.

2 Illustrated in Laregh 1992, fig.78.

3 George supposedly provoked Weimar governmental consternation when he daubed a swastika on the hat of Buttler, Wallenstien's murderer in a 1931 performance attended by Hitler: Fricke, *Spiel*, pp.39–40.

4 The previous day, 10 November, was the 175th anniversary of Schiller's birth.

5 Yvonne Shafer, 'Nazi Berlin and the Großes Schauspielhaus', in Glen W. Gadberry (ed.), *Theater in the Third Reich: The Prewar Years*, Westport, Connecticut 1995, pp.103–19.

6 George had previously performed in *Wallenstein* only once, as Wallenstein's murderer, Buttler.

7 Drew's robe, which Beckmann abstractly transformed into orange, yellow, and blue, was actually a dark blue.

8 Jan George repeatedly used this gesture as a child.

9 The figure differs greatly from initially suggestive sources in *Königin-Bar* 1935 (G417, then in Beckmann's studio) and *The Peruvian Soldier Wants to Drink* 1929 (G301).

10 Klaus Gallwitz, Uwe M. Schneede, Stephan von Weise (eds.), *Max Beckmann: Briefe*, vol.2: 1925–1937 (edited by Stehan von Wiese), Munich and Zurich, 1994, p.29 (11 January 1926), and Barbara

Copeland Buenger, *Max Beckmann: Self-Portrait in Words*, Chicago 1997, pp.190–225.

11 *Berliner Morgenpost*, 30 May 1976.

12 Hellmut Kotschenreuther, in the *Berliner Morgenpost* in 1964, said George paid a good price for the work. See Laregh 1992, p.251.

13 Karl Nierendorf arranged George's commission (Florian Karsh, 7 May 2002 interview with author). Fricke 2000, p.74 notes George's December 1934 offer to Dix.

14 *Otto Dix 1891–1969*, exh. cat., Tate Gallery, London 1992, pp.184, 195–6; Olaf Peters, *Neue Sachlichkeit und National-Sozialismus*, Berlin 1998, pp.71–98.

15 Drews 1959, pp.93–4.

16 Sylvan Laveissière, 'Le "Maitre du Pseudo-Borro": Charles Mellin?', *Jahrbuch der Berliner Museen*, N.S., no.32, 1990, pp.191–201.

17 Laregh 1992, p.200. The literature's record of their discussions of exile is inconsistent.

18 Fricke 2000, pp.41–2.

19 *Pace* Göpel 1976, vol.1, p.283 (G425, 1935); the letters 'All..' on the book represented refer to Binding's 1934 publication *An alle Deutschen*.

20 *Cf.* Barbara Copeland Buenger, 'Max Beckmann', in *Exiles and Emigrés*, exh cat., Los Angeles County Museum 1997, pp.58–67; Franz Schulze, *Mies Van der Rohe: A Critical Biography*, Chicago and London 1985, p.176, fig.118.

21 Correspondence of Waltraut van der Rohe and Mathilde Beckmann (24 August–25 September 1956), Art Institute of Chicago, and Jonathan Petropoulos, *Art as Politics in the Third Reich*, Chapel Hill and London 1996, pp.294–9.

22 *Max Beckmann: Briefe*, vol.2, 1994, pp.263–6, 19 August 1936.

no.93
Self-Portrait in Tails
1937
192.5 × 89
(75 ¾ × 35)
The Art Institute of
Chicago, Gift of
Lotta Hess
Ackerman and
Philip E. Ringer

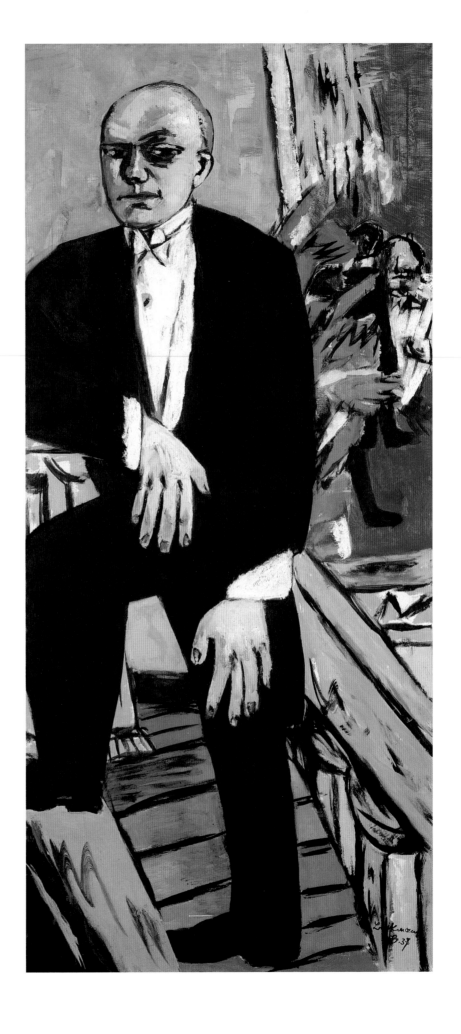

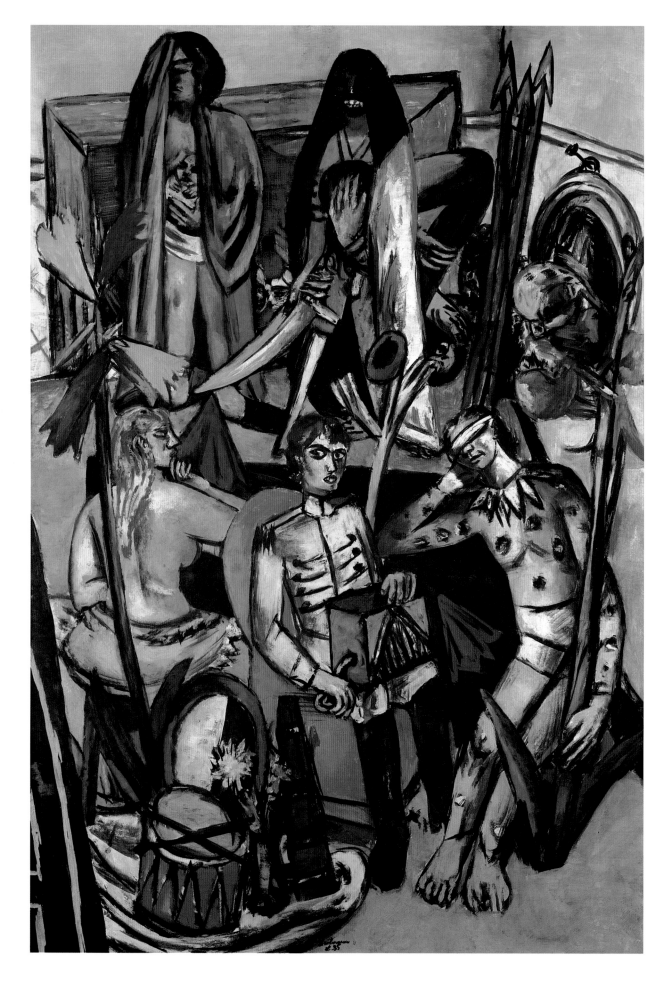

no.94
The Organ-Grinder
1935
150 × 120.5
(59 × 47 ¹/₂)
Museum Ludwig,
Cologne

Such interpretations build upon one aspect of the work, the timeless space of myth, at the risk of obscuring another, its historical immediacy. Günther Franke identified both themes in the triptych when he described its effect on the viewer as 'in terms of time, both topical and remote'.[45] There can be little doubt that the artist also anticipated that a political dimension to the triptych would be acknowledged.

With his public profile increasingly circumscribed after 1933, Beckmann's caution increased. Trimming sails to the new realities, together with a careful probing of people with whom he came into contact, became a common procedure for Beckmann and other artists in a similar position. This may be regarded as the beginning of the long process by which internal retreat eventually led to actual exile. Lilly von Schnitzler, who was introduced to Beckmann by the art historian Wilhelm Hausenstein around 1922 and acquired her first landscape as a result of that first meeting, carried on acquiring Beckmann's work throughout the 1930s and 1940s. Remembering her friendship with the artist after his death she recalled her first viewing of the *Departure* triptych in Beckmann's Berlin studio in early 1937:

On the easel was what for me was a completely overwhelming picture, the paint still wet. I cried 'I must have that painting whatever it costs'. Beckmann rather circumspectly and ironically, then fetched two side panels, narrow vertical formats. The colours in these side panels possessed an inimical quality, a *delicatesse de peinture*, which characterise Beckmann's paintings of the later Frankfurt period, and of works he made in Berlin and Amsterdam. But the composition had the pitilessness, the

dread of the pictures he made in 1918 immediately after the War. I could not resolve to have around me every day these powerful, apparently violent counterparts to the at once heroic and harmonious middle panel.[46]

From this single instance, it would be easy to overstate Beckmann's caution in his decision to show initially only the middle, 'harmonious' panel, even though the side panels were also completed. For the artist, there was a possible anxiety about the artistic success of the first three-panel painting he had made. The scale of the painting, in addition to the brutalities depicted on its outer panels, might have persuaded von Schnitzler that a domestic setting was inappropriate. Her husband Georg von Schnitzler was a senior manager at I.G. Farben, a company with increasingly close ties to the Government. His collector spouse, with Beckmann pictures on display at their home, might have wished to exercise some discretion in order to avoid offending some of the party elite among their visitors.

The art historian Erhard Göpel, later co-author of a *catalogue raisonné* of the artist's paintings, had a similar experience when Beckmann first showed him the central panel of *Departure* in his Berlin studio. Göpel continued to offer covert support to Beckmann throughout the war, even while closely connected to the cultural politics of the German government through his position as art historian advising on the purchase of artworks in Holland for the 'Führermuseum' in Linz.[47] As with Lilly von Schnitzler, Beckmann showed Göpel only the middle panel; unlike von Schnitzler the artist did not then show him the outer panels. In a eulogy delivered in January 1951 at the Städel in Frankfurt three weeks after the

artist's death, 'In Memoriam Max Beckmann', Göpel referred to their conversations of the time about the political situation.[48] Beckmann's reticence to show the triptych as a complete work, not once but twice, appears to indicate that he was well aware of the political message that could be inferred from the side panels of *Departure* and the impact such interpretations could have on his safety.

It is a measure, too, of the uncertainty of the times that Beckmann's caution, if indeed that is what it was, extended even to close allies such as von Schnitzler and Göpel. Göpel was, after all, the only person to publish an article commemorating the artist's fiftieth birthday, in the *Neue Leipziger Zeitung* on 17 February 1934. Göpel felt able to argue about Beckmann's artistic merit, while also seeing him as an artist in tune with his times. He made no attempt to present Beckmann in a way that could make him ideologically acceptable to the new regime but cited, above all, Beckmann's inner motivation, his 'passion for painting'.[49] However, Göpel's title, 'Der Weg eines deutschen Künstlers' (The Path of a German Artist), could be understood as something of a provocation at a moment when national characteristics were being subordinated to an extreme nationalist ideology and reasoned debate had given way to polemics and a first wave of politically motivated exhibitions. These were mounted by the National Socialists in 1933 in the immediate aftermath of electoral victory. Some showed Beckmann's works and had such titles as *Kulturbolschewismus* (Cultural Bolshevism; in Mannheim) and *Novembergeist im Dienste der Zersetzung* (The Spirit of November in the Service of Decay; in Stuttgart).[50] Although almost certainly aware of Beckmann's current position, Göpel placed Beckmann's early works in the specifically German tradition of Leibl but also acknowledged the technical debt Beckmann's early impressionist style owed to the 'Men around Liebermann'.[51] Liebermann was, by 1934, in his late eighties, a German Jewish artist and the President of the Prussian Academy since 1920. He was forced by the National Socialists to resign his official positions in 1933.

Göpel also addressed the issue of Beckmann's connection to his times. Beckmann's response to his times reflected, he believed, the artist's immersion in the ambiguities and tensions of the preceding, imperfect years: 'The nature of the questionable period of peace and the ambivalence of the War is deeply etched in Beckmann's pictures. Not because he was ahead of his time, rather because he was so completely part of them. His paintings were created in their moment, for the future.'[52] Göpel concluded by repeating his earlier comment about Beckmann's inner passion as the key driving force of his art and citing its continued relevance: 'for what happens today is given shape for the future because the artist follows passionately all topical events and the present moment as it unfolds.'[53] While asserting Beckmann's power as an artist, Göpel acknowledged his rootedness in his times, particularly in the politically controversial post-1918 period of his mature work. He praised Beckmann's ability to create an artistic vision for his times; by implication this was regardless of the prevailing political ideology. Beckmann's public isolation was growing, with few supporters inside Germany having the courage to state their views, or the means of honouring his achievements through public institutions.

Because of the shifting sands in the unfolding of cultural politics in the early to mid-1930s and their impact on individual artists, there remains a degree of ambiguity about

some of the events of that period. One example is Beckmann's dismissal from the Städel Art School in April 1933, an event that led the Beckmanns to leave Frankfurt for the relative anonymity in the much larger city of Berlin, where Beckmann had made his prewar reputation. Although clearly political in origin, the pretext given for the termination of his post at the School was the need to make cost savings.[54] Seven other staff were released at the same time.[55] Lilly von Schnitzler, however, relates that a difference of opinion with the rector, Professor Wichert, might have contributed to Beckmann's departure. Since the artist had been spending long periods in the preceding years in Paris, his extended absence from Frankfurt might also have become a bone of contention. In his draft contract of January 1930 extending his teaching post for a further five years to September 1935, Beckmann had committed himself to keeping his centre of activities in the city, which his extended visits to Paris jeopardised.[56]

Another event occurred, however, that would have underlined to Beckmann not merely the changing political realities that left him isolated, but the actual physical threat to his paintings that could follow. In 1930 Beckmann completed a commissioned painting for the newly opened Friedrich-Ebert school on the outskirts of Frankfurt.[57] His still life showed musical instruments and a globe, fitting subjects for a pedagogic institution. The painting, documented in photographs, was hung in the entrance hall over a doorway. In October or November 1933 the caretaker was ordered by the new rector, a party member, to remove and cut up the painting. Reluctant to do so, the caretaker contacted the municipal Building Surveyor's Office, which agreed to remove the painting and deliver it to the Städel Art School. Wichert

himself had by then been dismissed from his directorship of the Städel. The work was accepted by his successor, Richard Lisker, but was never seen again.[58]

Thus by late 1933 Beckmann had lost his post in Frankfurt and seen one work vindictively expropriated.[59] His achievements outside the city were also coming under pressure. A room of ten paintings, installed at the Kronprinzen-Palais, Berlin, as recently as 1932, which included loans from the artist and paintings sold at favourable prices, was removed in the summer of 1933. The new director, Eberhard Hanfstaengl, courageously attempted to maintain the continued presence of leading artists such as Beckmann, Nolde, Klee and Kandinsky in his galleries while under pressure from the National Socialists' increasingly intolerant opposition to modern artists. As a compromise Hanfstaengl exchanged *The Bark* 1926 (no.52) for two smaller works, *Ox Stall* 1933 (G375) and *Still Life with Crystal Ball and Ears of Corn* 1934 (G405). Aside from the less ostentatious, modest scale of these replacements, the oxen in their cowshed, earthy and predominantly brown in colour, could be interpreted as symbolising love of the land. The still life belonged to the least contentious of traditional artistic genres, the genre which was least represented in the later *Degenerate Art* exhibitions. But however ostensibly harmless the subject of these paintings, neither escaped eventual confiscation from the collection in the late 1930s.

These misfortunes resulted from changes in external circumstances that Beckmann appeared fully to appreciate. They occurred, moreover, during a period in which his art was finally breaking through internationally. Since the late 1920s Beckmann had experienced considerable commercial and

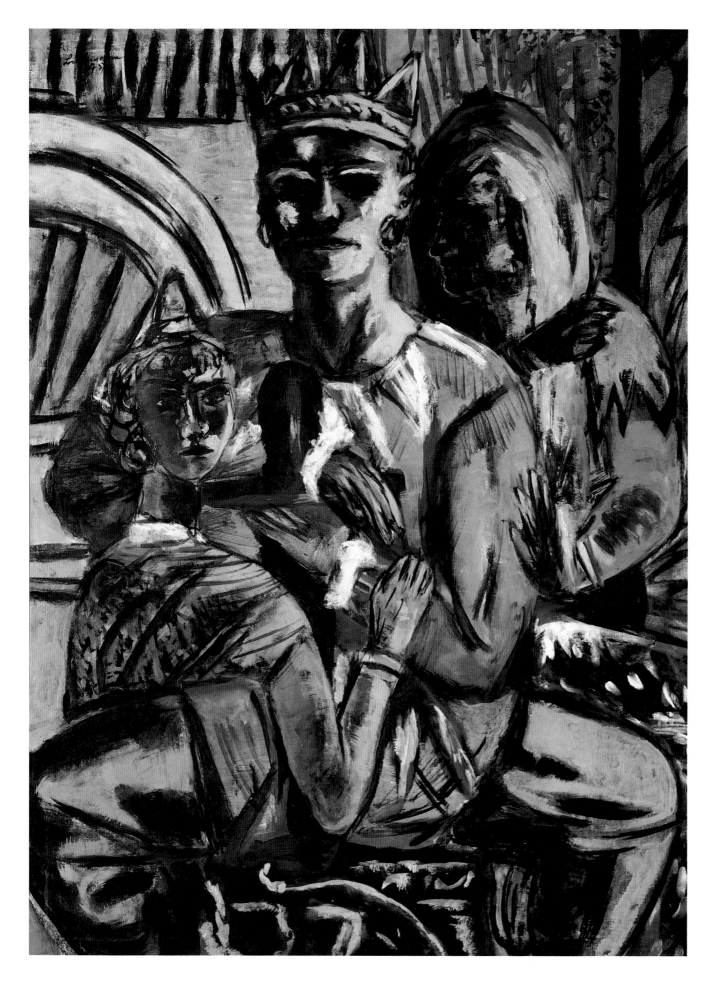

174

critical success. *The Loge* 1928 (G287) received an honourable mention in 1929 from the Carnegie Institute in Pittsburgh. His dealers' attempts to build recognition for Beckmann's work abroad, particularly in the United States, was making progress by the late 1920s in the form of sales to collectors.[60] Beckmann was represented at the 1930 Venice Biennale with six paintings.[61] His first major international exhibition was held in August 1930 in Basel[62] and toured to Zurich.[63] Beckmann's pictorial skills and international profile were recognised in the reviews.[64] Well aware of the importance of this international exposure, Beckmann noted to one of his most loyal patrons, Rudolf von Simolin, whom he met in Zurich in mid-September, that the year-end would see a 'big Beckmann orgy' in Paris.[65] This exhibition duly took place at the Galerie de la Renaissance but a little later than Beckmann anticipated, in March–April 1931. Beckmann, as always in his exchanges with his dealers, was anxious to secure maximum advantage, ordering Günther Franke to pay Waldemar George his essay fee promptly to keep him 'on side'.[66] A month later, anxious to exploit and publicise the sale of his first work to a French public institution, he wrote again to Franke, 'with immediate effect you must ensure that all German newspapers receive a photograph of the "Wood-cutters" with the caption "acquired by the French State"'.[67] Beckmann's long campaign for dealer activity that had begun in the mid-1920s and was leading to recognition in the French capital, was at last bearing fruit.[68]

If the accession to power of the Nazis in January 1933 had a negative impact on Beckmann's professional prospects, by the early 1930s he was already under no illusions about the direction politics were taking in Germany. In a letter to Quappi on 15 September 1930, just after a general election,

he reflects (literally, as he writes at her dressing table looking at himself in the mirror): 'outside people now know what Germany's fate will be'.[69] A sense of disquiet about current political developments and their impact on his life and work can be observed perhaps most directly throughout this period in Beckmann's landscapes. *Winter Landscape* 1930 (G333), although signed with an 'F' denoting it as a Frankfurt painting, was probably begun in Paris at the end of that year, shortly after the election results Beckmann refers to in his September letter. The view through a window, with or without the presence of figures, is familiar as a pictorial device from the Renaissance to Romanticism, and more recently in the modern variants by Manet, Matisse and even in the ironic reversal of Marcel Duchamp's opaque *Fresh Widow* of 1920. Beckmann adapts the formula to his own requirements. The scene, viewed through partially open windows, is of snow-clad facades interrupted by tall, though severely lopped trees. The trees appear oversized in comparison with the scale of the houses that surround them on all sides; they rise up in front of the open window to form a physical barrier to the blue sky beyond.

The edges of his canvas coincide with the frame of the window to give a precise identification of window and view. This symmetry excludes interior space from the picture, lessening the effect of the window as a passage from inside to outside and heightening the starkness of the wintery scene. The trees rendered in black-and-white suggest, moreover, a polarisation, while their abrupt truncation denotes amputated growth and the loss of potential for regeneration. This could be understood as a metaphor for a withering of optimism.[70] The view through the window is partially

no.95
The King 1933,
1937
135.5 × 100.5
(53 3/8 × 39 5/8)
The Saint Louis Art
Museum. Bequest
of Morton D. May

obscured by opaque glazing in the left-hand window panes. According to Göpel, this was a later modification to the picture and perhaps relates to how the artist came to view more pessimistically the changes to his and his country's prospects.[71] The right-hand panes, though, are transparent. This contrast alone, between a clear and an obliterated view, suggests uncertainty; one side a direct vision of bleak extremes in present reality, the other denying an outlook of any kind.[72]

Ortrud Westheider suggests that for Beckmann, unlike other painters such as Otto Dix, landscape did not represent a retreat into a non-political imagery.[73] Beckmann's deteriorating position in Germany during the early 1930s is expressed in landscapes of the period. Their symbolism is both direct and coded. This is the case with those made in

Bavaria between 1932 and 1934 where the Beckmanns spent several holidays at the von Kaulbach family house in Ohlstadt. Beckmann restricted his international travelling in the troubled years 1932–4 when the impact of the National Socialist accession to power was as yet unknown, and he encoded a personal response to his increasing ostracism in motifs of the surrounding area.

Two landscapes, *Large Quarry in Upper Bavaria* 1934 (no.96) and *The Moor (Moorsberg)* 1934 (G393) show the same quarry near the von Kaulbach's summer home. Ortrud Westheider suggests the absence of blue sky in *The Moor (Moorsberg)* removes any meteorological indicators about weather conditions or time of day, thus taking it outside the dimension of time. Moreover, she argues this absence, represented for example in the lack of scudding

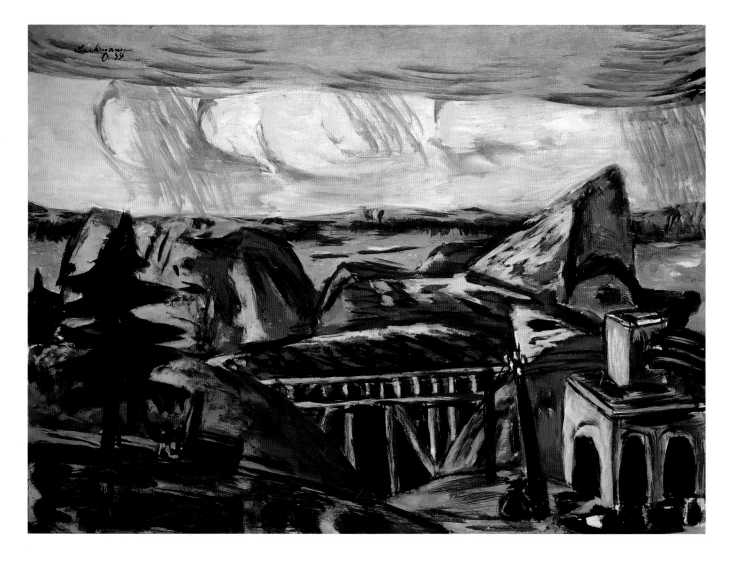

no.96
Large Quarry in Upper Bavaria
1934
86 × 118.5
(33 7/8 × 46 5/8)
Private collection,
Courtesy Richard
L. Feigen & Co.,
New York

clouds, removes from the picture any positive symbols that might indicate changing conditions.[74] Beckmann was probably aware that his subject, a local quarry, also added a further dimension that might have reflected obliquely on his current feelings of uncertainty: the quarry was the site of a Roman settlement established in 400 AD. Protected by this landscape feature, which acted as a natural fortress, it had been a sanctuary for the inhabitants against the Germanic tribes. Since the mid-1920s the stone from the Moorsberg was steadily quarried for state-sponsored construction projects, and by 1934 the Roman settlement had been completely destroyed.

By his inclusion of this motif in two separate paintings, one might discern perhaps a parallel threat to the artist seeking refuge from political upheavals and violations that had recently begun dramatically to affect his life.[75] It is a commonplace in the Beckmann literature to find his work interpreted as many-layered and hermetic and this is perhaps not surprising in light of the nuances within his life at the time. His is an art that stands at a remove from the realities of the moment, retreating instead to an inner world of fantasy and myth. A separation of art and life has frequently isolated his paintings from the time they were made. Usually, this interpretation ignores any sense of his paintings' timeliness or lessens their relevance to the artist's circumstances, or to the context of their production. It also opens the field for views that emphasise the premonitory aspects apparent in several of his most celebrated paintings. These certainly include *The Night* 1918–19 (no.59), *Galleria Umberto* 1925 (no.89) and the first of his triptychs, *Departure*, begun in 1932 (no.60).

By 1938, when Beckmann appeared personally in London to speak about his art, he had abandoned any expectations of returning to Germany. The London show, conceived during 1938 in parallel with plans for similar shows in Paris and Switzerland, was originally proposed, and understood as such by the National Socialists, as a riposte to the *Degenerate Art* exhibition in Munich. Through the inclusion of loans from Stephan Lackner, Beckmann presented several of his most powerful recent paintings, including the 1936–7 triptych *Temptation* (G439). The ambiguities of the previous half decade were no more. Unable to obtain a visa and take up an invitation in early 1939 to teach in America, Beckmann found himself in Amsterdam at the outbreak of war, and was forced to remain there for the next decade.

no.97
Self-Portrait 1936
Bronze
36.8 x 28.6 x 33
(14 1/2 x 11 1/4 x 13)
The Museum of
Modern Art, New
York. Gift of Curt
Valentin, 1951

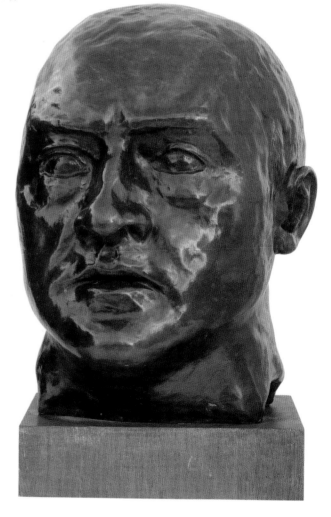

Notes

1 Rudolf Pillep (ed.), 'Über meine Malerei' in *Max Beckmann: Die Realität der Träume. Aufsätze und Vorträge Aus Tagebüchern, Briefen, Gesprächen 1903–1950*, Leipzig 1984, p.134. English translation published by Curt Valentin, Buchholz Gallery, New York 1941. Another translation in Barbara Copeland Buenger (ed.), *Max Beckmann: Self-Portrait in Words. Collected Writings and Statements, 1903–1950*, Chicago and London 1997, p.302.

2 Klaus Gallwitz, Uwe M. Schneede, Stephan von Weise (eds.), *Max Beckmann: Briefe*, vol.2: 1925–1937 (edited by Stephan von Wiese), Munich and Zurich, 1994, p.433. Two still lifes were shown in 1935 at the newly constituted Berlin Secession. The following year twenty-one prints were shown at the Hamburg Kunstverein.

3 Compared with other periods of his life, relatively little is documented about the period between Beckmann's move to Berlin in the spring of 1933 and his departure for Amsterdam in July 1937. In her *Nachwort*, in Mathilde Q. Beckmann, *Mein Leben mit Max Beckmann*, Munich 1983, p.213, Doris Schmidt relates Beckmann's wife Quappi telling her that the artist burned his diaries of the previous years when the German troops marched into Amsterdam in 1940. His published letters show a marked reduction in number compared to the previous four years; forty-seven letters for the period March 1933 to July 1937 as against 128 for the period January 1929 to February 1933. Quappi devotes about two pages to the years 1933–7 in her reminiscences of their twenty-five-year marriage.

4 For example *Golf Course in Baden-Baden* 1937 (G462) was acquired by the tyre magnate Ernst A. Teves.

5 Beckmann mentions negotiations which resulted in the Dawes Plan in London, 1924, in a letter of 9 August 1924, in *Max Beckmann: Briefe*, vol.1, 1993, pp.255, 480.

6 Klaus Gallwitz, Uwe M. Schneede, Stephan von Weise (eds.), *Max Beckmann: Briefe,* vol.1, 1899–1925 (edited by Uwe M. Schneede), Munich and Zurich 1993, pp.296–7.

7 Guido Müller and Vanessa Plichta, *Zwischen Rhein und Donau. Abendländisches Denken zwischen deutsch-französischen Verständigungsinitiativen und konservativ-katholischen Integrationsmodellen 1923–1957*, p.19. The author is indebted to views expressed in this article.8 There were ten more European states after the war than before it.

9 See Kurt Tucholsky's response to this situation discussed in Ian King, 'Kurt Tucholsky as Prophet of European Unity', in *South Bank European Papers*, no.5, 2001, pp.5–6.

10 *Max Beckmann: Briefe*, vol.2, 1994, pp.321–2.

11 *Max Beckmann: Briefe*, vol.1, 1993, p.490.

12 See Rohan's *Europa*, 1923, quoted in von Wiese (ed.), *Letters*, vol.2, p.322. On Rohan's activities after 1930 see Müller and Plichta, p.28, note 42.

13 See Erhard and Barbara Göpel, *Max Beckmann. Katalog der Gemälde*, Bern 1976, vol.1, p.181. Stephan von Wiese argues that the dream aspect of the vision is a departure from Beckmann's pre-1914 catastrophe paintings. He advances a further interpretation for the flood, a cod-scientific theory about the imminence of another ice age in 'Glacial-Kosmogonie' by Hanns Hörbiger, quoted in von Wiese, '"Zwiespältige Träume – laufen sie mir durcheinander": Realität und Rätsel im Gemälde "Galleria Umberto" von Max Beckmann' in *L'Arte del Disegno: Christel Thiem zum 3 Januar 1997*, Munich 1997, p.205. The threat to Mussolini's life was real enough. During 1925–6, while he was cementing his dictatorhip, there were four attempts on his life (see Martin Blinkhorn, *Mussolini and Fascist Italy*, London 1984, p.26).

14 Another portrait in the picture is that of the German ambassador in Paris Leopold von Hoesch. Hoesch was a strong supporter of the Briand Plan of 1930, in which the French Foreign Minister proposed concrete steps for establishing closer European cooperation, less directed at non-European states, intended more to strengthen the cause of peace, as suggested by Ian King (see note 12, pp.10–11). King cites Tucholsky's growing suspicion of Briand's commitment to the plan which led him to have a serious disagreement with Hoesch.

15 See King 2001, p.10.

16 See *Max Beckmann: Briefe*, vol.2, 1994, p.73.

17 See Barbara C. Buenger, 'Max Beckmann's "Idealogues": Some Forgotten Faces', in *Art Bulletin*, vol.71, no.3, Sept. 1989, pp.453–79.

18 *Max Beckmann: Briefe*, vol.2, 1994, p.76.

19 Ibid., p.74. See Buenger 1997, pp.284–7.

20 K.A. Rohan, *Europa*, Leipzig 1923, p.35–42. Rohan's position is discussed in Müller and Plichta, pp.26–7.

21 See Müller and Plichta, p.26.

22 Göpel 1976, vol.2, pp.34–5 lists only eleven publications on the artist between 1933 and 1937.

23 Jonathan Petropoulis, *Art as Politics in the Third Reich*, Chapel Hill 1996, p.297.

24 Petropoulis 1996, p.297.

25 'Schon zu lange wängelt er in meinem Leben herum ach langweilige Welt, tremblent vor Begeisterung wie bei Simons vor 15 Jahren.' Beckmann's invention of the verb 'wängeln' is probably a play on Furtwängler's name, with the negative connotation of being an irritating presence. *Max Beckmann: Briefe*, vol.2, 1994, p.260.

26 Ibid., pp.449–50.

27 Hitler's speech included the passage: 'So wie wir auf politischem Gebiet unser Volk befreiten von den anarchistischen Elementen der Zersetzung und damit Zerstörung, werden wir auch auf kulturellem Gebiet immer mehr diejenigen entfernen, die, sei es gewollt oder wegen mangelnden Könnens, mitgeholfen haben … die kulturelle Voraussetzung für den politischen Verfall zu schaffen', quoted in *Das Schicksal einer Sammlung*, exh. cat., Neue Gesellschaft für bildende Kunst, Berlin 1988, p.15.

28 Ibid., p.16.

29 See documentary photograph in *Max Beckmann: Graphik, Malerei, Zeichnung*, exh. cat., Museum der bildenden Künste, Leipzig 1984, p.43.

30 See Berlin 1988, p.20.

31 The bitter irony of 'worthless' 'degenerate' art auctioned in Switzerland to foreign buyers often for good prices and, perversely, gaining those defamed painters greater international recognition to add to their notoriety in Germany, is the subject of several articles by Paul Westheim, including 'Propaganda für "Entartete"', in *Paul Westheim: Kunstkritik aus dem Exil*, Hanau 1985, pp.95–101.

32 See Hans Ebert, 'Die Verfemung und Verfolgung moderner Künstler und Kunstwerke durch das Naziregime', in Berlin 1988, p.19.

33 See the guidance documentatation on spoilation issues, published by the German government: 'Handreichung zur Umsetzung er Erkärung der Bundesregierung, der Länder und der kommunalen Spitzenverbände zur Auffingung und zur Rückgabe NS-verfolgungsbedingt entzogenen Kulturgutes, insbesondere aus jüdischem Besitz', 1999, p.29.

34 Hans Ebert in Berlin 1988, p.12.

35 *Max Beckmann: Briefe*, vol.2, 1994, p.235.

36 Ibid., p.453.

37 Ibid., p.365.

38 Max Beckmann to Curt Valentin, Berlin, 11 May 1937, ibid., p.272.

39 Recalled in a letter to Stephen von Wiese, quoted ibid., p.456.

40 See exhibition poster for a '1936/7' exhibition of landscape watercolours by Beckmann, among others, in Felix Billeter, *Max Beckmann und Guenther Franke*, exh. cat., Max Beckmann Archiv, Staatsgemälde Galerie, Munich 2000, p.28.

41 Beckett's visit to Munich, where he saw the gallery and visited several artist's studios, is described in Billeter 2000, pp.26–7.

42 Paul Westheim, who was planning a protest exhibition in Paris around this time, comments on the redrafting of London publicity material to affect a more neutral tone, rather than the earlier intentions of the organisers 'to unmask the monstrous events in Munich'. See 'Die Vandalen. Der zerschnittene Kokoschka. Wird er in London ausgestellt?', in Westheim 1985, pp.231–3. For press response in UK and Germany, see also Helen Adkin's excellent commentary in Eberhard Roters (ed.), 'Stationen der Moderne. Kommentarband', Cologne 1988, pp.165–82.

43 Quappi recalled an invitation to teach in Chicago which would have taken the Beckmanns to America, but the visa request was refused by the American authorities in Europe, see Mathilde Q. Beckmann 1983, pp.26–7.

44 For example, Erhard Göpel, in 'Das Argonauten-Triptychon', in *Max Beckmann. Berichte eines Augenzeugen*, Frankfurt 1984, p.161, writes 'Das erste [Triptychon] "Departure" 1932 in Frankfurt begonnen, nimmt das Thema der "Ausreise" prophetisch vorweg.'

45 'Gleich zeitnah wie zeitfern.' See Billeter 2000, p.40.

46 *Kölner Stadtanzeiger*, 8 Feb 1958; see also Lilly von Schnitzler, 'Das Entstehen einer Beckmann-Sammlung', in *Blick auf Beckmann*,

Munich 1962, pp.175–82.

47 See note 34, p.29.

48 'Obwohl ich damals die Seitenteile des Triptychons, die in eindeutiger Sprache die Grausamkeiten der National-sozialisten verurteilten, nicht zu sehen bekam, lastete das politische Schicksal auf dem Gespräch. Damals hoffte er noch in Deutschland bleiben zu können. Die Ausstellung "Entartete Kunst" belehrte ihn jedoch, dass kein Kompromiss, ja nicht einmal die Duldung durch die Machthaber zu erreichen war', in Göpel 1984, p.184.

49 Ibid., p.10.

50 Göpel 1976, vol.2, p.97 for listings. A documentary photograph in Für die Kunst! Herbert Tannenbaum und sein Kunsthaus, exh. cat., Reiss-Museum der Stadt, Mannheim 1994, p.64 shows Beckmann's Chistus und die Sünderin 1917 (G197) in the Mannheim exhibition in the centre of a wall also hung with paintings by Jankel Adler, Oskar Schlemmer, Heinrich Hoerle and James Ensor, among others.

51 Göpel 1984, p.9. In The Germans and their Art, Munich 1993, English translation New Haven 1998, pp.67–9, Hans Beltingwrites: 'A generation after the 'Bremen art controversy' [brought about by Carl Vinnen's inflammatory manifesto of 1911, signed by 118 artists – Beckmann declined to join them – opposing the museum's purchase of a van Gogh instead of supporting German art] the national socialists were able to borrow all the political slogans they needed from the now traditional debate about German art'. This tradition included Vinnen's attacks on Liebermann and Lovis Corinth as 'anti-German impressionists', and recalls Liebermann's controversial place in the German art world.

52 Ibid., p.11.

53 Ibid.

54 In Max Beckmann. Frankfurt 1915–1933, exh. cat., Städtische Galerie im Städelschen Kunstinstitut, Frankfurt 1983, p.337; a copy of Beckmann's official notice of dismissal.

55 The relevant documents record that the newly created 'Amt für Wissenschaft Kunst und Volksbildung' required staff changes, 'um die Kunstgewerbeschule nach dem Grundsatz einer deutschen, in dem Handwerk wurzelnden Kunst umbauen zu können…', in Frankfurt 1983, p.336.

56 'Er verpflichtet sich, während dieser Zeit seine Wohnung und seinen Wirkungskreis in Frankfurt a.M. zu belassen', in Frankfurt 1983, p.335. Note also Beckmann's letter to Franke of 28 April 1930, in Max Beckmann: Briefe, vol.2, 1994, p.158, 'Ebenso muss ich noch einmal darauf dringen, dass die Sache mit Wichert in Gang komt, da das für meine spätere pekuniäre Existenz also auch für Sie selber äusserst wichtig ist.'

57 See Frankfurt 1983, p.330, 'Künstlerhilfe 1929/30', which lists this contract and sets against it a payment of 5,000 Marks.

58 Göpel 1976, vol.1, pp.239–40.

59 It was possibly more easily attacked because outside of a museum collection. His Städel paintings were confiscated later, in two tranches, in November 1936 and in 1937. See Revision: Die Moderne im Städel 1906–37, exh. cat., Städtische Galerie im Stäedelschen Kunstinstitut 1991, pp.159, 162, 164, 169–71.

60 Göpel 1976 lists eight sales in the USA between 'pre-1930' and 1931, (G221, 242, 252, 255, 270, 272, 279, 325). The most prominent collector, Abby Aldrich Rockefeller, acquired the most important of these paintings, Portrait of an Old Actress 1926 (G255) in 1930.

61 See Göpel 1976, vol.2, p.94 for press response.

62 One hundred paintings, plus twenty-one watercolours, gouaches and drawings at the Kunsthalle, prints at the Kunstmuseum.

63 September–October 1930; eighty-five paintings, twenty-three watercolours, gouaches and drawings, plus 113 prints.

64 Max Beckmann: Briefe, vol.2, 1994, pp.385–6. Quotes Arbeiterzeitung, Basel, 28 Aug. 1930: 'Beckmann wird immer mehr Gourmand. Stilleben bekommen intensivstes leben. Neue Farbe, gerissene Tricks werden erprobt. Vorbei ist der grausige Spuk; weit hinter ihm liegt die Banalität der deutschen Familie. Im D-Zug reist er von Genua nach Scheveningen. Er wird mondän, er wird vornehm-lustig, ohne die etwas kompromittierende Gesellschaft der Variete-Hungerleider …'

65 See letter to Quappi, 15 September 1930, in ibid., p.173. In her memoirs Quappi recalled: 'einer der wenigen, mit denen wir oft zusammenkamen, was Baron Rudolf von Simolin, ein sehr gebildeter, kultivierter Mann, ein grosser Kunstkenner, der eine hevorragende Sammlung … besass'. See Mathilde Q. Beckmann 1983, p.19.

66 Max Beckmann: Briefe, vol.2, 1994, p.192.

67 Ibid., p.193.

68 See his correspondence with I.B. Neumann, for example; ibid., p.32.

69 'Draussen wissen jetzt schon die Menschen, was aus Deutschland's Schicksel geworden ist…', in ibid., pp.172, 387. On 14 September the NSDAP achieved a political breakthrough in the Reichstag elections, taking 107 of the 575 seats.

70 By comparison, Spring Landscape (Park Louisa) 1924 (G228), painted in April–May, shows similarly lopped, oversized trees. However there would appear to be a sanctuary in the little hut at end of the path, sunlit beyond the barrier of trees, and there are shoots of new spring growth in sinuous branches snaking upwards at top of picture.

71 Göpel 1976, vol.1, p.236, 'Die Pentimente im Fenster links lassen eine Überarbeitung erkennen'.

72 Ortrud Westheider, in a section introduction in Max Beckmann: Landschaft als Fremde, exh. cat., Kunsthalle, Hamburg 1998, p.100, identifies the obscured window frame on the left as the reverse side of a stretched canvas. She also identifies a swastika in a combination of tree trunks, branches and window battens, which this writer is unable to discern.

73 Ortrud Westheider, 'Melancholie der Natur. Innere Emigration als Thema des Landschaftsbildes bei Max Beckmanns', in Max Beckmann. Abseits der Grosstadt – Oberbayerische Landschaft, exh. cat., Schlossmuseum, Murnau 1998, p.15.

74 Ibid., p.16.

75 Ibid., p.19.

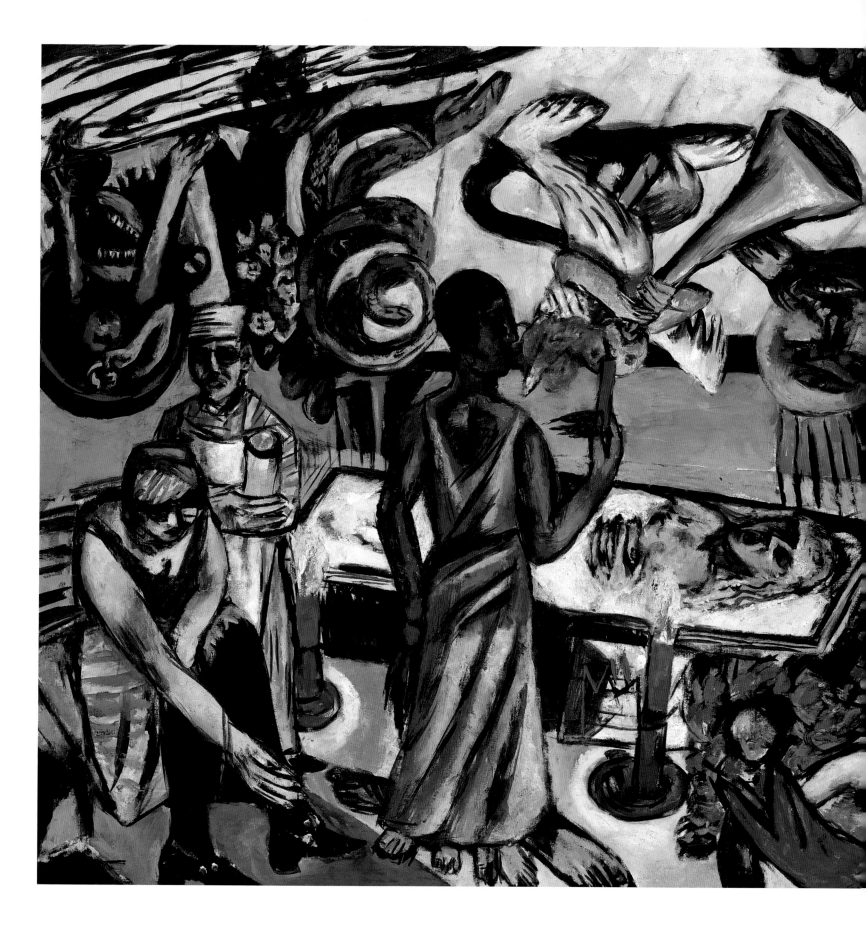

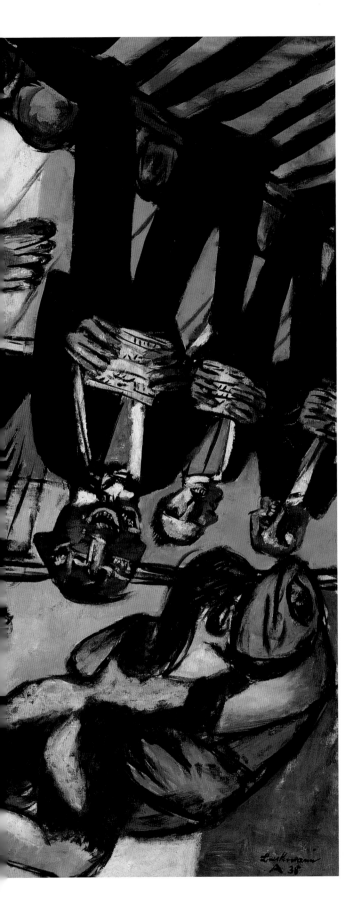

no.98
Death 1938
121 x 176.5
(47 5/8 x 69 1/2)
Staatliche Museen
zu Berlin,
Nationalgalerie

fig.25
Detail from
Michelangelo's
*The Last
Judgement*
1538–41
Fresco (before
restoration)
Sistine Chapel,
Vatican City

Beckmann's *Death*
William Kentridge

I have never seen Beckmann's painting *Death*, but have known it from a postcard since I was about fifteen. On and off over the last thirty years I have had this postcard close at hand in my studio.

I think the first thing that intrigued me about the painting was its reversibility – it demanded to be turned upside down, the choir either hanging like bats from the ceiling, or turned upright to be on stage. This ongoing riddle of the painting does not diminish. On a small scale it is like a Tiepolo ceiling which has one sense from one side of a room, but calls to be looked at from other perspectives. The viewer has to shift and change to complete the work. Beckmann's painting too will not allow peaceful viewing. And even though Beckmann's signature

marks the decision as to which way it should be seen, this orientation seems a provisional and not a final decision.

When I was about twelve, my grandfather gave me a book on Michelangelo's *Last Judgement*, a series of not very well reproduced details of the fresco. The elongated trumpet of the angel in Beckmann's painting reminded me of the angels blowing for the redemption of the souls in Michelangelo's fresco (fig.25). (Beckmann's angel is in itself a riddle: it has the white wings of an angel, but the tail and exaggerated vermilion phallus, which one would normally associate with the devil.) Thirty years on I still do not know if the dead woman is being blown into hell or being tempted from it.

The multi-headed singers are equally

ambiguous. One wears a bow-tie, one seems to have a priest's dog-collar. The painting of the singers seems neither benign nor malevolent. Their dark suits bring up another puzzle: the temporality of the painting. (It is obvious by now that it is the riddles in the painting rather than their solutions that provide its interest for me.) The painting seems neither a description of German society, nor lost entirely in Greek myth. The skirt and bare feet of the figure with the candle in the centre of the painting suggest classical antiquity, but the bare back of the top suggests rather Josephine Baker. The woman on the left taking off her shoe suggests the easy domesticity of a Degas, and the nurse and hospital chart under the body anchor this part of the picture in or around the First World War.

There are other associations that the painting seems to bring in. The figure – which is really an embodied mouth – in the top left-hand corner, immediately reminded me of Francis Bacon's series of mouths and teeth of popes and cardinals painted just after the war, and particularly the central panel of his *Three Studies for Figures at the Base of a Crucifixion* (fig.26). Bacon painted his figures in 1944 towards the end of the war. Beckmann painted his in 1938, at the start of his exile in Amsterdam; but for me the temporality is reversed – I knew the Bacon before seeing Beckmann's painting. Another reversal: when I saw Hieronymus Bosch's humans and fish intertwined, the association was five hundred years forward, towards Beckmann (fig.27). The hanging choir now reminds me of Baselitz. When I first saw Baselitz's work it was the

other way round – the Baselitz reminded me of the Beckmann, and I must confess to a prejudice against Baselitz for having changed a moment of invention in Beckmann into a principle of picture-making.

A less apt association, but one that sticks with me: the strange three-eyed head on feet – a kind of decapitated self-portrait – recalled another book I saw as a child, the Australian verse novel *The Magic Pudding*, published at the turn of the twentieth century, with its protagonist drawn as a circular pudding on feet. In looking at the painting some associations are pertinent, others like this, impertinent. What is certain is that the clarity of looking is a fiction. Chains of association extend. My wife, looking at the painting and at what I had written interjects, 'You must mention Chloraemia'. This in reference to the green skin of the dead women in the centre. Chloraemia was a medieval form of anorexia, suffered by virgins, supposedly cured by marriage, and accounts for the greenish hue of the flesh of some young women painted by Memling and other Flemish masters. I associate the green in the painting with hospitals and similar institutions.

I now know through subsequent reading that Beckmann was interested in gnosticism, Schopenhauer, and the possible redemption of a doomed world. But at the time that I first saw the postcard image I was intrigued not by the evocation of these philosophies but by the way the painting prompted memories of other images, made reference to parts of the historical world, and with complete abandon seemed to reorganise

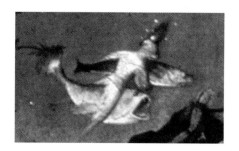

fig.27
Hieronymus
Bosch
Detail from
triptych *The
Temptation of
Saint Anthony*
c.1450–1516
oil on panel
Museo National
de Arte Antiga,
Lisbon

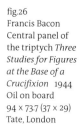

fig.26
Francis Bacon
Central panel of
the triptych *Three
Studies for Figures
at the Base of a
Crucifixion* 1944
Oil on board
94 × 73.7 (37 × 29)
Tate, London

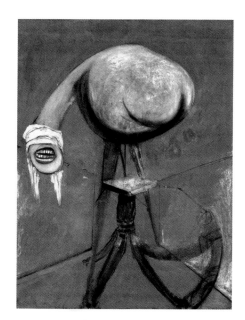

and reconstruct these worlds.

There is a piece of wood in the top left-hand corner which feels more like a floorboard than a ceiling rafter – which could also be the curved side of a ship, or even an elaboration of the wooden edges of the coffin at the centre of the painting, or perhaps an enlargement of the hair of the dead woman. None of these associations is necessary. All are possible. What is being given without doubt is an invitation to take part in the construction of the painting. To return to the question of the reversible nature of the painting, it is not that the painting should be on a spindle so that it can be easily turned upside down, but that it proposes the possibility of inversion, and provokes us to invert it in our heads.

There are footlights behind the choir

illuminating the angel and the magic pudding. The whole painting seems (as are all Beckmann's paintings) constructed as a stage-set: perspective can be used and abused, lighting heightened or abandoned to make a deeper or shallower space, and several different spaces exposed on stage at the same time. What seems remarkable is the way characters, colours, shapes in the painting are pushed around as actors on a stage. What Beckmann was doing was neither simply using these actors in the service of an idea, nor abandoning an idea in the service of colour, form and paint. The very way the elements of the painting are pressed into service in the act of constructing his image, evokes the world as a contested arena, where neither grace nor damnation

are inevitable. I was aware of this as part of the meat of the painting; the painting never filled me with awe at this battle between heaven and hell. But what it did do, and still does, was fill me with awe and hope at the way in which painting or drawing could so evoke the ambiguities, uncertainties and arcane ways in which we shape our sense of ourselves and our construction of the world.

no.99
Birth 1937
121 x 176.5
(47 5/8 x 69 1/2)
Staatliche Museen
zu Berlin,
Nationalgalerie

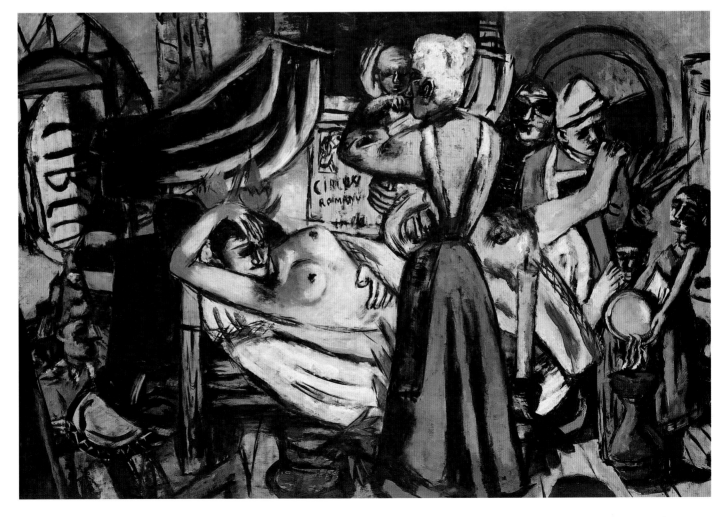

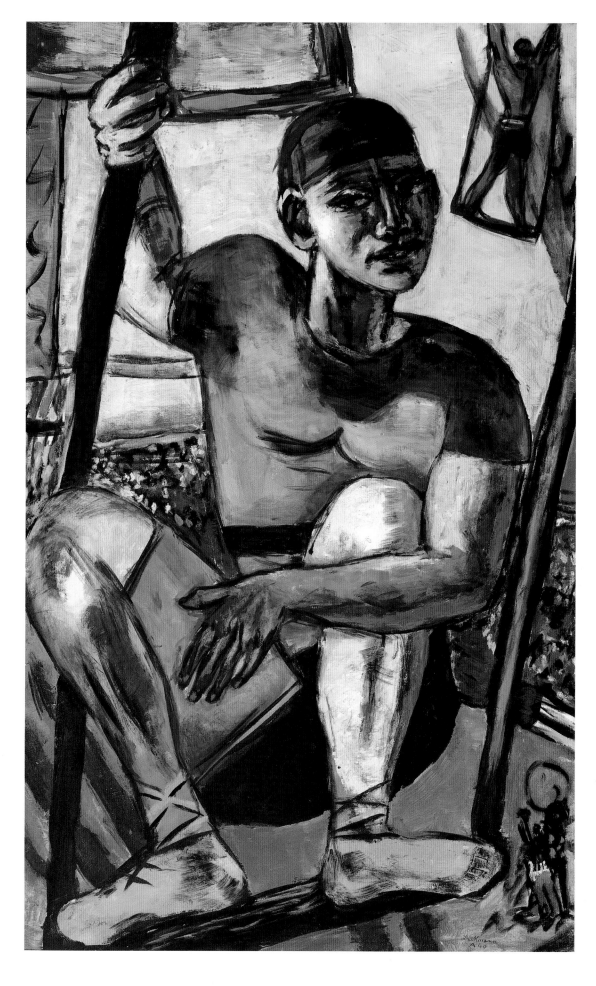

no.100
*Acrobat on a
Trapeze* 1940
146 × 90
(57 1/2 × 35 3/8)
The Saint Louis Art
Museum. Bequest
of Morton D. May

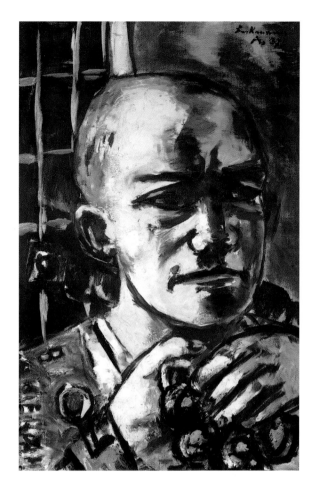

fig.28
The Liberated One
1937
60 × 40
(23 ⁵/₈ × 15 ³/₄)
Private collection
G476

Beckmann: Exile in Amsterdam 1937–47
Jill Lloyd

On 19 July 1937, the day that the *Degenerate Art* exhibition opened in Munich, Max Beckmann and his wife Quappi boarded a train in Berlin and fled to Holland. For the past five years Beckmann had been a target of the National Socialists' increasingly hostile attacks on modern art. When he heard Hitler's aggressive radio speech at the opening of the Haus der Deutschen Kunst, Beckmann realised that time had run out and he immediately put a plan of escape into action. As luck would have it, Quappi's sister Hedda, who lived in Amsterdam, was visiting their parents in Bavaria, and a telephone call brought her hurrying to Berlin to accompany the Beckmanns on their perilous journey. Taking with them no more than their hand-luggage and the ten Marks each that they were allowed to take out of Germany, they gave every appearance of leaving on a summer holiday. In her memoirs, Quappi

recalled the tension of this train ride and Beckmann's long sigh of relief as they rolled slowly over the Dutch border and began to pick up speed on their way towards Amsterdam.[1]

Max Beckmann could have had no idea on this fateful day that he would never set foot in Germany again and that Amsterdam would become his enforced home for the next ten years. In the course of these long years of exile, the city which he associated with his new found freedom in 1937 (and celebrated in his self-portrait *The Liberated One* (fig.28) would often seem more like a prison or a cage. The artist's physical imprisonment in Amsterdam nevertheless liberated his imagination and gave rise to one of his greatest periods of invention. Beckmann responded to the human drama of the war with a surge of intense creativity. Alongside his ambitious cycles of prints and drawings – *Apocalypse* 1941–2 (nos.111–27),

185

and *Faust II*, 1943–4 – Beckmann painted some two hundred and fifty paintings during his years of exile, including five of his monumental triptychs which are among the great masterpieces of twentieth-century art.

The hermetic imagery of Beckmann's triptychs has given rise to much detailed analysis relating, for example, to the artist's citations from Indian philosophy and esoteric literature.[2] Although this analysis has illuminated Beckmann's sources, there is a danger of losing sight of the wider historical picture. Few attempts have been made in recent years to return to the biographical sources and trace the historical circumstances in which the triptychs were made.[3] The biographical approach which is adopted in this essay aims to open new avenues of research and to raise the question of how far the encoded symbols and role-playing central to the imagery of Beckmann's greatest Amsterdam paintings relate to the conditions of his exile.

* * * *

On the day following the Beckmanns' hurried departure, their belongings and the contents of the artist's studio were sent on by their landlady in Berlin, who promptly dispatched the shipment before Gestapo agents could return with authorisation to stop her.[4] Although the Beckmanns initially stayed in a boarding house in Amsterdam, the art historian Hans Jaffé, whom they knew from Berlin, soon helped them to find centrally located living quarters and a studio in an old tobacco warehouse on the broad thoroughfare of the Rokin canal. Jaffé, who had emigrated to Amsterdam in 1933, studied art history and archaeology before securing a curatorial post at the Stedelijk Museum, which he held until 1940.[5]

In Amsterdam, there existed a close-knit community of exiled artists, writers and musicians, who had fled from Nazi Germany to Holland in the 1930s. Paul Citroen's private art school attracted a number of German émigrés to its faculty and student body, and the first exile publishing house, the Querido Verlag, was founded in Amsterdam in 1933.[6] The film director Ludwig Berger and the painters Herbert Fiedler and Friedrich Vordemberge-Gildewart (all of whom were on friendly terms with Beckmann) were among the wave of some thirty thousand Jewish and political refugees who arrived in the city in these years. Holland was initially a sympathetic haven, and most of these artists found some opportunities to exhibit their work. Heinrich Campendonk, who like Beckmann lost his Professorship in Germany when Hitler came to power, obtained a teaching post at the Imperial Academy until the German invasion in 1940 forced him into hiding.

By the time the Beckmanns arrived, Holland was in the grip of a severe economic crisis and the regulations for granting political asylum were tightening up. After 1938 no more visas were issued and political refugees were forbidden to work or engage in any kind of political activity. After September 1939, when the Dutch borders were closed, many émigrés were interned in the labour camp at Westerbork, which the Germans subsequently used as a transit camp for Jews en route to the death camps in Germany and Poland.[7]

Psychologically, things were made easier for Beckmann by regarding Holland as a temporary haven, an *Übergang*, which he hoped to exchange as soon as possible for the United States or Paris. Despite their improvised living conditions – which included a makeshift kitchen built on a platform and

a large lemon-scented geranium in the stead of curtains[8] – Quappi felt relatively at home in Holland. She was close to her sister Hedda who introduced her to such friends as the doctor Jo Kijzer and his wife Mimi. A short journey away, in The Hague, lived Ilse Leembruggen ('Tante Ilse' in Beckmann's diaries), the aunt of the artist Marie-Louise von Motesiczky in whose home in Vienna Beckmann and Quappi had met. This wealthy, cultured Jewish family played an important role during the Beckmanns' years of exile, as Marie-Louise persuaded Tante Ilse to buy a number of Beckmann's works.[9] In the autumn of 1937 the Beckmanns joined the von Motesiczkys and their Leembruggen cousins on the first of many bicycling trips to Hilversum.

One of these cousins, a teenage girl who was to spend the German occupation as a 'diver' or *onderduiker* (literally, a person who goes underwater), hidden from the Nazis like many other Jewish children, remembers Max Beckmann in Hilversum as a silent, intimidating man.[10] On the whole, Beckmann did not make a positive impression on the Dutch, and the feeling was largely mutual. Beckmann never learnt enough of the language to ask for more than a packet of cigarettes, and during the occupation, when he was too uncomfortable to speak German on the streets, he preferred to speak French, apparently with a strong German accent.[11] His clipped and acerbic manner was often taken for arrogance. An anecdote concerning his first visit to 85 Rokin, the two-roomed apartment and attic studio where he and Quappi later lived, typifies the reaction he aroused in the locals. At the time, an artist was living there who was about to move out. Max Beckmann rapped on the door, and barked out his name: 'Beckmann!' 'van't Net!' the Dutch artist barked

back, and shut the door in Beckmann's face.[12]

Nevertheless, the exhibition of Beckmann's paintings which was shown at the Kunstzaal van Lier in Amsterdam in June 1938 was extensively reviewed in the *Nieuwe Rotterdamsche Courant*.[13] Several of his most powerful recent works, including *The Liberated One* 1937 (fig.28), *Self-Portrait with Horn* 1938 (no.150) and *Apache Dance* 1938 (G495), were shown in this exhibition, but Beckmann was disappointed by the lack of sales and by the fact that the Stedelijk Museum took no interest in him. Not unreasonably, he believed that international success lay in Paris or New York rather than in provincial Amsterdam. In Paris, where Beckmann visited in September 1937, and spent the winter and spring of 1938–9, he had a faithful circle of supporters including Käthe von Porada and Stephan Lackner, who, after September 1938, paid Beckmann a monthly sum in return for paintings.[14] Beckmann's application for a French *carte d'identité* was granted in June 1939. If he had stayed in Paris after France and England declared war on Germany in September he would certainly have been arrested and interned.

These increasingly fraught political circumstances are the backdrop for Beckmann's speech, 'On My Painting,' which he delivered in London in July 1938 on the occasion of the exhibition of *Twentieth Century German Art* at the New Burlington Galleries.[15] Beckmann's triptych *Temptation* 1936–7 (G439) was among the works of art under attack by Hitler that were presented in protest here to an international audience. Although the scenes of torture and hysteria in Beckmann's paintings from this period (above all *Hell of the Birds* 1938; no.101), clearly mirror the brutalities of the Nazi regime, Beckmann went to some lengths to

emphasise his political neutrality whilst in London. A theme that recurs in all Beckmann's statements of this period is the responsibility of art to rise above the temporary turmoil of politics in order to reveal eternal truths. The only salvation from what he described as the 'catastrophic … collectivism' of the times was, in his view, a new humanism based on 'sympathy and understanding', and dedicated to the search for individual truth.[16]

The policy of appeasement that Britain was pursuing in 1938 meant that the original political intentions of the London exhibition had to be toned down, and Beckmann's political disclaimer may also have been an attempt to protect himself from German agents and spies.[17] Certainly the artist's émigré status forbade him overt political activities. But the fact remains that publicly acclaimed apoliticism from a humanistic point of view, involved voicing an overt opposition to Hitler's brutal politicisation of art. Beckmann's method, in his London speech, of making coded references to the world situation in poetic and visionary descriptions was also a key element of his creative approach in the years that followed.

* * * *

In June 1939 Beckmann returned to Amsterdam to work on his third triptych, *Acrobats* (G536), which was later described by a key eyewitness as a reference, through the familiar world of the circus and cabaret, to the artist's own precarious position.[18] With the outbreak of war in September, the Beckmanns were overtaken by events and the option of returning to Paris was cut off. Faced with the threat of internment in Holland, and with the general fear of German

no.101
Hell of the Brids
1938
120 × 160.5
(47 1/4 × 63 1/4)
Richard L. Feigen,
New York

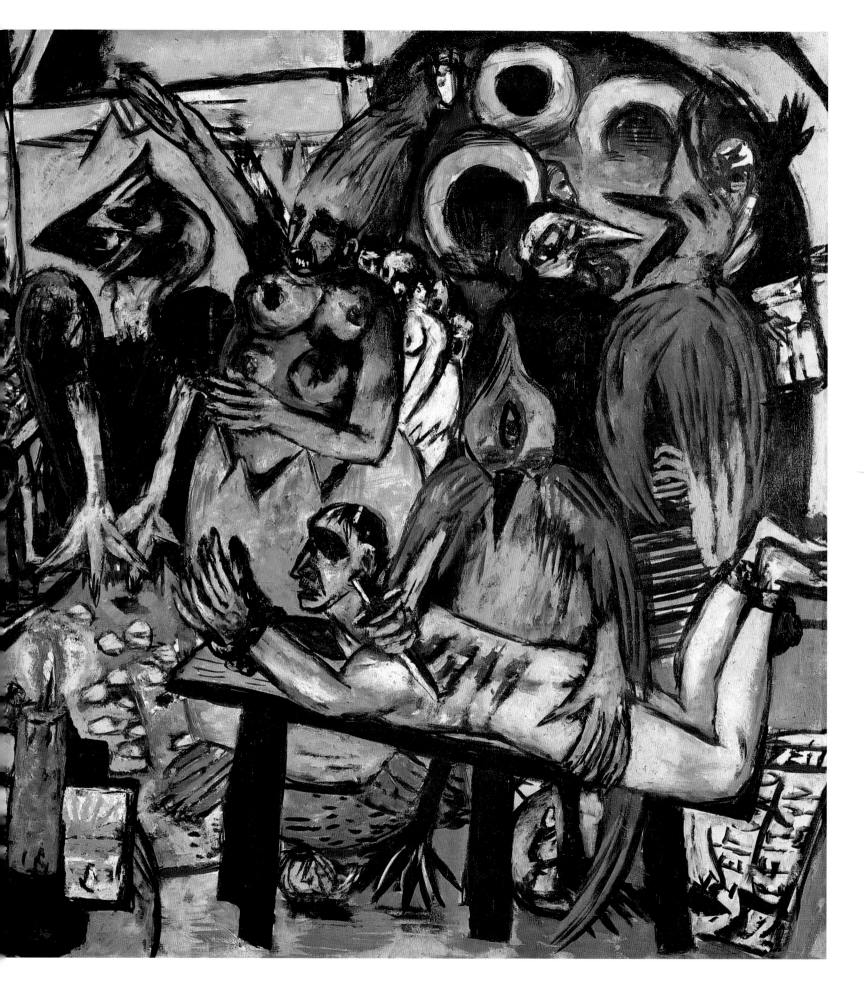

invasion, Beckmann persisted in his efforts to emigrate to the United States.[19] In May he had received an invitation to teach for a semester at the Art Institute of Chicago, but the imminent threat of war made it impossible to obtain a visa. The tone of his letters through the autumn and winter of 1939 was nevertheless upbeat, affirming his hope for a resolution to the conflict through a triumph of democracy. However, in his surviving diary entries, a darker mood prevails: on 4 May 1940 he noted his determination to confront events with 'pride and defiance of the invisible powers, even if the very worst should happen.' By 7 May the Dutch army had recalled its reservists, and Beckmann shared the general conviction that war would come to Holland: 'and then I shall be imprisoned and killed, or hit by one of the notorious bombs ... the pity of it is that I really paint quite well. – But perhaps I have already achieved enough.'[20]

Three days later German forces crossed the border and on 12 May the Dutch royal family fled to England. A brutal bomb attack on Rotterdam on 14 May (which Beckmann described as an unrecognisable city in a diary entry of 1943, wondering if Berlin had suffered a similar fate[21]) ended the five-day war. As German soldiers marched into Amsterdam, Max Beckmann burned his diaries dating from 1925 to 1940, except for these few entries which Quappi saved from the flames. If his home was to be searched by the Gestapo, Beckmann feared that they would find information that could compromise himself or his friends. When he resumed his diary in September 1940, people and events were alluded to in a cryptic, encoded script, in which initials, symbols, nicknames, or even false names were used to mask identities.[22]

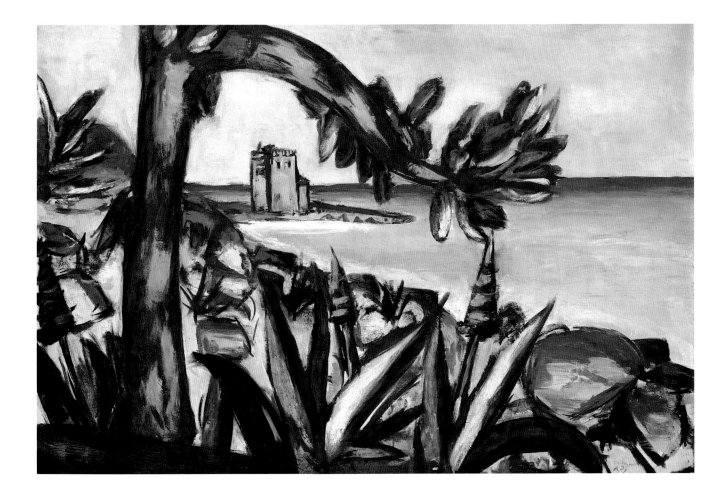

no.102
Seascape with Agaves and Old Castle 1939
60 x 90.5
(23 5/8 x 35 5/8)
Staatliche Museen zu Berlin, Nationalgalerie

Despite his status as a so-called degenerate artist, Beckmann was left largely alone by the German police. The daily discipline of the studio was relieved by long walks along the Amstel, visits to the Vondelpark Zoo, the circus or the cinema, and skating on the frozen canals during the icy winter months. Although Beckmann frequently complained about the monotony, the emptiness, the curfews, the air raids, the freezing mist and rain that plagued his days, being thrown back on his own resources allowed him to concentrate single-mindedly on his work. In the elegant hotels, bars and cabarets of Amsterdam such as the De Kroon, the Savoy and the Pays-Bas, or the smoky cafés which appear in such paintings as *Bar, Brown* 1944 (G669), Beckmann observed the human dramas which he transformed into visionary scenes in his triptychs. When British bombers were passing overhead, he took refuge with Quappi in a cellar bar called the Kaperschip near their home on the Rokin canal.

There were also bicycle and bathing trips and longer holidays spent in Valkenburg and the artists' colony at Laren, made famous in the paintings of Max Liebermann and Josef Israels. These trips relieved the state of high tension they felt in the city, and Beckmann chose to travel, when possible, on intercity trains which continued on to Brussels or Paris and gave him the illusion of going somewhere.[23] But the threat posed by Allied bombers made travelling dangerous, and in June 1942, Beckmann found one of his favourite beaches at Zandvoort cut off by barbed wire. Throughout these years, Beckmann returned to images of the sea: either the windswept northern coast or sun-drenched Mediterranean seascapes, conjured from his imagination and his memories of the French and Italian Rivieras. A small group of these seascapes – which had long been associated in Beckmann's imagination with ideals of freedom – hung in his living room in Amsterdam.

Despite shortages of food and materials, and frequent bouts of ill health, Beckmann had an easier time than most people in Nazi-occupied Holland. Although the occupation meant that he was no longer able to receive Lackner's monthly payments, he nevertheless kept up contacts in Germany and the United States. His longtime friend and patroness Lilly von Schnitzler sent funds through her sister Nora who was living in the Netherlands, and she visited Amsterdam to purchase paintings. Lilly and her husband Georg, who was the commercial chief of I.G. Farben, were on good terms with high-ranking Nazi officials, who visited their home in Berlin where Beckmann's work was hung. Apparently *The Organ-Grinder* 1935 (no.94) was hidden behind a curtain and shown only to selected guests. Beckmann was grateful for Lilly's support, but he found 'this combination of enthusiasm for the regime and me difficult to take'.[24] In 1942, after an arduous journey, Lilly took a makeshift bike-taxi to Rokin to find Beckmann's characteristic bulk looming towards her through the mist: although he had not seen her for two years, the artist curtly informed her that he had been drinking and advised her to come back the next morning as agreed. Notoriously punctual himself, Beckmann did not welcome unscheduled visits.[25]

Lilly von Schnitzler also helped initiate contact with the Frankfurt publisher Georg Hartmann, which led to the commissions to illustrate *Apocalypse* and *Faust II*.[26] In this instance, sponsorship from behind the enemy lines in Germany provided Beckmann not only with moral and

financial support, but also a means of integrating references to current historical events into the universal themes and traditions of European literature.

Karl Buchholz, one of the four German dealers whom the Nazi propaganda ministry allowed to sell abroad art defined by the regime as degenerate, also bought pictures from Beckmann in Amsterdam, providing a crucial link between the artist in exile and the support system Curt Valentin was establishing for him in the United States.[27] Under the cover of an officially acceptable exhibition programme of Romantic artists in his Munich gallery, the dealer Günther Franke meanwhile built up clandestine support for Beckmann inside Germany. In his summer house on the Starnberger See, Franke surrounded himself with forbidden works by Beckmann and other degenerate

artists. He celebrated Beckmann's sixtieth birthday with an exhibition there in February 1944, and in a letter to the artist's first wife, Minna Beckmann-Tube, dated 5 January 1943, he assured her that 'my Beckmann collection in Seeshaupt is frequently visited, and the circle of people open to his work is growing slowly but surely'.[28]

Franke initially smuggled paintings back to Germany in his hand luggage,[29] although before 1943 he mainly bought Beckmann's work from the artist's son Peter, who visited his father many times in Amsterdam. Making use of his position as an air force doctor, Peter undertook the dangerous task of transporting Beckmann's paintings to Germany in a military vehicle. On one memorable occasion in August 1942, with Beckmann's triptych *Perseus* 1940–1 (no.105) loaded in the van, Peter was stopped by the border police: he pretended

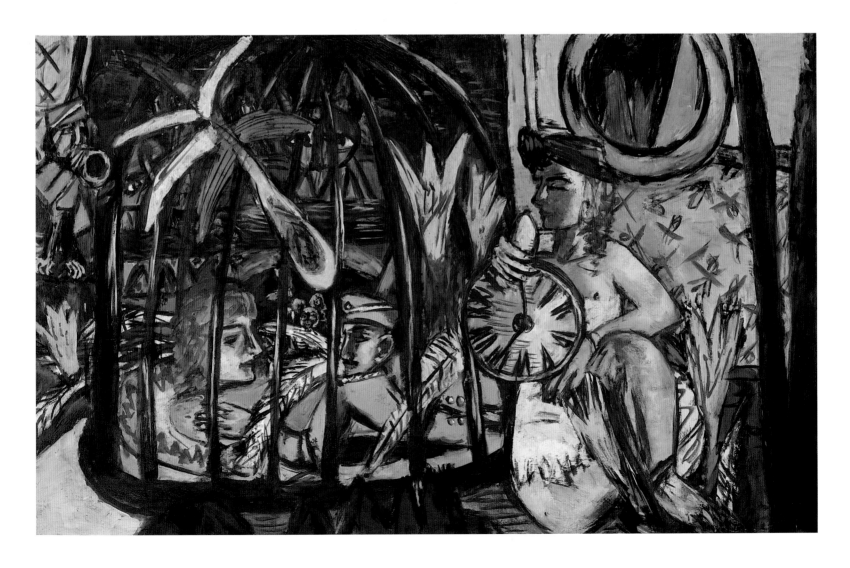

no.103
Soldier's Dream
1942
90 × 145
(35 ³/₈ × 57 ¹/₈)
Private collection,
Courtesy Richard L.
Feigen & Co.

no.104
Quappi in Blue and Grey 1944
98.5 × 76.5
(38 ³/₄ × 30 ¹/₈)
Museum Kunst
Palast, Düsseldorf

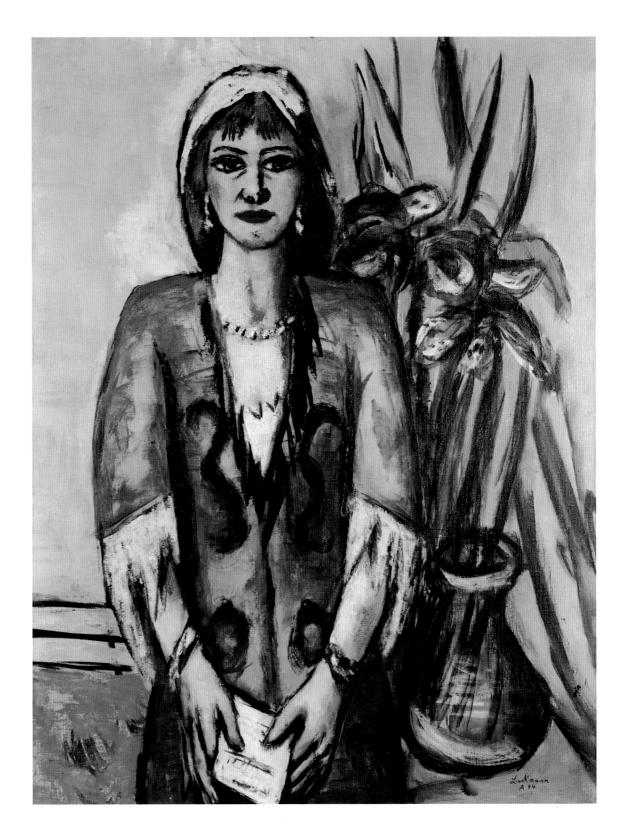

no.105
Perseus 1940–1
Side panels:
150.5 × 56
(59 ¹/₄ × 22)
Central panel:
150.5 × 110.5
(59 ¹/₄ × 43 ¹/₂)
Museum Folkwang,
Essen

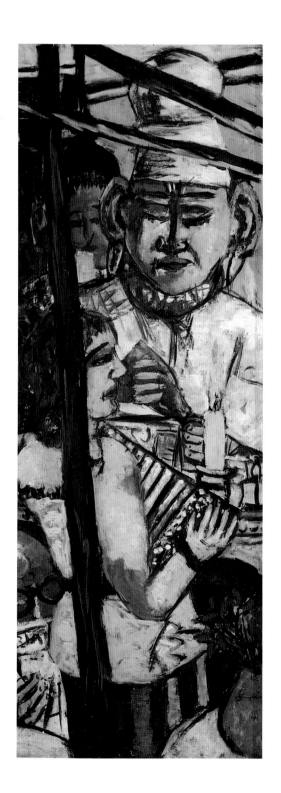

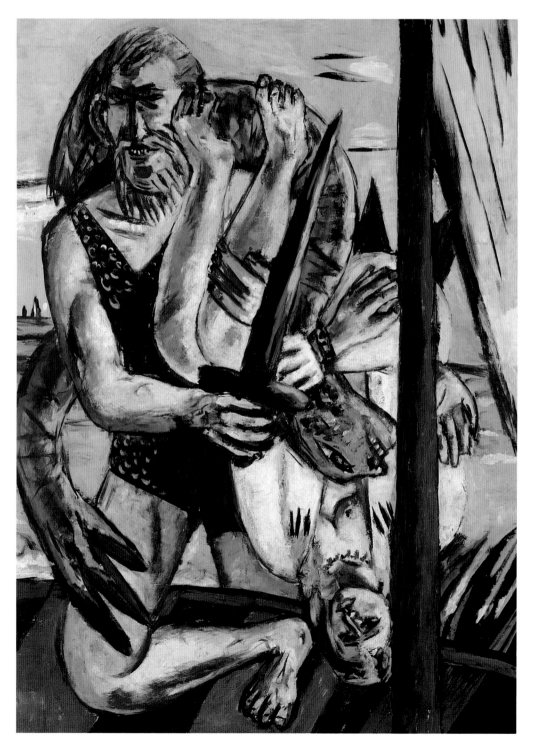

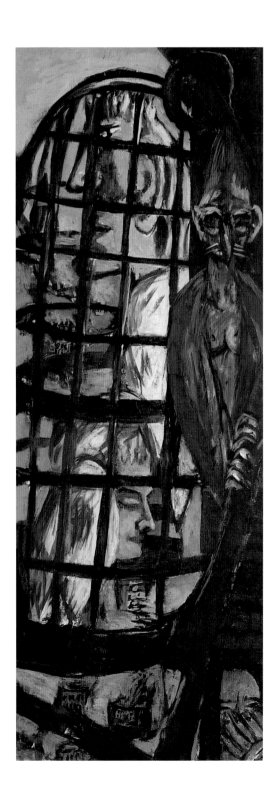

that he had painted the work himself as decoration for an officers' club. Peter's practical help in the risky business of transporting paintings was indispensable, but the contact with his son was also an important emotional link for the artist with his former world.[30]

The other key character in this cast of semi-official, clandestine supporters was the art historian Erhard Göpel ('Pöky' or 'Edgy' in the diaries) who, as an expert on Dutch and Flemish painting, was enlisted to track down works in the Netherlands for Hitler's projected museum in Linz. Göpel was stationed in The Hague but made monthly trips to Paris where the artists and writers he visited included Wassily Kandinsky, Georges Braque, André Segonzac, Paul Valéry and Ernst Jünger.[31] Beckmann's conversations about Dutch art with this shy, intellectual man whom he portrayed in 1944 (G660), complemented the artist's visits to the Rijksmuseum, the Rembrandthuis and the Mauritshuis in The Hague. The paintings Beckmann saw in these collections clearly influenced his work, above all the emblematic still lifes and Rembrandtesque self-portraits he painted in exile.[32]

Göpel made life more comfortable for Max and Quappi by supplying them with luxuries. He also bought paintings and attempted to drum up support for Beckmann. On occasion he risked transporting Beckmann's work – including the *Apocalypse* lithographs – back to Germany. Most importantly, Göpel protected Beckmann from being drafted into the German army. This was the greatest crisis of the Amsterdam years, which Beckmann ironically commemorated in his Grosz-like drawing, *Last Public Notice* 1944 (fig.29). The shock of his first call-up papers in 1942 precipitated the heart condition diagnosed as Angina

pectoris ('Peki' in Beckmann's diaries) from which he eventually died. Thanks to Göpel's intervention, Beckmann was twice declared unfit for military service.[33]

Among Göpel's unpublished papers, a curriculum vitae written in the 1960s suggests that he was indeed leading an extremely dangerous double life in Holland.[34] According to this testimony, Göpel used his position not only to help Beckmann, but also to ensure that the Dutch paintings he was collecting for Linz were bought from their owners for good prices. Despite his vulnerable position as a non-party member, Göpel claims to have saved some hundred and fifty Jews from being transported to the death camps. The shadow of Göpel's official wartime career nevertheless hung over his later life. Although he was cleared of all wrongdoing, in 1947 he was investigated for the minor role he played in the notorious Schloss affair, which had involved the seizure in 1943 of an important collection of Netherlandish paintings from a Jewish family in France.

The network of support from Germany that sustained Beckmann in Amsterdam put him in a very different category from other degenerate artists in exile such as Herbert Fiedler, who had met Beckmann in Berlin before the First World War. Fiedler was far more integrated into the local art scene. However, attacks on his work by the Dutch Nazi press and the lack of opportunity to exhibit and sell forced him to seek minor bureaucratic jobs in the occupying civilian administration. In 1944 he was drafted into the German army. When he returned to Amsterdam after the liberation he found his wife and child seriously ill, following the winter of hunger of 1944–5 which killed thousands of Dutch civilians.[35]

Beckmann met Fiedler about once a month during their

fig.29
Last Public Notice
1944
Ink on paper
50 × 63.2
(19 3/4 × 24 7/8)
Private collection

years of exile, mostly in the Café Americain on the Leidseplein, where they discussed art and politics and Beckmann talked about his current interests in Schopenhauer, Kant and Indian philosophy.[36] In his diary Fiedler noted that Beckmann was extremely depressed by current events: 'he looks old and ill and complains of neuralgia ... you can't help sensing that he is in decline. Beckmann lives an isolated existence, at least as an artist, the Dutch don't want to know about him.'[37]

Göpel later wrote that a group of about fifteen people constituted the whole of Beckmann's world during his years of exile. Alongside his semi-official group of supporters, Beckmann maintained relations with a circle of émigrés who were almost all involved in the Dutch resistance to the German occupation. By its very nature this resistance was informal and amorphous. Some reports suggest that fewer than 1,200 patriots worked full-time for the organised Dutch underground organisations, and yet 20,000 Dutch people were arrested because of their connections with the resistance.[38] Fierce emotional opposition to the persecution of the Jews and the labour draft erupted in the general strikes of February 1941, April 1943 and September 1944; and after 1943 a growing minority of Dutch residents hid Jewish children, students, former soldiers and young men who preferred to go underground as 'divers' rather than join the slave labour force in Germany. By 1944, 300,000 people were in hiding in Holland.

In her memoirs Quappi Beckmann recorded how their friend Mimi Kijzer was arrested twice for underground activities and sent to concentration camps, an ordeal which she miraculously survived. Hedda also provided temporary shelter for Jews and hid her future husband, the young Dutch organist Valentijn Schoonderbeek, who sought refuge on a church roof to escape the labour draft.[39] Friedrich Vordemberge-Gildewart, the German 'degenerate' artist whom Beckmann met every Thursday afternoon in the bars of Amsterdam, had close links to the resistance. He also produced a series of illegal art books with the young Dutch publisher Frans Duwaer, who was eventually shot by the Gestapo for more serious acts of sabotage.[40]

One of the most frequent visitors to Beckmann's studio during the occupation was Wolfgang Frommel, a German writer and poet from the circle of Stefan George. His conservative utopian tract entitled *Der dritte Humanismus* (The Third Humanism), which Frommel published under a pseudonym in 1932, achieved a certain notoriety in Germany in the mid-1930s, where it was initially embraced by conservative circles and subsequently banned by the Gestapo. Frommel responded to Hitler's cultural ideology by insisting, like Beckmann in his London speech, on a strict separation between art and politics. He fiercely opposed anti-Semitism and launched a camouflaged attack through a series of radio programmes, the 'Mitternachtssendungen' (Midnight Broadcasts), in which he enlisted scholars and scientists to quote clandestinely from Jewish authors by using pseudonyms. Frommel was forced to stop his radio transmissions in 1935, and he left Germany two years later. At the outbreak of war he was stranded in the Netherlands while visiting friends.[41]

Together with the artist Gisèle Waterschoot van der Gracht, Frommel spent the occupation protecting Jewish teenagers by sheltering them in Gisèle's house on the Herengracht.

no.106
*In the Circus
Wagon* 1940
86.5 × 118.5
(34 × 46 5/8)
Städtische Galerie
im Städelschen
Kunstinstitut,
Frankfurt am Main

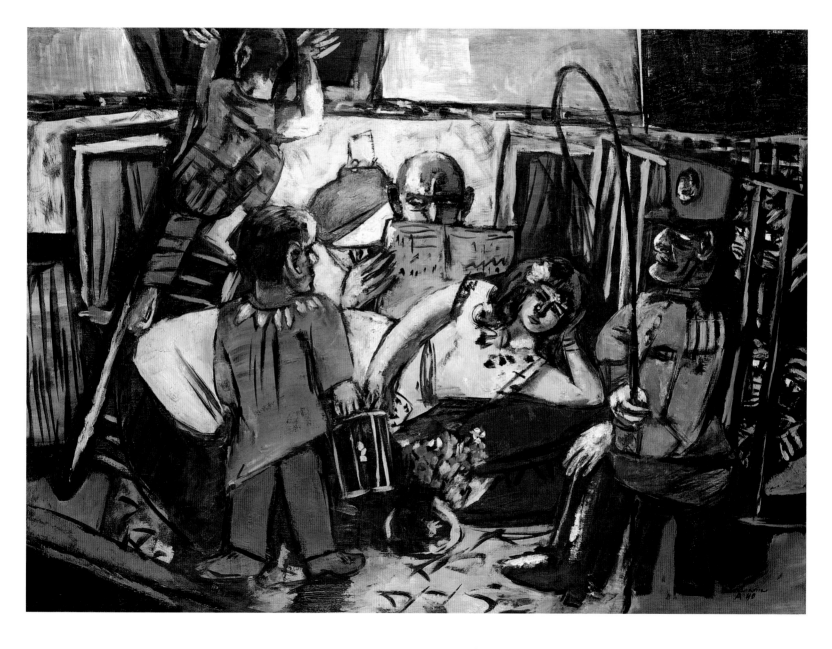

Herengracht. Frommel introduced the group (who remained together after the war and founded the Castrum Peregrini publishing house) to Greek art, literature and history, keeping their spirits up with a busy programme of writing, copying and reading verse.[42] The poet named his group the Argonauts, and gave Beckmann an essay to read on this theme which Göpel suggests directly inspired his triptych *Argonauts* 1949–50 (no.163).[43] Apparently, during one of his Sunday morning visits to the studio, Frommel asked why Beckmann only painted the 'chthonic underworld' of the cabaret, circus and brothel, and not the ideal classicism represented by his group.[44] 'All in good time, all in good time, Frommel', Beckmann had answered, 'Be patient!'[45] Beckmann undoubtedly valued his conversations with Frommel about the classical world, which complemented his discussions with Göpel about Dutch and Flemish painting. Both traditions fed into his triptychs, creating on occasion a dramatic counterpoint.

How much Beckmann knew about the underground activities of his friends remains questionable. Several laconic entries in his diary mention the 'bad news' he hears from Hedda or Vordemberge-Gildewart, and he also refers to arrests and internments. Ilse Leembruggen, for example, was sent to the Jewish transit camp at Westerborg in January 1943 because the Gestapo believed she knew where her Jewish granddaughters were hiding. With the help of an acquaintance who was collaborating with the Germans, Ilse was released two days later, but a heavy cloud hung over Beckmann in the wake of these events.[46] In July 1942, when the deportation of the Jews from Holland began, Beckmann noted in his diary 'Night-time, after midnight, J Transports'

and there are references in 1943 to his walks through the 'desolate and empty' Jewish streets.[47] In her memoirs, Quappi recalls a young resistance fighter jumping through an open window into their house as he fled from the Gestapo across the rooftops. Beckmann let him out through the front door, and subsequently visited Gestapo headquarters to plead successfully for the release of the local milkman, who had lodged the fugitive unawares.[48] In his diary Beckmann refers to these events only with the terse remark 'Window crashed in.'[49] His references to the Dutch strikes in 1941 and 1943 are similarly brusque: on 27 February 1941, he wrote: 'The strike is over. Terrible weather – *Brown Sea* finished'.[50] And on 30 April 1943, at the peak of the general strike: 'Bicycle ride in the woods. At night the English were at it again – hour after hour. Otherwise everything finished at 8pm again due to the strike.'[51]

This apparent lack of interest underlines the distance Beckmann maintained from the dangerous affairs of his friends. Gisèle Waterschoot van der Gracht confirms that Beckmann knew about and appreciated their protection of the Jewish youths.[52] In his diary he carefully masks Gisèle's identity, but there is no sign that he knew how close Frommel's group was sailing to the wind. In 1944 they were joined by Percy Gothein, who aimed to establish contact between the Kreisauer Kreis of resistance fighters inside Germany and the British, via a Dutch radio transmitter. After the assassination attempt on Hitler failed on 20 July, Gothein was arrested. He died in December in the concentration camp at Neuengamme.[53]

The left wing of Beckmann's triptych *Actors* 1941–2 (no.107) may represent an occasion when the Gestapo searched

no.107
Actors 1941–2
Side panels:
200 × 85
(78 ³/₄ × 33 ¹/₂)
Central panel:
200 × 150
(78 ³/₄ × 59)
Courtesy of the
Fogg Art Museum,
Harvard University
Art Museums

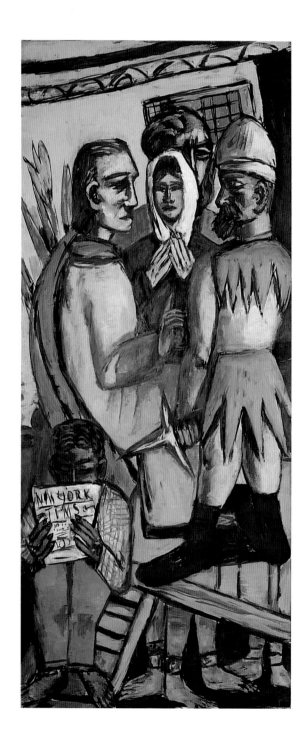

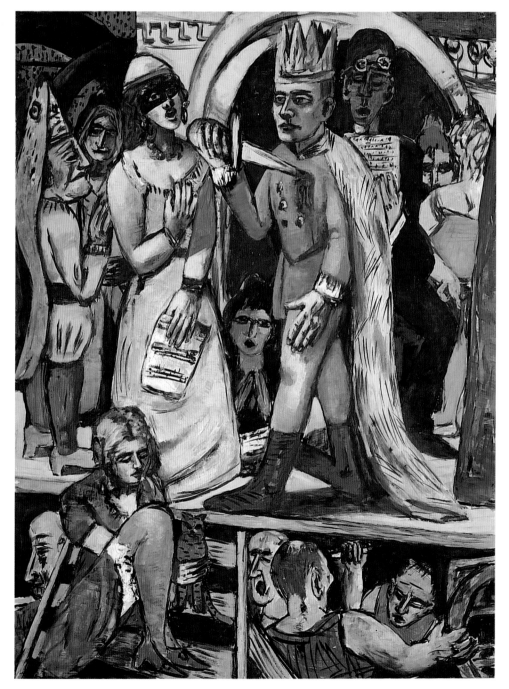

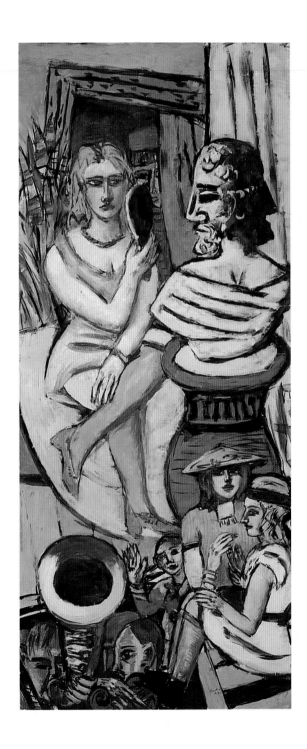

no.108
Double-Portrait,
Max Beckmann
and Quappi 1941
194 × 89
(76 3/8 × 35)
Stedelijk Museum,
Amsterdam

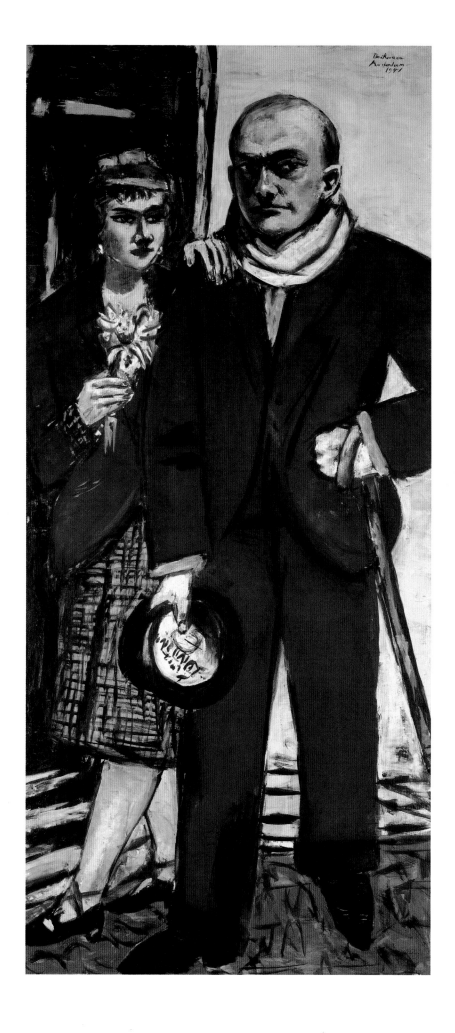

Gisèle's house. During this terrifying raid one Jewish boy hid inside a pianola while the others climbed into a concealed attic.[54] In a conversation with Göpel, Frommel claimed that the feet beneath the stage in *Actors* belong to the divers, while he and Gisèle confront a German field marshal who has been transformed into a fierce Nordic warrior.[55] Beckmann's Jewish dealer, I.B. Neumann, who had emigrated to the United States in 1923, perches on the stage steps reading a forbidden copy of the *New York Times*.

Whether or not we are convinced by this interpretation,[56] a more general point needs to be made in relation to Wolfgang Frommel and Beckmann's other exiled and semi-official friends. Everybody was involved in what Göpel later described as the 'masquerade of concealment'.[57] Disguise and role-playing are themes that run through all the Amsterdam triptychs, as well as the scenes of torture, rape and pillage, which are more obviously connected to the horrors of war. Moreover, the strategy of masked criticism which Frommel employed in his *Mitternachtsendungen* and continued to use in the wartime publications he wrote under various pseudonyms, was one of the limited means of resistance available to artists at the time.

Coded references and symbols were endemic to Beckmann's vision because they reflected, in his mind, the mystery of the universe and the multiple and paradoxical significance of objects and events. During the years of exile, coding nevertheless took on an extra dimension. In a letter written in August 1945, Vordemberge-Gildewart remarked that 'it still seems incredible to be able to write a letter where I am not forced to make coded, veiled references because of those damned Gestapo'.[58] There are instances in Beckmann's Amsterdam paintings where he clearly uses coded references of this kind, for example, by writing the word 'London' inside his hat in *Double-Portrait, Max Beckmann and Quappi* 1941 (no.108). While he was working on this painting, we learn in his diary that English bombers were continually passing overhead. Beckmann had delivered his speech in London in 1938, and London was also the refuge of the Dutch royal family and the seat of the government in exile. For the Dutch people who listened in their thousands to Radio Orange, the city was a potent symbol of their resistance to German rule. Although he had no special talent for languages, Beckmann had a habit of peppering his speech with foreign idioms, and it seems likely in this instance that he is literally 'taking off his hat' to the British. Possibly this reference was acknowledged by the director of the Stedelijk, Jonkhheer David Roëll, who bought Beckmann's double portrait for the Stedelijk in May 1945, just before the liberation.

Topical references recur in many of Beckmann's Amsterdam paintings, for example in the banned foreign or possibly underground newspapers which so many of his characters read. Yet Beckmann threads these references into a tapestry of far greater complexity and scope. In a conversation with Frommel, he once referred to his ambition to mirror the fundamental characteristics of his epoch, in the way that Balzac mirrored nineteenth-century society in his *Comédie humaine*.[59] But Beckmann also wanted to elevate the capricious, ephemeral events of the present onto a visionary plane which would reflect eternal truths. His enthusiasm for the paintings of William Blake, which he saw in London in 1938, surely relates to Blake's ability to encompass both topical and universal realms. Beckmann's

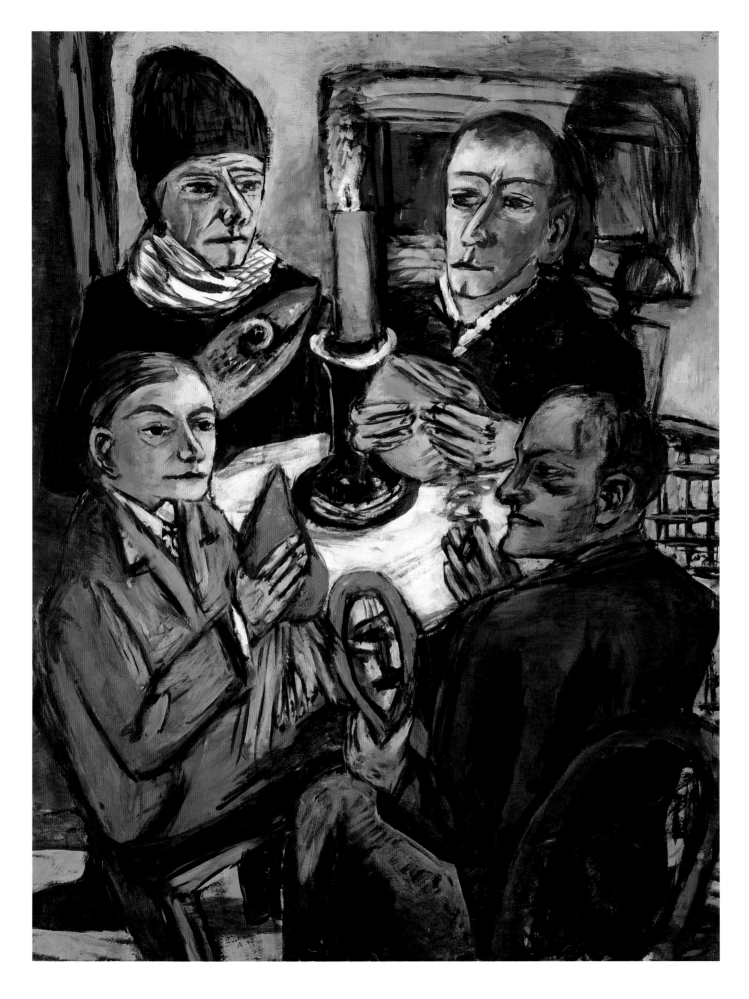

204

Amsterdam triptychs are ambitious attempts to combine these different and potentially contradictory aims within single, polyphonic works.

Meanwhile Beckmann orchestrated his meetings with the diverse characters who made up his world in Amsterdam, observing a human drama made more intense and tragic by the events of war. Beckmann kept the various strands of his life apart because it was too dangerous to bring them together, and the artist was at his most alert and creative performing a precarious balancing act between opposing camps. His sympathies, however, were clearly with the small group of artists who were struggling to survive in Amsterdam and resisting the German occupation as best they could. Symbolically, he united these friends for a ceremonial meal in *The Artists with Vegetables* 1943 (no.109). Vordemberge-Gildewart is on the left, holding a large carrot, while Herbert Fiedler, wearing a hat and scarf to protect him from the cold and grasping a fish, sits behind the table alongside Wolfgang Frommel, who is holding a cabbage. Beckmann completes the group, seated in the foreground and holding a mirror which reflects a hidden face. The large burning candle in the middle of the table (which recurs in numerous Amsterdam paintings), like the simple foods and winter clothes, refers to the blackouts and hardships of the occupation. But this is also a ritual meal, a symbolic last supper, in which the figures gather around a candle that represents the eternal flame of the spirit, but which, like the mirror, is also a symbol of our frail mortal state.

In the last two years of the war, one other Amsterdam figure took on crucial importance in Beckmann's life. This was Dr Helmuth Lütjens, a German art historian who assumed Dutch nationality and had directed the Amsterdam branch of Paul Cassirer's gallery since 1923. In February 1943, Göpel became aware of a threat to confiscate Beckmann's paintings, and he asked Lütjens to hide a number of works from the artist's studio in his house on the Keizersgracht. In this sense, Beckmann's paintings also became 'divers', and a friendship grew up between the artist and the cultured, reserved man whom Beckmann referred to as 'Knight L' in his diary. During the winter of 1944–5 they spent their Friday mornings together, viewing Beckmann's paintings from the hidden store.

During the occupation, Lütjens hid works of art for many Jewish families which he returned to survivors after the liberation. He was close to Willem Sandberg, the curator and subsequent director of the Stedelijk Museum who was also a leading figure in the Dutch resistance. Sandberg was forced into hiding in March 1943, when he was involved in the spectacular resistance attack on the Amsterdam population registry in the Plantage neighbourhood, close to the notorious Hollandsche Schouwburg where Jews were collected for deportation. The efficient population registration in Holland made going into hiding more difficult, and the destruction of these records was a major coup for the resistance. Sandberg continued to visit the Lütjens household when he was in hiding, using a false identity.[60]

When the liberation seemed imminent in September 1944, the Beckmanns sheltered in Lütjens's house for one week, fearing that they would be attacked as German nationals by Dutch patriots and deported to Germany when the Allies arrived. During this time Beckmann conceived the idea for a family portrait, which was assembled from separate studies

no.110
Portrait of Family
Lütjens 1944
179.5 × 85
(70 ³/₄ × 33 ¹/₂)
Private collection

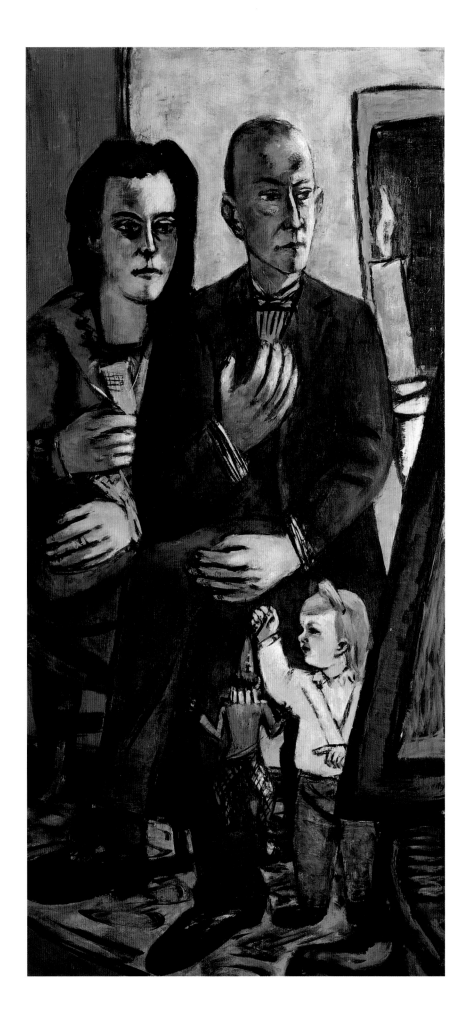

and shows the grave, shadowed faces of Lütjens and his wife Nelly alongside a symbolic blackout candle, which floods their small daughter, Rietje, with light. During the 1944–5 winter of hunger, when there was no electricity or fuel, the Lütjens family shared their rations with the Beckmanns, and in May 1945, when the Allies finally arrived in Amsterdam, they sheltered the artist and his wife once again until their position was more or less secure.[61] The dinner they shared with the Beckmanns and other friends to celebrate the liberation was an emotional event: Gisèle Waterschoot van der Gracht arrived on this occasion in the company of twenty young Jewish men intent on toasting their new-found freedom with a single bottle of gin![62]

The end of the war heralded a new phase in Max Beckmann's life. He quickly re-established his contacts in the United States, which facilitated his final odyssey to the new world in 1947 and a period of emigration which was very different from the years of exile in Amsterdam. When he learnt of the successful opening of his first postwar exhibition at the Buchholz Gallery in spring 1946, he remarked to his friend Vordemberge-Gildewart that Amsterdam was merely 'a suburb of New York'.[63]

However relieved Beckmann was to leave Holland, he was also attached to the city where he had created a number of his most important works. The war was a source of extreme anxiety and depression, but it had also presented him with a unique challenge. Max Beckmann's resistance took the form of the 'pride' and 'defiance' which allowed him to preserve his imaginative freedom.[64] In December 1940, at the beginning of his ordeal, he reminded himself that 'the role you are playing at present is the most difficult but also the greatest

that life could offer you – don't forget it'.[65] Looking back on their years of isolation and exile six years later, Vordemberge-Gildewart remarked:

it really was no small effort to stand in front of the canvas and act as though everything was going fine. And yet it was outside circumstances which gave one the impetus to go on working fanatically and conscientiously to create something better and healthy and positive in the face of all the rottenness. Only recently I was saying to Max Beckmann that we almost needed to recreate the attitude of protest artificially, so that we could work as strongly as we had before.[66]

Notes

1 Mathilde Q. Beckmann, *Mein Leben mit Max Beckmann*, Munich 1983, p.22.

2 See in particular F.W. Fischer's publications, *Max Beckmann – Symbol und Weltbild. Grundriß zu einer Deutung des Gesamtwerkes*, Munich, and *Der Maler Max Beckmann*, Cologne, both 1972, which have greatly influenced subsequent scholarship.

3 Dagmar Walden-Awodu, *Geburt und Tod. Max Beckmann in Amsterdamer Exil*, Worms 1995 examines the period from an art historical rather than a biographical and historical viewpoint. The author does not, for example, trace Beckmann's friendships in Amsterdam and their potential influence on his work.

4 Mathilde Q. Beckmann 1983, pp.22–3.

5 The first anti-Jewish regulation in occupied Holland was the introduction of the 'ancestry forms' in October 1940 which all 200,000 civil servants, including museum employees, were required to fill in, indicating their religion and that of their parents and grandparents. One month later Jewish civil servants, including Jaffé, were dismissed. In Leiden and Delft students went on strike to protest against the dismissal of their Jewish university teachers.

6 Querido Verlag was actually the German branch of the Dutch publishing house Querido, led by the anti-fascist social democrat Emanuel Querido. The German branch was led by Fritz Landshoff, who was fired from his position as director of Kiepenheuer Verlag in Berlin in 1933, and fled to Holland together with several of his Jewish staff. In 1933 Allert de Lange started a German branch of his publishing house in Holland. See Hans Würzner and Karl Kröhnke (eds.), *Deutsche Literatur im Exil in den Niederlanden, 1933–1940* Amsterdam 1994, and Kurt Löb, *Exil-Gestalten, deutsche Buchgestalter in den Niederlanden, 1932–1950*, Arnhem 1995. I am grateful to Beatrice von Boorman for indicating these sources and for generously sharing her knowledge and discussing many aspects of the present essay.

7 See Stephanie Barron (ed.), *Exiles and Emigrés: The Flight of European Artists from Hitler*, exh. cat., Los Angeles County Museum of Art 1997.

8 Mrs Nelly Lütjens, interviewed by the author on 28 June 2002, remembered this detail.

9 See Hans Gallwitz, Use M. Schneede and Stephan von Weise, Max Beckmann, *Briefe*, vol.3, 1937–1950, Munich 1996, p.20. Several unpublished letters in the Marie-Louise von Motesiczky archives in London refer to these events.

10 Author's interview with Miriam Kahn, Amsterdam, 15 November 2001.

11 See Rudolf M. Heilbrunn, 'Errinerungen an Max Beckmann', *Frankfurter Rundschau*, 28 December 1960, p.6.

12 The artist was Gerrit van't Net. I am grateful to Beatrice von Boorman for this information..

13 16 June 1938. This article gives a review of Beckmann's career and attempts to relate him to the modern tradition represented by Gauguin and Cézanne.

14 Käthe von Porada, whom Beckmann had known since the 1920s, organised a private exhibition of Beckmann's work in her Paris flat in June 1938. Stephan Lackner (or Ernst Morgenroth as he was then known) met Beckmann in 1932 and began to collect his work. His memoirs of their friendship are recorded in several texts, including *Ich erinnere mich gut an Max Beckmann*, Mainz 1967. By the same author: *Max Beckmann: Memories of a Friendship*, Miami 1969, 'Exil in Amsterdam und Paris' in *Max Beckmann Retrospektive*, exh. cat., Haus der Kunst, Munich 1984 pp.147–72 and 'Shared Exile: My Friendship with Max Beckmann, 1933–50,' in *Max Beckmann in Exile*, exh. cat., Guggenheim Museum, New York 1997, pp.107–16. Lackner fled France to the United States in September 1939.

15 English translation in Barbara Copeland Buenger (ed.), *Max Beckmann: Self-Portrait in Words. Collected Writings and Statements, 1903–1950*, Chicago and London 1997, pp.298–307.

16 Ibid., p.305.

17 Rudolf Pillep (ed.), *Max Beckmann, Die Realität der Träume in den Bildern*, Leipzig 1987, p.433.

18 Erhard Göpel, 'Die Entstehung des Werkes,' in G.G. Heise (ed.), *Max Beckmann, Die Argonauten*, Werkemonographien zur bildenden Kunst, 1957, p.18: 'In Holland, after his emigration in 1937, he painted *Acrobats*, which refers to the balancing act of his situation, and to the threat of war – Mars appears in the right-hand panel.'

19 *Max Beckmann: Briefe*, vol.3, 1996, pp.67–8. Letter to Sigmund Morgenroth, 30 November 1939

20 Erhard Göpel (ed.), *Max Beckmann, Tagebücher 1940–50*, Munich 1955, revised ed. 1979. Beckmann's later painting of the airport, *Schipol* 1945 (G700), depicts a site which became symbolic of the air attacks on Amsterdam. The airport was destroyed first by Allied bombers aiming at the German occupying forces, then by the Germans themselves as they began to flee Holland in September 1944. The airport was subsequently used as a dropping off point for Allied food parcels in spring 1945, and it was finally rebuilt by the Dutch in November 1945.

21 Ibid., entry for 7 December 1943.

22 The manuscript of Beckmann's diary, which Quappi edited and published in an abridged form in 1955, is written in a spidery hand which is almost impossible to decipher. These manuscripts are in the possession of Beckmann's family.

23 Interview with Barbara Göpel, 21 November 2001.

24 *Briefe*, vol.3, 1996, pp.54, 387. Letter to Quappi, May 1939.

25 Lilly von Schnitzler-Mallinckrodt: 'Das Entstehen einer Beckmann-Sammlung' in *Blick auf Beckmann, Dokumente und Vorträge*, ed. E. Göpel, Munich 1962. p.178.

26 *Apocalypse* escaped the censorship of the Nazi ministry of propaganda by being produced in a private edition of under twenty-five copies. In the event, about thirty-five copies were produced, including several handcoloured versions.

27 Buchholz visited Beckmann in Amsterdam in January 1942. On 27 August 1942, he bought six paintings from Beckmann by letter. See *Max Beckmann: Briefe*, vol.3, 1996, p.398. Buchholz financed the Buchholz Gallery in New York, directed by Curt Valentin.

28 Felix Billeter, *Max Beckmann und Günther Franke*, exh. cat., Max Beckmann Archivs in Staatsgalerie moderner Kunst, Munich 2000, p.33.

29 Ibid., p.32.

30 Beckmann maintained a close relationship with his son for the rest of his life. After 1947, when Beckmann emigrated to the USA, they kept up a steady correspondence and the artist frequently consulted Peter about his declining state of health.

31 Göpel arranged for Beckmann to paint Ernst Jünger's portrait, but apparently Jünger lost his nerve about this project. Interview with Barbara Göpel, Munich 21 November 2001.

32 See Barbara Copeland Buenger, *Max Beckmann's Artistic Sources*, PhD dissertation, Columbia University 1979, Facsimile by UMI, Ann Arbor 2000, and Christian Lenz, *Max Beckmann und die alten Meister*, Munich 2000.

33 June 1942 and May 1944.

34 Gopel's archives are in the Bayerische Staatsbibliothek, Munich.

35 See Beatrice von Boorman, *Herbert Fiedler (1891–1962) Berlijn, Parijs, Amsterdam*, Laren 2001, pp.21–3.

36 Fritz Erpel, *Max Beckmann, Leben im Werk. Die Selbstbildnisse*, Berlin 1985, p.78.

37 Von Boorman 2000, p.25.

38 See, for example, Werner Warmbrunn, *The Dutch under German Occupation 1940–45*, Stanford 1963, pp.266–8. Statistics are also given in the catalogue of the Verzetsmuseum Amsterdam, which provides a detailed history of the Dutch resistance in the context of everyday life.

39 Mathilde Q. Beckmann 1983, p.33.

40 Deitrich Helms (ed.), *Vordemberge-Gildewart: The Complete Works*, Munich 1990, pp.25–6. Herbert Fiedler also hid his friends in his garden shed. He was released from internment after the war partly because of these activities.

41 *Wolfgang Frommel, Argonaut im 20. Jahrhundert. Ein Leben in Dichtung und Freundschaft*, exh. cat., Oberrheinische Dichtermuseum, Karlsruhe 1994 and Michael Philipp, *Vom Schicksal des deutschen Geistes, Wolfgang Frommels Rundfunkarbeit an den Sendern Frankfurt und Berlin 1933–35 und ihre oppositionelle Tendenz*, Postdam 1995.

42 See Claus Victor Bock, *Untergetaucht unter Freunden, Ein Bericht 1942–1945*, Amsterdam 1998; also author's interview with Gisèle Waterschoot van der Gracht, 14 November 2001.

43 See Göpel 1957, p.24. An exchange took place in 1943 which was commemorated by a photograph of *Young Men by the Sea* 1943 (no.3) which Beckmann gave to Frommel and inscribed: 'In memory of our Argonauts conversation'.

44 'Kommt alles, kommt alles, Frommel, warten Sie nur!' Ibid., p.5.
45 Frommel 1994, p.29.
46 Göpel 1955 entries for 18 and 20 January 1943: 'Aunt Ilse to W – very depressed' and 'Ilse is back. Nevertheless, a bad day, no wish to work, to live or to die.'
47 Göpel 1979, entries for 27 July 1942, 29 May and 22 July 1943.
48 Mathilde Q. Beckmann 1983, pp.31–2.
49 Göpel 1979, entry for 21 August 1943.
50 Ibid., p.30
51 Ibid p.62.
52 Interview with Gisèle Waterschoot van der Gracht, 14 November 2001.
53 Bock 1998, p.97, 116–17.
54 Interview with Gisèle Waterschoot van der Gracht 14 November 2001.
55 Göpel 1957, p.4, based on a recorded conversation with Frommel that took place in 1953.
56 In Bock 1998, p.136 Claus Victor Bock, who was in the house, dates this event after Gothein's arrest in 1944 and Quappi disagreed with the identification of the figures.
57 Göpel 1957, p.18.
58 Letter to Julius Bier, 17 August 1945 in Helms 1990, p.25.
59 Frommel 1994, p.27.
60 Interview with Mrs Nelly Lütjens and Dr Annemarie Lütjens, Bergen 28 June 2002.
61 Lütjens enlisted the help of Johnkheer David Roëll, Director of the Rijksmuseum after 1945, to ensure that the Beckmanns were allowed to remain at liberty in Amsterdam. Roëll, who was director of the Stedelijk Museum during the war, not only purchased *Double-Portrait, Max Beckmann and Quappi* in May 1945, but also mounted an exhibition of about fourteen of Beckmann's paintings at the Stedelijk that September. During the period directly after the war when it was impossible to draw money from the bank, Lütjens shared his salary with the Beckmanns and paid their electricity bills. He also helped other emigré artists, including Herbert Fiedler. In August 1946 Beckmann was granted non-enemy status by the Allies.
62 Interview with Mrs Nelly Lütjens, 28 June 2002. Beckmann was apparently ovewhelmed at this dinner and withdrew to his room in the Lütjens house.
63 'Über die Begegnung mit Max Beckmann' (1954) in Dieter Helms, *Friedrich Vordemberge-Gildewart, Schriften und Vorträge*, St Gallen 1976, p.42. Possibly with a typical interest in word play, Beckmann was referring to New York's old name, New Amsterdam.
64 This reference is to Beckmann's diary entry of 4 May 1940, Göpel 1955, p.10.
65 Göpel 1979, entry for 18 December 1940.
66 Letter to Kate Steinitz, 7 July 1946 in Helms 1990, pp.27–8.

Apocalypse 1941–2
Day and Dream 1946

nos.111–27
Apocalypse
1941–2
82 page book
including 27
handcoloured
lithographies
(17 exhibited)

Published by
Bauersche
Gießerei, Frankfurt
am Main 1943
Numbered edition
of 24
Artist's proof
Private collection

no.111
Illus.1
Frontispiece
Image size:
33.3 × 27.8
(13 1/8 × 11)

During the last ten years of his life Beckmann was commissioned to make two print portfolios: *Apocalypse* and *Day and Dream*. Both portfolios depict visionary images that are nonetheless rooted in reality. In terms of style and the circumstances of their commission, however, the portfolios diverge widely.

Beckmann received the commission for *Apocalypse* from Georg Hartmann in 1941, while living in exile in Amsterdam. Hartmann, a young successful businessman, owned the Bauersche Gießerei, a typeface foundry in Frankfurt. He was an important art patron in Frankfurt, where Beckmann had lived for almost twenty years. In addition, Hartmann asked Beckmann in 1943 to produce a portfolio of ink drawings illustrating

the second part of Goethe's *Faust*, thereby providing much needed financial support during Beckmann's years in Dutch exile.

Beckmann drew the twenty-seven images for the *Apocalypse* portfolio with lithography crayon on transfer paper. The drawings were pressed on stone in Frankfurt and privately printed at Hartmann's foundry. The printing was limited to an edition of twenty-four to avoid the stipulation that any edition exceeding twenty-five had to be submitted to the Propaganda Ministry for approval. Beckmann probably handcoloured four to six editions, while others were illuminated by watercolourists in Frankfurt. The set illustrated here was almost certainly handcoloured by Beckmann and kept as the archive copy at the Bauersche Gießerei.

It only came to light at an auction in early 2002 and is now exhibited for the first time.

The *Apocalypse* portfolio illustrates the New Testament Book of Revelation prophesying the apocalyptic doom of humankind. For Beckmann, who worked on the drawings for the portfolio during the height of the Second World War, the disastrous account by John the Evangelist must have been at once visionary and real. The colophon of the portfolio recites: 'This book was printed in the fourth year of the Second World War, as the visions of the apocalyptic seer became dreadful reality.' In some of the prints Beckmann lends his own features to the Evangelist, identifying with the visionary John amidst disastrous scenes unfolding in contemporary Europe. In other prints he

no.112
Illus.6
Rev. 4:1–8:
'"... in Heaven an
open door! ... with
one seated on the
throne!"; round the
throne were twenty-
four elders, before it a
"sea of glass", and the
four living creatures
full of eyes'

Image size:
27.6 x 21.1
(10 7/8 x 8 1/4)

no.113
Illus.7
Rev. 5:1–7:
'The scroll "sealed
with seven seals"
and the lamb
"standing as
though it had
been slain, with
seven horns and
with seven eyes"'

Image size:
20.3 x 19.5
(8 x 7 3/4)

depicts himself as the tormented and consoled souls of John's visions, perhaps reflecting his own frightening experiences exiled in Amsterdam under German occupation and attacked by the National Socialists, who had branded his work 'degenerate'.

Day and Dream was commissioned in early 1946, shortly after the war ended, by Curt Valentin, one of Beckmann's dealers who had emigrated from Berlin to New York. While Beckmann was working on this portfolio, Valentin organised the first postwar exhibition of Beckmann's paintings and prints in New York. It was an enormous success: almost all of the works were sold amid positive reviews by art critics.

Beckmann was given wide latitude to

choose his subject matter and technique for the fifteen lithographs of *Day and Dream*. Valentin determined only the size and number of the prints. Beckmann worked in a variety of styles to complete the commission. He executed most of the drawings on transfer paper with lithographic ink and a sharp quill pen, a technique he had not used since his first experiments in printmaking. He also worked with a soft lithography crayon in three drawings. In some prints Beckmann drew his motifs with a complex and dense configuration of lines, and in others he rendered them with a bare outline. Beckmann handcoloured four sets of the portfolios in 1948.

Day and Dream was intended to introduce and promote Beckmann's work to a wide

American audience, bringing together diverse images and themes from Beckmann's oeuvre. The portfolio starts characteristically with a self-portrait (no.128). It defines, as a signature piece, the creator and narrator, who at the age of sixty-two is still determined, unflinchingly, to confront the world in all its facets. The subject matter of *Day and Dream* is representative of Beckmann's work: the circus, the relationship between man and woman, the brutality of life as experienced during the two world wars, and various mythological and Christian iconographies. The overarching theme of the commission is loosely given by its title *Day and Dream*, which refers to Beckmann's fascination with the interplay between reality and visionary experience.
Susanne Bieber

no.114
Illus.8
Rev. 6:2–8:
'The riders of the
apocalypse'
Image size:
24.9 × 17
(9 3/4 × 6 3/4)

no.115
Illus.11
Rev. 8:6–13:
'The four plagues of
the seven trumpets:
Hail, a burning
mountain being
thrown into the sea,
a great star that fell
from the heaven, and
the partial eclipse of
the sun and the moon'
Image size:
34.3 × 26.7
(13 1/2 × 10 1/2)

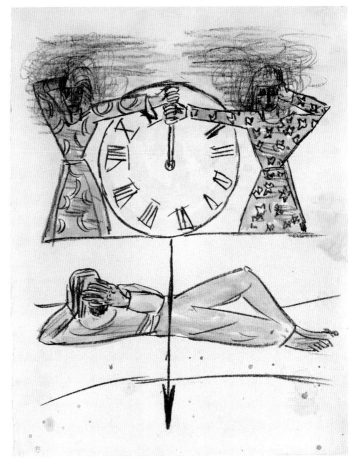

no.116
Illus.12
Rev. 9:3–10:
The aftermath of
the fifth trumpet:
locusts with crowns,
human faces,
women's hair, lions'
teeth and 'their
power of hurting
men for five months'
Image size:
32.4 × 27.4
(12 3/4 × 10 3/4)

no.117
Illus.13
Rev. 10:1–8:
The depiction of
the sixth trumpet:
the angel, standing
on sea and land,
who swore 'that
there should be no
more delay'
Image size:
31.3 × 25.4
(12 3/8 × 10)

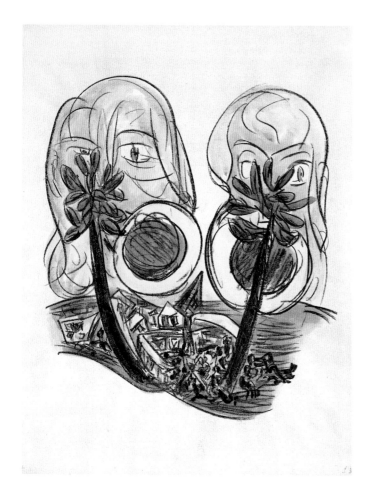

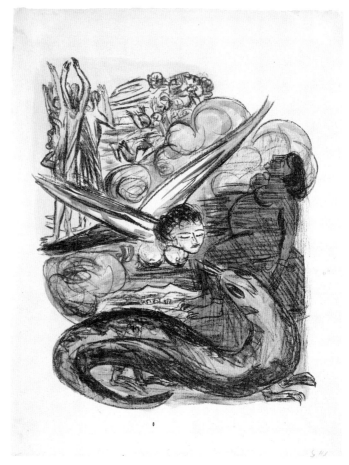

no.118
Illus.14
Rev. 11:1–13:
'The two
witnesses, the
two olive trees'
Image size:
31.1 x 27.4
(12 1/4 x 10 3/4)

no.119
Illus.15:
Rev. 12:2–16:
'The woman and
dragon of the
apocalypse'
Image size:
31.9 x 26.7
(12 1/2 x 10 1/2)

no.120
Illus.16
Rev. 13:1–14:
'The beast from the
sea with ten horns
and seven heads,
one of which
seemed to have a
"mortal wound",
and the beast from
the earth with two
horns'
Image size:
34.5 × 26.6
(13 5/8 × 10 1/2)

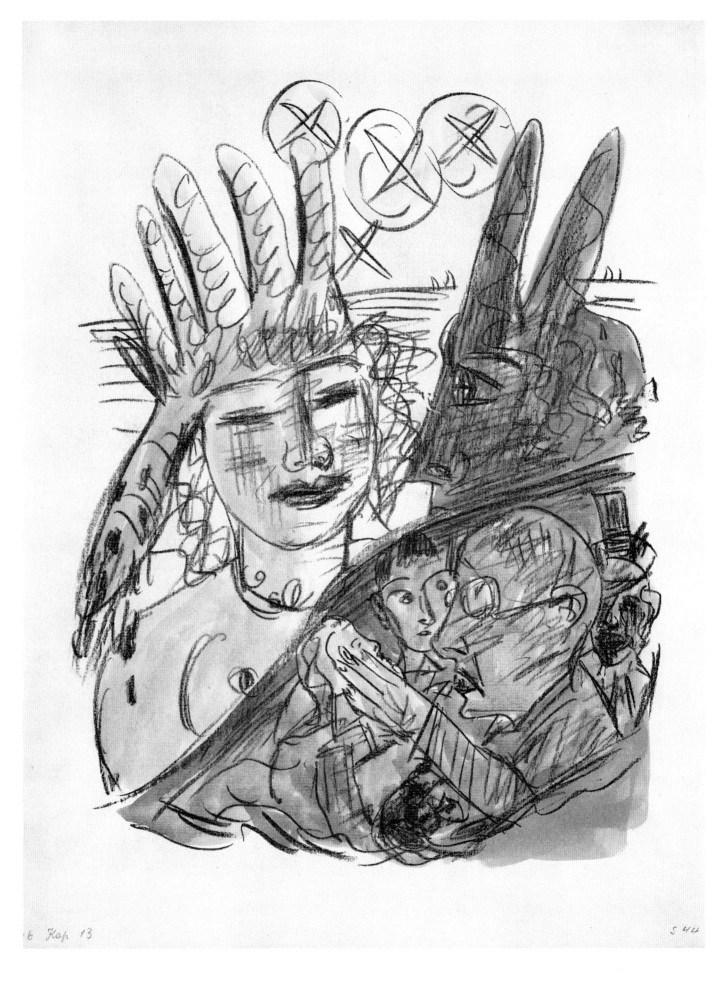

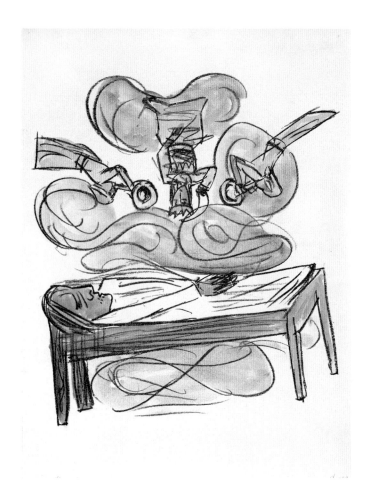

no.121
Illus.17
Rev. 14:13–16:
'"One like a son of
man" on a white
cloud, with a
golden crown and
a sickle'
Image size:
27 × 25.6
(13 7/8 × 10 1/8)

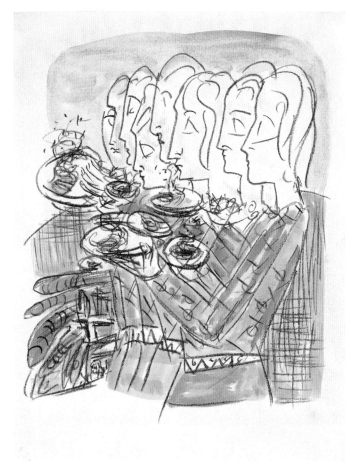

no.122
Illus.18
Rev. 15:6–8:
'The seven bowls of
wrath which were
given to the "seven
angels" as "seven
golden bowls full of
the wrath of God …
and the temple was
filled with smoke."'
Image size:
32.2 × 27.8
(12 3/4 × 11)

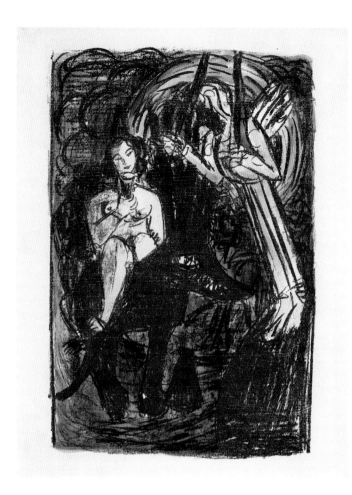

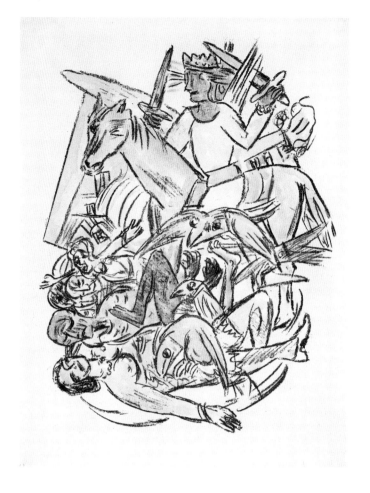

no.123
Illus.21
Rev. 17:3–5:
'The harlot with a
golden cup, sitting
on a beast with
seven heads and
ten horns'
Image size:
34.9 × 23.3
(13 3/4 × 9 1/4)

no.124
Illus.23
Rev. 19:11–19:
'The rider who "will
tread the wine press
of the fury of the
wrath of God the
Almighty", on a
white horse, and the
call to all the birds to
eat the flesh of men'
Image size:
35.2 × 27
(13 7/8 × 10 5/8)

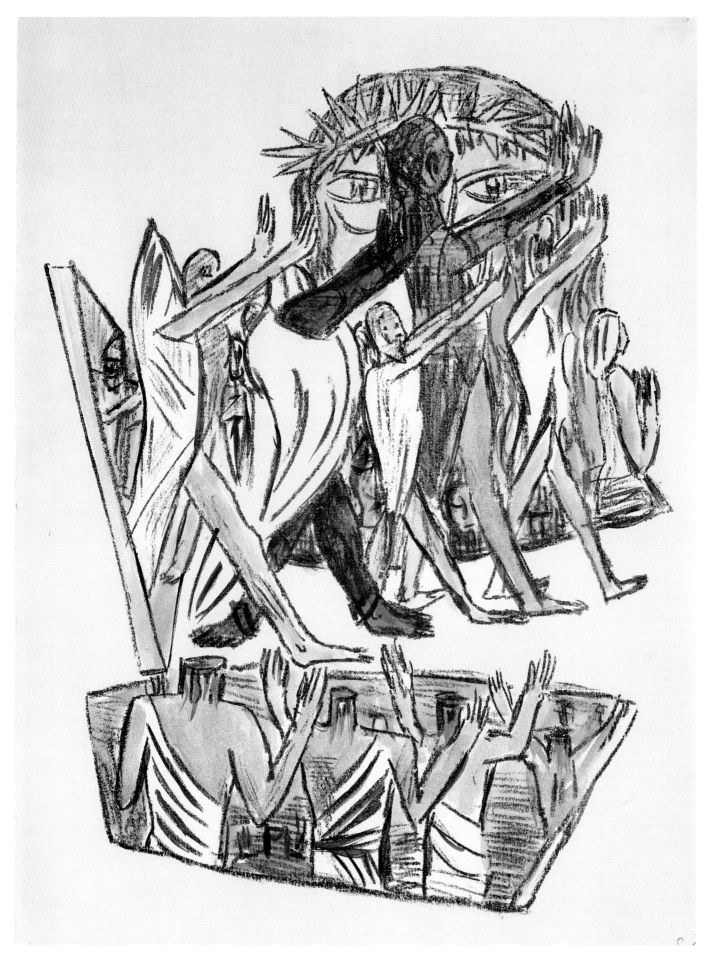

no.125
Illus.24
Rev. 20:4 and
20:11–12:
'The resurrection
of "the souls of
those who had
been beheaded"
and the Last
Judgement with
the "dead, great
and small,
standing before
the throne" and
"him who sat upon
it; from his
presence earth and
sky fled away"'
Image size:
33.2 × 26.1
(18 1/8 × 10 1/4)

no.126
Illus.25
Rev. 21:1–4:
'"Then I saw a
heaven and a new
earth." "...[and] He
[God] will wipe
away every tear."'
Image size:
33.2 x 26.3
(13 1/8 x 10 3/8)

no.127
Illus.26
Rev. 22:5–8:
'"The Lord God will
be their light." "And
I, John, am he who
heard and saw
these things" and
those "who keep
the prophesies of
this book".'
Image size:
33.7 x 27
(13 1/4 x 10 5/8)

nos.128–142
Day and Dream
1946
Portfolio of 15
handcoloured
lithographs
Published by Curt
Valentin, New York
1946
Edition of 90
No.29/90
40 × 30
(15 ³/₄ × 11 ⁷/₈)
Kunsthalle Bremen

no.128
Plate 1:
Self-Portrait

no.129
Plate 2:
Weather-vane

no.130
Plate 3:
Sleeping Athlete

no.131
Plate 4:
Tango

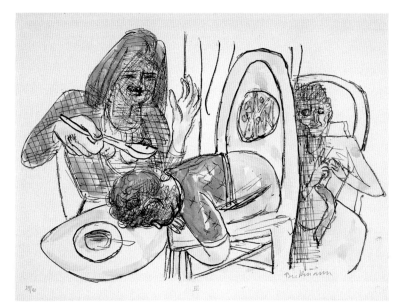

no.132
Plate 5:
Crawling Woman

no.133
Plate 6:
*I Don't Want To Eat
my Soup*

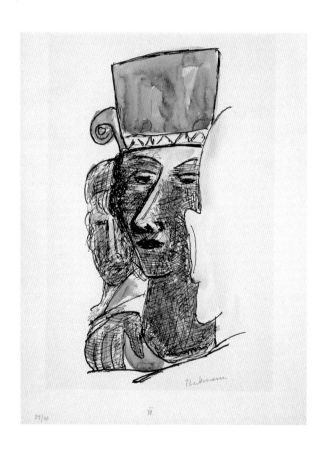

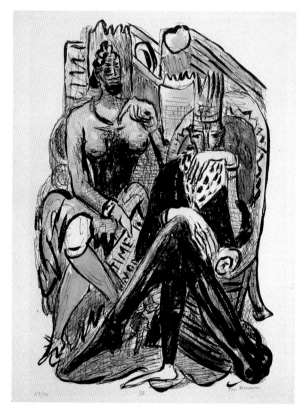

no.134
Plate 7:
Dancing Couple

no.135
Plate 8:
*King and
Demagogue (Time
Motion)*

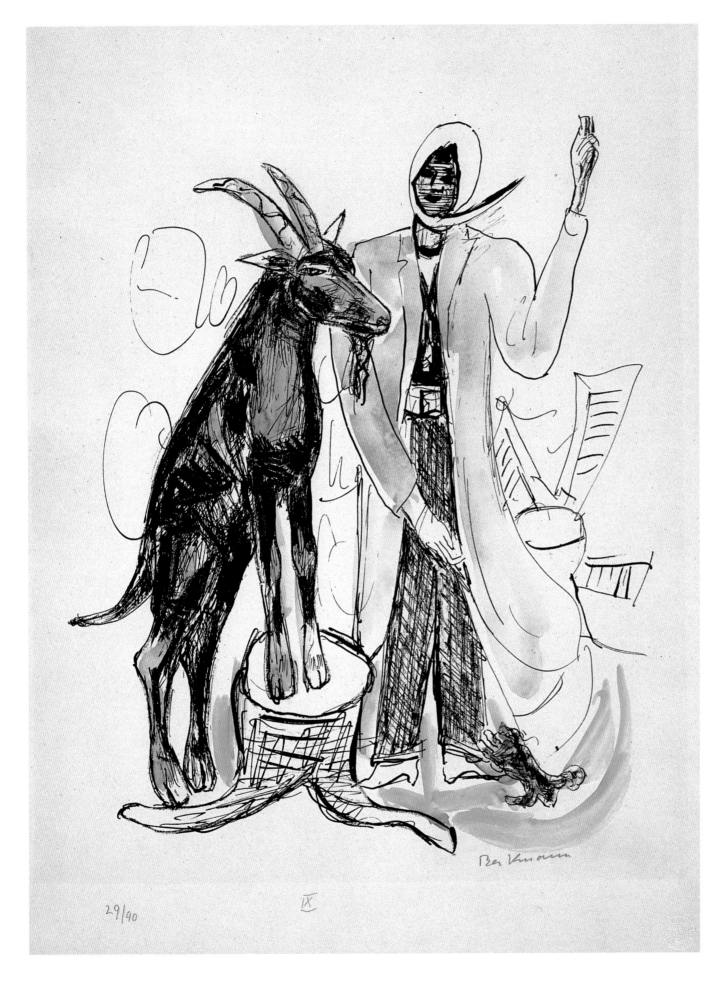

29/40

IX

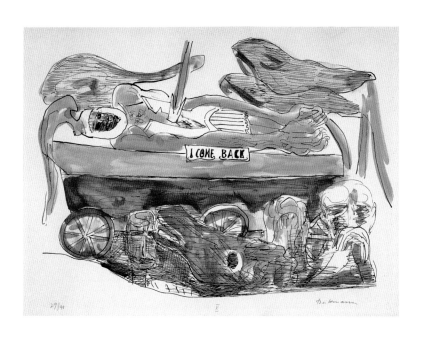

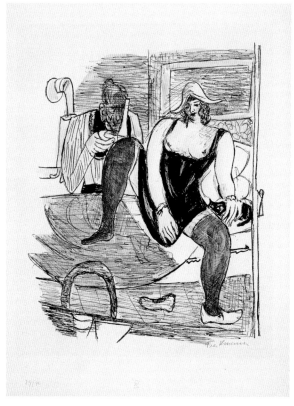

no.137
Plate 10:
Dream of War

no.138
Plate 11:
Morning

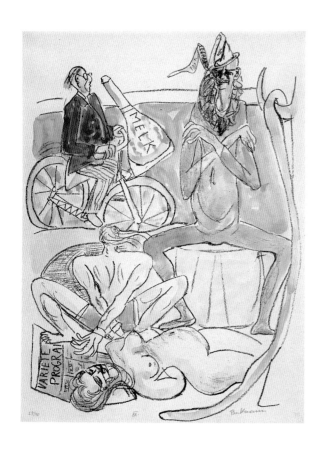

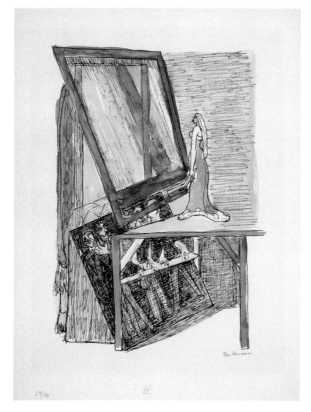

no.139
Plate 12:
Circus

no.140
Plate 13:
Magic Mirror

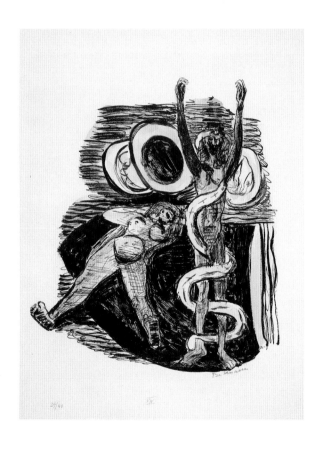

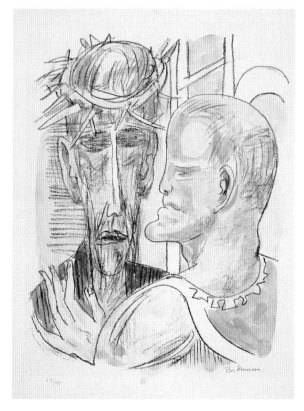

no.141
Plate 14:
The Fall of Man

no.142
Plate 15:
Christ and Pilate

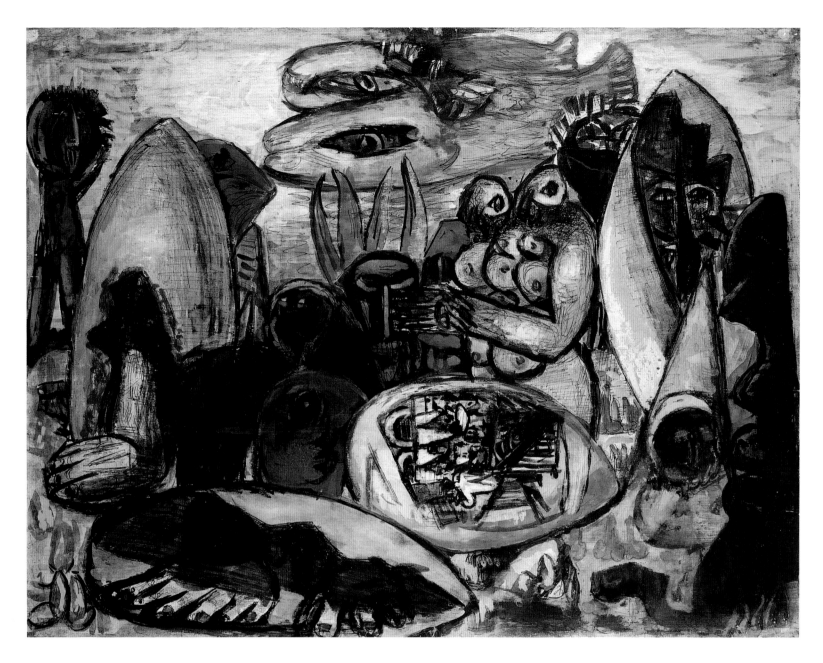

no.143
Early Humans
1946, 1948–9
Gouache, aquarelle
and ink on paper
75 × 64.5
(29 1/2 × 25 3/8)
Private collection

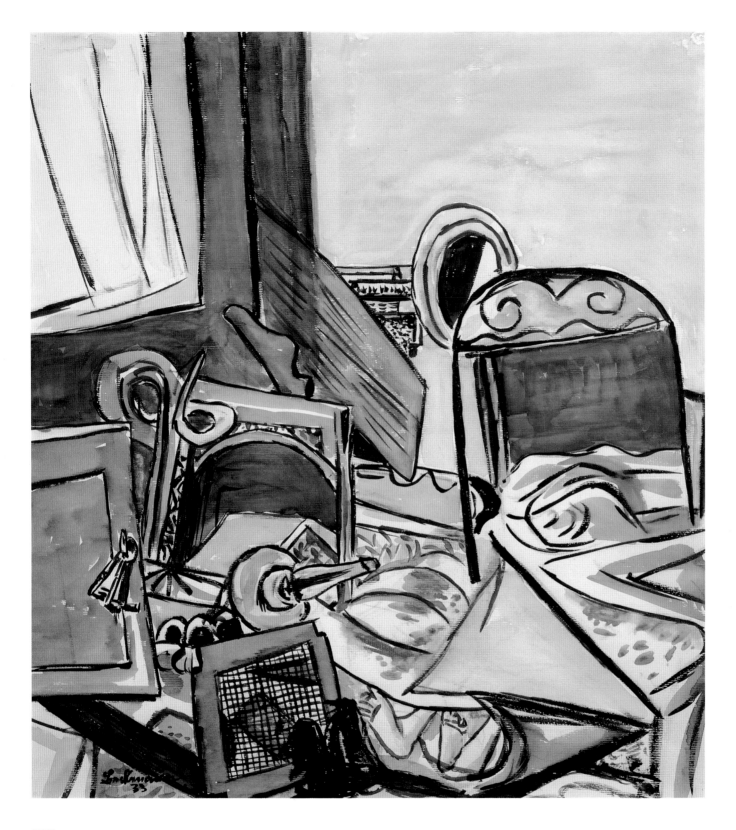

no.144
The Murder 1933
Aquarelle over
charcoal on paper
50 × 45
(19 5/8 × 17 3/4)
Karin and Rüdiger
Volhard

no.145
Mirror on an Easel
1926
Charcoal and
crayon on paper
50.2 x 64.9
(19 ³/₄ x 25 ¹/₂)
The Museum of
Modern Art, New
York. Gift of
Sanford Schwartz
in memory of
Irving Drutman

no.146
*Self-Portrait
(Manon)* 1940
Ink on paper
20.5 x 17.5
(8 ¹/₈ x 6 ⁷/₈)
Private collection

no.147
A Walk
(The Dream) 1946
Ink on paper
32 x 26.5
(12 5/8 x 10 3/8)
Private collection

no.148
Young Woman with Glass 1946–9
Ink, watercolour and gouache on paper
42.2 × 30.2
(16 5/8 × 11 7/8)
Galerie Pels-Leusden, Zurich

no.149
Figure Skating
1928
Pastel on paper
80 x 72
(31 1/2 x 28 3/8)
Private collection

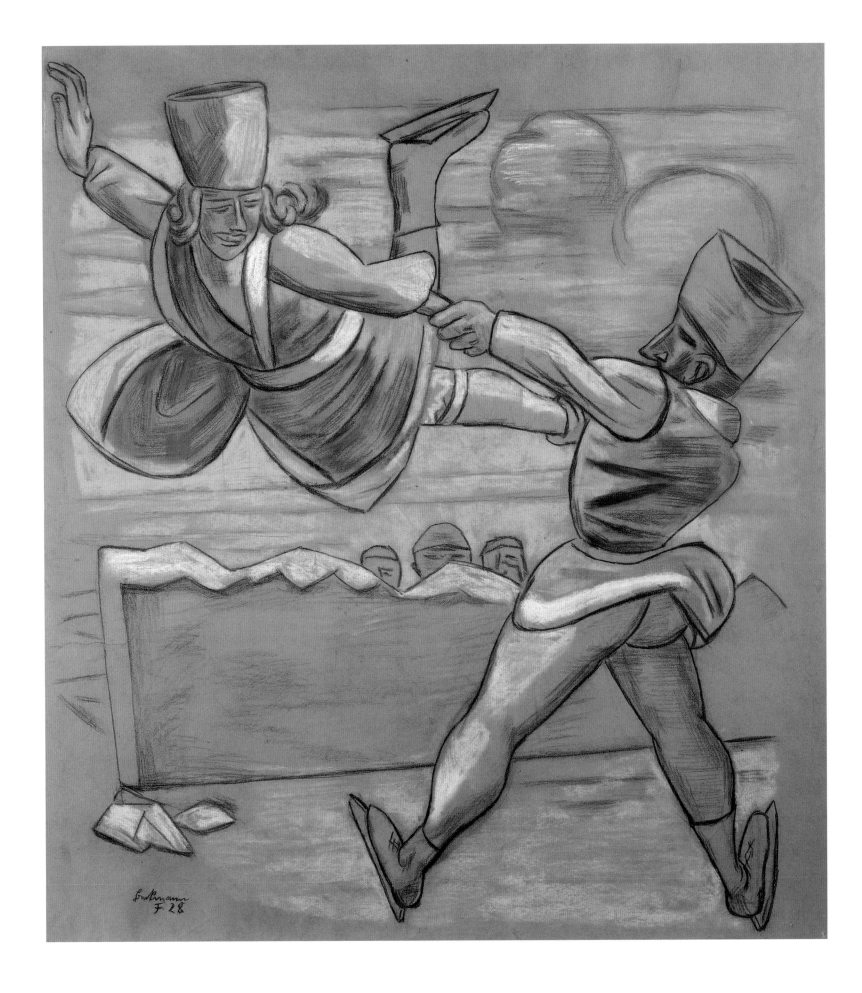

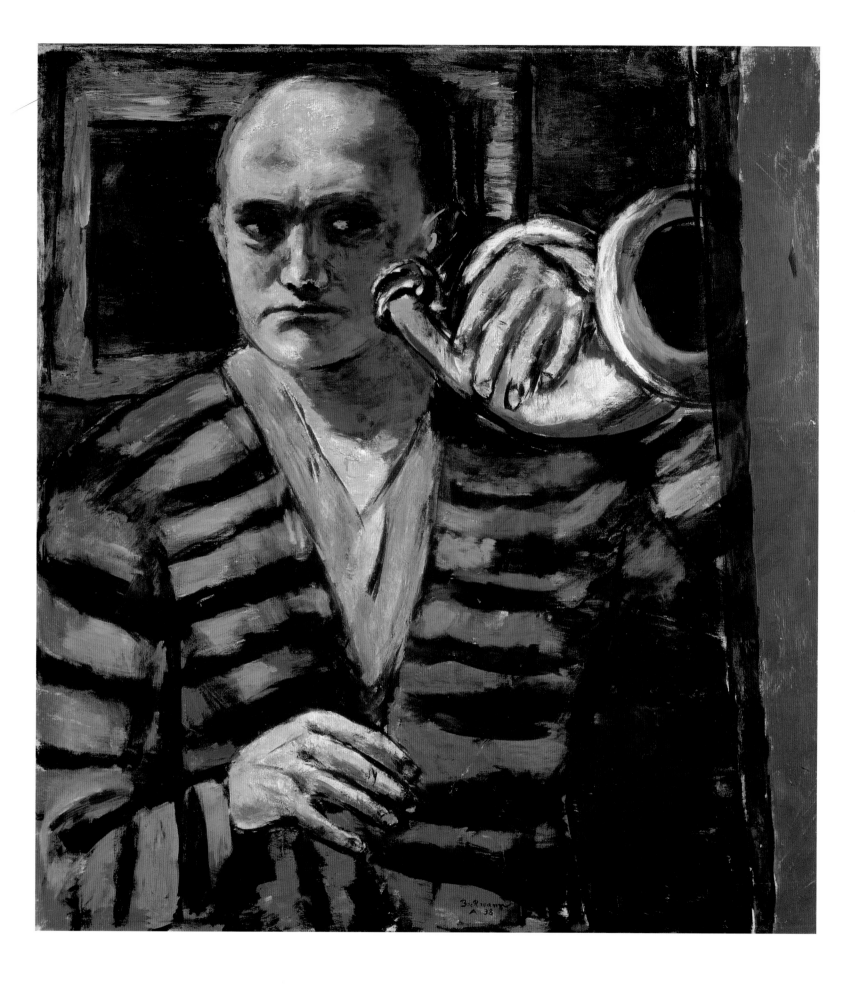

Boston, Beckmann and After
Ellsworth Kelly

Within the first year of his arrival in the United States Max Beckmann travelled to Boston to appear as a visiting lecturer and critic at the School of the Museum of Fine Arts. There, Ellsworth Kelly, a veteran with an educational stipend from the G.I. Bill, was a student of the German-born Expressionist painter Karl Zerbe. Excerpts from Beckmann's diaries recount his experience:

> *Friday March 12, 1948 – In the morning Zerbe came to take us to the charming director of the School of Fine Arts. Then we went to Harvard University where a certain Mr. R. received us and where we had to admire an exhibition of the Newberry collection including some Beckmanns and some expressionist drawings ...*
>
> *Saturday March 13, 1948 – In the morning a tiff with Q. [Quappi], a car tour of Boston, really very beautiful images in the area of the port. Precipitous return full of anxiety to President Swarzenski at the museum; despite terrible fatigue saw magnificent statue with serpents from Crete. Lunch with Swarzenski and the director of the Art School and then an interminable walk to the school for my lecture. 150 students, teachers, etc. Quappi read very well; thunderous applause then a lot of sherry and very amusing feminine discussions ...*

Stirred by having seen the present Beckmann retrospective at its first venue at the Centre Georges Pompidou in Paris, Kelly's thoughts about his encounter with and the lasting impact of Beckmann follow.

Zerbe arrived in Boston from Germany just before the Second World War. He knew Beckmann and invited him to come to the museum school to give a lecture. His visit made a great impression on me, but even before that, because of Zerbe's emphasis on the German School, I was influenced by his work. There is a full-length self-portrait I did in 1947 that initially was inspired by Pollaiuolo's painting of David and Goliath. I used the stance of Pollaiuolo's David, but the painting needed another element. I added a bugle I had in my studio referencing Beckmann's *Self-Portrait with Horn* 1938 (no.150). A smaller self-portrait from that year was done in encaustic, which was Zerbe's preferred medium. In this painting, the position of my head and shoulders in relation to the easel – cropped at the left side forming a diagonal – is a device from Beckmann (*Self-Portrait in Olive and Brown* 1945; G705). I admired the intensity of his colours against their black outlines and his often brutal and erotic subjects. He was able to express the most disturbing subjects with great virtuosity.

When Beckmann came to the Boston Museum School to give a lecture in 1948, his wife delivered it because Beckmann's English was very limited. She read his 'Letter to a Woman Painter'. He later visited our painting studio where we were all painting nudes from the model. I was disappointed at first since he only was interested in the female students. But even this brief encounter made a deep impression on me. It was not long before his death, and he looked tired but was still jovial. At that time he was the most important painter that I had come in contact with. It was a very significant event in my life.

One of the first things I did when I went to France later that year was to go to Colmar to see Grünewald's Isenheim Altarpiece, which of course had an important impact on modern German Expressionism. Picasso and Beckmann were the most important artists to me during my student years. I always felt Beckmann was under-appreciated. Although I was influenced by the work of both these artists, I realised I couldn't do what they did. You can continue to love and admire painting that you cannot necessarily follow. Soon after arriving in Paris I started working with collage, which developed into multiple colour panels. Every time I see a Beckmann, I'm impressed by the content of his work, his structure, colour, and especially his brushwork. Even though my work is not Expressionist, Beckmann's visual force has informed my painting and my admiration for his art only grows with time. Seeing the exhibition in Paris recently was like seeing old friends.

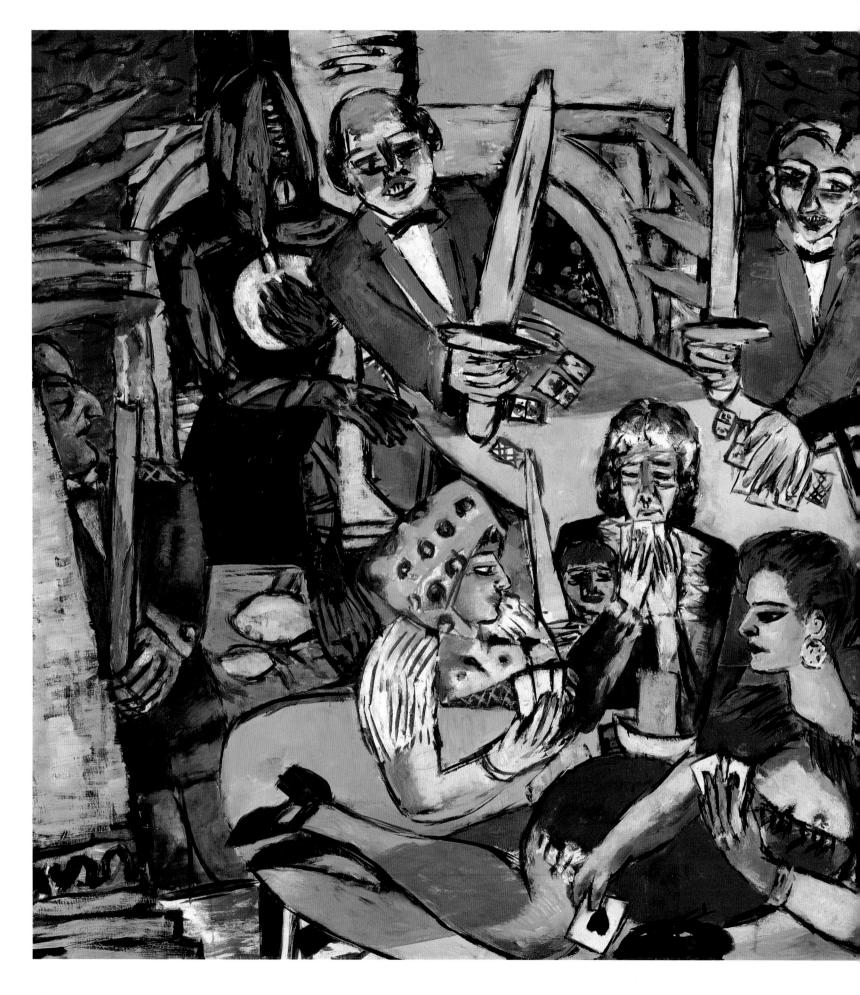

no.151
*Dream of Monte
Carlo* 1940–3
160 × 200
(63 × 78 3/4)
Staatsgalerie
Stuttgart

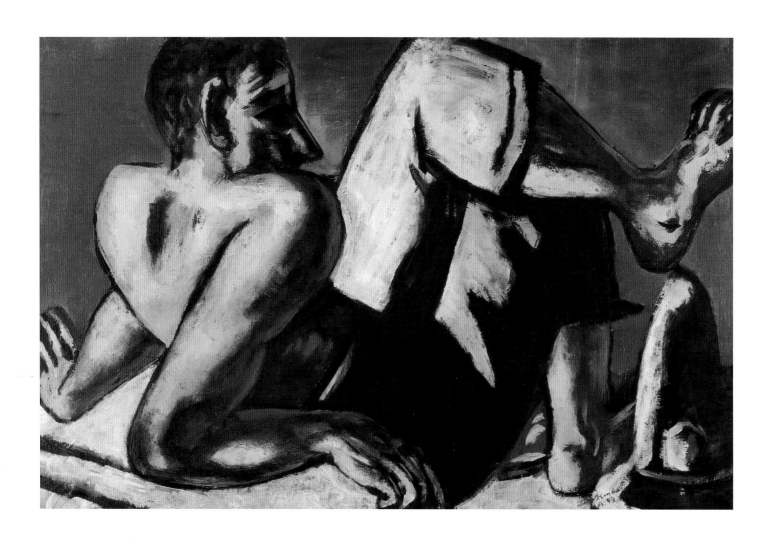

no.152
Half-nude Clown
1944
60 x 90.5
(23 ⁵/₈ x 35 ¹/₂)
Sprengel Museum
Hannover

no.153
Prunier 1944
100.3 x 76.8
(39 ¹/₂ x 30 ¹/₄)
Tate, London.
Purchased 1979

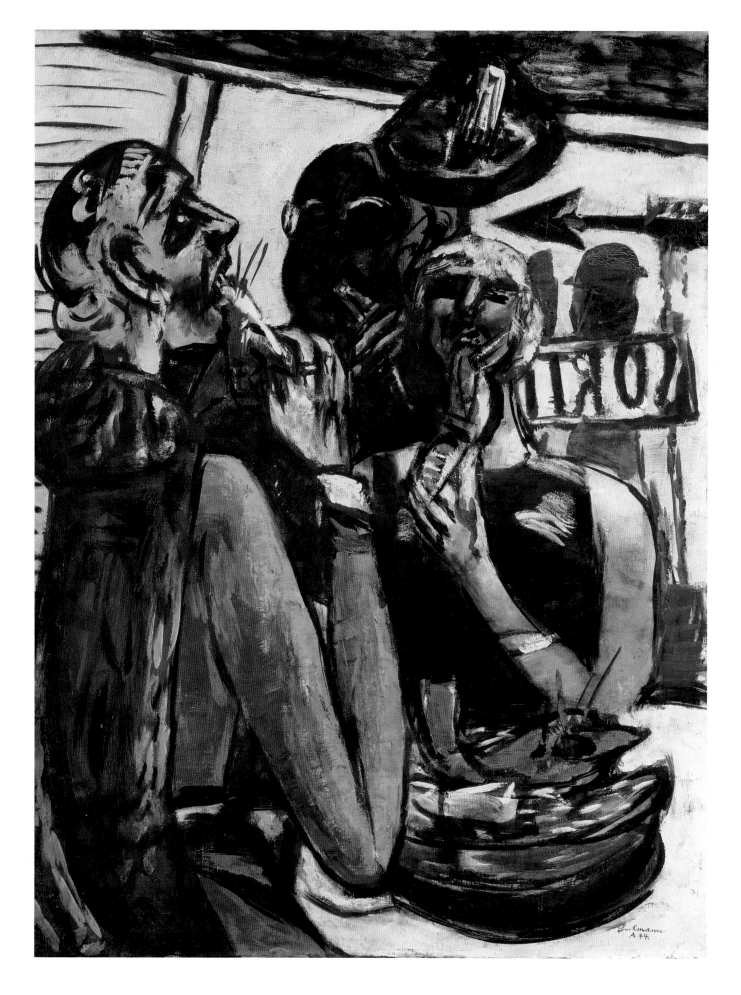

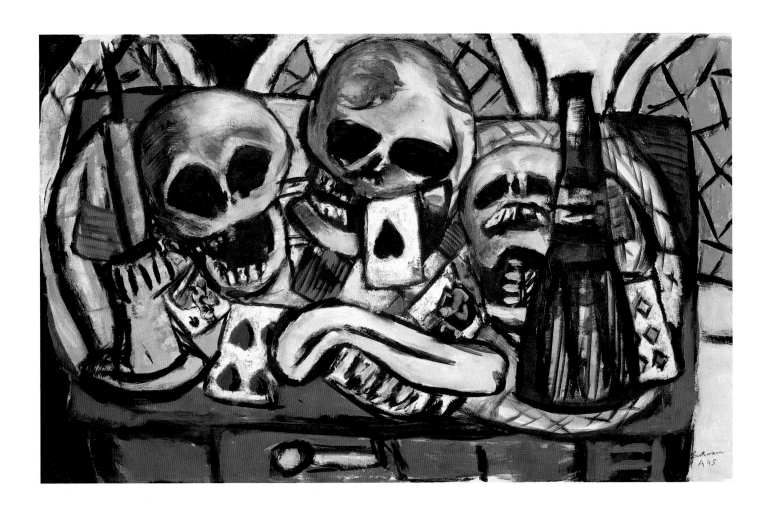

no.154
Still Life with Three Skulls 1945
55.2 × 89.5
(21 3/4 × 35 1/4)
Museum of Fine Arts, Boston. Gift of Mrs Culver Orswell

no.155
Air Balloon with Windmill 1947
138 × 128
(54 3/8 × 50 3/8)
Portland Art Museum, Oregon. Helen Thurston Ayer Fund

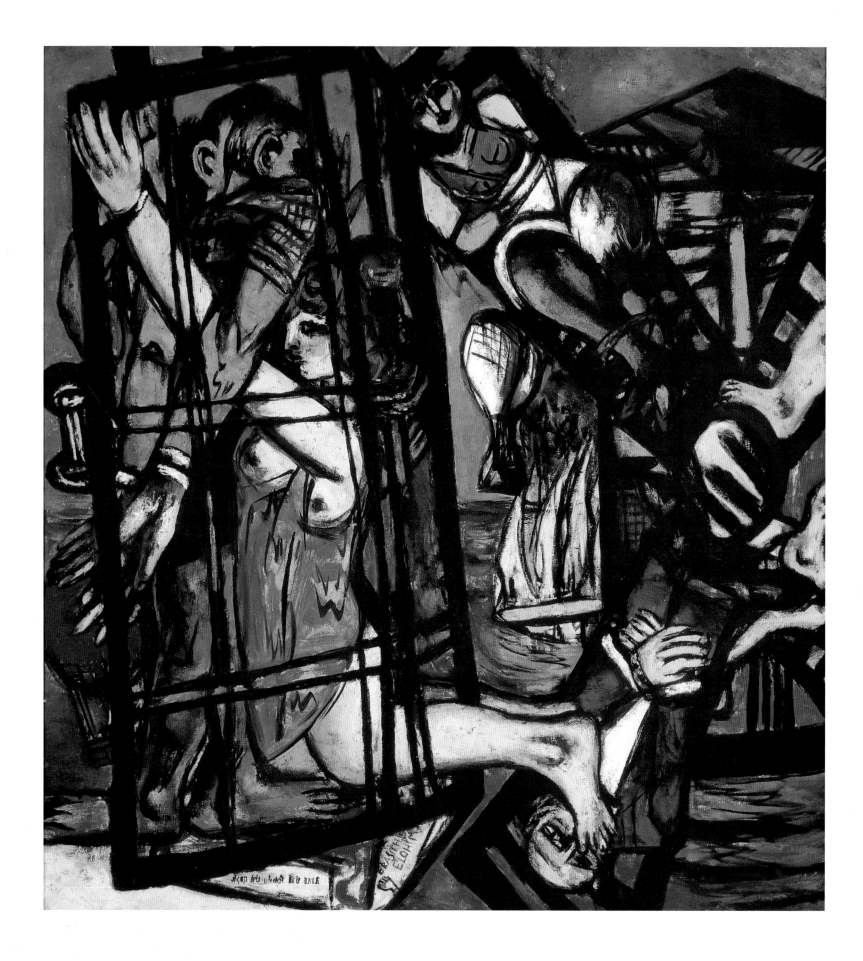

no.156
Cabins 1948
139.5 × 190
(54 7/8 × 74 3/4)
Kunstsammlung
Nordrhein-
Westfalen,
Düsseldorf

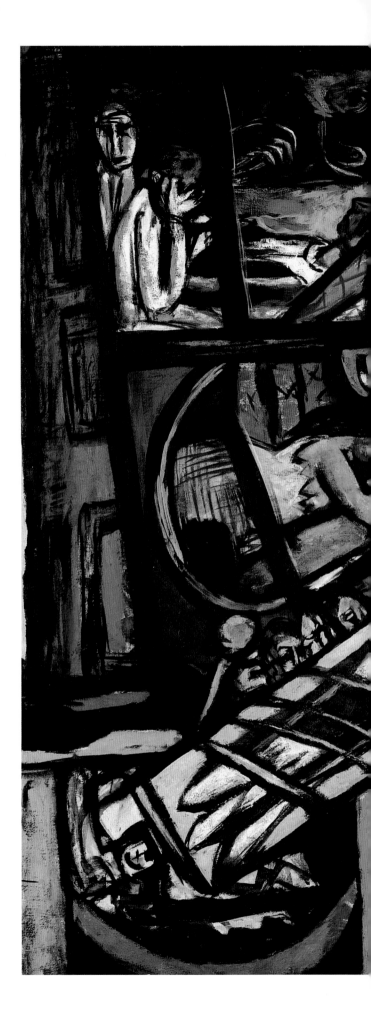

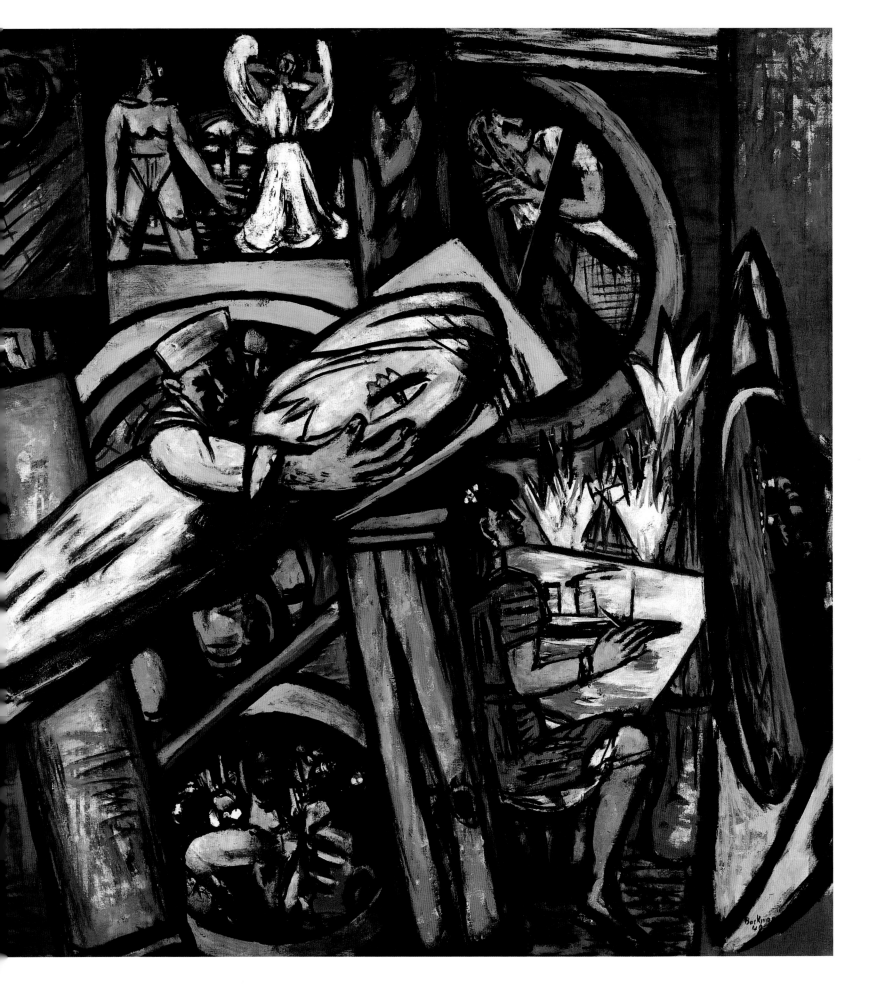

no.157
Quappi in Grey
1948
108.5 × 79
(42 ³/₄ × 31)
Anonymous

no.158
*Female Head in
Blue and Grey*
1942
60 × 30
(23 ⁵/₈ × 11 ³/₄)
Private collection

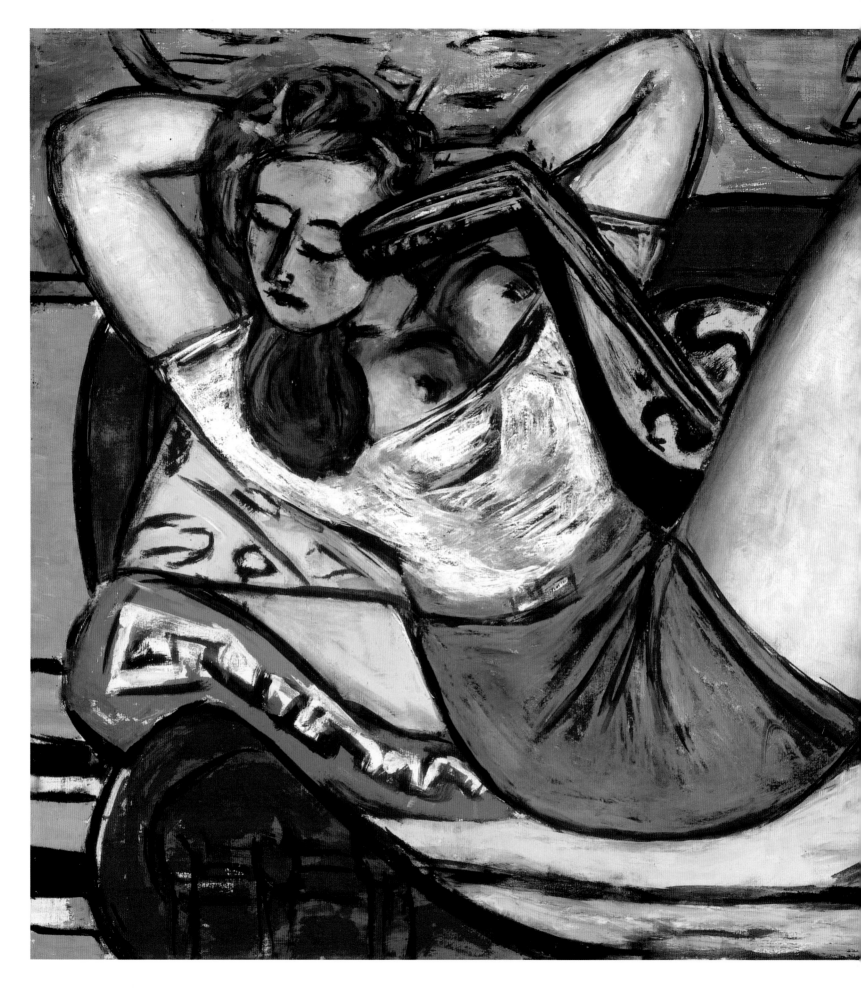

no.159
*Woman with
Mandolin in Yellow
and Red* 1950
92 × 140
(36 1/4 × 55 1/8)
Bayerische
Staatsgemälde-
sammlungen,
Munich,
Pinakothek der
Moderne

fig.30
Sketch for a composition
1944
Pencil on paper
20.7 x 16.3
(8 ¹/₈ x 6 ¹/₂)
National Gallery
of Art,
Washington DC.
Gift of Mrs Max
Beckmann

A Poetics of Space:
Beckmann's *Falling Man*
Charles W. Haxthausen

In 1912, in a polemic directed against his contemporaries in the German avant-garde, the young Max Beckmann professed his belief that the true task of modern art was to extract 'from our own time – murky and fragmented though it may be – types that might be for us, the people of the present, what the gods and heroes of past peoples were to them'.[1] In an era when history painting was dead, when the most influential modernist critics scorned even an interest in subject matter as regressive, as 'literary', Beckmann's ambition to forge a new mythic pictorial language must have seemed bizarrely anachronistic, not to say quixotic.[2]

After a false start as a latter-day history painter, Beckmann, bruised by criticism, abandoned such subjects. Having reinvented

himself during the First World War, throughout the Weimar Republic he was widely hailed by German critics as a Realist, as the visual chronicler of the epoch. But in the 1930s, apparently renewing his ambition to 'create a new mythology from present day life',[3] he began to paint imaginative subjects that went well beyond anything that could be understood as Realism. In these paintings Beckmann occasionally paid homage to traditional mythological or religious subjects, but for the most part he invented his own highly personal imagery, as is dramatically evident in the first of his nine triptychs, *Departure* 1932–3, 1935 (no.60), and the remarkable *Journey on the Fish* 1934 (no.80).[4]

Inevitably, such pictures inspire the iconographic question: 'What does it mean?' –

a question that must be answered with words. This was the query that the emigré dealer Curt Valentin, showing *Departure* in his New York gallery, twice addressed to Beckmann.[5] Irritated and stubbornly uncooperative, he responded that for him the picture spoke 'of truths impossible to put in words and of which I was previously unaware'.[6] Beckmann must have had this incident in mind when, four months later, in July 1938, in his speech at London's New Burlington Galleries, he insisted that 'it is not the subject that matters but the translation of the subject into the abstraction of the surface by means of painting'.[7] Rather than trumpeting his embrace of myth, represented in the gallery's exhibition by *The King* 1933, 1937 (no.95) and his second triptych, *Temptation* 1936–7

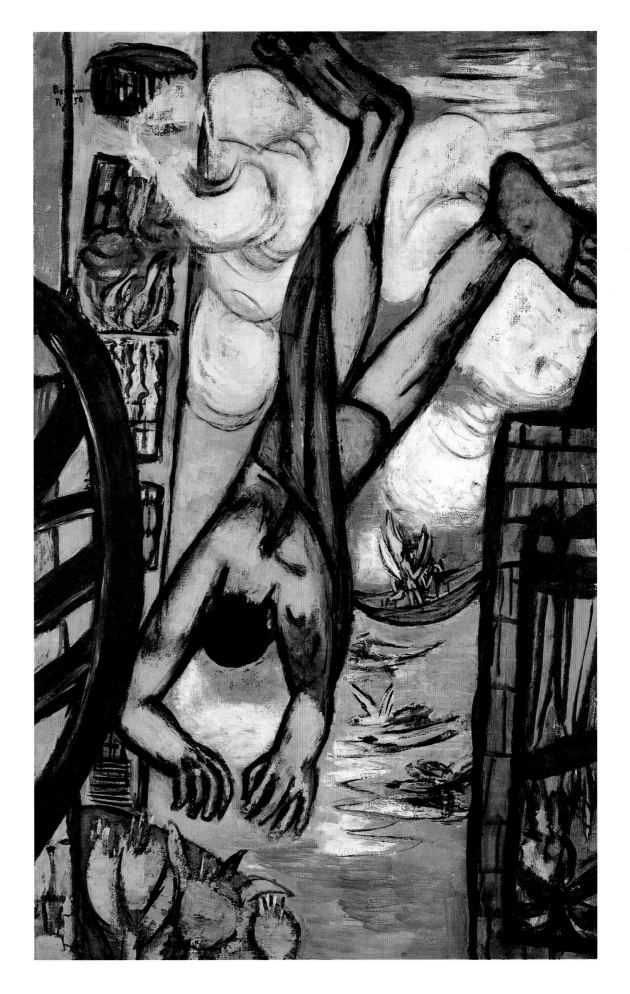

no.160
Falling Man 1950
142 × 89 (55 7/8 × 35)
National Gallery
of Art, Washington
DC. Gift of Mrs
Max Beckmann

(G439), Beckmann seemed concerned not only to ward off more questions like Valentin's but also any accusations of 'literariness': 'Nothing could be more ridiculous or irrelevant than a 'philosophical conception' painted purely intellectually without the terrible fury of the senses grasping each form of beauty and ugliness. If from those forms that I have found in the visible, literary subjects result … they have all originated from the senses, in this case from the eyes, and each intellectual subject has been transformed again into form, color, and space.'[8] In other words, in the end it was these plastic elements that ultimately did the communicative work.

Space had a privileged, strategic role in Beckmann's visual poetics, and this became most apparent with the shift towards mythic subject matter. Space was not an inert envelope in which the actions of his painted figures unfolded; it assumed a semantic dimension. Beckmann's acutely idiosyncratic imagery eludes conclusive iconographic decipherment, but no matter: with the intense spatial effects of his strongest early efforts in this new vein – *Man and Woman (Adam and Eve)* 1932 (no.82), *Journey on the Fish*, and *Departure* – Beckmann probably hoped to provoke what he called the 'co-productivity' (*Mitproduktivatät*) of the viewers who shared his 'metaphysical code', eliciting not merely a formal and emotional response but imparting knowledge 'of the essential things in themselves that are concealed by appearances'.[9] In *Departure* the open expanse of the central panel has an exhilarating effect of liberation, of redemptive release from the cramped, oppressive, dungeon-like spaces of the side panels. Beckmann must have hoped that this contrast – as reportedly confirmed to him by the response of his friend Lilly von Schnitzler[10] – would convey its essential 'content', even if certain details of this hermetic work may have remained meaningful only to him.

Falling Man (no.160), a work Beckmann completed during the last year of his life, is spatially unlike any painting in his oeuvre. In his figure compositions the spaces are usually constricted, often claustrophobic, with forms densely packed into a shallow, upwardly tilted proscenium.[11] In *Falling Man*, however, we encounter a figure released from all spatial contingence. Between skyscrapers, one of them in flames, a man plunges headlong to his death. Or does he? For here the spatial effect is uncanny. There is no horizon below; instead, traversing the entire vertical axis of the canvas is an ethereal expanse of blue and white. In the distance, nude, winged beings can be seen in a barque, though whether in the ether or on water is unclear. This ambiguous, horizon-less blue and the foreshortened balcony railing, seen from above, disorient us spatially, neutralising the distinction between above and below. The ether seems to brake the fall of the man. Seen from the perspective of the balcony, his body turns; no longer falling, it floats out into infinite space.[12]

The ambiguous effect of simultaneously falling and floating, the exhilarating sense of release, of liberation, fit a literary passage that Beckmann had earlier illustrated with a drawing of a figure plunging through space (fig.31). The text is from Goethe's *Faust II*, words uttered by Mephistopheles to Faust as he dispatches him to the realm of The Mothers, outside of time and space. 'Descend, then! I might also tell you: Soar! / It's all the same. Escape from the Existent / To phantoms' unbound realms far distant!'[13] It was shortly after making this drawing that Beckmann sketched, in 1944, a composition that anticipates *Falling Man* (fig.30). Here he flattened the plunging figure and placed it against a backdrop of skyscrapers, including even an indication of the foreshortened balcony.

Falling Man, with its image of a man plunging or soaring from a world in flames into the serene blue firmament, is widely interpreted as a painting about death, death as a passage of the self into a higher realm. Paradoxically, the man, his toes cropped by the framing edge, his body flattened by thick black outlines, remains securely anchored to the surface. In his London lecture, Beckmann confessed that the compression of depth and volume into the two-dimensionality of the picture plane, characteristic of all his mature painting, made him feel secure before 'the *infinity* of space' (original emphasis).[14] Yet here, the man's upper body, arched backward and slightly foreshortened, swings in toward the open expanse of space, an effect reinforced by the repoussoir of the balcony railing. It is as though the man's right foot pushes off from the picture frame to propel his dive into boundless space, that 'great void and uncertainty of the space that I call God'.[15]

fig.31
Illustration to Goethe,
Faust II,
Mephistopheles:
'Descend, then! I might also tell you: Soar!'
1943–4
Ink on paper
24.8 x 16.7 (9 3/4 x 6 5/8)
Freien Deutchen Hochstift /
Frankfurter Goethe-Museum, Frankfurt am Main

Even as Beckmann obeys his own planar imperative, he now seems prepared, in the final year of his life, to experience that infinity.

The idea that infinite space is identical with God is one that Beckmann must have first encountered in the Indian mystical texts, *The Upanishads*. This belief is taken up in Helena Petrovna Blavatsky's *The Secret Doctrine* (1888), a book that he acquired in the early 1930s and read and reread until the end of his life. Space, according to Blavatsky, is not a limitless void but 'the ever-incognisable deity'. Next to the following passage Beckmann made a double line in the margin of his copy: ' "What is that which was, is, and will be, whether there is a Universe or not; whether there be gods or none?" asks the esoteric Senzar Cathechism. And the answer made is – SPACE.'[16] Beckmann may have found such esoteric texts so fascinating in part because they invested space, his lifelong obsession as an artist, with metaphysical meaning. Perhaps it allowed him to hope that, even in the fragmented culture of modernity in which there was no longer a dominant iconographic code, he could, by means of plastic form, create the 'new mythology' that was his fervently desired goal.

Notes

1 Max Beckmann, 'Thoughts on Timely and Untimely Art', in Barbara Copeland Buenger (ed.), *Max Beckmann: Self-Portrait in Words. Collected Writings and Statements, 1903–1950*, Chicago and London 1997, p.117. Slightly altered translation.

2 For an expanded discussion of this issue, see my ' "Das Gegenwärtige zeitlos machen und das Zeitlose gegenwärtig": Max Beckmann zwischen Formalismus und Mythos', in Anette Kruszynski (ed.), *Max Beckmann: Die Nacht*, Düsseldorf 1997, pp.35–52.

3 A formulation Beckmann used in conversation in the 1930s as recorded by his friend and patron Stephan Lackner in *Max Beckmann Memories of a Friendship*, Miami 1969, p.31.

4 To be sure, Beckmann remained primarily a painter of portraits, still lifes, and landscapes – from 1932 to 1940, there are fewer than twenty such 'mythic' works out of more than two hundred paintings. The percentage increases in the last decade of his life, but these works always constituted a small share of his production, even as they have provoked the most commentary.

5 One of those on whose behalf Valentin was asking was Alfred H. Barr, Jr., who later acquired the work for the Museum of Modern Art, New York. Valentin's letter of 3 February 1938 is quoted in Peter J. Gärtner, *Der Traum von der Imagination des Raumes: Zu den Raumvorstellungen auf einigen ausgewählten Triptychen Max Beckmanns*, Weimar 1996, p.87.

6 Letter of 11 February 1938 to Curt Valentin, in Klaus Gallwitz, Uwe M. Schneede and Stephan von Wiese (eds.), *Max Beckmann: Briefe*, vol.3, Munich 1996, p.29.

7 Beckmann, 'On My Painting,' in Buenger 1997, p.302.

8 Ibid., pp.303–4.

9 See note 6.

10 Lilly von Schnitzler recounted her discussion with Beckmann in his Berlin studio in 1937 in a 1954 letter to Alfred H. Barr, Jr. The full English text is printed for the first time in Gärtner 1996, p.76.

11 For a concise and illuminating discussion of Beckmann's treatment of space, see Reinhard Spieler, *Max Beckmann Bildwelt und Weltbild in den Triptychen*, Cologne 1998, pp.58–63.

12 Siegfried Gohr has written a perceptive analysis of the two spatial axes in the painting, in 'Max Beckmanns Spätstil,' in Siegfried Gohr (ed.), *Max Beckmann*, Cologne 1984, p.198. The point was developed by Jeannot Simmen, 'Max Beckmann: Schwebe-Sturz im Luftmeer,' in Hartmut Zinser, Friedrich Stentzler and Karl-Heinz Kohl (eds.), *Foedera Naturai: Klaus Heinrich zum 60. Geburtstag*, Würzburg 1989, pp.312–24.

13 Johann Wolfgang von Goethe, *Faust*, trans. George Madison Priest, New York 1941. The connection was first made by Friedhelm W. Fischer, *Max Beckmann: Symbol und Weltbild*, Munich 1972, p.207. See also Hans Belting, *Max Beckmann: Tradition as a Problem in Modern Art*, trans. Peter Wortsman, New York 1989, p.105; Reinhard Spieler, *Max Beckmann 1884–1950: The Path to Myth*, trans. Charity Scott Stokes, Cologne 1995, p.174.

14 Max Beckmann, 'On My Painting' in Buenger 1997, p.302.

15 Ibid., p.303.

16 H.P. Blavatsky, *The Secret Doctrine: The Synthesis of Science, Religion, and Philosophy*, Pasadena, Calif. 1988, pp.8, 9; Peter Beckmann and Joachim Schaffer (eds.), *Die Bibliothek Max Beckmanns: Unterstreichungen, Kommentare, Notizen und Skizzen in seinen Büchern*, Worms 1992, p.126.

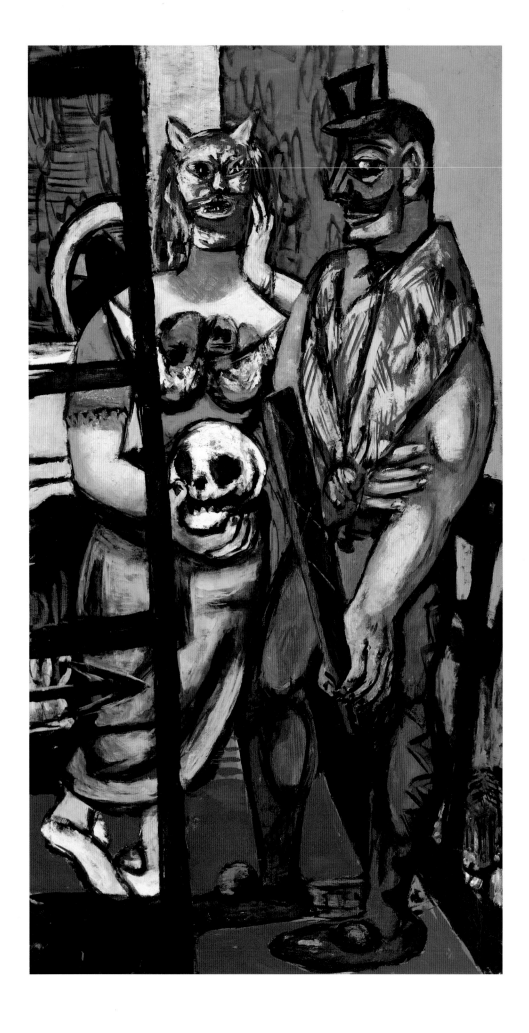

no.161
Masquerade 1948
164.6 × 88.2
(64 3/4 × 34 3/4)
The Saint Louis Art
Museum. Gift of
Mr and Mrs Joseph
Pulitzer Jr

no.162
Carnival Mask,
Green Violet and
Pink (Columbine)
1950
135.5 × 100.5
(53 3/8 × 39 5/8)
The Saint Louis Art
Museum. Bequest
of Morton D. May

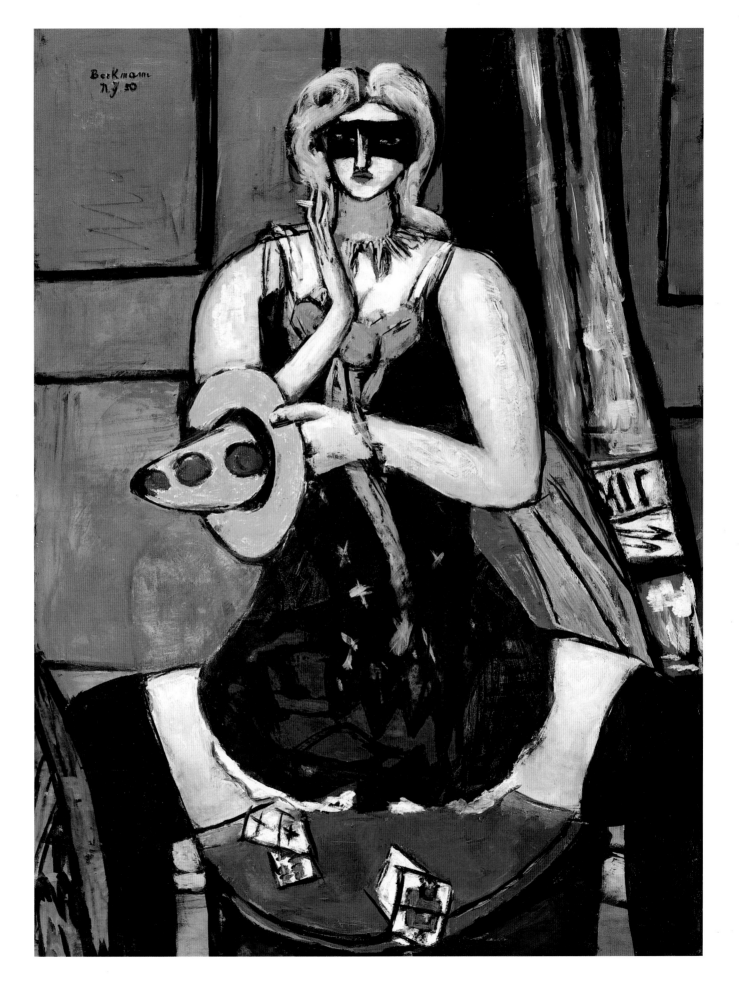

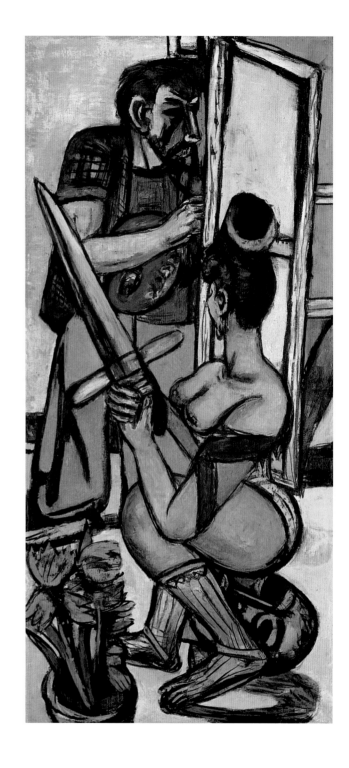

no.163
The Argonauts
1949–50
Side panels:
189 × 84
(74 3/8 × 33 1/8)
Central panel:
203 × 122
(79 7/8 × 48)
National Gallery of
Art, Washington
DC. Gift of Mrs
Max Beckmann

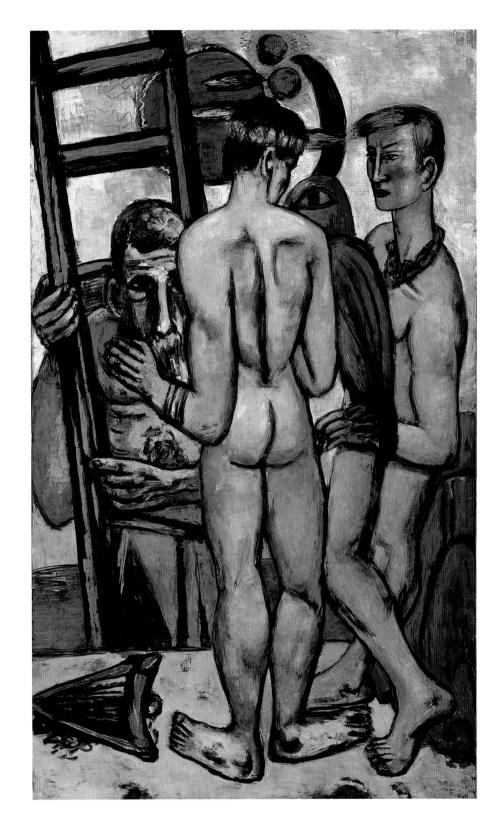
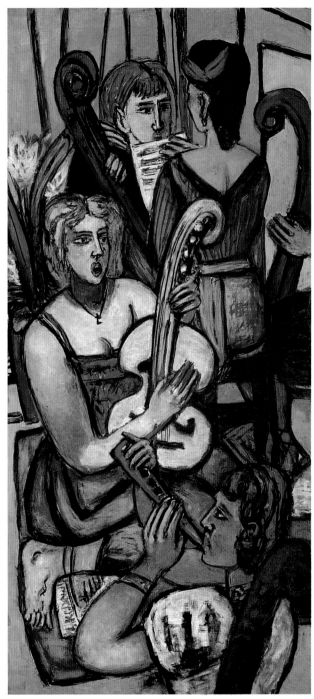

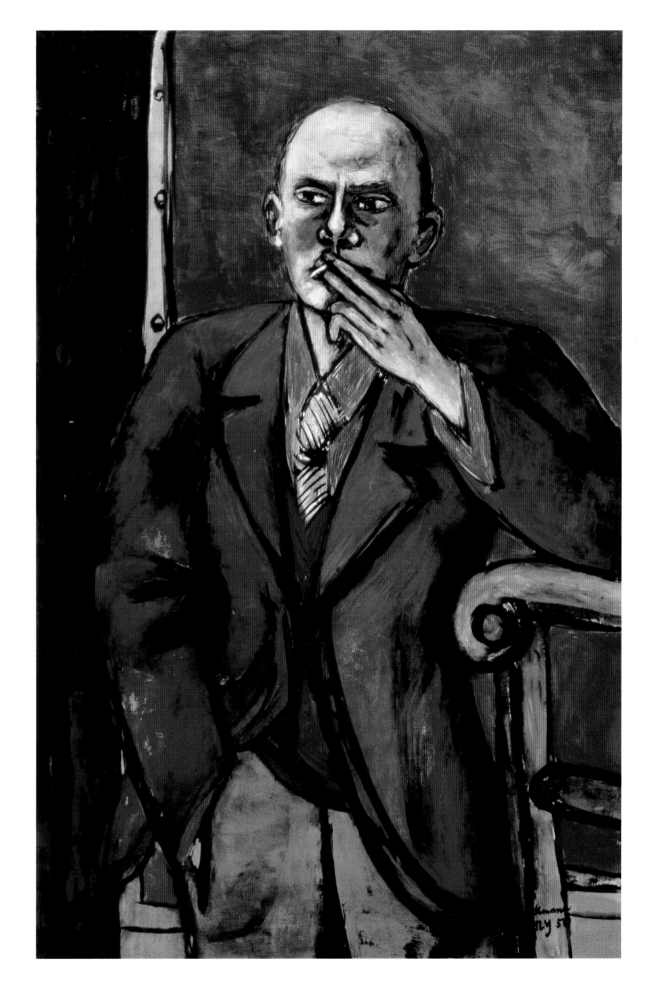

no.164
Self-Portrait in Blue Jacket 1950
139 × 91.5
(54 3/4 × 36)
The Saint Louis Art Museum. Bequest of Morton D. May

Chronology
Compiled by
Susanne Bieber

CHILDHOOD

1884 Max Beckmann is born on 12 February 1884 in Leipzig. His parents Antoinette (née Düber, b. 1846) and Carl Beckmann (b. 1839), and their two children, Margarethe and Richard, had moved to Leipzig four years earlier from Braunschweig, Lower Saxony, where they had their roots. Carl Beckmann had worked as a real estate agent and had been a mill owner; after their move to Leipzig he experiments in a laboratory on the invention of meerschaum.

1892–4 From 1892–4 Max Beckmann lives with his sister, by now Margarethe Lüdecke, who is fifteen years older than Beckmann and married to a pharmacist in Falkenburg, Pomerania. After

1894 his father dies in 1894 at the age of fifty-five, Max moves with his mother and twenty-three year old brother Richard back to Braunschweig, where he attends several schools in Braunschweig and Königslutter. He also attends a boarding school, from which he runs away.

1897 In 1897 he paints his first self-portrait. He applies for a position as a cabin steward with a shipping company plying the Amazon,

1898 but is rejected because of his young age. A year later he applies unsuccessfully to the Academy in Dresden.

STUDIES AND TRAVEL

1900 In 1900 Beckmann is accepted to the Grand Ducal Art Academy in Weimar, where he attends the antique class of Otto Rasch. After a year

1901 at the academy he enters the class of the Norwegian Frithjof Smith, who teaches him to sketch with charcoal directly onto the canvas.

In class he meets his fellow student Ugi Battenberg, who will become his lifelong friend.

1902 In 1902 Beckmann receives an honourable diploma for drawing. In the same year he falls in love with Minna Tube, who also studies art in Weimar and will later continue her studies with Lovis Corinth in Berlin. She comes from a highly cultivated Lutheran pastor's family.

During his student years he is a committed reader of Schopenhauer, who strongly influences his thinking. He also shows an interest in the writings of Kant, Hegel and particularly Nietzsche. He acquires a paperback copy of Nietzsche's *Beyond Good and Evil*. In addition, Beckmann is an enthusiastic reader of Jean Paul and will refer to his humorous and sentimental novels throughout his life.

1903 In October 1903 Beckmann completes his studies at the Academy and moves to Paris, where he sets up his studio at 117 rue Notre Dame des Champs. He is deeply impressed by the work of Paul Cézanne and will mention him frequently in later statements:

I must refer you to Cézanne again and again. He succeeded in creating an exalted Courbet, a mysterious Pissarro, and finally a powerful new pictorial architecture in which he really became the last old master, or I might better say he became the first "new master"' ('Letters to a Woman Painter', 3 Feb 1948, in Barbara Copeland Buenger, *Max Beckmann: Self-Portrait in Words. Collected Writings and Statements, 1903–1950*, Chicago and London 1997, p.316).

1904 Beckmann leaves Paris in March 1904 and plans to travel to Italy. On his journey he visits Colmar, and sees Isenheim's altar by Matthias Grünewald, and also visits the studio of the Swiss artist Ferdinand Hodler in Geneva: 'With regard to my painterly style, I have found almost everything that I had developed myself in rather difficult struggles as my future language here in Geneva with Hodler' (Letter to Caesar Kunwald, 17 April 1904, in Klaus Gallwitz, Uwe M. Schneede, Stephan von Weise (eds.), *Max Beckmann: Briefe,* vol.1: 1899–1925 (edited by Uwe M. Schneede), Munich and Zurich 1993, p.22). However, Beckmann abruptly ends his journey when his mother becomes ill, and returns via Frankfurt and Braunschweig to Berlin.

EARLY CAREER IN BERLIN

In the autumn he moves to 103 Eisenacher Strasse, Berlin-Schöneberg. By 1905 Beckmann,
1905 his mother, brother and sister are all living in Berlin. Beckmann spends the summer by the sea (as he will in many years to come), where he paints landscapes and seascapes, among them *Sunny Green Sea* (no.8). He also paints *Young Men by the Sea* (no.3), for which he receives the prize of honour from the German
1906 Artist's League in June 1906: the prize includes a six-month scholarship at the Villa Romana in Florence. The painting is acquired by the museum in Weimar. Beckmann exhibits for the first time at the Berlin Secession, which he will join officially as a member in the following year. A large historical show, *Exhibition of German Art from 1775 to 1875*, spurs heated discussions

in artistic circles about tradition in German art.

During the summer his mother dies of cancer, an event that probably inspires his *Large Death Scene* (G61) and *Small Death Scene* (no.2), which he painted shortly afterwards. In September Max Beckmann and Minna Tube marry, and travel to Paris on their honeymoon. Back in Berlin, Minna starts taking singing lessons. In November they both move to Florence for him to take up his scholarship.

1907 Back in Berlin again, in 1907 the Beckmanns build, after plans drawn up by Minna, a house with a studio in Berlin-Hermsdorf, 8 Ringstrasse.

1908 In 1908 their son Peter is born.

Beckmann has his second show in two years at the Berlin gallery of Paul Cassirer, a leading dealer of modern and particularly French art. His work is included in major group exhibitions throughout Germany. Beckmann works on large

1909 history paintings and exhibits them in 1909 at the Berlin Secession, but receives harsh criticism. He also exhibits for the first time in Paris, at the Salon d'Automne in the Grand Palais. Beckmann is visited by the eminent art historian and art critic Julius Heier-Graefe in his Hermsdorf studio.

In Berlin he visits a Matisse show at Cassirer's gallery and an exhibition of Chinese art, and comments on the latter:

> too aesthetic for me, too delicate ... This in spite of the sometimes grotesque and gruesome pieces. Also too decorative; I want a stronger spatial emphasis ... My heart beats more for a rougher, commoner, more vulgar art: not one that generates dreamy fairy-tale moods between one poem and the next, but one that offers direct access to the terrible, the crude, the magnificent, the ordinary, the grotesque, and the banal in life. An art that can always be right there for us, in the realest things of life' (Diary, 9 January 1909, in Buenger 1997, p.98).

1910 In 1910 Beckmann is nominated to the board of the Berlin Secession, becoming its youngest member, and helps select the spring exhibition. This show becomes notorious for its exclusion of many young Expressionist artists, including Erich Heckel, Ernst Ludwig Kirchner, Emil Nolde, Max Pechstein, and Karl Schmidt-Rottluff. In response these artists group together to form the New Secession, which will only last for two years. Beckmann, who is also very critical of the Berlin Secession, especially of Cassirer's dominant position, resigns from its board in 1911, but will remain a member of the group until 1913.

The Beckmanns rent an additional studio at 6 Nollendorfplatz, which they will use, mainly during the winter months, until 1914.

1911 In 1911 Beckmann meets the dealer and publisher I.B. Neumann, who will publish some of Beckmann's prints in the following year – the beginning of a long collaboration. Beckmann is mainly working in lithography, but in the coming years will shift his attention to etching.

1912 In 1912 the publisher Reinhard Piper visits Beckmann in Berlin and buys one of his paintings, the starting point of Piper's life-long

support for Beckmann's work. Piper will publish many of Beckmann's prints and portfolios, especially in the period following the First World War.

Inspired by newspaper accounts, Beckmann paints *The Sinking of the Titanic*, an enormous canvas, which will be heavily criticised (no.6). He has his first solo exhibitions in Magdeburg and Weimar.

Herwarth Walden's gallery Der Sturm opens with a show on Expressionism. Beckmann, who is very critical of the new Expressionist art, writes an article in response to a text by Franz Marc in which the Expressionist painter champions the new abstract tendencies in art and refers to Cézanne as a great inspiration. Beckmann's shrewd response is entitled 'Thoughts on Timely and Untimely Art':

Mr Marc speaks of what he – not without a certain self-confidence – calls the new painting. It occurs to me that Cézanne, whom he hails as his special patron saint, said something that does not at all agree with the article in question ... I myself revere Cézanne as a genius. In his painting he succeeded in finding a new manner in which to express that mysterious perception of the world that had inspired Signorelli, Tintoretto, El Greco, Goya, Gericault, and Delacroix before him. If he succeeded in this, he did so only through his efforts to adapt his coloristic visions to artistic objectivity and to the sense of space, those two basic principles of visual art ... There is one thing that always happens

in good art. This is the conjunction of artistic sensuality with the artistic objectivity and actuality of the things to be represented. Abandon this, and you inevitably fall into the domain of the applied arts (Buenger 1997, pp.115–16).

1913 At the beginning of 1913 Beckmann has a large one-man show with forty-seven paintings at Cassirer's gallery. Cassirer also publishes the first monograph on Beckmann, written by Hans Kaiser. Beckmann's work starts to be exhibited widely throughout Europe.

Under the leadership of Max Liebermann, Beckmann, together with Cassirer, Lovis Corinth and Max Slevogt, leaves the Secession

1914 to form the Free Secession. In 1914 Beckmann is nominated to the board of the new group and participates, as in subsequent years, in the group's annual exhibitions.

The critic Karl Scheffler, who earlier had written a very supportive review of Beckmann's Cassirer show, initiates a number of statements from artists including Beckmann, August Macke, Ludwig Meidner, Heckel and others, which he publishes under the title 'The New Programme' in the March issue of his *Kunst und Künstler*. Beckmann writes:

As for myself, I paint and try to develop my style exclusively in terms of deep space, something that in contrast to superficially decorative art penetrates as far as possible into the very core of nature and the spirit of things. I know full well that many of my

fig.35
Beckmann,
Harvestehuder Weg,
Hamburg 1913
Max Beckmann
Archive, Munich

feelings were already part of my makeup. But I also know that there is within me what I sense as new, new from this age and spirit. This I will and cannot define. It is in my pictures (Buenger 1997, pp.115)

EXPERIENCE OF WAR

Following the outbreak of war in July 1914, Beckmann volunteers to join a supply convoy to the Baltic Sea and then, probably after a short training, works as a nurse in East Prussia. In a letter to Minna he writes:

my will to live is stronger than ever right now, although I have experienced some truly horrible things and even died with a few already. But the more one dies, the more intensely one lives. I made drawings. That protects a person from death and danger' (3 October 1914, in Buenger 1997, p.140).

He briefly returns to Berlin-Hermsdorf, where he is formally trained as a medical orderly for the Red Cross. Minna's brother is killed in the war and her sister dies of a lung infection.

1915 In early 1915 Beckmann travels to the Belgian front where he works in various hospitals. In Wervicq he is commissioned to paint a mural for the hospital's thermal baths. He also travels to Lille, Brussels and Ghent. In Ostende he meets Erich Heckel, who is working there as a medical orderly.

Beckmann regularly writes to his wife about his experience on the war front. His letters are subsequently published in *Kunst und Künstler*:

fig.36
Max Beckmann as
a medical orderly
in Ypern 1915
Max Beckmann
Archive, Munich

There are some remarkable people and faces among them, many of whom I like and all of whom I will sketch. Coarse, bony faces with an intelligent expression and wonderfully primitive, unspoiled point of view. Giant military cooks, plump and heavy. Mask-like faces, senselessly humorous ones talking constantly next to grotesquely humorous, truly humorous ones. People with big heads and black, thick eyebrows next to good-natured, smiling creatures eating enormous amounts. Yes, this is life again! … I myself constantly vacillate between great excitement at everything new that I see, depression at the loss of my individuality, and a feeling of deepest irony about myself and, occasionally, the world. Finally, however, the world always compels my admiration. Its capacity for variety is indescribable and its power of invention is unlimited' (Letter to Minna Beckmann-Tube, 2 March 1915, in Buenger 1997, p.146).

Later he writes: 'For me the war is a miracle, even if a rather uncomfortable one. My art can gorge itself here' (Letter to Minna Beckmann-Tube, 18 April 1915, in Buenger 1997, p.159). In another letter to Minna, he states:

And just as I consciously and unconsciously pursue the terror of sickness and lust, love and hate to their fullest extent – so I'm trying to do now with this war. Everything is life, wonderfully changing and overly abundant in invention. Everywhere I discover deep lines of beauty in the suffering and endurance of this terrible fate (24 May 1915, in Buenger 1997, p.173).

In July Beckmann suffers a nervous breakdown and is sent to Strasbourg.

FRANKFURT: A NEW HOME
In October 1915 Beckmann takes a leave of absence from medical service and goes to Frankfurt, where he stays with his student friend from Weimar Ugi Battenberg and his wife Fridel. Beckmann lives with the couple at 3 Schweizer Strasse, where he can use his friend's studio. Minna remains in Berlin and is engaged as a singer by the opera in Elberfeld (in 1918 she will work for the opera in Graz).

After a few months in Frankfurt Beckmann makes new friends, including Walter Carl and his wife Käthe. Carl is the brother of Fridel Battenberg, and is an art dealer. The couple are the first collectors of Beckmann's work in Frankfurt. Beckmann makes the acquaintance of Major Fritz von Braunbehrens, who is influential in winning Beckmann's dismissal from medical service in the military, and his wife Wanda. Their daughter Lili writes poems and Beckmann will later illustrate her work *City Night* to be published by Piper in 1920. Beckmann also finds a good friend in the writer Kasimir Edschmid, Ugi Battenberg's cousin. In 1917 he produces etchings for Edschmid's short story *The Princess*.

In the same year Beckmann has a large exhibition of works on paper at Neumann's

1917

fig.37
Beckmann in the home of Herman Feith in Frankfurt, with Ugi and Fridel Battenberg and the Feith daughters 1916 or 1917
Max Beckmann Archive, Munich

gallery in Berlin. After producing mainly prints and drawings in the preceding years, Beckmann creates three major paintings, *Adam and Eve, Descent from the Cross,* and *Christ and the Woman Taken in Adultery* (nos.8–10).

1918 In 1918 Beckmann writes an artistic statement entitled 'A Confession' for Edschmid's *Tribüne der Kunst und Zeit*, a journal that focuses on contemporary art and society. The issue that includes Beckmann's contribution alongside other artists' statements is entitled 'Creative Credo', but will not be published until 1920:

> I believe that essentially I love painting so much because it forces me to be objective. There is nothing I hate more than sentimentality. The stronger my determination grows to grasp the unutterable things of this world, the deeper and more powerful the emotion burning inside me about our existence, the tighter I keep my mouth shut and the harder I try to capture the terrible thrilling monster of life's vitality and to confine it, to beat it down and to strangle it with crystal-clear, razor-sharp lines and planes ... Right now we have to get as close to the people as possible. It's the only course of action that might give some purpose to our superfluous and selfish existence – that we give people a picture of their fate. And we can do that only if we love humanity ... I hope we will achieve a transcendental objectivity out of a deep love for nature and humanity (Buenger 1997, pp.183–5).

Beckmann shows the first sign of interest in the Gnosis and the Kabbala. He will later acquire a copy of Helena Blavatsky's *Secret Doctrine*, which he will read over and over, and annotate.

1919 In 1919 Beckmann completes *The Night*, one of his major paintings of the postwar period (no.59). He is also working on a group of Frankfurt cityscapes and landscapes. Neumann publishes Beckmann's graphic cycle *Hell* (nos.29–39).

An exhibition in Frankfurt of Beckmann's recent work spurs major acquisitions by museums. Beckmann is a founding member of the Darmstädter Secession under the leadership of his friend Edschmid. He declines an offer to teach as professor at the Weimar Art Academy.

Beckmann spends the early summer with his wife and son in Berlin, but otherwise Minna and Beckmann have lived apart since 1915. Back in Frankfurt Beckmann temporarily stays at the home of Heinrich Simon, the editor of the *Frankfurter Zeitung*, and his wife Irma. Also living there is Benno Reifenberg, a supportive writer and critic of Beckmann's work and later editor of the popular literature section of the *Frankfurter Zeitung*. Beckmann then moves back to 3 Schweizer Strasse, where he sublets the fourth floor.

1920 During 1920 Beckmann tries his hand at writing. He starts working on his comedy *Ebbi*, which will be published in 1924, and on the drama *Hotel*, which he probably completes over the next three years, but which will not be published until 1984.

Peter Zingler exhibits Beckmann's prints in his Frankfurt gallery, publishes several of his

etchings and in the future will represent Beckman's work in Frankfurt. Beckmann signs his first contract with gallery owner I.B. Neumann in Berlin, which secures a professional collaboration that is based on a mutually fond appreciation.

1921 In 1921 Beckmann meets the writer Wilhelm Hausenstein, who will contribute an essay for a monumental monograph on Beckmann that Piper is preparing. Zingler introduces Beckmann to the eminent actor Heinrich George who is performing and directing plays in Frankfurt. The Frankfurt Kunstverein mounts a major show of Beckmann's work. Neumann organises an exhibition of Beckmann's paintings in his

1922 Berlin gallery and in 1922 publishes Beckmann's graphic cycle *Trip to Berlin*. (During 1922 and 1923 Beckmann produces over ninety prints: these constitute more than a third of his total output of graphic work.)

Beckmann has a deep revernce for the German old masters. In the Städelsches Kunst Institut in Frankfurt he admires the newly acquired altarpiece by Hans Holbein the Elder. During a stay with Piper in Munich Beckmann visits the Alte Pinakothek and is impressed by a work attributed to Gabriel Mäleßkircher. In an earlier statement Beckmann had written: 'My heart goes out to the four great painters of masculine mysticism: Mäleßkircher, Grünewald, Brueghel, and van Gogh' (catalogue foreword for his exhibition at Neumann's Gallery, 1917, in Buenger 1997, p.180).

1923 In 1923 Neumann moves from Berlin to New York. He leaves his Berlin office in the hands of Karl Nierendorf and transfers the management of his print gallery in Munich to the art dealer Günther Franke, who will continue to show Beckmann's work. Beckmann reads the correspondence of Gustave Flaubert, whose novels, such as *The Temptation of St Anthony*, affect him throughout his life.

Piper asks Beckmann to write a 'Self-Portrait', which is written in a typical ironic style and published in the company's almanac:

> Dear Editorial Board, You have asked that I present you with a written self-portrait. My God, I feel downright faint, what should I say? And above all else, what should I not say? I find that much more significant than what I should say. So the result will be music that consists of nothing but pauses ...By chance I landed in Frankfurt am Main. Here I found a stream that I liked, a few friends, and a studio as well. Now I decided to become self-sufficient. At first the business was quite small. Slowly it expanded. What will become of it now? – We live from one day to another (Buenger 1997, pp.273–6).

1924 The following year he writes another short 'Autobiography', in the third person, for the twentieth anniversary of the company: 'Beckmann had the bad luck not to have been endowed by nature with a money-making talent, but rather with a talent for painting ... Beckmann suffers from an unshakeable weakness for that faulty invention "life"' (Buenger 1997, pp.277–8).

In 1924 Piper publishes a comprehensive

monograph on Beckmann with contributions by Wilhelm Fraenger, Curt Glaser, Wilhelm Hausenstein, and Julius Meier-Graefe. It coincides with a large show of Beckmann's work at Cassirer's gallery. Beckmann signs a contract with Cassirer, who will be his representative in Berlin, and with Zingler in Frankfurt.

Beckmann's friends in Frankfurt include Georg Swarzenski, museum director of the Städelsches Kunst Institut, and Fritz Wichert, who since 1923 has headed the Städel Art School. Beckmann is a regular guest at the Friday luncheons organised by the Simons, where he meets distinguished writers, critics, artists and intellectuals such as Rudolf Binding and Fritz von Unruh. He makes the acquaintance of Lilly von Schnitzler, the wife of a senior executive at the I.G. Farbenindustrie in Frankfurt, who starts collecting Beckmann's work. Irma Simon, born into an aristocratic Viennese Jewish family, introduces Beckmann to the Motesiczkys in Vienna, where he meets Mathilde von Kaulbach, nicknamed Quappi. She is the youngest daughter of the Munich painter August Friedrich von Kaulbach and is in Vienna training to be a singer.

In the summer Beckmann spends two weeks with his wife and son in Pirano on the Adriatic, which inspires a group of Italian paintings. Beckmann's social and economic situation improves enormously during these years, due in part to the stabilisation of the German economy.

Beckmann's work features dominantly in the exhibition *Neue Sachlichkeit: German Painting since Expressionism* organised by Gustav

Hartlaub, director of the Kunsthalle Mannheim.

1925 In 1925 the Beckmanns divorce by mutual agreement: Minna continues to enjoy great success as a singer. On 1 September Beckmann marries Quappi, his junior by twenty years, who has declined an offer from the opera in Dresden. For their honeymoon they travel to Rome, Naples and Viareggio. Back in Frankfurt they live in the Hotel Monopol-Metropol across from the central train station, while Beckmann maintains his studio flat in 3 Schweizer Strasse. He is appointed to teach a master class at the Städel Art School.

Beckmann signs a three-year contract with Neumann: in return for an annual guaranteed income of DM 10,000, Beckmann grants Neumann sole sales rights to his paintings. Neumann organises an exhibition in New York in

1926 1926 but no sales result. At this time Beckmann has regular solo exhibitions throughout Germany and his work is constantly included in national and international group shows, for example, at the Venice Biennale, or in Bern, Paris and New York.

The Beckmanns move to an apartment at 7/II Steinhausenstrasse on the Sachsenhäuser Berg. They spend the summer months of 1926 in Spotorno on the Italian Riviera and the following summer in Rimini. Beckmann frequently visits the circus and cabarets. His brother Richard dies.

1927 In 1927 Beckmann writes an article for the *Europäische Revue*, a respected organ for the discussion of the European question published by Prince Karl Anton von Rohan. Despite the editor's right-wing position, the journal presents

271

a wide variety of views. Beckmann's first submission is entitled 'The Social Stance of the Artist by the Black Tightrope Walker', but it is not published, probably because of its ironic tone. His second response, 'The Artist in the State', is more serious in approach:

> The artist in the contemporary sense is the conscious shaper of the transcendent idea. He is at one and the same time the shaper and the vessel. His activity is of vital significance to the state, since it is he who establishes the boundaries of a new culture ... The concept of a state must first be derived from this transcendent idea, and the contemporary artist is the true creator of a world that did not exist before he gave shape to it. Self-reliance is the new idea that the artist, and with him, humanity, must grasp and shape. Autonomy in the face of eternity. The goal must be the resolution of the mystic riddle of balance, the final deification of man ... Only then will we become the conscious masters of eternity – free from time and space' (Buenger 1997, pp.287–290).

In the same year Beckmann receives the Honorary Empire Prize of German Art (Reichsehrenpreis Deutscher Kunst) and the Gold Medal of the City of Düsseldorf. Berlin's National Gallery displays *The Bark* (no.52). This is the first painting by Beckmann to enter its collection, having been donated by art patrons: in the following year the museum also purchases

1928 *Self-Portrait in Tuxedo* (no.88). In 1928 the Mannheim Kunsthalle organises a large retrospective of Beckmann's work that includes 106 paintings and works on paper. Rudolf Baron von Simolin starts his significant Beckmann collection with the purchase of two paintings.

Beckmann spends several weeks in Scheveningen and travels with Quappi to St Moritz for the New Year, where they go skiing.

1929 During the summer of 1929 they holiday in Viareggio. Beckmann also rents a studio in Paris where he spends most of the winters until 1932, returning to Frankfurt only for monthly critiques with his students. From Paris he will occasionally travel to southern France over the next years.

Beckmann receives the title of 'Professor' and an Honorary Prize from the City of Frankfurt.

1930 In 1930 his teaching contract is extended up to 1935 and the Städelsche Kunst Institut displays thirteen of Beckmann's paintings as part of their collection, for a while in a room of their own. During a visit to Paris Neumann introduces Beckmann to Alfred H. Barr, Jr, Director of The Museum of Modern Art in New York, who will include six of Beckmann's paintings in a group show during 1931. Heinrich Simon completes the monograph *Max Beckmann*, published by Klinkhardt & Biermann in Berlin and Leipzig.

Beckmann is eager to exhibit in Paris and competes with his French rivals, especially Picasso, but is very critical of their art. He writes to Neumann:

> You are the person ... to pass on to humanity the idea which I realise. – To bring them back

fig.39
Beckmann and Quappi in Saint-Moritz, December 1928
Max Beckmann Archive, Munich

fig.40
Beckmann and Quappi at Viareggio, summer 1929
Max Beckmann Archive, Munich

fig.41
Beckmann and
Quappi at
Lunapark, Paris
1930
Max Beckmann
Archive, Munich

from their mechanical slavery to something that is alive and human in the beautiful sense – in contrast to the Rosenberg-Picasso wave, which makes the world sterile ...

The clique around Rosenberg is in shivering fear of the first real strike, which threatens their whole edifice. Because it is hollow. (13 October and 4 December 1930, in Klaus Gallwitz, Uwe M. Schneede, Stephan von Weise (eds.), *Max Beckmann: Briefe,* vol.2: 1925–1937 (edited by Stehan von Wiese), Munich and Zurich, 1994, pp.175, 185).

1931 In 1931 the Galerie de la Renaissance in Paris organises a Beckmann show with thirty-six paintings and the Musée du Jeu de Paume acquires the work *Forest Landscape with Woodcutters* 1927 (G273).

The National Socialist and Fascist press increasingly attack Beckmann's work and particularly criticise his show in Paris; they had also disapproved of the Beckmann paintings selected for the 1930 Biennale in Venice.

Beckmann's prolonged absence from the Städel Art School causes a quarrel with the director, Wichert. Beckmann gives notice, but colleagues persuade him to stay.

1932 In 1932 Ludwig Justi, Director of the National Gallery in Berlin, establishes a permanent display with ten paintings by Beckmann in the Kronprinzenpalais. Beckmann starts work on his triptych *Departure,* which he will complete in 1935 (no.60).

The growing political and economic crisis forces Beckmann to give up his apartment

fig.42
The Beckmann
room in the
Kronprinzen-
Palais, National
Gallery, Berlin 1932
On the walls, left
to right: *Self-
Portrait as Clown*
1921 (no.58);
*Landscape at St
Germain* 1930
(G321); *The Bark*
1926 (no.52);
*Landscape near
Saint-Cyr-sur-Mer*
1931 (G352); *Self-
Portrait in Tuxedo*
1927 (no.88)
Bildarchiv
Preußischer
Kulturbesitz,
Berlin

and studio in Paris. Attacks on his work by the National Socialists are increasing and are also directed at many of Beckmann's friends in Frankfurt.

EXILE IN BERLIN

1933 The Beckmanns move to 27 Hohenzollernstrasse (later renamed 3 Graf-Spee-Strasse) in Berlin, in January, just days before Hitler seizes power on the 30th. In March, Wichert is discharged as Director of the Städel Art School: a few days later Beckmann, along with other colleagues, also receives his notice, effective from 15 April. The paintings in the Beckmann room at the Berlin National Gallery are replaced with less controversial landscapes and still lifes after Justi is suspended from his directorship. In the spring, an exhibition of Beckmann's work goes ahead in the Hamburger Kunstverein, but a show planned for Erfurt is cancelled.

1934 During the summers of 1933 and 1934 Beckmann works in the former studio of his father-in-law in Ohlstadt. He works on *Man in the Dark* (no.90), his first sculpture, which will be followed by a second piece, a self-portrait, two years later (no.97).

Only a single article is published to celebrate Beckmann's fiftieth birthday in 1934; the art historian Erhard Göpel, having met Beckmann in Paris the previous year, writes a piece for the local newspaper in Leipzig. Beckmann has no solo exhibitions and is

1935 only represented in group shows in the United States. In 1935 a few Beckmann works are included in exhibitions at the Berlin

Secession and at the Munich Pinakothek.

In Berlin Beckmann makes the acquaintance of the book and art dealer Karl Buchholz, and Curt Valentin, who manages Buchholz's gallery on the upper level of the bookshop. He frequently meets up with Stephan Lackner who had become interested in Beckmann's work, and had already bought one of his paintings.

1936 In 1936 Beckmann has his last solo exhibition in Germany until 1946, in the gallery of Hildebrand Gurlitt in Hamburg. Shortly afterwards, art criticism is banned in Germany. Beckmann travels to Paris to discuss with Lackner and Lackner's father, who lives in Paris, the possibility of emigrating to the United States.

1937 In 1937 more than five hundred works by Beckmann are confiscated from German museums, among them twenty-eight paintings. The exhibition *Degenerate Art* is staged in Munich: among over six hundred and fifty works on show are about ten paintings and ten prints by Beckmann. The exhibition attracts more than two million visitors before travelling to various cities in Germany. Beckmann listens on the radio to Hitler's opening speech in the Haus der Deutschen Kunst in Munich: the next day the Beckmanns leave Germany.

EXILE IN AMSTERDAM

The Beckamanns move to Amsterdam, where Quappi's sister is married to an organist. In Amsterdam the art historian Hans Jaffé, who knows Beckmann from Berlin, arranges for an apartment and studio in an old tobacco warehouse at Rokin 85. The wife of the janitor

fig.43
Beckmann in his studio in Amsterdam 1938
Max Beckmann Archive, Munich

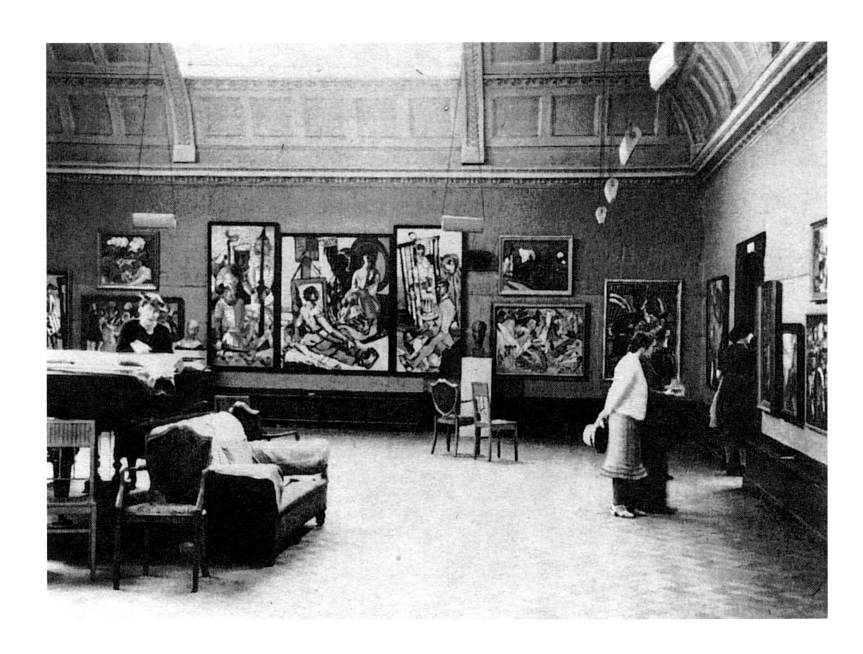

fig.44
*Exhibition of
Twentieth Century
German Art*, New
Burlington Gallery,
London 1938,
including
Beckmann's
triptych
Temptation
1936–7 (G439)

fig.45
Beckmann in his
studio in
Amsterdam 1938
Max Beckmann
Archive, Munich

of their Berlin home packs and sends the Beckmanns' belongings on to them, including works of art.

Beckmann travels to Paris, where he meets some of his supporters and collectors. Lackner, who had moved to Paris, buys several of Beckmann's paintings, among them the triptych *Temptation* (G439). From 1938 he supports Beckmann financially, by paying him a monthly fee in exchange for two paintings. He also initiates a solo exhibition of Beckmann's work in Bern, which travels to Winterthur, Zurich and Basel.

Valentin, who had emigrated to New York, organises an exhibition at the American branch of the Buchholz Gallery, which travels to other American cities. Buchholz and later Günther Franke are able to buy some of Beckmann's confiscated works, which are being sold by the German government with the condition that they are neither exhibited publicly nor sold in Germany. Some works enter private collections and others are sent to Valentin in New York.

In London the *Exhibition of Twentieth Century German Art*, which is conceived in reaction to the *Degenerate Art* exhibition , is presented at the New Burlington Galleries. Herbert Read, the eminent English poet and art critic, is the chairman for the exhibition, which includes six paintings and a print by Beckmann. Lackner writes an essay on Beckmann's work specifically for this exhibition and at the opening Beckmann delivers his famous speech 'On My Painting', which includes the following words:

Before I begin to give you an explanation, an explanation that it is nearly impossible to give, I would like to emphasize that I have never been politically active in any way. I have tried only to realize my conception of the world as intensely as possible ... My aim is always to get hold of the magic of reality and to transfer this reality into painting – to make the invisible visible through reality ... In my opinion all important things in art since Ur of the Chaldees, since Tell Halaf and Crete have always originated form the deepest feeling about the mystery of Being. Self-realization is the urge of all objective spirits. It is this self that I am searching in my life and in my art ... The greatest danger that threatens humanity is collectivism. Everywhere attempts are being made to lower the happiness and the way of living of mankind to the level of termites. I am against these attempts with all the strength of my being ... I am immersed in the phenomenon of the Individual, the so-called whole Individual, and I try in every way to explain and present it. What are you? What am I? Those are the questions that constantly persecute and torment me and perhaps also play some part in my art. (Buenger 1997, pp.302–6)

Whilst in London he visits the Tate Gallery and is particularly impressed by the work of William Blake.

In addition to his flat in Amsterdam, Beckmann rents a furnished apartment in

1938

1939 Paris, from where he travels to the South of France and Geneva. In 1939 he travels to Cap Martin on the Côte d'Azur, which inspires many of his landscape paintings over the following years. He considers settling permanently in Paris, but after returning to Amsterdam the threat of war hinders his plan.

A large number of artworks that had been confiscated from German museums are destroyed in a fire that is orchestrated in the courtyard of the Berlin Fire Department. Other 'degenerate works' are auctioned in Lucerne, where three paintings by Beckmann are sold. At the Golden Gate International Exhibition of Contemporary Art in San Francisco, Beckmann is awarded the first prize for his triptych *Temptation*.

On 1 September Nazi troops invade Poland: two days later Great Britain, France, Australia and New Zealand declare war on Germany. German
1940 troops invade Holland in May 1940 and in fear Beckmann burns the diaries he has kept since 1925, but continues to write new ones.

Beckmann's dealers and friends in the United States have been trying to find a teaching position for him at an American university to enable him to emigrate. He is asked to teach a summer course at the art school of the Art Institute of Chicago, but the US Consul in The Hague refuses him a visa. Göpel, who works for the German army and is responsible for the protection of art works in Holland, is able to offer the Beckmanns some protection during the next difficult years.
1941 During 1941 all correspondence with friends

in the United States is interrupted.

Beckmann's son Peter infrequently visits Amsterdam and over the next few years manages to bring back paintings to Germany. Franke also returns with rolled-up canvases from his visits to Amsterdam. Beckmann receives a commission from Georg Hartmann, owner of a foundry in Frankfurt, to illustrate biblical scenes from the Apocalypse; he creates twenty-seven lithographs which will be privately published in 1943 (see nos.112–28).

The Beckmanns can only travel within Holland, but are able to take trips to the coast. In The Hague they visit Ilse Leembruggen, an aunt of Marie-Louise von Motesiczky, who starts to collect Beckmann's works. In Amsterdam Beckmann is in regular contact with the German painters Friedrich Vordemberge-Gildewart and Herbert Fiedler and with the writer Wolfgang
1942 Frommel. During 1942 he receives rare visits from Piper, Buchholz, and Lilly von Schnitzler, who buys two paintings. The Museum of Modern Art in New York acquires his triptych *Departure* (no.60).

Beckmann is ordered to be examined for military service, but is declared to be unfit, a scenario that will be repeated in two years time.

Helmut Lütjens (who manages the Amsterdam branch of Paul Cassirer & Co.) and his family become good friends with the
1943 Beckmanns. In 1943 he hides a large number of Beckmann's paintings in his house to save them from possible confiscation by German occupying troops. Theo Garve, one of Beckmann's students from Frankfurt, visits his former teacher and

acquires a picture. Franke buys the *Perseus* triptych during one of his visits to Amsterdam (no.105). Hartmann commissions another portfolio, this time for Goethe's *Faust, Part II*, for which Beckmann creates 143 pen drawings, which he completes in February of 1944.

1944 In 1944 Beckmann becomes ill with pneumonia; he suffers from insomnia and a weak heart. He celebrates his sixtieth birthday. The pianist Willy Hahn, who performs for German soldiers in Holland, meets Beckmann and buys three of his paintings.

In June the Allied Forces land in Normandy, and fighting in Amsterdam is anticipated. German troops leave Holland and all of Beckmann's contact with German friends and family is broken. During the summer the Beckmanns take day trips to Overveen and Haarlem.

1945 In 1945 the Allied Forces march into Amsterdam, then into Germany, and the war ends on 4 May. Minna Beckmann-Tube, who leaves Berlin shortly before the end of the war, must leave all her Beckmann paintings in Hermsdorf, but will get back the majority of them in 1950. Beckmann's paintings in Franke's collection also survive the war undamaged.

As a German, Beckmann is under surveillance and is afraid of deportation from Holland. He can again take up correspondence with his American friends, who send care packages with food and painting supplies. He also takes English lessons.

The Stedeljik Museum in Amsterdam acquires the *Double-Portrait of Max Beckmann and Quappi* (no.108) and in the autumn exhibits

1946 fourteen of his paintings. In 1946 Curt Valentin organises Beckmann's first postwar exhibition in New York with roughly thirty works, half of which are paintings. The exhibition is very positively received and almost all of the works are sold. Franke's exhibition in his Munich gallery is the first public showing of Beckmann's work in Germany since 1936. Beckmann is offered a teaching position in Munich and then in Darmstadt, but declines, as he will do with all other offers from German universities, for example from Berlin in the following year and later from Hamburg.

In August he is classified as 'Non-Enemy' and 1947 can officially stay in Amsterdam. In 1947 the Beckmanns take their first journey since the beginning of the war outside Holland, to Nice with a brief stop in Paris.

The Indiana University in Bloomington offers Beckmann a teaching position, as does the Washington University Art School in St Louis. He accepts the offer from St Louis, even though it is a limited contract covering for the absence of the painter Philip Guston. Perry Rathbone, Director of the City Art Museum in St Louis, visits Beckmann in Amsterdam to select pictures for an exhibition to be opened in the following year.

The Städel Art Institute displays a large exhibition of Beckmann's work, with sixty-five paintings and works on paper. For this occasion Beckmann plans to visit Germany for two weeks, but changes his mind. Before their departure to the United States, the Beckmanns meet frequently with their friends in Amsterdam, especially with the Lütjens.

fig.46
Beckmann and Quappi in their apartment in Amsterdam 1947

The Beckmanns leave Europe from Rotterdam on *The Westerdam* on 29 August 1947. After a ten-day stay in New York, where they visit old friends who had emigrated from Frankfurt and Berlin, they arrive in St Louis on 17 September and in October move to 6916 Millbrook Boulevard.

Beckmann's inaugural address to his students is read in English by Quappi:

I hope that you won't expect me to instil in your minds at once – like a mighty magician – the spirit of fiery genius. In my opinion you ought to learn very much, in order to forget most of it later on. That means that I wish you to discover your own selves, and to that end many ways and many detours are necessary ... Please do remember this maxim, the most important I can give you. If you want to reproduce an object, two elements are required: first, the identification with the object must be perfect; and second, it should contain, in addition, something quite different. This second element is difficult to explain. Almost as difficult as to discover one's self. In fact, it is just this element of your own self that we are all in search of (Buenger 1997, p.310).

Despite the language barrier – Quappi always acts as interpreter – Beckmann makes good friendships with his students, in particular with Walter Barker and Warren Brandt. He can work

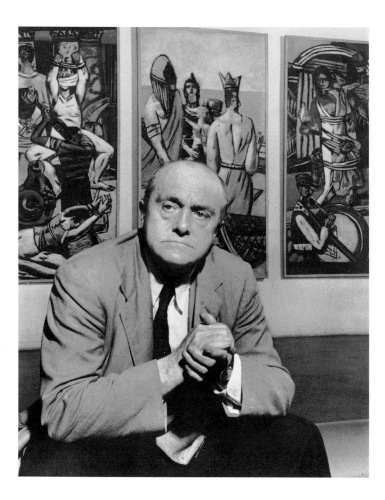

fig.47
Beckmann in front of
Departure 1932, 1933–5
(no.60), at The
Museum of Modern
Art, New York 1947
Max Beckmann
Archive, Munich

fig.48
Beckmann at the
Brooklyn Art
School, New York
1950
Max Beckmann
Archive, Munich

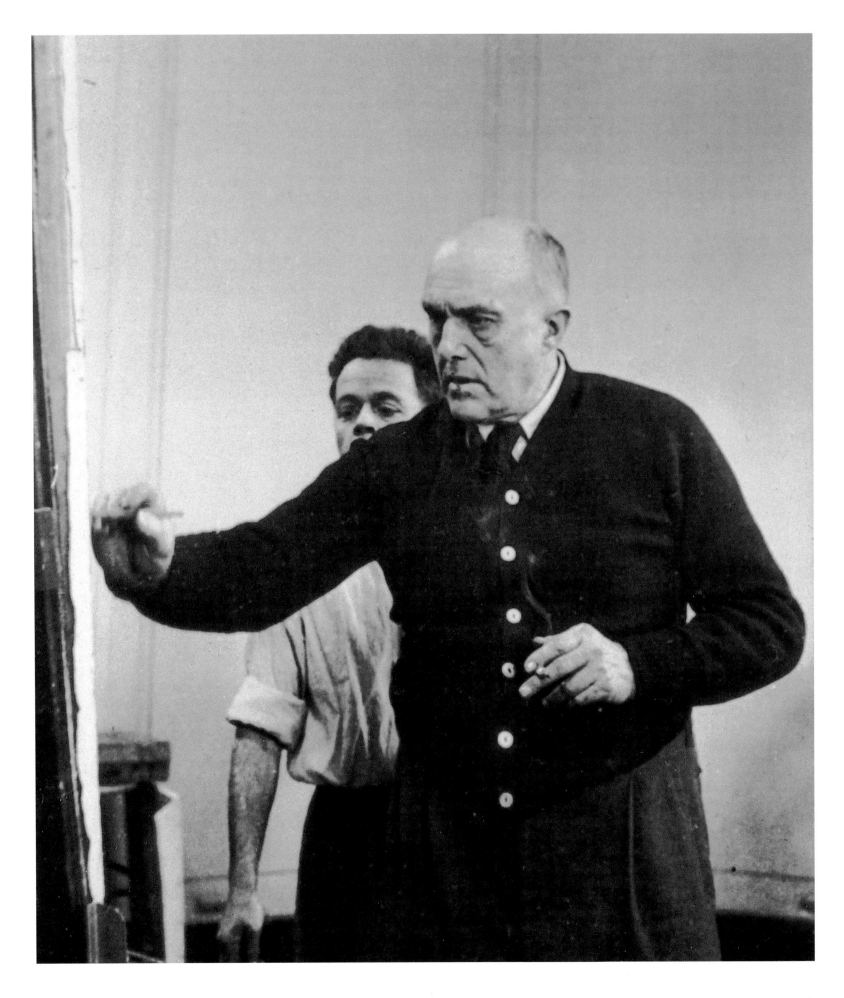

in a studio that is provided on campus. He sits on the jury of the Seventh Annual Museum Exhibition in St Louis and, to the surprise of some critics, votes for the inclusion of abstract and Surrealist works. In November Beckmann travels to New York for an opening of his exhibition at the Buchholz Gallery.

1948 In 1948 Beckmann writes the lecture 'Letters to a Woman Painter' for a presentation at the Stephens College in Columbia. The 'Letters' are translated by Rathbone and Quappi; the latter also reads them to the audience:

For the visible world in combination with our inner selves provides the realm where we may seek infinitely for the individuality of our own souls. In the best art this search has always existed. It has been, strictly speaking, a search for something abstract. And today it remains urgently necessary to express even more strongly one's own individuality ... Art, love and passion are very closely related because everything revolves more or less around knowledge and the enjoyment of beauty in one form or another ... The impression nature makes upon you in its every form must always become an expression of your own joy or grief, and consequently in your formation of it, it must contain that transformation that only then makes art a real abstraction ... We are all tightrope walkers. With them it is the same as with artists, and so with all humanity. As the Chinese philosopher Lao-tse says, we have 'the desire to achieve balance, and to keep it' (Buenger 1997, pp.313–17).

Various other American universities invite the Beckmanns to present the 'Letters to a Woman Painter', which gives them the opportunity to travel throughout the United States. Georg Swarzenski, who is art professor in Boston, for example, invites them for a presentation.

Rathbone opens the largest Beckmann show in the United States to date, which travels from St Louis to other American cities. The exhibition catalogue is the first thorough introduction to Beckmann's work in the English language. The University in St Louis extends Beckmann's contract for another year.

The Beckmanns return to Amsterdam for the summer to change their visa status and to move their belongings. They give up their flat in Amsterdam and return to St Louis via New York. They apply for American citizenship.

In St Louis Beckmann befriends the painter and teacher Fred Conway, as well as his colleagues Werner Drewes and Kenneth Hudson. He gets to know the publisher and collector Joseph Pulitzer, Jr, the art historian Horst Jansen, and the anthropologist Jules Henry, whose wife Zunia is a pianist and is frequently joined by Quappi playing the violin.

1949 The Beckmanns spend New Year in New York. He meets the Mexican painter Rufino Tamayo, who teaches at the Brooklyn Museum Art School. On Tamayo's suggestion August Peck, the School's Director, offers Beckmann a teaching position. Despite the fact that the Washington University Art School in St Louis extends Beckmann's contract to September 1950, when Guston plans to return, Beckmann

accepts Peck's offer for September 1949.

The Beckmanns travel with the Rathbones to Minneapolis for the opening of Beckman's touring exhibition. Beckmann receives the first prize for his work *Fisherwomen* (G777) in the exhibition *Painting in the United States* organised by the Carnegie Institute in Pittsburgh. Morton May, a businessman and art patron in St Louis, commissions his portrait and starts to collect works by Beckmann and the German Expressionists. A monograph on Beckmann written by Reifenberg and Hausenstein is published by Piper in Munich.

In June Beckmann teaches a summer course in Boulder, Colorado, before leaving St Louis for New York, where he and Quappi live near Gramercy Park, at 234 East 19th Street. He starts teaching at the Brooklyn Museum Art School, where, in 1950, his contract is extended for another six years. The Beckmanns move into a new apartment at 38 West 69th Street.

At the 1950 Biennale in Venice Beckmann is represented with fourteen paintings in the German Pavillion and receives the Conte-Volpi-Prize. He receives an honorary doctorate from Washington University in St Louis and gives a speech during commencement week:

Friends have asked me to say something about art during this reunion. Should one embark again on the discussion of this old theme, which never arrives at a satisfactory conclusion because everyone can speak only for himself? Particularly the artist who, after all, can never escape his calling. Isn't it much nicer to go for a walk ...? ... But above all you should love, love, and love! Do not forget that every man, every tree, and every flower is an individual worth thorough study and portrayal ... Art resolves through form the many paradoxes of life, and sometimes permits us to glimpse behind the dark curtain that hides those unknown spaces where one day we shall be unified (Buenger 1997, pp.319–20).

From St Louis the Beckmanns travel to California, where they visit Carmel and San Francisco, and take a trip to Reno in West Nevada. During the summer Beckmann teaches at the Mills College in Oakland at the invitation of Alfred Neumeyer. Back in New York he continues teaching at the Brooklyn Museum Art School, and additionally at the private American Art School.

Hanns Swarzenski, Stephan Lackner and Ernst Holzinger, Director of the Städel Art School in Frankfurt, visit Beckmann in New York. Holzinger tries to convince Beckmann to return as a teacher or visiting artist to the Städelsches Art Institute in Frankfurt.

Beckmann works on his triptych *Argonauts* (no.163), which he completes on 26 December 1950. A day later he leaves his apartment to walk through Central Park to see the exhibition *American Painting Today* at the Metropolitan Museum, which includes his *Self-Portrait in Blue Jacket* (no.164). At the corner of 61st Street and Central Park West he collapses and dies of a heart attack.

1950

fig.49
Max Beckmann (2nd left) when awarded the title of Doctor Honoris Causa by the Washington University, Saint Louis, 6 June 1950
Max Beckmann Archive, Munich

fig.50
Beckmann in front of *Falling Man* (no.160) in his New York apartment 1950
Max Beckmann Archive, Munich

Select Bibliography

Writings by Max Beckmann

Chronological by date of first publication

'Gedanken über zeitgemäße und unzeitgemäße Kunst', *Pan*, no.2, 1912, p.499

'Das neue Programm', *Kunst und Künstler*, no.12, 1914, p.301

Max Beckmann: Briefe im Kriege 1914/15, collected by M. Tube, afterword by P. Beckmann, first pub. 1916, 1955, Munich and Zurich 1984

'Schöpferische Konfession', in Edschmid, K. (ed.), *Tribüne der Kunst und Zeit*, vol.13, Berlin 1920 (first ed. 1918), p.61

Das Hotel: Drama in vier Akten, completed by 1923, ed. G.U. Feller, Gerlingen 1984. English trans. in Buenger 1997, pp.226–71

Ebbi, Komödie von Max Beckmann, Vienna 1924, ed. G.U. Feller, Gerlingen 1984. English trans. in Buenger 1997, pp.190–225

'Autobiographie', 1924, privately published, English trans in Buenger 1997, pp.277–8

'Die soziale Stellung des Künstlers (Vom Schwarzen Seiltänzer)', 1926–7, unpublished. English trans. in Buenger 1997, pp.279–83

'Der Künstler im Staat', *Europäische Revue*, no.3, 1927, p.288

'On My Painting'. Paper presented at the New Burlington Galleries, London, 21 July 1938, pub. New York 1941. English trans. in Buenger 1997, pp.298–307

'Letters to a Woman Painter' (Briefe an eine Malerin), first presented 3 Feb. 1948 at Stephens College in Columbia, in Buenger 1997, pp.312–17

'Can Painting Be Taught? Beckmann's Answer, Interview' [with D. Seckler], *Art News*, vol.50, no.1, 1951, p.39

Tagebücher 1940–1950. Collected by M.Q. Beckmann, ed. E. Göpel, Munich 1955, 1984

Blick auf Beckmann. Dokumente und Vorträge, Erläuterungen und Anmerkungen, Schriften der Max Beckmann Gesellschaft, ed. H.M.F. von Erffa and E.Göpel, Munich 1962

Leben in Berlin. Tagebuch 1908/1909, ed. H. Kinkel, Munich and Zurich 1966

Die Realität der Träume in den Bildern. Aufsätze und Vorträge. Aus Tagebüchern, Briefen, Gesprächen 1903–1950, ed. R. Pillep, Leipzig 1984

Frühe Tagebücher, 1903–1904, 1912–1913, ed. D. Schmidt, Munich and Zurich 1985

Die Bibliothek Max Beckmanns. Unterstreichungen, Kommentare, Notizen und Skizzen in seinen Büchern, ed. P. Beckmann and J. Schaffer, Worms 1992

Max Beckmann: Briefe. ed. K. Gallwitz; U.M. Schneede; and S. von Wiese, 3 vols., Munich and Zurich 1993–6

Max Beckmann: Self-Portrait in Words: Collected Writings and Statements, 1903–1950, ed. B.C. Buenger; trans. B.C. Buenger; R. Heller; and D. Britt, Chicago and London 1997

Catalogues

In chronological order

Max Beckmann, Das Gesammelte Werk. Gemälde, Graphik, Handzeichnungen aus den Jahren 1905–1927, Städtische Kunsthalle, Mannheim 1928

Max Beckmann, City Art Museum of St Louis 1948

Max Beckmann zum Gedächtnis 1884–1950, Haus der Kunst, Munich 1951

Max Beckmann: Die Druckgraphik – Radierungen, Lithographien, Holzschnitte, Badischer Kunstverein, Karlsruhe 1962

Max Beckmann retrospective: 200 Paintings, Drawings and Prints from 1905–1950, The Museum of Modern Art, New York 1964

Max Beckmann, 1884–1950: Paintings, Drawings and Graphic Work, Tate Gallery, London 1965

Max Beckmann: Gemälde, Aquarelle, Zeichnungen, Kunstverein in Hamburg 1965

Max Beckmann: Gemälde und Aquarelle der Sammlung Stephan Lackner, USA, Kunsthalle Bremen 1966

Max Beckmann, Musée National d'Art Moderne, Paris 1968

Max Beckmann, Palais des Beaux-Arts, Brussels 1969

The Complete Series of Drawings by Max Beckmann for Goethe's 'Faust II', Sotheby's & Co., London, 1 Dec. 1971

The Apokalypse, University of Maryland Art Gallery 1973

Max Beckmann: A Small Loan Retrospective of Paintings, Centred around his Visit to London in 1938, Marlborough Fine Art Ltd, London 1974

Max Beckmann in der Sammlung Piper: Handzeichnungen, Druckgraphik, Dokumente, 1910–1923, Kunsthalle Bremen 1974

Max Beckmann. Aquarelle und Zeichnungen 1903–1950, Kunsthalle Bielefeld 1977

Neue Sachlichkeit and German Realism of the Twenties, Hayward Gallery, London 1978

Der Zeichner und Grafiker Max Beckmann, Kunstverein in Hamburg 1979

Max Beckmann. Pierrette und Clown, 1925, Mannheimer Kunsthalle, Mannheim 1981

Max Beckmann: The Triptychs, Whitechapel Art Gallery, London 1981

Aquarelle, Zeichnungen und Graphik des 20. Jahrhunderts: Sammlung Reinhard Piper (1879–1953), Karl & Faber, Munich, 29/30 June 1981

Max Beckmann Die Triptychen im Städel, Städische Galerie im Städelschen Kunstinstitut, Frankfurt a/M 1981

Max Beckmann: Die frühen Bilder, Kunsthalle Bielefeld 1982

Max Beckmann: Die Hölle, 1919, Staatliche Museen Preußischer Kulturbesitz, Kupferstichkabinett, Berlin 1983

Max Beckmann: Frankfurt 1915–1933. Eine Ausstellung zum 100. Geburtstag, Städische Galerie im Städelschen Kunstinstitut, Frankfurt a/M 1983

Max Beckmann, Josef-Haubrich-Kunsthalle, Cologne 1984

Max Beckmann, 1884–1950. Gemälde, Zeichnungen, Grafik, Nationalgalerie (GDR), Berlin 1984

Max Beckmann. Retrospective, Haus der Kunst München, Munich 1984

Max Beckmann. Seine Themen – seine Zeit. Zum 100 Geburtstag des Künstlers, Kunsthalle Bremen 1984

Max Beckmann. Graphik, Malerei, Zeichnung. Ausstellung zum 100. Geburtstag, Museum der bildenden Künste, Leipzig 1984

Huldigung an Max Beckmann. 30 zeitgenössische Maler und Bildhauer zum 100. Geburtstag, Galerie Poll, Berlin 1984

Five Students of Max Beckmann, Bixby Gallery, Washington DC, University School of Fine Arts, St Louis 1984

Max Beckmann: Aus dem Menschenorchester. Graphische Zyklen um 1920, Kaiser Wilhelm Museum, Krefeld 1985

German Art in the 20th Century: Painting and Sculpture 1905–1985, Royal Academy of Arts, London 1985

Nationalsozialismus und 'Entartete Kunst': die 'Kunststadt' München 1937, Staatsgalerie Moderner Kunst, Munich 1987

Max Beckmann: Apokalypse, Städtische Galerie Albstadt 1988

Max Beckmann: Gemälde 1905–1950, Museum der bildenden Künste, Leipzig 1990

Hinter der Bühne Backstage Max Beckmann 1950, Städtische Galerie im Städelschen Kunstinstitut, Frankfurt a/M 1990

'Degenerate Art', The Fate of the Avantgarde in Nazi Germany, County Museum of Art, Los Angeles 1991

Max Beckmann: Prints from the Museum of Modern Art, Fort Worth 1992

Max Beckmann: The Self-Portraits, Gagosian Gallery, New York 1992

Max Beckmann : Selbstbildnisse, Hamburger Kunsthalle, Hamburg 1993

Max Beckmann : Meisterwerke 1907–1950, Staatsgalerie Stuttgart 1994

Max Beckmann, Gravures (1991–1946), Musée de l'Abbaye Sainte-Croix, Ville des Sables D'Olonne 1994

Max Beckmann in Exile, Guggenheim Museum, SoHo, New York 1996

Max Beckmann: Die Nacht, Kunstsammlung Nordrhein-Westfalen, Düsseldorf 1997

Max Beckmann and Paris: Matisse, Picasso, Braque, Léger, Rouault, Kunsthaus Zürich, Cologne and Saint Louis Art Museum 1998

Circus Beckmann, Sprengel Museum Hannover 1998

Max Beckmann: Zeichnungen aus dem Nachlass Mathilde Q. Beckmann, Museum der bildenden Künste, Leipzig 1998

Max Beckmann. Landschaft als Fremde, Hamburger Kunsthalle, Hamburg 1998

Max Beckmann: Selbstbildnisse: Zeichnung und Druckgraphik, Bayerische Staatsgemäldesammlungen, Munich 2000

Max Beckmann und Günther Franke, Staatsgalerie Moderner Kunst, Munich 2000

Stephan Lackner– der Freund Max Beckmanns, Staatsgalerie moderner Kunst, Munich 2000

Spektakel des Lebens. Max Beckmann – Arbeiten auf Papier, Sinclair-Haus, Kulturforum Alatana, Bad Homburg v.d. Höhe 2001

Max Beckmann: The Eight Sculptures, Richard L. Feigen and Co., New York 2002

Books and Articles
Alphabetical by author

Beall, K.F. 'Max Beckmann – Day and Dream', *Quarterly Journal of the Library of Congress*, vol.27, no.1, pp.2–19

Bealle, P. 'I.B. Neumann and the Introduction of Modern German Art to New York, 1923–1933', *Archives of American Art Journal*, vol.29, no.1, 1989, pp.2–15

Beckmann, M.Q., *Mein Leben mit Max Beckmann*, Munich 1983

Beckmann, P. *Schwarz auf Weiß – Max Beckmann. Wege zur Wirklichkeit*, Stuttgart and Zurich 1977

——. *"Die Versuchung". Eine Interpretation des Triptychons von Max Beckmann*, Heroldsberg bei Nürnberg 1977

——. *Max Beckmann. Leben und Werk*, Stuttgart and Zurich 1982

——. 'Max Beckmann in seinen Illustrationen und seine Symbolwelt am Beispiel der Illustrationen zur Apokalypse' in *Max Beckmann Symposium*, 15/16 May 1984, ed. S. Gohr, Cologne 1987, pp.37–47

——. *Max Beckmann. Sichtbares und Unsichtbares*, Stuttgart

—— (ed). *Max Beckmann, Apokalypse. Die Offenbarung Sankt Johannis in der Übertragung von Martin Luther*, Leipzig 1989

Belting, H. *Max Beckmann: Tradition as a Problem in Modern Art*, trans. Peter Wortsman, New York 1989

Buenger, B.C. 'Beckmann's Beginnings: "Junge Männer am Meer"', *Pantheon*, vol.41, no.2, 1983, pp.134–44

——. 'Max Beckmann's "Amazonenschlacht": Tackling "die grosse Idee"', *Pantheon*, vol.42, no.2, 1984, pp.140–50

——. 'Max Beckmann's "Ideologues": Some Forgotten Faces', *Art Bulletin*, vol.71, no.3, 1989, pp.453–79

——. *Max Beckmann's Artistic Sources: The Artist's Relation to Older and Modern Traditions*, Ann Arbor 2000

Clark, M.O. 'Max Beckmann: Sources of Imagery in the Hermetic Tradition', PhD Thesis, Washington University, St Louis

——. 'The Many-Layered Imagery of Max Beckmann's "Temptation" Triptych', *Art Quarterly*, vol.1, no.3, pp.244–64

Cooke, L. 'Beckmann and Myth', *Artscribe*, vol.27, Feb. 1981, pp.16–22

De Francia, P. 'Max Beckmann: "A Homer in a Concierge's Lodge"', *Fine Art Newletter*, vol.3, May 1981, pp.7–17

Eberle, M. *Max Beckmann. Die Nacht. Passion ohne Erlösung*, *(Kunststück)*, Frankfurt a/M 1984

——. *World War I and the Weimar Artists. Dix, Grosz, Beckmann, Schlemmer*, New Haven and London 1985

Erpel, F. *Max Beckmann*, Berlin 1981

Fischer, F.W. *Max Beckmann. Symbol und Weltbild*, Munich 1972

——. *Der Maler Max Beckmann*, Cologne 1972

Franciscono, M. 'The Imaginary of Max Beckmann's "The Night"', *Art Journal*, vol.33, no.1, 1973, pp.18–22

Franzke, A. *Max Beckmann. Skulpturen*, Munich 1987

Gallwitz, K. 'Max Beckmann in Frankfurt', in Gallwitz, K. (ed.), *Max Beckmann in Frankfur*t, Frankfurt a/M 1984, pp.7–15

Gandelman, C. 'Max Beckmann's Triptychs and the Simultaneous Stage of the '20s', *Art History*, vol.1, no.4, 1978, pp.472–83

Gässler, E. 'Studien zum Frühwerk Max Beckmanns. Eine motivkundliche und ikonographische Untersuchung zur Kunst der Jahrhundertwende', Diss., Göttingen 1974

Gay, P. *Weimar Culture: The Outsider as Insider*, London 1969

Glaser, C.; Meier-Graefe, J.; Fraenger W.; and Hausenstein, W. *Max Beckmann*, Munich 1924

Göpel, E. *Max Beckmann. Berichte eines Augenzeugen*. Göpel, B. (ed.), Busch, G. (afterword), Frankfurt a/M 1984

——; and Göpel, B. *Max Beckmann. Katalog der Gemälde*, 2 vols., Bern 1976

Güse, E.-G. *Das Frühwerk Max Beckmanns. Zur Thematik seiner Bilder aus den Jahren 1904–1914*, Frankfurt a/M and Bern 1977

Haberer, J. 'Christus und die Sünderin (1917). Max Beckmann', in *Kunst und Botschaft*. Hildesheim 1990, pp.40–1

Hofmaier, J. *Max Beckmann: Catalogue Raisonné of his Prints*, 2 vols., Bern 1990

Hüneke, A. *Das Schicksal einer Sammlung ... Die Avantgarde in Deutschland 1905–1920*, Nationalgalerie, Berlin (GDR) 1986

——. 'Beobachtungen zu einigen Motiven im Werk Max Beckmanns', in *Max Beckmann Colloquium*, Leipzig 1984, Berlin 1985, pp.138–42

Kaiser, H. *Max Beckmann*, Berlin 1913

Kersting, H. 'Max Beckmann – Das überschätzte Individuum', in *Städel-Jahrbuch*, N.F. 10, 1985, pp.261–76

Kessler, C.S. *Max Beckmann's Triptychs*, Cambridge, Mass. 1970

Lackner, S. *Ich erinnere mich gut an Max Beckmann*, Kupferberg 1967, English trans. as *Max Beckmann, Memories of a Frindship*, Miami 1969

Lenz, C. *Max Beckmann und Italien*, Frankfurt a/M 1976

——. 'Max Beckmanns Synagoge', *Städel Jahrbuch*, N.F. 4, 1973, p.299

——. 'Max Beckmann. 'Das Martyrium', in *Jahrbuch der Berliner Museen*, N.F., vol.16, 1974, pp.185–210

——. 'Moderne Kunst. Ernst Ludwig Kirchner und Max Beckman', *Universitas*, vol.35, 1980, pp.1187–1194

——. *Max Beckmann und die Alten Meister: "Eine ganz nette Reihe von Freunden"*, Bönningheim 2000

——; Zeiller, C. (eds.). *Minna Beckmann-Tube*, Bayerische Staatsgemäldesammlungen Max Beckmann Archiv, Munich 1998

Maur, K. von. 'Max Beckmanns Schicksalsbild "Reise auf dem Fisch"', in *Max Beckmann. Reise auf dem Fisch*, Kulturstiftung der Länder in Verbindung mit der Staatsgalerie Stuttgart, Berlin 1992, pp.7–25

Motesiczky, M.L. von. 'Max Beckmann as Teacher', *Artscribe*, vol.47, 1984, pp.50–3

Mück, H.-D.; Pillep, R. *Max Beckmann und Thüringen. Eine Documentation: Weimar 1900 – Erfurt 1937*, Stuttgart and Frankfurt a/M 1997

Paret, P. *The Berlin Secession: Modernism and its Enemies in Imperial Germany*, Cambridge and London 1980

Peter, N. *Max Beckmann: Landschaften der Zwanziger Jahre*, Frankfurt a/M 1992

Poeschke, J.; Lenz, C.; Güse, E.-G. et al. *Max Beckmann: Vorträge 1996–1998*, Bayerische Staatsgemäldesammlungen, Max Beckmann Archiv (ed), Munich 2000

Reifenberg, B.; Hausenstein, W. *Max Beckmann*, Munich 1949

Rother, S. *Beckmann als Landschaftsmaler*, (Beiträge zur Kunstwissenschaft, vol. 34) Munich 1990

Schubert, D. *Max Beckmann. Auferstehung und Erscheinung der Toten*, Worms 1985

Schulze, I. 'Jahrmarkt-Metapher, Tiersatire und "verkehrte Welt" bei Max Beckmann', *Bildende Kunst*, no.4, 1989, pp.35–7

——. 'Zirkus, Karussel und Schaubude. Max Beckmanns Graphikmappe "Der Jahrmarkt" von 1921 ... ', *Weimarer Beiträge*, vol.37, no.2, 1991, pp.196–212

Schulz-Hoffman, C. *Max Beckmann. Der Maler*, Munich 1991

Schuster, P.-K. (ed.). *Dokumentation zum nationalsozialistischen Bildersturm am Bestand der Staatsgalerie Moderner Kunst in München*, Munich 1987

Schütz, H.G. *Sphinx Beckmann : Exemplarische Annäherungen an Max Beckmanns Kunst*, Munich 1997

Selz, P. *Max Beckmann*, New York and London 1996

Soine, K. 'Das Mann-Frau-Verhältnis und das Fisch-Symbol. Zur Ikonographie Max Beckmanns und Bezüge zur zeitgenössischen Kunst', *Kritische Berichte*, vol.12, no.4, 1984, pp.42–67

Spieler, R. *Max Beckmann: 1884–1950: The Path To Myth*, Cologne 1995

——. *Max Beckmann: Bildwelt und Weltbild in den Triptychen*, Cologne 1998

Storm, U. 'Zu Max Beckmanns Gemälde "Tod" in der Berliner Nationalgalerie', *Zeitschrift des deutschen Vereins für Kunstwissenschaft*, vol.39, no.1/4, 1985, pp.121–47

Wachtmann, H.G., 'Zu Max Beckmanns "Luftakrobaten"', *Niederdeutsche Beiträge zur Kunstgeschichte*, **v**ol.16, 1977, pp.227–35

Wagner, Ernst, *Max Beckmann: Apokalypse: Theorie und Praxis im Spätwerk*, Berlin 1999

Walden-Awodu, D. '"Geburt und Tod". Max Beckmann im Amsterdamer Exil. Eine Untersuchung zur Entstehungsgeschichte seines Spätwerks', Munich 1993

Wankmüller, R.; Ziese, E. *In deinem Nichts hoff ich das All zu finden. Max Beckmann: Illustrationen zu Faust II. Federzeichnungen – Bleistiftskizzen*, Munich and Münster 1984

Westheider, O. *Die Farbe Schwarz in der Malerei Max Beckmanns*, Berlin 1995

Wiese, S. von. *Max Beckmanns zeichnerisches Werk 1903–1925*, Düsseldorf 1978

Willett, J. *The New Sobriety 1917–1933: Art and Politics in the Weimar Period*, New York 1978

Winters, D.R. *Seven Max Beckmann Triptychs 1932–1945*, Ann Arbor 2000

Zenser, H. *Max Beckmanns Selbstbildnisse*, Munich 1984

List of Works

Measurements are in centimetres, followed by inches in parentheses, height before width.

Abbreviations
G Erhard Göpel and Barbara Göpel, *Max Beckmann. Katalog der Gemälde*, Bern 1976
H James Hofmaier, *Max Beckmann: Catalogue Raisonné of his Prints*, Bern 1990
vW Stephan von Wiese, *Max Beckmanns zeichnerisches Werk 1903–1925*, Düsseldorf 1978

Paintings

All works are oil on canvas

Young Men by the Sea
1905
Junge Männer am Meer
148 × 235
(58 1/4 × 92 1/2)
Kunstsammlung zu Weimar
G18
no.3 on p.14

Sunny Green Sea 1905
Sonniges grünes Meer
80 × 110
(31 1/2 × 43 1/4)
Private collection
G28
no.8 on p.23

Small Death Scene
1906
Kleine Sterbeszene
110 × 71
(43 1/4 × 28)
Staatliche Museen zu Berlin, Nationalgalerie, Eigentum des Landes Berlin
G62
no.2 on p.13

Conversation 1908
Unterhaltung
177 × 168.5
(69 5/8 × 66 3/8)
Staatliche Museen zu Berlin, Nationalgalerie
G88
no.7 on p.20

Balloon Race (Ascent of the Balloons in the Gordon-Bennett Race)
1908
Ballonwettfahrt (Aufstieg der Ballons beim Gordon-Bennett-Rennen)
70 × 80.5
(27 1/2 × 31 3/4)
Staatsgalerie Stuttgart
G100
no.5 on p.17

Double-Portrait of Max Beckmann and Minna Beckmann-Tube 1909
Doppelbildnis Max Beckmann und Minna Beckmann-Tube
143.5 × 112
(56 1/2 × 44 1/8)
Staatliche Galerie Moritzburg Halle, Landeskunstmuseum Sachsen-Anhalt
G109
no.4 on p.14

The Sinking of the Titanic 1912
Untergang der Titanic
265 × 330
(104 3/8 × 129 7/8)
The Saint Louis Art Museum. Bequest of Morton D. May
G159
no.7 on p.18–19

Descent from the Cross
1917
Kreuzabnahme
151.2 × 128.9
(59 1/2 × 50 3/4)
The Museum of Modern Art, New York. Curt Valentin Bequest, 1955
G192
no.9 on p.28

Self-Portrait with Red Scarf 1917
Selbstbildnis mit rotem Schal
80 × 60
(31 1/2 × 23 5/8)
Staatsgalerie Stuttgart
G194
no.1 on p.10

Landscape with Balloon
1917
Landschaft mit Luftballon
75.7 × 100.5
(29 7/8 × 39 5/8)
Museum Ludwig, Cologne
G195
no.49 on p.82–3

Adam and Eve 1917
Adam und Eva
79.5 × 56.7
(31 1/4 × 22 3/8)
Staatliche Museen zu Berlin, Nationalgalerie
G196
no.11 on p.30

Christ and the Woman Taken in Adultery 1917
Christus und die Sünderin
149.2 × 126.7
(58 3/4 × 49 7/8)
The Saint Louis Art Museum. Bequest of Curt Valentin
G197
no.10 on p.29

The Night 1918–19
Die Nacht
133 × 154
(52 3/8 × 60 5/8)
Kunstsammlung Nordrhein-Westfalen, Düsseldorf
G200
no.59 on pp.98–9

The Synagogue 1919
Die Synagoge
89 × 140
(35 × 55 1/8)
Städtische Galerie im Städelschen Kunstinstitut, Frankfurt am Main
G204
no.41 on p.73

Carnival 1920
Fastnacht
186.4 × 91.8
(73 3/8 × 36 1/8)
Tate, London. Purchased with assistance from the National Art Collections Fund and Friends of the Tate Gallery and Mercedes-Benz (UK) Ltd 1981
G206
no.13 on p.32

Family Portrait 1920
Familienbild
65.1 × 100.9
(25 5/8 × 39 3/4)
The Museum of Modern Art, New York. Gift of Abby Aldrich Rockefeller, 1935
G207
no.12 on p.31

The Dream 1921
Der Traum
184 × 87.5
(72 1/2 × 34 1/2)
The Saint Louis Art Museum. Bequest of Morton D. May
G208
no.14 on p.33

The Nizza in Frankfurt am Main 1921
Das Nizza in Frankfurt am Main
100.5 × 65.5
(39 1/2 × 25 3/4)
Öffentliche Kunstsammlung Basel, Kunstmuseum
G210
no.43 on p.75

Self-Portrait as Clown
1921
Selbstbildnis als Clown
100 × 59
(39 3/8 × 23 1/4)
Von der Heydt-Museum Wuppertal
G211
no.58 on p.94

Landscape near Frankfurt (with Factory)
1922
Landschaft bei Frankfurt (mit Fabrik)
66 × 100.5
(26 × 39 1/2)
Rose Art Museum, Brandeis University, Waltham, Massachusetts. Gift of Mr and Mrs Harry N. Abrams, New York
G214
no.46 on p.80

The Iron Footbridge
1922
Der Eiserne Steg
120.5 × 84.5
(47 1/2 × 33 1/4)
Kunstsammlung Nordrhein-Westfalen, Düsseldorf
G215
no.44 on p.77

Portrait of Frau Dr Heidel 1922
Bildnis Frau Dr Heidel
100 × 65
(39 3/8 × 25 5/8)
Kunsthalle Hamburg
G217
no.87 on p.148

Self-Portrait in front of a Red Curtain 1923
Selbstbildnis vor rotem Vorhang
110 × 59.5
(43 3/8 × 23.5 1/2)
G218
Private collection, Courtesy of Neue Galerie, New York
[Frontispiece in MoMA catalogue only]

Still Life with Fish and Pinwheel 1923
Stilleben mit Fischen und Papierblume
60.5 × 40.3
(23 3/4 × 15 7/8)
Frederick R. Weismann Art Museum, University of Minnesota, Minneapolis. Gift of Ione and Hudson Walker
G220
no.71 on p.124

Self-Portrait with Cigarette on a Yellow Background 1923
Selbstbildnis auf gelbem Grund mit Zigarette
60.2 × 40.3
(23 5/8 × 15 3/4)
The Museum of Modern Art, New York. Gift of Dr and Mrs F.H. Hirschland, 1956
G221
no.85 on p.145

Landscape with Lake and Poplars 1924
Seelandschaft mit Pappeln
60 × 60.5
(23 5/8 × 23 7/8)
Kunsthalle Bielefeld
G232
no.48 on p.81

Lido 1924
Lido
72.5 × 90.5
(28 1/2 × 35 5/8)
The Saint Louis Art Museum. Bequest of Morton D. May
G234
no.51 on p.85

Carnival (Pierrette and Clown) 1925
Fastnacht (Pierette and Clown)
160 × 100
(63 × 39 3/8)
G236
Städtische Kunsthalle Mannheim
no.61 on p.113

Italian Fantasy 1925
Ialienische Fantasie
127 × 43
(50 × 16 7/8)
Kunsthalle Bielefeld
G238
no.53 on p.87

Double-Portrait Carnival 1925
Doppelbildnis Karneval
160 × 105.5
(63 × 41 1/2)
Museum Kunst Palast, Sammlung der Kunstakademie, Düsseldorf
G240
no.62 on p.114

Galleria Umberto 1925
Galleria Umberto
113 × 50
(44 1/2 × 19 5/8)
Private collection
G247
no.89 on p.159

The Bark 1926
Die Barke
177.8 × 88.9
(70 × 35)
Richard L. Feigen, New
York
G253
no.52 on p.86

Quappi in Blue 1926
Bildnis Quappi in Blau
60.8 × 35.2
(24 × 13 7/8)
Bayerische
Staatsgemäldesamm-
lungen, Munich,
Pinakothek der
Moderne. Donation
Günther Franke
G256
no.63 on p.115

*Self-Portrait with White
Hat* 1926
Selbstbildnis mit
weißer Mütze
100 × 71
(39 3/8 × 28)
Anonymous
G262
no.75 on p.128

Female Nude with Dog
1927
Weiblicher Akt mit
Hund
67 × 47
(26 3/8 × 18 1/2)
Museum Wiesbaden
G268
no.64 on p.116

The Harbour of Genoa
1927
Der Hafen von Genua
90.5 × 169.5
(35 5/8 × 66 3/4)
The Saint Louis Art
Museum. Bequest of
Morton D. May
G269
no.54 on pp.88–9

Self-Portrait in Tuxedo
1927
Selbstbildnis im
Smoking
141 × 96
(55 1/2 × 37 3/4)
Courtesy of the Busch-
Reisinger Museum,
Harvard University Art
Museums, Association
Fund
G274
no.88 on p.156

Portrait of N.M. Zeretelli
1927
Bildnis N.M. Zeretelli
140 × 96
(55 1/8 × 37 3/4)
Courtesy of the Fogg
Art Museum, Harvard
University Art
Museums. Gift of Mr
and Mrs Joseph
Pulitzer, Jr
G277
no.86 on p.147

Gypsy Woman 1928
Zigeunerin
136 × 58
(53 1/2 × 22 7/8)
Kunsthalle Hamburg
G289
no.65 on p.117

Scheveningen, Five a.m.
1928
Scheveningen, fünf Uhr
früh
56.9 × 63
(22 3/8 × 24 3/4)
Bayerische
Staatsgemäldesamm-
lungen, Munich,
Pinakothek der
Moderne. Donation
Günther Franke
G293
no.69 on p.122

Bathing Cabin (Green)
1928
Badekabine (grün)
70.2 × 85.7
(27 5/8 × 33 3/4)
Bayerische
Staatsgemäldesamm-
lungen, Munich,
Pinakothek der
Moderne, Donation
Günther Franke
G297
no.70 on p.123

Aerial Acrobats 1928
Luftakrobaten
215 × 100
(84 3/8 × 39 3/8)
Von der Heydt-Museum
Wuppertal
G299
no.68 on p.121

*Still Life with Fallen
Candles* 1929
Stilleben mit
umgestürzten Kerzen
55.9 × 62.9
(22 × 24 3/4)
The Detroit Institute of
Arts. City of Detroit
Purchase
G302
no.72 on p.125

Football Players 1929
Fußballspieler
213 × 100
(83 7/8 × 39 3/8)
Wilhelm-Lehmbruck-
Museum, Duisburg
G307
no.67 on p.120

Reclining Nude 1929
Liegender Akt
83.4 × 119
(32 7/8 × 46 7/8)
The Art Institute of
Chicago. Joseph
Winterbothom
Collection
G308
no.77 on p.130

Marine (Côte d'Azur)
1930
Marine (Côte d'Azur)
90 × 60
(35 3/8 × 23 5/8)
Private collection,
Courtesy Galerie
Kornfeld, Bern
G318
no.81 on p.136

*Self-Portrait with
Saxophone* 1930
Selbstbildnis mit
Saxophon
140 × 69.5
(55 1/8 × 27 3/8)
Kunsthalle Bremen
G320
no.73 on p.126

Artists by the Sea 1930
Künstler am Meer
36.5 × 24
(14 3/8 × 9 1/2)
Private collection,
Courtesy Richards L.
Feigen & Co., New York
G332
no.83 on p.139

The Bath 1930
Das Bad
174 × 120
(68 1/2 × 47 1/4)
The Saint Louis Art
Museum. Bequest of
Morton D. May
G334
no.74 on p.127

Parisian Society 1925,
1931, 1947
Gesellschaft Paris
110 × 176
(43 1/4 × 69 1/4)
Guggenheim Museum,
New York
G346
no.91 on p.162

*Man and Woman
(Adam and Eve)* 1932
Man und Frau (Adam
und Eva)
175 × 120
(68 7/8 × 47 1/4)
Private collection
G363
no.82 on p.138

*Large Quarry in Upper
Bavaria* 1934
Grosser Steinbruch in
Oberbayern
86 × 118.5
(33 7/8 × 46 5/8)
Private collection,
Courtesy Richard L.
Feigen & Co., New York
G392
no.96 on p.176

Journey on the Fish
1934
Reise auf dem Fisch
134.5 × 115.5
(53 × 45 1/2)
Staatsgalerie Stuttgart
G403
no.80 on p.135

Departure 1932, 1933–5
Abfahrt
Side panels:
215.3 × 99.7
(84 3/4 × 39 1/4)
Central panel:
215.3 × 115.2
(84 3/4 × 45 3/8)
The Museum of
Modern Art, New York.
Given anonymously (by
exchange), 1942
G412
no.60 on pp.106–7

The Organ-Grinder
1935
Der Leiermann
150 × 120.5
(59 × 47 1/2)
Museum Ludwig,
Cologne
G414
no.94 on p.170

*Family Portrait of
Heinrich George* 1935
Familienbild Heinrich
George
215 × 100
(84 5/8 × 39 3/8)
Staatliche Museen zu
Berlin, Nationalgalerie
G416
no.92 on p.165

Self-Portrait in Tails
1937
Selbstbildnis im Frack
192.5 × 89
(75 3/4 × 35)
The Art Institute of
Chicago. Gift of Lotta
Hess Ackerman and
Philip E. Ringer
G459
no.93 on p.169

The King 1933, 1937
Der König
135.5 × 100.5
(53 3/8 × 39 3/8)
The Saint Louis Art
Museum. Bequest of
Morton D. May
G470
no.95 on p.174

Birth 1937
Geburt
121 × 176.5
(47 5/8 × 69 1/2)
Staatliche Museen zu
Berlin, Nationalgalerie
G478
no.99 on p.183

Self-Portrait with Horn
1938
Selbstbildnis mit Horn
110 × 101
(43 1/4 × 39 3/4)
Neue Galerie, New York
G489
no.150 on p.237

Death 1938
Tod
121 × 176.5
(47 5/8 × 69 1/2)
Staatliche Museen zu
Berlin, Nationalgalerie
G497
no.98 on pp.180–1

Hell of the Birds 1938
Hölle der Vögel
120 × 160.5
(47 1/4 × 63 1/4)
Richard L. Feigen, New
York
G506
no.101 on pp.188–9

*Seascape with Agaves
and an Old Castle* 1939
Meerlandschaft mit
Agaven und altem
Schloss
60 × 90.5
(23 5/8 × 35 5/8)
Staatliche Museen zu
Berlin, Nationalgalerie
G534
no.102 on p.190

Acrobat on a Trapeze
1940
Akrobat auf der
Schaukel
146 × 90
(57 1/2 × 35 3/8)
The Saint Louis Art
Museum. Bequest of
Morton D. May
G547
no.100 on p.184

In the Circus Wagon
1940
Im Aristenwagen
86.5 × 118.5
(34 × 46 5/8)
Städtische Galerie im
Städelschen
Kunstinstitut, Frankfurt
am Main
G552
no.106 on p.198

Dream of Monte Carlo
1940–3
Traum von Monte Carlo
160 × 200
(63 × 78 3/4)
Staatsgalerie Stuttgart
G633
no.151 on pp.238–9

*Double-Portrait Max
Beckmann and Quappi*
1941
Doppelbildnis Max
Beckmann und Quappi
194 × 89
(76 3/8 × 35)
Stedelijk Museum,
Amsterdam
G564
no.108 on p.202

Perseus 1940–1
Perseus
Side panels:
150.5 × 56
(59 1/4 × 22)
Central panel:
150.5 × 110.5
(59 1/4 × 43 1/2)
Museum Folkwang,
Essen
G570
no.105 on pp.194–5

Actors 1941–2
Schauspieler
Side panels:
200 × 85
(78 3/4 × 33 1/2)
Central panel:
200 × 150
(78 3/4 × 59)
Courtesy of the Fogg
Art Museum, Harvard
University Art
Museums
G604
no.107 on pp.200–1

*Female Head in Blue
and Grey* 1942
Weiblicher Kopf in Blau
und Grau
60 × 30
(23 5/8 × 11 3/4)
Private collection
G606
no.158 on p.247

Soldier's Dream 1942
Traum des Soldaten
90 × 145
(35 3/8 × 57 1/8)
Private collection,
Courtesy Richard L.
Feigen & Co., New York
G616
no.103 on p.192

The Artists with Vegetables 1943
Les Artistes mit Gemüse
150 × 115.5
(59 × 45 1/2)
Washington University Gallery of Art, St Louis. University purchase, Kende Sale Fund, 1946
G626
no.109 on p.204

Half-nude Clown 1944
Halbakt-Clown
60 × 90.5
(23 5/8 × 35 5/8)
Sprengel Museum Hannover
G658
no.152 on p.240

Prunier 1944
Prunier
100.3 × 76.8
(39 1/2 × 30 1/4)
Tate, London. Purchased 1979
G667
no.153 on p.240

Quappi in Blue and Grey 1944
Quappi in Blau und Grau
98.5 × 76.5
(38 3/4 × 30 1/8)
Museum Kunst Palast, Düsseldorf
G673
no.104 on p.193

Portrait of Family Lütjens 1944
Familienbild Lütjens
179.5 × 85
(70 5/8 × 33 1/2)
Private collection
G683
no.110 on p.206

Still Life with Three Skulls 1945
Totenkopfstilleben
55.2 × 89.5
(21 3/4 × 35 1/4)
Museum of Fine Arts, Boston. Gift of Mrs Culver Orswell
G694
no.154 on p.242

Air Balloon with Windmill 1947
Luftballon mit Windmühle
138 × 128
(54 3/8 × 50 3/8)
Portland Art Museum, Oregon. Helen Thurston Ayer Fund
G749
no.155 on p.243

Quappi in Grey 1948
Bildnis Quappi in Grau
108.5 × 79
(42 3/4 × 31)
Anonymous
G761
no.157 on p.246

Masquerade 1948
Maskerade
164.6 × 88.2
(64 3/4 × 34 3/4)
G765
The Saint Louis Art Museum. Gift of Mr and Mrs Joseph Pulitzer Jr
no.161 on p.254

Cabins 1948
Cabins
139.5 × 190
(54 7/8 × 74 3/4)
G770
Kunstsammlung Nordrhein-Westfalen, Düsseldorf
no.156 on pp.244–5

The Beginning 1946–9
Der Anfang
Side panels:
165 × 85 (65 × 33 1/2)
Central panel:
175 × 150 (69 × 59)
The Metropolitan Museum of Art, New York. Bequest of Miss Adelaide Milton de Groot, 1967
G789
no.84 on pp.140–1

Falling Man 1950
Abstürzender
142 × 89
(55 7/8 × 35)
National Gallery of Art, Washington DC. Gift of Mrs Max Beckmann
G809
no.160 on p.251

Self-Portrait in Blue Jacket 1950
Selbstbildnis in blauer Jacke
139 × 91.5
(54 3/4 × 36)
The Saint Louis Art Museum. Bequest of Morton D. May
G816
no.164 on p.259

Woman with Mandolin in Yellow and Red 1950
Frau mit Mandoline in Gelb und Rot
92 × 140
(36 1/4 × 55 1/8)
Bayerische Staatsgemäldesammlungen, Munich, Pinakothek der Moderne
G818
no.159 on pp.248–9

Carnival Mask, Green Violet and Pink (Columbine) 1950
Fastnacht-Maske grün violette und rosa (Columbine)
135.5 × 100.5
(53 3/8 × 39 5/8)
The Saint Louis Art Museum. Bequest of Morton D. May
G821
no.162 on p.255

The Argonauts 1949–50
Argonauten
Side panels:
189 × 84
(74 3/8 × 33 1/8)
Central panel:
203 × 122
(79 7/8 × 48)
National Gallery of Art, Washington DC. Gift of Mrs Max Beckmann
G832
no.163 on pp.256–7

Sculptures

All works are in bronze

Man in the Dark 1934
Mann im Dunkeln
58 × 40 × 40
(22 7/8 × 15 3/4 × 15 3/4)
Sprengel Museum Hannover
G789
no.90 on p.161

Female Dancer c.1935
Die Tänzerin
17.5 × 70 × 25
(6 7/8 × 27 5/8 × 9 7/8)
Galerie Pels-Leusden, Berlin
no.79 on p.133

Crouching Woman 1935
Kriechende Frau
(not cast before 1962)
17.8 × 22.9 × 50.8
(7 × 9 × 20)
Private collection, Courtesy Richard L. Feigen and Co., New York
no.78 on p.131

Self-Portrait 1936
Selbstbildnis
36.8 × 28.6 × 33
(14 1/2 × 11 1/4 × 13)
The Museum of Modern Art, New York. Gift of Curt Valentin, 1951
no.97 on p.177

Adam and Eve 1937
Adam und Eva
85.1 × 38.1 × 30.5
(33 1/2 × 15 × 12)
Private collection, Courtesy Richard L. Feigen & Co., New York
no.76 on p.129

Watercolours and Drawings

All works are on paper

Five sketches for *The Night*
Die Nacht
Museum Kunst Palast, Sammlung der Kunstakademie, Düsseldorf

– 1917
Pencil
16.5 × 19.7
(6 1/2 × 7 3/4)
vW366
no.26 on p.55

– 1917
Pencil
20 × 21.6
(7 7/8 × 8 1/2)
vW367
no.28 on p.55

– 1918
India ink
16.1 × 21
(6 3/8 × 8 1/4)
vW391
no.27 on p.55

– 1918
Blue ink
18.8 × 23.8
(7 1/2 × 9 3/8)
vW392
no.24 on p.54

– 1918
Black ink
21.5 × 29.5
(8 1/2 × 11 5/8)
vW394
no.25 on p.54

Portrait of Fridel Battenberg with her Head in her Hands 1916
Bildnis Fridel Battenberg, mit auf beide Hände gestütztem Kopf
Pencil
30.8 × 23.5
(12 1/8 × 9 1/4)
Städtische Galerie im Städelschen Kunstinstitut, Frankfurt am Main
vW339
no.15 on p.45

Garden View from the Window 1916
Blick aus dem Fenster auf einen Garten
Pencil
24 × 31.8
(9 1/2 × 12 1/2)
Städtische Galerie im Städelschen Kunstinstitut, Frankfurt am Main
vW363
no.45 on p.78

Self-Portrait 1917
Selbstbildnis
Pen and black ink
31.7 × 24.3
(12 1/2 × 9 1/2)
The Art Institute of Chicago. Gift of Mr and Mrs Allan Frumkin
vW368
no.17 on p.47

Sketch for 'The Street' 1919
Skizze zu 'Die Straße'
Black chalk
85.5 × 61
(33 3/4 × 24)
The British Museum, London
vW411
no.23 on p.53

Study of Houses for 'The Nizza in Frankfurt am Main' 1921
Häuserstudie zu 'Das Nizza in Frankfurt am Main'
Pencil
37.8 × 37.2
(14 7/8 × 14 5/8)
Graphische Sammlung im Städelschen Kunstinstitut, Frankfurt am Main
vW472
no.42 on p.74

Mirror on an Easel 1926
Spiegel auf einer Staffelei
Charcoal and crayon
50.2 × 64.9
(19 3/4 × 25 1/2)
The Museum of Modern Art, New York. Gift of Sanford Schwartz in memory of Irving Drutman
no.145 on p.231

Young Boy with a Lobster 1926
Junge mit Hummer
Charcoal with whitening
64 × 48
(25 1/4 × 18 7/8)
Karin and Rüdiger Volhard
no.56 on p.92

Rimini 1927
Rimini
Pastel
48.5 × 64
(19 1/8 × 25 1/4)
Private collection
no.55 on p.91

Figure Skating 1928
Eiskunstlauf
Pastel
80 × 72
(31 1/2 × 28 3/8)
Private collection
no.149 on p.235

Newspaper Seller 1928
Zeitungsverkäuferin
Black chalk
63.5 × 48.5
(25 × 19 1/8)
Private collection
no.57 on p.93

The Night 1928
Die Nacht
Black chalk
65.5 × 187
(25 3/4 × 73 5/8)
Sprengel Museum Hannover. Gerda and Theo Garve Foundation, in memory of Christoph and his mother Else Garve
no.66 on pp.118–19

The Murder 1933
Der Mord
Aquarelle over charcoal
50 × 45
(19 5/8 × 17 3/4)
Karin and Rüdiger Volhard
no.144 on p.230

Self-Portrait (Manon) 1940
Selbstbildnis (Manon)
Ink
20.5 × 17.5
(8 1/8 × 6 7/8)
Private collection
no.146 on p.231

A Walk (The Dream) 1946
Spaziergang (Der Traum)
Ink 32 × 26.5
(12 5/8 × 10 3/8)
Private collection
no.147 on p.232

Early Humans 1946, 1948–9
Frühe Menschen
Gouache, aquarelle and ink
75 × 64.5
(29 1/2 × 25 3/8)
Private collection
no.143 on p.229

Young Woman with Glass 1946–9
Junge Frau mit Glas
Ink, watercolour and gouache on paper
42.2 × 30.2
(16 5/8 × 11 7/8)
Galerie Pels-Leusden, Zurich
no.148 on p.233

Prints and Portfolios

All works are on paper

The Grenade 1916
Die Granate
Drypoint
38.6 × 28.9
(15 1/4 × 11 3/8)
The British Museum, London
H80
no.18 on p.48

Happy New Year 1917
Prosit Neujahr
Plate 17 of portfolio
Faces
Drypoint
23.9 × 30
(9 3/8 × 11 3/4)
The British Museum, London
H108
no.19 on p.49

Lovers II 1918
Liebespaar II
Plate 5 of portfolio
Faces
Drypoint
21.9 × 25.7
(8 5/8 × 10 1/8)
The British Museum, London
H126
no.20 on p.50

Main River Landscape 1918
Mainlandschaft
Sheet 6 of portfolio
Faces
Drypoint
Drypoint on paper
25.1 × 30
(9 7/8 × 11 3/4)
The British Museum, London
H128
no.47 on p.80

The Yawners 1918
Die Gähnenden
Plate 7 of portfolio
Faces
Drypoint
30.8 × 25.5
(12 1/8 × 10)
The British Museum, London
H129
no.21 on p.51

Resurrection 1918
Auferstehung
Plate 12 of portfolio
Faces
Drypoint
24 × 33.2
(9 3/8 × 13 3/8)
The British Museum, London
H132
no.22 on p.52

Landscape with Balloon 1918
Landschaft mit Luftballon
Sheet 14 of portfolio
Faces
Drypoint
23.3 × 29.5
(9 1/4 × 11 5/8)
The British Museum, London
H134
no.50 on p.83

Hell 1919
Die Hölle
Portfolio of ten transfer lithographs plus cover
Published by I.B. Neumann, Berlin 1919
Edition of 75
No.4/75
37.1 × 27
(14 5/8 × 10 5/8)
National Gallery of Scotland, Edinburgh
H139–49

– *Self-Portrait* 1919
Selbstbildnis
Cover
63.4 × 41.8
(25 × 16 1/2)
H139
no.29 on p.56

– *The Way Home* 1919
Der Nachhauseweg
Plate 1
73.3 × 48.8
(28 7/8 × 19 1/4)
H140
no.30 on p.56

– *The Street* 1919
Die Straße
Plate 2
67.3 × 53.5
(26 1/2 × 21)
H141
no. 31 on p.59

– *The Martyrdom* 1919
Das Martyrium
Plate 3
54.5 × 75
(21 1/2 × 29 1/2)
H142
no.32 on pp.60–1

– *Hunger* 1919
Der Hunger
Plate 4
62 × 49.8
(24 3/8 × 19 5/8)
H143
no.33 on p.62

– *The Ideologues* 1919
Die Ideologen
Plate 5
71.3 × 50.6
(28 1/8 × 19 7/8)
H144
no.34 on p.63

– *The Night* 1919
Die Nacht
Plate 6
55.6 × 70.3
(21 7/8 × 27 5/8)
H145
no.35 on p.64

– *Malepartus* 1919
Malepartus
Plate 7
69 × 42.2
(27 1/8 × 16 5/8)
H146
no.36 on p.66

– *The Patriotic Song* 1919
Das patriotische Lied
Plate 8
77.5 × 54.5
(30 1/2 × 21 1/2)
H147
no.37 on p.67

– *The Last Ones* 1919
Die Letzten
Plate 9
75.8 × 46
(29 7/8 × 18 1/8)
H148
no.38 on p.68

– *The Family* 1919
Die Familie
Plate 10
76 × 46.5
(29 7/8 × 18 1/4)
H149
no.39 on p.69

Self-Portrait 1922
Selbstbildnis
Woodcut on paper
22.2 × 15.4
(8 3/4 × 6 1/4)
Lent to Tate, London, by the Trustees of the Marie-Louise von Motesiczky Charitable Trust 1996
no.16 on p.46

Group Portrait Eden Bar 1923
Gruppenbildnis Edenbar
Woodcut
70 × 55.5
(27 1/2 × 21 7/8)
Private collection
H277
no.40 on p.71

Apocalypse 1941–2
Apokalypse
82 page book including 27 handcoloured lithographs (17 exhibited)
Published by Bauersche Gießerei, Frankfurt am Main 1943
Numbered edition of 24
Artist's proof
Private collection
nos.111–27 on pp.210–19

– Illus.1
Frontispiece
Image size: 33.3 × 27.8
(13 1/8 × 11)
H330
no.111 on p.210

– Illus.6
Rev. 4:1–8:
Image size: 27.6 × 21.1
(10 7/8 × 8 1/4)
H335
no.112 on p.211

– Illus.7
Rev. 5:1–7:
Image size: 20.3 × 19.5
(8 × 7 3/4)
H336
no.113 on p.211

– Illus.8
Rev. 6:2–8:
Image size: 24.9 × 17
(9 3/4 × 6 3/4)
H337
no.114 on p.212

– Illus.11
Rev. 8:6–13:
Image size: 34.3 × 26.7
(13 1/2 × 10 1/2)
H340
no.115 on p.212

– Illus.12
Rev. 9:3–10:
Image size: 32.4 × 27.4
(12 3/4 × 10 3/4)
H341
no.116 on p.213

– Illus.13
Rev. 10:1–8:
Image size: 31.3 × 25.4
(12 3/8 × 10)
H342
no.117 on p.213

– Illus.14
Rev. 11:1–13:
Image size: 31.1 × 27.4
(12 1/4 × 10 3/4)
H343
no.118 on p.214

– Illus.15
Rev. 12:2–16:
Image size: 31.9 × 26.7
(12 1/2 × 10 1/2)
H344
no.119 on p.214

– Illus.16
Rev. 13:1–14:
Image size: 34.5 × 26.6
(13 5/8 × 10 1/2)
H345
no.120 on p.215

– Illus.17
Rev. 14:13–16:
Image size: 27 × 25.6
(13 7/8 × 10 1/8)
H346
no.121 on p.216

– Illus.18
Rev. 15:6–8:
Image size: 32.2 × 27.8
(12 3/4 × 11)
H347
no.122 on p.216

– Illus.21
Rev. 17:3–5:
Image size: 34.9 × 23.3
(13 3/4 × 9 1/4)
H350
no.123 on p.217

– Illus.23
Rev. 19:11–19:
Image size: 35.2 × 27
(13 7/8 × 10 5/8)
H352
no.124 on p.217

– Illus.24
Rev. 20:4 and 20:11–12:
Image size: 33.2 × 26.1
(18 1/8 × 10 1/4)
H353
no.125 on p.218

– Illus.25
Rev. 21:1–4:
Image size: 33.2 × 26.3
(13 1/8 × 10 3/8)
H354
no.126 on p.219

– Illus.26
Rev. 22:5–8:
Image size: 33.7 × 27
(13 1/4 × 10 5/8)
H355
no.127 on p.219

Day and Dream 1946
Portfolio of 15 handcoloured lithographs
Published by Kurt Valentin, New York 1946
Edition of 90
No.29/90
40 × 30
(15 3/4 × 11 7/8)
Kunsthalle Bremen
H357–71

– *Self-Portrait*
Plate 1
H357
no.128 on p.220

– *Weather-vane*
Plate 2
H358
no.129 on p.220

– *Sleeping Athlete*
Plate 3
H359
no.130 on p.221

– *Tango*
Plate 4
H360
no.131 on p.221

– *Crawling Woman*
Plate 5
H361
no.132 on p.222

– *I Don't Want To Eat my Soup*
Plate 6
H362
no.133 on p.222

– *Dancing Couple*
Plate 7
H363
no.134 on p.223

– *King and Demagogue (Time-Motion)*
Plate 8
H364
no.135 on p.223

– *The Buck*
Plate 9
H365
no.136 on p.224

– *Dream of War*
Plate 10
H366
no.137 on p.225

– *Morning*
Plate 11
H367
no.138 on p.225

– *Circus*
Plate 12
H368
no.139 on p.226

– *Magic Mirror*
Plate 13
H369
no.140 on p.226

– *The Fall of Man*
Plate 14
H370
no.141 on p.227

– *Christ and Pilate*
Plate 15
H371
no.142 on p.227

Lenders

PUBLIC COLLECTIONS
Stedelijk Museum, Amsterdam
Öffentliche Kunstsammlung Basel,
 Kunstmuseum
Staatliche Museen zu Berlin,
 Nationalgalerie
Galerie Kornfeld, Bern
Kunsthalle Bielefeld
Kunsthalle Bremen
Museum of Fine Arts, Boston
Busch-Reisinger Museum and Fogg
 Art Museum, Harvard University
 Art Museums, Cambridge,
 Massachusetts
The Art Institute of Chicago
Museum Ludwig, Cologne
The Detroit Institute of Arts
Wilhelm-Lehmbruck-Museum,
 Duisburg
Museum Kunst Palast, Düsseldorf
Kunstsammlung Nordrhein-
 Westfalen, Düsseldorf
National Gallery of Scotland,
 Edinburgh
Museum Folkwang, Essen
Städtische Galerie im Städelschen
 Kunstinstitut, Frankfurt am Main
Staatliche Galerie Halle,
 Landeskunstmuseum Sachsen-
 Anhalt
Kunsthalle Hamburg
Sprengel Museum Hannover
The British Museum, London
Städtische Kunsthalle Mannheim
Frederick R. Weismann Art
 Museum, University of
 Minnesota, Minneapolis
Bayerische
 Staatsgemäldesammlungen,
 Munich, Pinakothek der Moderne
Richard L. Feigen & Co., New York
The Metropolitan Museum of Art,
 New York
Neue Galerie, New York
Portland Art Museum
The Saint Louis Art Museum
Washington University Gallery of
 Art, St Louis
Staatsgalerie Stuttgart
Rose Art Museum, Brandeis
 University, Waltham,
 Massachusetts
National Gallery of Art, Washington
 DC
Kunstsammlungen zu Weimar
Museum Wiesbaden
Von der Heydt-Museum Wuppertal

PRIVATE COLLECTIONS
Richard L. Feigen
Karin and Rüdiger Volhard
and all other private lenders who
 wish to remain anonymous

Photographic Credits

Arthothek, Weilheim
Thomas Ammann Fine Art AG,
 Zurich
Basel Öffentliche Kunstsammlung /
 Martin Buhlerol
Gemäldegalerie, Staatliche Museen
 zu Berlin
Max Beckmann Archiv, Munich
Bildarchiv Preußicher Kulturbesitz,
 Berlin
Bielefeld Kunsthalle
Bremen Kunsthalle
British Museum, London
The Bridgeman Art Library, London
Museum of Fine Arts, Boston
Art Institute of Chicago
Rheinisches Bildarchiv, Cologne
Detroit Institute of Arts
Scottish National Gallery of Modern
 Art, Edinburgh
Ursula Edelmann
Frankfurt am Main, Städelches
 Kunstinstitut und Städtische
 Galerie
Folkwang Museum, Essen
René Gerritsen, Amsterdam
The Solomon R. Guggenheim
 Foundation, New York / David
 Heald
Hamburger Kunsthalle Fotoarchiv /
 Elke Walford
Courtesy of the President and
 Fellows of Harvard College
Halle, Staatliche Museum
McKee Gallery
Kornfeld Gallery, Bern / Peter Lauri
Mannheim Stadtische Kunsthalle
Bayerische
 Staatsgemäldesammlungen, Alte
 Pinakothek, Munich
Staatsgemäldesammlungen,
 Staatsgalerie Moderner Kunst,
 Munich
The Metropolitan Museum of Art,
 New York
The Museum of Modern Art, New
 York
Kunstsammlung Nordrhein-
 Westfalen, Düsseldorf
Neue Galerie, New York
Musée Picasso, Paris / J.G. Berizzi
Portland Museum of Art
Galerie Pels-Leusden, Berlin, Zurich
Kunst Palast, Düsseldorf
Rose Art Museum, Brandeis
 University
Rijksmuseum, Amsterdam
The Saint Louis Museum of Art
Ursula Seitz-Gray
Sprengel Museum Hannover
Stedelijk Museum, Amsterdam
Staatsgalerie Stuttgart
Galerie der Stadt, Stuttgart
Tate Photography, London

Von der Heydt Museum Wuppertal
National Gallery of Art, Washington
Weimar Kunstsammlung
Frederick R.Weisman Art Museum
 at the University of Minesota
The Whitney Museum of American
 Art, New York / Geoffrey Clements
Wiesbaden Museum

Index

Errata

In this catalogue the titles and dates
attributed to the paintings are based on those
given in the *catalogue raisonné* of Beckmann's
oils by Erhard Göpel and Barbara Göpel (see
Bibliography). (The German titles used by
Göpel and Göpel appear in the List of Works.)
However, some of the English translations
used are not those by which the works are
currently known. The correct titles are as
follows:

no.9	*The Descent from the Cross*
no.12	*Family Picture*
no.85	*Self-Portrait with a Cigarette*
no.101	*Birds' Hell*

Likewise, dates for the following works
should read:

no.60	*Departure* 1932–3
no.95	*The King* 1937
no.97	*Self-Portrait* cast 1951

The publishers would like to apologise that
credit lines for the following works have been
cited incorrectly.

no.77 *Reclining Nude* 1929
The credit line should read:
'The Art Institute of Chicago. Joseph
Winterbotham Collection'

no.83 *Artist at the Beach* 1930
The credit line should read:
'Richard L. Feigen, New York

no.107 *The Actors* 1941–2
The credit line should read:
'Courtesy of the Fogg Art Museum, Harvard
University Art Museums. Gift of Lois Orswell